THE PELICAN HISTORY OF ART

JOINT EDITORS: NIKOLAUS PEVSNER AND JUDY NAIRN

ROMAN ART

DONALD STRONG

Garden scene, detail of wall painting from the villa of Livia at Prima Porta, late first century B.C.
Rome, Museo Nazionale Romano

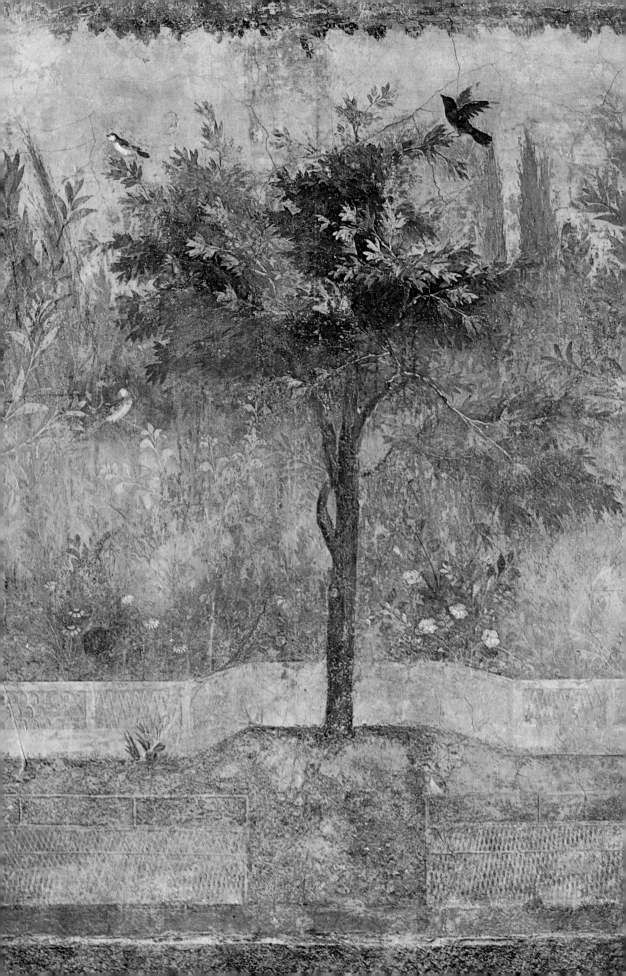

DONALD STRONG

ROMAN ART

PREPARED FOR PRESS BY
J. M. C. TOYNBEE

THE · PELICAN · HISTORY · OF · ART ·

PUBLISHED BY PENGUIN BOOKS

Penguin Books Ltd, Harmondsworth, Middlesex, England
Penguin Books Inc., 7110 Ambassador Road, Baltimore, Maryland 21207, U.S.A.
Penguin Books Australia Ltd, Ringwood, Victoria, Australia
Penguin Books Canada Ltd, 41 Steelcase Road West, Markham, Ontario, Canada
Penguin Books (N.Z.) Ltd, 182–190 Wairau Road, Auckland 10, New Zealand

★

Text printed by Richard Clay (The Chaucer Press) Ltd, Bungay, Suffolk
Plates printed by Balding & Mansell Ltd, London
Made and printed in Great Britain

★

ISBN 0 14 0560.39 4

★

First published 1976

CONTENTS

v

CONTENTS

CONTENTS

CONTENTS

The Plates

LIST OF PLATES

When Donald Emrys Strong died suddenly at Nicaea (Iznik) in Turkey in September 1973, he had completed the first draft of this book, down to the end of the final chapter. The book is therefore wholly his. But while much of it was already in typescript, he had added later large portions in manuscript and had not yet fully integrated them with the earlier typed sections. It was therefore necessary for another student of Roman art, with the invaluable and indispensable help of Mrs Shirley Strong, to revise the whole, deciphering the manuscript pages, incorporating them in their proper places, and eliminating, as far as possible, repetitions in content due to the fact that the author did not have time to revise the text himself. The whole book could then be retyped and presented to me. The onerous work was undertaken by Professor Jocelyn M. C. Toynbee. She did it admirably, and all users of The Pelican History of Art *will be grateful to her. Shirley Strong has asked me to add her special thanks to Professor Toynbee, whose teaching first inspired her husband with his love for Roman art, whose help and advice so kindly given he had valued throughout his life, and whose work he so much admired.*

Volumes in The Pelican History of Art *are normally richly equipped with footnotes. In the case of* Roman Art *they have had to be dispensed with, since the author left virtually none, having obviously intended to compose them at a later stage; and it was naturally impossible for anyone to know what his wishes were in their regard. On the other hand, he did incorporate in the body of the text a certain number of valuable references, and Professor Toynbee has thought it best to leave them as they are. He also left very little in the way of bibliography. But the books and articles that he did cite have been included in a lengthy bibliography compiled by Professor Toynbee in the hope that it, together with the above-mentioned text-references, will compensate, in part at least, for the lack of footnotes and equip the book with reasonably adequate documentation.*

Similarly, the author, while noting in the text a few of the works of art that he wanted illustrated, did not have time to draw up a full list of plates. The task of choosing pictures to illustrate the whole book has thus also devolved on Professor Toynbee. I have no doubt that those that she has selected will, by and large, coincide with what Donald Strong's wishes were. This part of Professor Toynbee's task has been made particularly pleasurable, so she told me, through the eager co-operation of Mrs Susan Rose-Smith of Penguin's, who collected the copy for the plates from innumerable sources both at home and abroad.

This book represents the mature fruit of Donald Strong's lifelong devotion to the study of Roman art against its hellenistic and Etruscan backgrounds – as a research student at the British School at Rome, as Assistant Keeper in the Department of Greek and Roman Antiquities in the British Museum, and finally as Professor of the Archaeology of the Roman Provinces in the University of London. In the last capacity he proved himself to be a brilliant, devoted, and greatly beloved teacher, enchantingly witty in speech and unstintingly generous of time, energy, inspiration, and knowledge that he lavished on colleagues and pupils alike. All who knew him,

whether personally, or only through his numerous publications, will rejoice that this book, his major, but alas his final, achievement, has been bequeathed by him to the worlds of art and learning.

NIKOLAUS PEVSNER

PREFACE

THE history of Roman art begins in the dim mists of semi-historical time when Rome was founded and continues through the period of expansion under the Republic into the Empire and the establishment of an official art designed to express the new and increasingly absolutist order of the Roman government. The influence of Roman art continues long after the decline of the Empire in the West and it has been responsible for many subsequent artistic revivals.

Works of art, especially sculpture, were part of the everyday life of ancient cities. Sculpture and painting gave form to the gods, commemorated the great men of the State, celebrated the events of history, depicted the dead on their tombs. In Rome they took on an even greater significance. They became an essential part of political propaganda, of public display, indeed, of any architectural design, and in private settings they became commonplace and, in many contexts, inevitable; and inevitably the appreciation of art for itself is subordinated to purpose or setting. The established rhythms of architecture and sculpture, for example the standing figures in niches or on pedestals, the relief friezes or figured spandrels of arches, place sculpture in a subordinate, almost decorative role. These are the essential patterns of Graeco-Roman architecture revived by the Renaissance.

The prevailing attitude to 'works of art' is that of Cicero, who recognizes that sculpture is essential to certain settings; he defines 'topiary work', for example, as off-setting the sculpture of his garden porticoes and looks to Atticus for appropriate furnishings in his 'Academy'. Just as the gardens of Rome, public and private, have certain appropriate buildings – porticoes, *nymphaea*, etc., – so there is an appropriate artistic décor: Satyrs, Nymphs, ornamental reliefs of Bacchus and other set groups. Everything tends to be created for a specific purpose or with a specific meaning and, inevitably, valued less for itself. Nor is there any high regard for the contemporary artist as a creative being; he is rewarded for his services on scales related to the usefulness and skill involved. Creative genius is admired, but generally in the work of artists long dead. At no time were works of art more prominent, more essential to palatial and social life.

Creative artists do not dictate the development of art in Rome. At every period it is the patron, whether he be a private citizen or an official of the imperial government, who plays the leading role. Because the patronage is fundamentally Roman, there is always something specifically Roman in Roman art; and for the same reason, at least until the late Empire, the Greek tradition is basically unchallenged, not simply because the artists were generally of Greek nationality but because classical Greek art was the acceptable standard of the Roman patron. The Ara Pacis is not Greek in design, if Greek it is, because the artists who made it were Greeks, as they seem to have been; it is so because whoever was responsible for its erection felt that this particular design best expressed the political and religious needs of the moment. The caryatids of the Erech-

theum were chosen to decorate part of the forum of Augustus because the style they expressed suited the design of that austere dynastic monument; the man who carved some of them has in fact an Italian name.

It is generally unprofitable to attempt to isolate specifically Roman elements of style and technique in the study of Roman art. Many supposedly 'Roman' elements are found to have a basis in the earlier Greek tradition and to develop logically from it. Almost all the subject matter of Roman art is derived in some way from the Greek, but the interpretation or the emphasis is genuinely Roman, developing and changing as Roman taste and ideas change. Other elements may indeed be 'inventions' of Roman-age artists, but most of them will be found to arise not so much from the creative ability of the artist as from some need expressed by the patron. Analysis of late republican portraits or historical reliefs is more easily made in terms of the intentions of the patron than by any attempt to analyse objectively the elements of style. Patronage holds the key to all the chief phases of Roman art; the kings with their attempts to rival the splendours of the Lucumones in neighbouring Etruscan city-states, the somewhat cautious conservatism of the early centuries of the Republic, the rapid development of public munificence after the Punic Wars, the rise of philhellenism and its influence on all levels of society in the late Republic, the creation of an official State art under Augustus, the increasing autocracy of the governments under later emperors – these are also the keys to the development of Roman art.

But the concept of patronage as the driving motive can be over-simplified. The patron does not always get what he wants or what he expects. In the later Empire a recognizably Roman style had been created in architecture, sculpture, and painting, but it was increasingly subjected to outside pressures due to new religious concepts, new ideas of kingship which were slowly transforming the classical tradition, i.e. the very framework in which Roman patronage operated. We must remember too that patrons of very different kinds existed at the same time, although of course the State is the leading patron and effectively dictates the main lines of development.

It is also true that the classical tradition has an impetus of its own, and in areas which are outside the main stream of artistic development new ideas of technique and style can develop and make their influence felt without being the conscious taste of contemporary patronage. One may take the case of the building programme inaugurated by Septimius Severus at Lepcis Magna, which involved the creation of an artistic programme to glorify the birthplace of the emperor. It is clear that the artists used in this programme came from Asia Minor, probably because they were readily available. The result was that a new style of carving, and indeed a new method of artistic representation, dominate the architecture and sculpture at Lepcis; and this is a prelude to an even wider extension of its influence later on. But we have to ask ourselves how much of this is a matter of deliberate imperial choice and whether Septimius' advisers were particularly devoted to this method of artistic expression.

One must also recognize that official patronage is strongly influenced by patronage of other kinds, especially private patronage. From the hellenistic world the Roman patricians inherited a taste for the pleasures of art which they used to decorate the

interiors of their houses and the gardens of their country villas. In public places, these Roman patricians created buildings which became museums of works of art from all over the Mediterranean world, and this is one of the main reasons why the symbolism of their religious and political life came to be conceived in terms of classical art. Without this deep-rooted private taste for Greek art Roman official art would have taken a far different direction.

The purpose of this book is to fill a place in a series devoted to the history of art. It ought strictly to be concerned only with those branches of art which are in the main stream of artistic development; it ought also to be concerned only with the products of the best artists of the period. In the case of Roman art, however, neither of these aims can be consistently followed. In painting, for example, we have only the work of interior decorators, mostly in Campanian cities, with a few in Rome and in the provinces, which demonstrates, as we should expect, that we are dealing with a remarkably high, and uniformly high, standard of craftsmanship, but one which rarely allows us to glimpse the quality and technique of the best painters. We know almost nothing about the best portrait painters or about the masters of triumphal pictures or about Court painters in general. Even in the case of sculpture, where the documents are more plentiful and much work of high quality has been preserved, it is clear that almost all the best bronze statuary has disappeared, and so have most official portraits. Sculpture from buildings probably provides us with the most consistent record of the best craftsmanship available at the time; but this record always needs to be supplemented from other sources.

It is not always easy to recognize the different role of art in societies other than our own, especially in ancient societies. In Rome in particular sculpture was involved in very many activities of public life. The precise relationship between the image and the god is not clear, but images certainly act for the divinity on many occasions. The statue of Hercules in the temple of Hercules Musarum was clad in rich vestments and moved to the temple threshold to watch the triumphal procession go past. At the so-called *lectisternia* effigies of the gods, arranged in pairs, reclined at a banquet; gods were normally fed at their altars, but here they were present to dine. In the procession of the *Ludi Magni* a *tensa* carried the statues of the gods. In scenes of sacrifice the god, in the form of a well-known statue, was shown taking part. Cult statues held within them some of the powers of the god himself. When the Romans conquered a foreign city they carried off the statues, persuading them to abandon their old places if they were not, as sometimes, quite willing to come (Livy 5.22). Tales of magic associated with cult statues abound.

The statues of the gods created their personalities. Jupiter did not, perhaps, have to wait for a statue to become a person, but in the guise of the Greek Zeus he must have become a somewhat different person; and other gods changed their character when first represented in human form. When gods are like humans it is easier for men to appear as gods. Scipio claimed Jupiter as his father, and in the confusions of the last centuries of the Republic the gods were treated with increasing familiarity. Sulla with his golden locks, who embodied his luck in Venus, could easily be thought of, and think of himself,

as semi-divine. Caesar used the Olympians for his own ends, claimed divine descent, was eventually declared a god, and after his death went up to heaven. All these men were acutely aware of the role of art in bringing their aspirations to fruition.

Another problem concerns the extent of the area that must be covered. The Roman Empire reached from Spain to the Euphrates and included provinces of widely different character. The eastern provinces were a prime creative force throughout the period, although they influenced rather than dictated the progress of Roman art. The ideas come from the centre, but the interpretations may be widely different in various parts of the Empire. In a book of this kind it is difficult to deal thoroughly with so vast an area; but those provinces which make a significant contribution to the progress of Roman art, or those whose artistic output is particularly interesting, cannot be omitted. Moreover, the impact of Roman art on local traditions is a fascinating subject which can only be touched upon here. This account will therefore concentrate on the artistic output of Rome and Italy, but will range as widely as is necessary to explain the major artistic developments that took place elsewhere.

Similarly, its subject matter must be limited. The creative themes of Roman art are funerary, religious, commemorative, and decorative, and all these categories must be included. The book will be mainly concerned with the major arts of painting and sculpture; but there are several branches of what are nowadays called the 'minor arts' which assume considerable importance in certain periods in the history of Roman art. In the later Republic some of the finest metalworkers were employed in the production of silver plate which reflected the political and religious ideas of the Roman aristocracy; and under the Empire the manufacture of plate for propaganda and other purposes continued to be in the hands of artist-craftsmen of the highest ability. Semi-precious stones, notably the big cameos, were used in the late Republic as media to express the political propaganda of powerful Romans and continued to be an important aspect of imperial propaganda in the hands of Court artists, whose reputation often stood higher than that of any contemporary sculptor or painter.

It may be worth while to preface this account of Roman art with a brief history of the study of the subject. This concerns the development of the concept of 'Roman Art'. Although the Renaissance used originals in Italy, and its Roman background was positive and clear-cut, the study of classical art as it developed increasingly stressed the Greek origins of the classical tradition. In the first systematic study of classical art beginning with J. J. Winckelmann in the eighteenth century no distinction was made between Greek and Roman. The continuity of the classical tradition was the main theme; and its history after the fourth century B.C. was treated as one of steady and inevitable decline in creative inspiration and achievement.

It was the Vienna School of art historians, whose ideas were quickly taken up in England, who began to think of the period of the Roman Empire as in any way significant in the history of art and to recognize that the Romans had made their own contribution to it. F. Wickhoff, in his introducton to the manuscript of the Book of Genesis in Vienna, tried to establish a specific contribution by artists of the Roman age; he found it in what he called the 'illusionism' of the sculpture and painting of the

Flavian period. Another member of the same school, A. Riegl, stressed the importance of the Roman period as a link between the Greek and the Byzantine and characterized the change as essentially that from a three-dimensional concept of art to an 'optical' or two-dimensional method of representation. The work of these two men effectively created the subject of Roman art.

Although Wickhoff's and Riegl's detailed arguments may now be rejected, all subsequent work has been influenced by them. The problems are now argued about in terms of the development of the Roman Empire and its social structure and as an index of complicated cross-currents of thought and inspiration. The simplicity of Strzygowski's famous antithesis between Rome and the East has now been replaced by a much more elaborate series of hypotheses about the various factors that contributed to the ultimate decline of the classical tradition. These factors are seen to reflect changing patterns in Roman political and social life.

One of the key issues has always been the significance of the Italic background of Roman imperial art. Some scholars look for more than the inspiration of Italic traditions in religion, burial customs, and so on, and try to find a specifically Roman or Italic sense of form, and to assess what this may have contributed to the art of the Roman period and to the ultimate development of the Byzantine method of representation. In the most general terms, the fundamental artistic change is from the hellenistic concept of form and the achievement of the Greeks in creating pictorial space to the 'closed' style of Byzantium. Although we cannot explain this change in terms of simple antithesis between, for example, Greek and Roman, the problems remain, and we must weigh up very carefully the contributions of Italy itself and of the various parts of the Empire in this process. These contributions will, it is hoped, become clearer as the book proceeds.

There are certainly fundamental differences between Greek and Roman art; and they can be quite simply illustrated by comparison between the Parthenon frieze and the frieze of the Ara Pacis Augustae. The former is a clear expression, quite self-explanatory, of an ideal; while the Ara Pacis is a complicated expression of political, social, and historical ideas expressed fundamentally in a Greek artistic language. The Greek artist, in his Roman context, has to serve new ideals, but not a fundamentally different sense of form; he modifies his own artistic traditions to express an unfamiliar allegory and symbolism. This is one reason why the archaeologist and the art historian can take fundamentally different views of Roman art and why the problem of the originality of Roman art is so much discussed. No one could deny that the monuments discussed by Wickhoff are distinctively Roman, but further study has shown that their style largely derives from the classical and hellenistic tradition. No one has yet succeeded in discovering a distinctively Italian sense of form in art despite the undeniable originality of many of the Roman art forms.

The problem is most clearly seen in the field of Roman architecture, where certain fundamental differences are obvious between Etruscan and Roman planning, some of them deriving from Italic and Etruscan religious ideas. Some of the latter characteristics run right through the history of Roman architecture, but the architectural language is

very largely common to the Greeks and the Romans. The most important point to bear in mind is that the Roman age does represent fundamentally the continuation of the classical tradition, although that tradition was often put to the service of fundamentally different ideas.

It is easy to underestimate the influence of the creative artist in the Roman Empire. A monument such as the Ara Pacis, with its complex propaganda programme, its bewildering mixture of 'styles' and elements of design, seems best explained as the creation of a man close to the aspirations and policies of the new government. It is difficult to see a sufficiently influential artist in this role at that time. On the other hand recent studies have tended to result in the emergence of definite artistic personalities whose influence on the course of art must have been decisive – the designer of Trajan's column and other monuments of that reign (G. Becatti, *La colonna coclia istoriata*, Rome, 1960, 79 ff.), the man who was responsible for the Aurelian Column, and perhaps other sculptors of the time of Marcus Aurelius. It is generally recognized, too, that certain emperors, among them Nero and Hadrian, must themselves have exerted considerable influence on the course of Roman art. If such personalities are ignored, then Roman art, at least in its official aspects, appears simply as a dull mirror of social and political and even economic change involving the breakdown of old ideas and the inevitable appearance of new. This is how some will read the reliefs made for the arch of Constantine, although they are unique and obviously the creation of a single artistic spirit, who may or may not represent the ideas and aspirations of his contemporaries.

The systematic study of Roman portraiture began with the publication in 1827–9 of Visconti's *Iconographie romaine*, which made use of coin evidence to identify the subjects of the portraits. The great standard work of Bernoulli, *Römische Ikonographie*, was published in 1882–94 and is still the basis of Roman iconographic studies. Monographs on particular periods have followed in this century, including L'Orange's work on late antique portraits and the series of *Das Römische Herrscherbild*. The study of portraits on gems has become an important aspect of the subject. Literary sources on ancient portraiture are very thin and descriptions of the features of famous men almost always inadequate. A great deal of physiognomical theory is known to have existed and must have influenced the portraiture of emperors whose purpose was to create or improve their 'image'.

Recent research in Roman portraiture has recognized the subjective character of many of the identifications based on coins and has sought for more objective criteria by preparing frequency tables of specific physiognomical features (as K. Fittschen did for portraits of Gordian III: *J.d.A.I.*, LXXXIV, 1969, 197 ff.); but it is doubtful whether the statistical approach can ever supersede the 'eye' of the scholar. Another profitable line of research lies in regional studies, which attempt to show the relationship between portraits produced in provincial areas and those made at the centre; clearly this approach is bound to throw light on the methods by which imperial likenesses were distributed.

The study of mosaics depends on adequate and well illustrated publication. Their chief interest is not artistic but social. A new corpus of mosaics is now being prepared under the auspices of the Association Internationale pour l'Étude de la Mosaïque Antique

(A.I.E.M.A.) as a result of a colloquium held in 1963. There is also a *Recueil général des mosaïques de la Gaule* running from 1957 and superseding the *Inventaire des mosaïques de la Gaule et de l'Afrique*, published under the auspices of the Académie des Inscriptions from 1909.

LIST OF THE PRINCIPAL ABBREVIATIONS USED IN TEXT AND BIBLIOGRAPHY

A.A.	*Archäologischer Anzeiger*
A.J.A.	*American Journal of Archaeology*
B.d.A.	*Bollettino d'Arte*
Beckwith	Beckwith, John, *Early Christian and Byzantine Art* (Pelican History of Art), Harmondsworth, 1970
C.I.G.	*Corpus Inscriptionum Graecarum*
C.I.L.	*Corpus Inscriptionum Latinarum*
D.O.P.	*Dumbarton Oaks Papers*
I.G.	*Inscriptiones Graecae*
I.L.S.	*Inscriptiones Latinae Selectae*
Inv. Gaule	*Inventaire des mosaïques de la Gaule*, Paris
J.d.A.I.	*Jahrbuch des Deutschen Archäologischen Instituts*
M.A.A.R.	*Memoirs of the American Academy in Rome*
M.E.F.R.	*Mélanges d'Archéologie et d'Histoire* (École Française de Rome)
P.B.S.R.	*Papers of the British School at Rome*
Repertorium	Deichmann, F. W., etc., *Repertorium der christlich-antiken Sarkophage*, 1: *Rom und Ostia*, Wiesbaden, 1967
R.I.C.	Mattingly, H., and Sydenham, E. A., etc., *The Roman Imperial Coinage*, London, 1923–67
R.M.	*Mitteilungen des Deutschen Archäologischen Instituts, Römische Abteilung*
S.A.H.	Scriptores Historiae Augustae
Wirth	Wirth, F., *Römische Wandmalerei*, Berlin, 1934

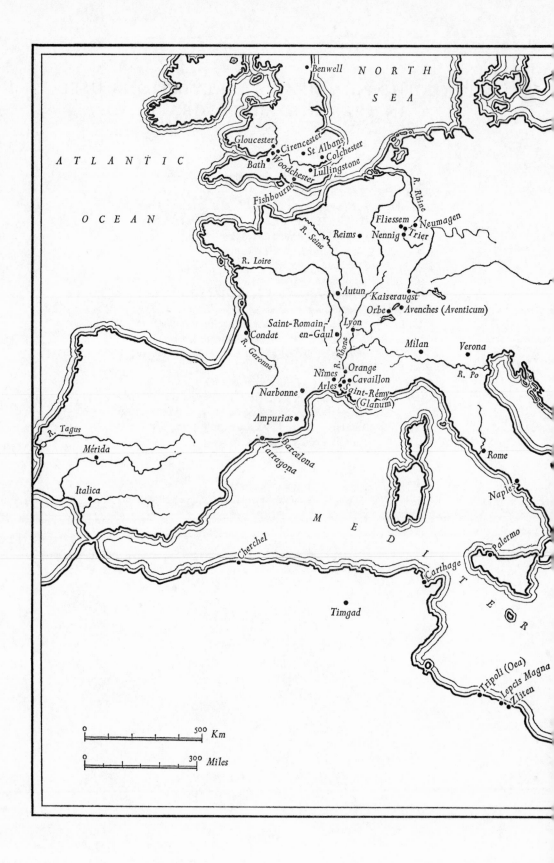

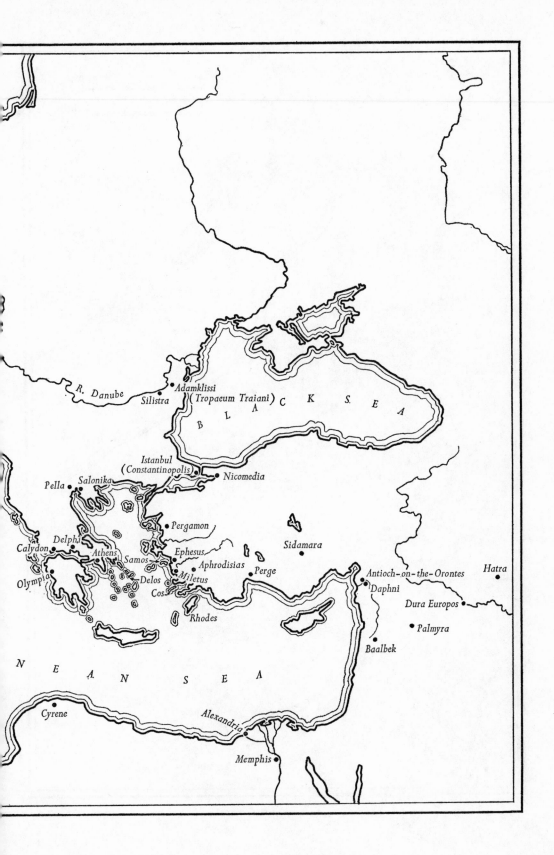

R. Danube

Adamklissi

Silistra (Tropaeum Traiani)

B L A C K S E A

Istanbul
(Constantinopolis)

Nicomedia

Pella

Salonika

Pergamon

Sidamara

Delphi

Calydon

Athens

Samos

Ephesus

Aphrodisias

Perge

Olympia

Delos

Miletus

Cos

Rhodes

Antioch-on-the-Orontes

Hatra

Daphni

Dura Europos

Palmyra

Baalbek

N E A N S E A

Cyrene

Alexandria

Memphis

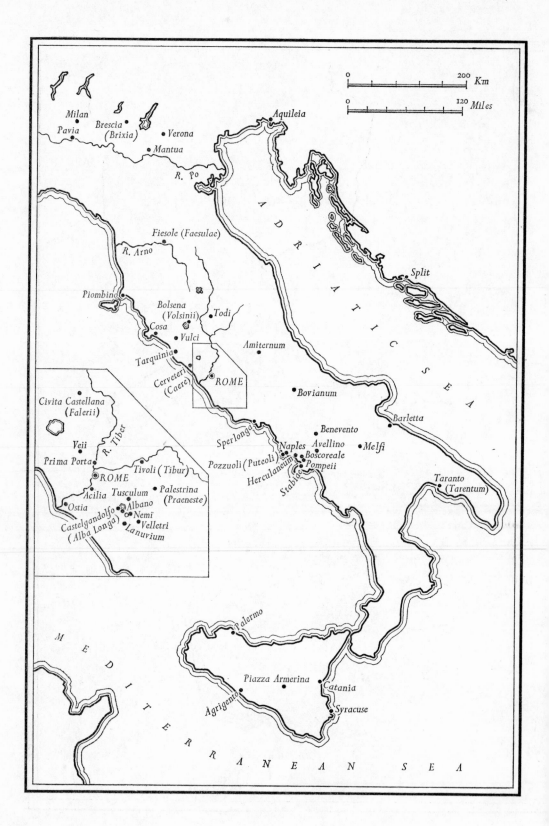

THE BEGINNINGS

THE earliest evidence for art in Rome comes from the graves of the Early Iron Age in the area of the later city. These graves, the oldest of which belong to the tenth and ninth centuries B.C., contain simple human figures, male and female, some of which come from the house-urns that are especially common in Rome and Latium. The figures are probably meant to be representations of the Genii of the persons buried; offerings would be made to them at the tomb. There is little doubt that behind these figures lies an elaborate body of belief about the life after death and about the connections between the figures and the divine powers; and they illustrate the fact that funerary customs were from the beginning, and always remained, one of the driving forces of Roman art. It is less likely that these simple figurines were meant as divinities. It has been argued that the house-urns are representations of the ancient temple of Vesta, since Vesta was supposed to be one of the earliest deities. But we know that Vesta for a long time resisted anthropomorphization, and there is a tradition that the religion of Numa had no idols and that it was only under the influence of Etruscan art that the Roman divinities began to assume human form.

The development of Rome as an Etruscan city-state introduces the prehistory of Roman art. The final stage of the process of urbanization, i.e. the formation of a city out of a series of related villages, was probably political and did involve direct Etruscan rule. But this must have been preceded by an infiltration of Greek and Etruscan elements culminating in strong Etruscan influence. Fine bucchero ware from Cerveteri (Caere) and Veii is the chief evidence, and it shows where Rome's commercial and artistic connections lay. No doubt the early reaction to Etruscan influence varied. Differences of taste between the inhabitants of the Palatine and the Esquiline hills in pre-urban days may reflect different cultural traditions. But Rome in general followed the same process of development as the rest of Iron Age Latium. The amount of Greek pottery imported into Rome before the city-state was established is very small, and this seems to suggest that there was very little direct contact with the Greeks. On the other hand, Greek imports increased enormously in the period after 575 B.C., which must be the approximate date for the synoecism which constituted the founding of Rome.

It was therefore the influence of Etruria that established the artistic contacts of Rome with Greece and Etruria in the sixth century B.C., and Etruscan art and architecture dominated the newly founded city. For some time after there was no massive programme of temple building. The tradition that Numa had specifically forbidden *deorum simulacra* is perhaps reflected in the fact that a number of old sanctuaries continued without temple buildings and that the appearance of Etruscan-style terracotta revetments, which indicate the spread of the typical timber and terracotta sacred architecture, is not necessarily earlier than about 550 B.C. and may perhaps be even later. It is difficult

to assess the contribution of the different Etruscan artistic centres whose influence was felt in Rome. It is suggested that South Italy played a part in the development of terracotta designs about 530 B.C., but clearly around 500 the neighbouring city of Veii was the predominant influence. The temple of Jupiter Capitolinus, which was probably built at the end of the century, must have been the greatest single influence on the development of Roman architectural sculpture. Only a few fragments of terracotta, including an antefix in the form of a Silenus head, can be attributed to it with certainty, but contemporary sculpture from the temple on the Portonaccio probably gives us a clear idea of the general style.

The Veii sculptures, found in 1916, have been attributed to the school of Vulca of Veii, who, according to our sources, was brought in to make the cult statue of Jupiter and to design the acroterial sculptures of the Roman temple. Originally, it seems, statues of gods were made of terracotta in the Etruscan manner. Vulca's Jupiter in the Capitolium survived until 83 B.C., and he also made a clay Hercules in Rome. The first cult statue of bronze was that of Ceres made in 484 for a temple which appears to have had Greek artists associated with it, although Pliny has two references to statues of gods in bronze of remote date – a Hercules of Evander and a Janus of King Numa (but cf. p. 3).

Another area of Etruscan Rome which gave evidence of strong Veientine influence is the sacred area, excavated mainly in 1937, between Via del Mare and Piazza della Consolazione; some further stratigraphic excavations were carried out in 1959. There were primitive huts in this area as early as c. 600 B.C. and it seems to have been paved as a sanctuary about 575. The first temple was built about 500 B.C., following a long period of open-air cult. The revetment plaques from this temple, showing processional and similar scenes, belong to a class which is also represented at Veii and Velletri and is probably Veientine in origin; on the evidence of black-figure vases they are of the late sixth or early fifth century. Other terracottas from the same temple include a series of spiral acroteria which are very similar to those appearing on coin representations of the Capitoline temple. A second temple on the site appears to have had some re-used terracottas together with others of the fourth century. The two temples have been identified with those of Fortuna and Mater Matuta which are said to have been built by Servius Tullius and restored by Camillus.

Veii was not the only Etruscan centre whose artistic influence can be seen in Rome at this time. The well-known antefix of a Maenad from the *arx* is generally thought to be Caeretan in style, and it seems likely that during the early fifth century the area of Rome and Latium formed a distinct province of the Etruscan style, with Rome, perhaps, as the leading centre. It is not easy to define this style, but the subject matter of terracotta reliefs seems to have changed, with the figured frieze going out of fashion and being replaced by floral ornament of Campanian inspiration. A change of taste at this time would fit well into the historical framework. Rome had broken with Etruria in the early fifth century and was now going her own way, although still strongly dependent on Etruscan artistic inspiration. As Etruscan influence waned, the Greek contacts became more direct, and there is some evidence for increasing Greek influence in some of the towns of Latium and the Faliscan country and especially in Rome itself. The fragment

of a wounded warrior found on the Esquiline hill may be part of a pedimental composition and is perhaps more Greek than Etruscan in style. The fragment was, in fact, found in a tomb near S. Vito, but came originally from a temple and was probably preserved as sacred. A frieze, a plaque with a winged horse, very like one from Velletri, was found in a chamber tomb in Via Napoleone on the Esquiline.

In the early fifth century, therefore, with the collapse of Etruscan power, something like a distinctive Latian style rather more florid than the earlier Etruscan style seems to have developed. Typical of its rich ornamental qualities are the decorated column revetments known from several sites in Rome including the Velia, the Esquiline, and S. Omobono, although they are rare elsewhere. The development of pedimental sculpture at this time was probably due to direct Greek influence. The literary tradition certainly confirms the idea of closer and more direct contact with the Greek cities. We are told that two artists, Damophilos and Gorgasos, were commissioned to decorate a temple in Rome. They were painters and sculptors of obviously Greek origin who applied both their skills to the temple of Ceres near the Circus Maximus, which Dionysius of Halicarnassus assigns to the year 493. Like the Capitoline temple, this building obviously had an important influence on the creation of style; and in the time of Augustus, when taste for archaic Greek and early Etruscan art was very strong, paintings or painted reliefs were removed from the walls of the building and framed, while sculptures, probably from the pediment, were dispersed among collectors. The chief point that Pliny makes here, on the authority of Varro, is that up until the time of this temple Tuscan styles had dominated in the city; and we may expect a deliberate change of policy on the part of the Roman patricians. The archaeological record is too fragmentary to sustain this hypothesis further, although it is worth noting the fact that Greek imports to Rome continued until about 450, followed by a gap down to 400, while in Etruria the break in direct contact seems to have come rather earlier; thus it may be suggested that Rome was the chief medium through which Greek influence spread in Central Italy about 480.

If Rome cultivated a deliberately anti-Etruscan policy at this time, the grass roots of the Etrusco-Roman tradition were not affected. It seems likely that the art of casting large bronze statues, like that of modelling in terracotta, was part of the Etruscan legacy to Rome. Since almost all ancient bronze statuary has disappeared, our information must come from literary sources. A few references to bronzes of really remote antiquity (cf. p. 2) – the Hercules dedicated by Evander and the Janus Geminus of Numa – may be discounted. In fact the bronze figure of Ceres made in 484 from the confiscated property of Spurius Cassius is supposed to have been the earliest bronze cult statue in Rome, and this suggests that before this date statues of divinities were made of terracotta and wood. However, three statues of the Fates are traditionally said to have been put up near the Rostra in the time of Tarquinius Priscus, and the literary record tells us that from an early period honorific statues of men were publicly erected in Rome especially in the Forum and on the Capitol; but the reliability of this information is a much discussed question. Tarquinius Priscus is also reputed to have put up a bronze statue of Attus Navius, the augur, which still existed in Augustan times (Pliny, *N.H.* 34, 21 f.).

There were, we are told, statues of the seven kings on the Capitol, and Pliny notes that two of them, Romulus and Titus Tatius, were differently dressed, wearing the toga without a tunic. At the beginning of the Republic a bronze statue of Horatius was dedicated, and Plutarch says that there was an old statue of Porsenna in front of the Curia. In the fifth century a number of statues of Romans and Gauls are recorded; in 439 that of L. Minucius Augurinus on a column, the earliest example of a traditional Roman type, and a little later those of the ambassadors of Fidenae. The earliest equestrian statue, that of Cloelia, is recorded for the fifth century.

It is difficult to judge the validity of this tradition. Clearly it cannot all be rejected, but it is equally clear that the statues were not always what they seemed. If there were statues of kings, the most likely assumption is that they were made in the third and second centuries, in the antiquarian era of Fabius Pictor and Ennius; and this view is, to some extent, borne out by the coins. A recent attempt (*R.M.*, LXXVI, 1969, 14 ff.) to associate some of the 'idealized' portrait-herms, widely identified as fifth-century Greek *strategoi*, with heroes of old Rome (e.g. Horatius with the Munich 'Miltiades'), argues for a Greek portrait tradition in Rome, which would suggest strong Greek influences in the aftermath of Etruscan rule. Some of these heads, if correctly identified, could, of course, be 'archaizing' work of the first century B.C. when the Greek portrait-herm was at the height of its popularity – cf. the Numa of the Casa dei Vestali (*B.d.A.*, XXXIV, 1949, 100 ff.). There are also heads in a style which may be called Etrusco-Italian, e.g. the famous head of 'Brutus' (Plate 8), but few would date these as early as the fifth century B.C.

Although Rome was open to Greek and Etruscan influence in the fifth century, it is likely that most honorific statues of this and earlier periods would follow Etrusco-Roman traditions. The various early Etruscan types – the togate figure, the armed man (Richardson, *M.A.A.R.*, XXI, 1953, 71 (or 77) ff.) – would also have served for these, with the details of achievements inscribed below. It is interesting to note that one fifth-century statue, that of Minucius on a column, is shown on later coins, and there is little doubt that the details of the column are Etruscan archaic. In this case it looks as though the figure had survived all through, but in general it must be supposed that most early statuary did not outlast such disasters as the Gallic sack or the fire of the Capitol in 83 B.C. and that many of the traditionally early examples are, in fact, later restorations.

Hardly any of the early bronzes have survived. One of the few which may reasonably be attributed to the fifth century is the sculptured figure of a wolf known as the Lupa Capitolina (Plate 1) which has remained above ground since antiquity. In the tenth century it stood in front of the Lateran palace. Sixtus IV gave it to the city of Rome, and it is now in the Palazzo dei Conservatori Museum. The Twins were added in the Renaissance. The style is certainly archaic and probably related to the series of terracottas from Veii. It illustrates the high quality of bronze casting in this early period. The rest of our evidence comes from small bronzes which give us some idea of the range of figure types, but tell us very little about the quality of the best works.

The period of Etruscan influence in Rome culminated at the time when Rome turned the tables on Etruria. We know that the affinity between Roman and Etruscan art and

religion was one of the main factors in the origins of Roman art collecting, which, in its various forms, was to become the key factor in the development of art in Rome. As Livy puts it, the cult statues looted from Veii after the sack were taken largely for religious motives; but there very soon entered in an element of artistic taste which alone could justify the removal of 2,000 statues from Volsinii. Both the Etruscan background of Roman art and this enormous influx of Etruscan statuary during the fifth and fourth centuries, with the consequent fashion for *signa tuscanica*, were essential factors in the development of Roman taste. Even in late republican and Augustan times this taste was still so strong that a Tuscan Apollo of bronze was among the outstanding pieces in the temple of Augustus, one of the chief art galleries of the time.

There is very little evidence in the fifth and fourth centuries for the development of those branches of art which have been looked upon as specifically Roman: it is only in the third century and later that we have direct evidence for such development, in which funerary practices were one of the leading factors. Roman funerary art was many-sided and merged with other branches of commemorative art. It has two main facets: the commemoration of the dead on earth; and an expression of the belief in the continuation of life after death in the tomb which settlers in the area of Rome seemed to have held from the earliest times. As we have seen, at least six of the early Roman graves contain human figures, four of them in association with house-urns in which the ashes of the dead were interred (cf. p. 1). But the early ideas of the Romans about life after death were, unlike those of the Etruscans, basically pessimistic. While the splendid funerary rites of the patricians glorify the dead person, there is much less hope for the spirits of the dead in another world, and the funerary rites seem to have been more concerned with providing an earthly home for the soul. The underlying Roman belief is that, if the life of a famous person is adequately celebrated and his person is vividly remembered and his body richly housed and cared for on earth, then a happy and prosperous life in the tomb is assured. For these reasons, therefore, the commemoration of the dead is always a central theme of Roman art.

This commemoration is achieved in two ways. First, the famous dead, statesmen, generals, writers, etc., were honoured with publicly dedicated statues. The Greeks had similarly commemorated such persons with portrait statues which might be factual or idealized or purely mythical, and many of the traditional Greek types served similar purposes in Rome. But there was also a very different and particularly Roman commemoration of the dead associated with the patrician families of Rome. This was the practice of preserving in the *atria* of houses a collection of masks made of painted wax which were brought into use on the occasions of family funerals. These masks were worn by actors dressed up to play the parts of particular ancestors. The origins of this custom apparently go back to the earliest times and may be connected with the Etruscan canopic urns, where a mask of bronze or clay served to represent the dead person. Certainly these masks were part of a very primitive funerary ritual, and the *ius imaginum*, the right of keeping and using them, was an ancient privilege of the Roman aristocracy.

This practice clearly underlies the whole history of Roman funerary portraiture. In the House of the Menander at Pompeii there was a series of plaster heads, very primitive in

character, kept in a niche, perhaps versions of wood and wax originals. But little is known about the form of these masks in the earliest times. We do not know, for example, how realistic the portraits were meant to be, and there is no evidence that they were made in the form of death masks, despite the fact that death-mask features do appear in late republican portraiture. The exhibition of masks in the *atrium* seems to have been largely replaced by portraits of marble and bronze in the late Republic, but collections of masks were maintained into the Empire, and in funerals of emperors much of the old practices survived: wax images of Caesar and Augustus were exhibited at their funerals, and Tacitus reports that at the funeral in A.D. 23 of the widow of C. Cassius, half-sister of M. Brutus, there were twenty such masks. The old ritual magic still survived in the processes of imperial apotheosis as described by Herodian, where a wax image of the emperor lay in state for seven days and was then officially pronounced dead and taken to the Campus Martius where a large funeral pyre was set up. There were parades of horsemen and chariots, with the drivers wearing masks of emperors and famous men. Finally the pyre was set alight, and the soul of the emperor ascended to heaven in the form of an eagle let loose from the top of it.

Equally important to the subject matter of Roman art is the commemoration of important political and military events. Pictures of famous battles are found in early Greek art, for example in Panainos' picture of the Battle of Marathon and in the celebrated battle pictures of fifth-century Athenian painters. The Roman tradition, although again we only know it from later sources, seems to have been fundamentally different. Roman paintings were didactic in intention and designed to be a factual, rather than an idealized, commemoration of events. In 264 M. Valerius Messalla exhibited in the Senate House pictures of the battles that he had won in Sicily, and in 146 L. Hostilius Mancinus used painted illustrations as visual aids in lectures on his campaigns. These both pleased and educated the Roman public, which in the latter case responded by electing Hostilius to the consulship. Paintings of this kind seem to have combined a map treatment of the landscape with vignettes of battles, sieges, etc.; but there does not appear to be much evidence that the style goes back to a very early period of Roman art. Such pictures were made by *topographoi*; and the art form, which seems to be Greek in origin, is probably more important in the history of cartography than of painting. But the taste for factual representation that it serves does seem to have something fundamentally Roman about it, and we find its influence recurring in later Roman art.

The problem of Roman historical painting raises the whole question of the development of specifically Roman themes in art. Roman mythology is rich in events and personalities, but strikingly little of it, as compared with Greek mythology, has survived in art. The Roman repertoire is quasi-historical; the Greek frankly imaginative. We know that some of the early Roman foundation myths, such as that of the Trojan origins of the Roman people, were already being celebrated in Etruscan and Roman art from the fifth century; and in the fourth century some were given a canonical form. However, the subject matter of Roman art continues to be mainly the mythology of the Greeks, which had been inherited by the Romans from Etruscan sources and was kept fresh in their minds by constantly renewed contacts with the Greek cities.

It is very difficult therefore to distinguish Roman art from that of the rest of Central Italy, either in style or subject matter, during the fifth and fourth centuries. In broad terms, there was a weakening of direct Greek contact after 450, although there are some very fine Etruscan and Central Italian terracotta carvings in the early classical style and a few in the developed Pheidian manner. Contacts remained open all the time, and some of the finest terracottas come from places like Civita Castellana (Falerii) which were not strictly in Etruria but were very much in the Roman orbit. Unquestionably by the end of the fourth century Rome was becoming the leading artistic influence in Central Italy. The period culminated in the work of the first recorded Roman painter, Fabius Pictor, who, in the year 303, decorated the temple of Salus in a style which, to judge from Dionysius of Halicarnassus' description, must have been very similar to that of the paintings of the Tomba dell'Orco or the Amazon sarcophagus from Tarquinia, which are distinguished by fine outline drawing and delicate colouring, although they may be a little bit backward in terms of contemporary Greek painting. The skill of Central Italian draughtsmen in this period is shown by the engravings on the bronze cylindrical box known as the Ficoroni cista (Plate 2), which has an inscription stating that it was made in Rome by Novios Plautios and given to her daughter by Dindia Macolnia. The drawing is lively and skilful and copied from a famous Greek painting of a Greek mythological scene; the figures on the lid would be extremely difficult to distinguish from work produced in other South Etruscan centres. It is important, however, to remember that Roman customs were fundamentally different from those of the Etruscans. Roman funerary practice, as we have seen, had at this stage nothing in common with the elaborate funerary symbolism implied in the contemporary Etruscan urns and sarcophagi.

THE MID AND LATE REPUBLIC

Early Coinage

THERE is no doubt that Rome's contacts with South Italy and the cities of mainland Greece were the chief factors in the great revival of art in Central Italy which began around 300 B.C. and gathered momentum in the next fifty years. In the fourth century the decline of the Greek city-States meant that artists began to travel widely for work and that the prosperous South Italian and Sicilian cities such as Taranto (Tarentum) and Syracuse maintained high reputations as art centres; and it was from this area that artists came to Central Italy. One sees their work in many different media: in painting, in life-size terracottas, and in funerary sculpture.

We now get for the first time a series of dated works of art which enables us to give a consistent, if partial, account of the development of art under Roman influence. The sequence is provided by the coinage, which gives a basis for the study of republican art in the next two centuries. The earliest silver and bronze coins are the didrachmas and litrae struck in pure Greek style about 290 B.C., probably in South Italy. The heads of divinities on the obverse are modelled in fine classical style and the animal figures of the reverse are cast from finely carved moulds (Plate 3, A–D). Similarly, the modelling of the earliest silver pieces is very delicate. A didrachma with the bust of the youthful Hercules on the obverse has a group of the Wolf and Twins on the reverse – the Wolf a handsome, naturalistic creature craning backwards and the Twins chubby, rather theatrical Erotes in graceful poses. On the didrachmas with Diana in a Phrygian helmet on the obverse, the Victories of the reverse are slim, graceful hellenistic girls in swinging poses and clinging draperies.

The contrast with the coins of the next period is obvious. Now the big *aes grave* with a Diana or youthful Mars on the obverse is modelled very differently (Plate 3, E and F); the features of the head are gross, with thick lips, big nose, and deeply sunken eyes. The whole face seems to be shortened from back to front, and the features are exaggerated: some heads have immense noses and small eyes and mouth. Similarly ugly and unclassical features are produced, for example, on the wheel-type dupondius with Diana in a Phrygian cap on the obverse. In the silver coinage the same features can be seen on the quadrigati with Janus obverse and incuse ROMA on the reverse (Plate 3, G and H). The heads on the obverse are stiff and upright and often very heavy-featured. The chariots on the reverse are awkwardly rendered, and the Jupiter in the chariot has a disproportionately large head and an uncomfortable pose. It is interesting to note the contrast between coin dies in this style and the famous gold staters and half-staters of the Second Punic War with the oath-taking theme, which is one of the earliest Roman scenes of this kind (Plate 3, I and J). The figures are rendered in a fine hellenistic genre style,

and one notes especially the carefully studied stance of the bearded man and the noble relaxed pose of the soldier, as well as the complex kneeling figure of the youth. The figures are so related to one another as to make this a very successful evocative scene.

The striking contrast between coins in Greek style and those with apparently anti-classical tendencies becomes even clearer in the period after the Punic Wars, which has been characterized as one of decline and temporary collapse in the monetary system. In the bronze coins a strong tendency towards pattern-making stylization can be seen in the Janus heads, where we have characteristically exaggerated features – nose with hard and wide nasal ridge, pop-eyes, bobbly beard and beaded forehead, hair converging towards the ear with the back hair forming a series of horizontal wavy lines (Plate 3, K and L). Here we have a process very similar to the well-known degeneration of Gaulish coins based on staters of Philip of Macedon. Striking examples are the series of Janus heads in which the hair is but a beaded mass, and a few horizontal lines frame ugly faces that point irresistibly to the soldiers on the arch of Septimius Severus several hundred years later. In the silver coinage, although the early denarii of the war period often show graceful hellenistic figures, the post-war victoriati are often harsh in detail, with the drapery of the Victories very formal and patterned, the poses uncomfortable, and the proportions distinctly bottom-heavy (Plate 3, M and N). Generally speaking, the Dioscuri reverses on early denarii consist of disproportionately and uncomfortably large little men on stiffly prancing steeds, such as one finds later in Roman sculpture. The heads are often too big and the clothes modelled in a very linear, conventional style. The obverse head often exaggerates the eye and gives it a very staring look and sharp modelling.

There is very little stylistic change down to the later years of the second century, when the historical content becomes more interesting. On the well-known coins of Sextus Pompeius Fostlus the features of the Roma head are extremely ugly, as they are on coins of the mint of Rome, including those of the moneyers L. Postumius Albinus and L. Opimius. By this time there are a variety of reverse types connected with events in the lives of ancestors of the moneyers, for example a representation of the columnar monument outside the Porta Trigemina of L. Minucius Augurinus of 439 (cf. p. 4). A particularly interesting contrasting style is provided by the coins of Ti. Veturius which have an oath-taking scene similar in poses and composition to that on the early stater, although the style is very different; the hunched back and enormous head of the figure on the left, together with the stiffness of the figure on the right, are a far cry from the natural grace of the earlier figures (Plate 3, O and P). Among the most interesting coins of all are those of P. Nerva which represent a voting scene, shown in a very down-to-earth way, containing little, oddly proportioned figures in natural poses, but with very strange, if acceptable, inconsistencies of scale and pose (Plate 3, Q and R).

The coin series provides, if only in a limited field, a history of the development of style in Rome from the third century down to about 100 B.C., and the striking differences between what may be called 'Greek' coins and those which show non-Greek features needs to be explained. They seem to reflect two quite distinct currents in Roman art, the existence of which is perhaps confirmed by our literary sources for this period. When the earliest coinage started, the Romans were beginning to acquire masses

of Greek booty from South Italy. Tarentum was one of the first cities to be thus ransacked after the Pyrrhic War, when the first Greek statues by master sculptors and many other works of art came into Rome with the triumph of M. Curius Dentatus over Pyrrhus and the Samnites in 275. About this time Greek craftsmen must have cut the first coin dies for the Roman coinage. The problem, from the point of view of Roman art history, is to establish how far the non-Greek element represents a deliberate antithesis to Greek methods of representation and how far it is based on purely Italic artistic taste. It must be stressed that such a reaction is highly probable, since it is well known that Greek art was not to the taste of the majority of Roman patricians in the period. Traditional methods of building and of design were still being used in Central Italy. The structures erected when the Romans founded the colony of Cosa in Etruscan territory in 273 were in purely Etruscan style, the temples with timber superstructure and terracotta decoration of traditional form.

Early Terracottas and Bronzes

If we accept that the non-Greek elements of the coinage represent more than a decadent version of the Greek, there seems little doubt that the positive elements of this reaction derive from Central Italian taste. It is clear that features of the style are shared with a number of works of sculpture and painting from the area. We have, for example, a whole series of clay votive heads which show the same exaggerated forms and stiff-necked pose as the heads on the obverses of second-century coins. The faces are generalized and few have anything to do with portraiture, but they all share a structural form which involves a tightly enclosing facial contour and a tendency to simplify the physical features. They belong to a late Etruscan tradition of terracotta modelling, and there are a few complete terracotta figures of this form wearing early versions of the characteristic Roman toga. The drapery folds form simple patterns which contrast with the richly plastic rendering of contemporary hellenistic art. The proportions of these terracotta figures are often inconsistent; the chief interest is in the head, which is often too large for the body.

Many of the characteristics of these first-century Italic terracottas are to be seen on the few surviving contemporary bronzes; for example the fine head of a youth in the British Museum (Plate 4) has the same sharp, clearly defined, and somewhat exaggerated facial details. It is instructive to compare the head with a hellenistic ideal head and to contrast the flatness and controlled form of the one with the richer and more rounded modelling of the other. It seems clear that the features shared by these terracottas and bronzes derive from a long-standing Etruscan tradition. Most of the early Etruscan and Roman big bronze sculpture has disappeared, but the main stylistic features can be followed in the series of fine small-scale votives which have come down to us. These bronzes illustrate most of the types which must have been commonplace in Rome during the fourth and third centuries. A typical military figure is the so-called Mars of Todi in the Museo Etrusco Gregoriano of the Vatican (Plate 5), where the inspiration is clearly Greek but the pose and the proportions and also the details of the face are conspicuously Etruscan. The face has enlarged and simplified features and the

whole head is somewhat too large for the body. A contemporary female figure is very similar in style, with less complex handling of the drapery; and one gets a good impression of one of the early Romans wearing a toga without a tunic in the little bronze from Pizzirimonte illustrated on Plate 6.

The relation between Etruscan and Roman portraiture in the last centuries of the Republic has been much discussed. The head of the so-called Brutus illustrates the problems (Plate 8). It must represent an 'old Roman', but can it be linked with Etruria? Does it represent the Italic-Etruscan counterpart of the idealized fifth-century Greek heads, or can it be linked with the series of votive heads and heads on sarcophagi which seem to belong to the third and second centuries? A series of terracotta figures of life-size *togati*, many of poor quality, representing Etruscan votive figures of the last three centuries B.C., are simple, straightforward, unlearned. Is this the sort of figure being created in Rome? Some show more influence from such rather theatrical Greek portrait studies as those of Sophocles and Aeschines. There is very little characterization in the heads, with their big eyes and full lips; they look rather mass-produced. Some influence must have come from the terracotta modellers of Campania, who in the same period made clay versions of Greek portraits and figures.

The Italian statues seem to be men in the toga, the Roman national dress, which in the republican period was a modest garment, wrapped around one shoulder with full hanging folds and without a *sinus* (F. W. Goethert, *Zur Kunst der römischen Republik*, Berlin, 1931, 15 ff.). It was a semicircular piece of cloth (originally perhaps rectangular) which could apparently be worn in several ways, leaving the right shoulder bare or (in the Greek manner) covering the right shoulder and passing over the left. The Arringatore (Orator) who wears a mantle-toga and the other portraits from Central Italy could represent a late phase of this votive and commemorative tradition with strongly individualized features. The picture is of traditional Etrusco-Roman types modified by contact with Greece and Magna Graecia and finally superseded by the late hellenistic traditions of strictly realistic portraits which we find on Delos and which prevail especially in the first century B.C.

The series of bronze portraits of pre-imperial date from Central Italy illustrates the difficulty of isolating 'Etruscan', 'Italic', and Roman elements. There do seem to be certain common characteristics which link, say, the Conservatori 'Brutus' at the beginning of the series (third century B.C.? but see p. 18) and the head of the Arringatore in Florence at the end (first century B.C.). The technique is Greek, and strong Greek influence distinguishes these works from the run of late Etruscan funerary and votive heads. But although they are inspired by contemporary Greek portraiture they seem to have characteristics that are peculiar to Central Italy. The Brutus has been known since the early sixteenth century; the Arringatore was discovered near Perugia and bears an inscription in Etruscan giving the name of the man, AVLES METELIS, who is dressed as a Roman in tunic, toga, and *calcei*. The head of a man from Fiesole near Florence belongs chronologically between the two and is thought of as a very typical example of this group of portraits, combining Greek techniques with an Italic simplicity of form and surface detail.

The Influence of Greek Art

The question of the Italic-Etruscan style and its influence on the development of Roman art will arise again in the discussion of a series of portrait heads from various Italian sites which are here attributed to the first century B.C. (cf. p. 18). What is clear is that the influx of Greek works of art did not completely overwhelm local traditions, and that the old materials continued to play a leading part in Roman art during the second century B.C. But the Second Punic War did produce a major revolution in taste which is summed up in two passages of the historian Livy: the first alludes to the capture of Syracuse by Marcellus in 212, to the vast amount of loot brought in, and to the fact that this was the beginning of the admiration for Greek art among the Roman nobility; the second stresses the reaction to this new taste of the Romans of the old school, who praised the old-fashioned materials of the Etrusco-Italic tradition that had become identified with the virtues of the Roman past.

It is important to recognize the subtle change in attitude which now took place. A considerable influx of Greek booty had already made Greek art familiar to people in Rome a few years before Marcellus' activities. Most of the religious statuary was not brought away from Tarentum, even though a colossal Hercules by Lysippos was destined for dedication on the Capitol: these Greek gods were different from the familiar Etruscan divinities, and Fabius preferred to leave them with the Tarentines. But religious considerations had disappeared from Marcellus' mind; and from his time onwards the amount of looting increased, with the main motive now being the acquisition of major works of art or of lesser objets d'art. At first the major works continued to be set up in public places, as, for example, when M. Fulvius Nobilior dedicated a statue of Hercules and a fine series of hellenistic Muses (which later appear on coins) in his temple of Hercules Musarum. Indeed art had a very important role in architectural contexts from the late Republic, when buildings began to be specifically designed to accommodate sculpture and painting. In the interiors of temples, apart from the cult statue, subsidiary statues were housed in niches and sometimes statuary and painting decorated the *pronaos*. Whether or not architectural form allows a place for sculpture, gates and triumphal arches, the theatre façade, the *spina* of the circus, the baths, the monumental fountain, the colonnade, all demand statuary for their effect. When L. Aemilius Paullus brought back a statue of Athena by Pheidias, he dedicated it in an appropriate temple.

The attitudes of the generals in the period after the Punic Wars are important to understand. Fabius, who took the colossal Hercules but was daunted by the colossal Zeus of the same sculptor, was clearly interested chiefly because the statutes were huge and famous. But soon a different attitude of mind developed. Aemilius Paullus, who defeated Perseus of Macedon in 168, was a genuine admirer of Greek art, which produced in him something approaching real reverence. When he gazed upon Pheidias' colossal gold and ivory statue of Zeus at Olympia he is said to have felt himself in the presence of the god. Such men not only were, but thought of themselves as, the successors of the hellenistic kings. A monument at Delphi consisting of an equestrian statue on a tall pillar, originally intended for Perseus himself, was taken over by Aemilius Paullus and

given a simple inscription to celebrate the Battle of Pydna. This type of monument had already been used by Romans, the earliest recorded being that of M. Acilius Glabrio earlier in the century.

The frieze of the monument of Aemilius Paullus is not a major work; its importance comes from the fact that it is the earliest example of Greek sculpture in a specifically Roman context. It crowned the tall rectangular pillar which carried the equestrian statue of the general, a type of monument traditional in hellenistic Greece. The scale is small, the figures in high relief a little less than two feet high, the marble is veined white with brown patina. The battle scene is a lively, varied composition with a lot of ambitious foreshortening; the finish is good, with careful attention to detail. There is very little Roman about the frieze, and most of the figures of horsemen and soldiers are taken from the stock repertoire of hellenistic art. However, the details of Roman and Macedonian equipment are shown; a Roman rider engaged in the battle is possibly Paullus himself, and there is a specific reference to Pydna in the riderless horse which occupies the centre of one side: in the account of this battle a runaway horse appears to have been the occasion for the armies coming together in combat, and in the frieze he is a stronger figure in low relief, rather odd, but none the less striking. No other figure stands out in what is a typical hellenistic mêlée.

There is a delicacy about this which reminds one of earlier work at Delphi, where there had long been a tradition of small-scale sculpture associated with buildings – the Siphnian Treasury, the Treasury of the Athenians, the Tholos with its metopes – and one would like to think of it as the work of a local 'school', or at least influenced by the 'miniature' tradition of Delphic sculpture. In a similar way, the proportions of the figures on the first-century A.D. frieze from the theatre seem to be influenced by those of Lysippic work.

We know almost nothing of the portraiture of these early generals. But in the case of T. Quinctius Flamininus we have gold coins struck in Greece in honour of his achievements, where his portrait on the obverse (Plate 7), the earliest certain surviving portrait of a famous Roman, is in purely Greek style. He looks not at all unlike Philip V of Macedon, except that he wears no royal diadem. This man received divine honours at Chalcis and other places and, whatever the native Roman traditions of portraiture may have been, Flamininus was following the tradition of hellenistic rulers who for many years had been represented on their coinage. Men like Flamininus not only brought back great quantities of booty; they also employed Greek artists both in Greece and in Italy to commemorate their deeds. Thus Fulvius Nobilior, after the defeat of the Aetolians in 188, came back with many artists from Greece to do him honour. They painted triumphal pictures, like the ones done for L. Scipio after his Asiatic victory, and there is nothing to suggest that these were all in the tradition of Roman historical painting, which, as we have seen, was largely didactic and apparently consisted of drawn maps with the insertion of views of country and episodes in the campaign (cf. p. 6). Scipio's pictures are much more likely to have been grand compositions in the tradition of Greek historical paintings. The collections and dedications of such men transformed the appearance of the public monuments of Rome, where the porticoes that they erected

must often have looked like the painted stoas of classical Greece. One of these men, Q. Metellus Macedonicus, built a splendid *porticus*, the centrepiece of which was a vast bronze group of Alexander and his companions at the Granicus which was the work of Lysippos.

In a statue from Tivoli (Tibur) (Plate 9) the general rests against a cuirass and he probably held a spear; an almost contemporary republican general now in the museum at Munich raises his right hand vertically and also holds a spear. The poses and gestures of these portrait figures are almost certainly derived from statues of hellenistic rulers, although the armed warrior had long been acclimatized in the city of Rome. The equestrian statue, which also had a long republican history, was used to honour the great men of the last century B.C. On coins of 82 Sulla is shown as he appeared in bronze in the Forum Romanum. His mount is perhaps a little stiff and heavy in comparison with the prancing horses of the hellenistic tradition, but the whole is impressive in its statuary strength, as are all the best equestrian figures of the Empire.

The generals also inherited much of the hellenistic taste for collecting great works of art. Cicero, railing against Verres, the great plunderer, refers to those generals down to and including Mummius in 146 who, although they had the opportunity, did not collect pictures and statues in their own homes. But as time went on the build-up of private collections increased until they became very much a part of Roman private life. The earliest of the hellenistic kings to be enthusiastic art collectors were apparently the Attalids of Pergamon (cf. p. 28), who seem to have commissioned the earliest copies of Greek sculpture and sent artists to copy famous pictures in the Greek homeland. This mantle, too, fell on the Roman generals of the last two centuries B.C.

Roman Art in the Second and Early First Centuries B.C.

The development of Roman sculpture and painting in the second century B.C. cannot be followed in surviving monuments from the city of Rome. There are, however, a number of very interesting sculptures carved in local stone before the use of marble was at all common, and they give a good idea of the Roman hellenistic style of the period. Most come from tomb monuments and were once covered with stucco and painting; paint survives on several of them. There is a good peperino head of a Gaul in the Museo Capitolino which shows the late hellenistic 'pathetic' style, and a well carved female head in travertine. The best known peperino sculpture is the Orpheus group – fragments of several figures carved in a very precise and economical style – from a cemetery area outside the Porta Tiburtina and clearly from a tomb (Plate 10). In the first century travertine seems to have become the principal medium for funerary sculpture and surviving pieces include a few outstanding works, for example the Summanus pediment in the Capitoline Museum and a number of very richly carved fragments of acanthus scrollwork which seem to be closely related to Pergamene and late hellenistic models.

As far as painting is concerned we have only a few fragments from the interiors of tombs on the Esquiline hill, the most famous being that now in the Museo Capitolino (cf. p. 22) (Plate 11). The historical scenes appear to be associated with episodes in the

Samnite War; of the three surviving registers, the top shows two generals, named as Fannius and Fabius, parleying with one another; the middle, a similar scene in front of a city; and the bottom a lively battle, of which very little survives. A few other fragments survive from tombs near by; one series, now nearly destroyed but known from old drawings, seems to have shown funeral games in a rather rough and summary style. This tradition of tomb painting seems to be closely related to contemporary Etruscan decoration; the choice of subject may be compared with the scenes from the so-called François Tomb at Vulci (Plate 12), the date of which is disputed but appears to be third- or second-century.

By activities of this kind the stage was set for the climax of republican art in the first century, and it may shed light on a complex period if one looks first at the comparatively simple sequence of the late republican coinage to establish the main trend of artistic development. Coins of the early first century B.C. still retain many elements of non-classical style; but those of some moneyers show a very clear-cut classical manner. The propaganda of distinguished republican families and the mythology and early history of Rome are the main themes. There is a very lively equestrian statue of L. Philippus on a coin of 105 and a stirring combat scene on a coin of Q. Thermus, but the figure style is hard and summary with stylized drapery and rather large and somewhat ugly heads. The compositions are often interesting and varied, as on a coin of L. Pomponius Molo (Plate 13, A and B) which shows King Numa sacrificing at an altar to which an attendant seen backview is bringing a goat. The coins of C. Serveilius represent M. Serveilius Pulex Geminus, consul in 202, in a famous single-handed combat (Plate 13, C and D). He is shown on horseback on the left, his vast head supported on a long thin neck, and the rest of his body masked by a shield. The victim appears in three-quarter view from behind, the buttocks of his stumbling horse reminding one of the well-known figure on the Alexander mosaic; this other warrior is considerably smaller, and the whole composition looks very much like a traditional battle scene, but with the scale adapted to stress the importance of one of the figures. Perhaps the coin type derives from a series of pictures, another of which may be recognized again on the coin of Thermus, where two dismounted warriors are fighting on foot, the Roman on the left dominating a cringing foe. More prosaic scenes appear on coins of Aulus Postumius Albinus where a sacrifice is shown with a diminutive ox, a small altar, and a very big man. Some grand triumphal composition is surely reflected in the coins of Paullus Lepidus, where a splendid Roman figure stands by a trophy with little figures of King Perseus and his sons on the left.

These various scenes show the development of Roman commemorative art, but the style remains very much the same as in the previous century. As the last century B.C. advances we find much more obvious and self-conscious imitation of Greek models. The head of Juno on a coin of L. Papius is modelled in fine classical style, and on the reverse there is a finely naturalistic figure of a prancing Griffin (Plate 13, E and F). On the obverse of Molo's coin a splendid classical profile represents Apollo, obviously copied from an early classical Apollo of the school of Pheidias. The coins of Vibius Pansa show a late classical Silenus head, and Q. Titius has a fine fifth-century bearded head on the obverse and a statue of Pegasus on the reverse.

An interesting contrast in style is provided by the heads of Titus Tatius on coins of the moneyer Titurius (Plate 13, G and H), where the modelling is extremely delicate; but the inspiration lies not in classical originals but in heads of a very different style. The head shape, the profile, the long striated hair and unkempt beard of this representation of an early Roman make quite a different impression. The reverses illustrate Roman mythological themes including Tarpeia and the Rape of the Sabine Women, where the long slender figures remind one of those in scenes from the François Tomb and on some contemporary sculpture.

Stylistic contrasts are very marked throughout the first century. On one coin we may find a figure of the Satyr Marsyas delicately engraved in a fine hellenistic style; on another, a splendid group of Hercules and the Nemean Lion. An archaizing or archaic Juno appears on a coin of L. Procilius. But at the same time more typically Italic themes often have rather dumpy little figures and odd details of scale. Most of the best coin dies seem to have been carved by Greek artists, who also cut intaglios in semi-precious stones for their Roman patrons; and they are capable of an endless range of subjects derived from the traditional repertoire of the Greek craftsmen.

A special interest in the coinage of the time is the portraits of men of the last two centuries B.C. in what may be called a characteristic republican style; one such group represents the heads of kings and heroes of the early Republic including T. Tatius, Brutus, and Ahala. Some are modelled in a dry and very concise style which looks like the numismatic counterpart of that of the Conservatori Brutus. But there is great variety even among these imaginary portraits, so that Ancus Marcius on a coin of L. Marcius Philippus looks just like a hellenistic ruler, as indeed does Sulla on coins of Q. Pompeius Rufus (Plate 13, I and J). The very detailed style characteristic of the late Republic comes into its own on issues such as those of C. Coelius Caldus, who puts on his coins a portrait of his grandfather. There is some variety, but basically all have the same dry and uncompromising features of distinguished late republican portraits. On the coins of C. Antius Restio (Plate 13, K and L) the famous 'bruiser' obverse type is combined with a reverse with a fine classicizing Hercules; indeed the direct influence of classical masterpieces and famous works of art, for instance the Ephesian Artemis and the Hermes of Alkamenes, are very common on reverses, particularly during the revolutionary period. The influence of historical pictures continues: Vaala has a soldier attacking a *vallum*, while Regulus has a wild beast hunt; the perspective and the scale of the figures in the *vallum* scene are particularly interesting.

The late republican coinage as a whole is rich in reflections of major art and very varied in its elements of style. From our point of view, it is the artistic background of the coinage which must be established, and especially the rapid development of what may be called the characteristically 'Roman art'. This may be considered from three main points of view: those of Roman portraiture, of commemorative sculpture largely from buildings, and of characteristically Roman forms of painting. Just as important is the development of a specifically Roman taste and of an artistic language in which to express it.

Early Portraits and Reliefs

It is generally believed that the main Roman portrait series begins early in the first century B.C., although the earliest certainly identifiable sculptural portrait of a famous Roman is that of Pompey; Sulla, for example, despite his appearance on coins and gems, has yet to be identified in the round. About 105 B.C. the portrait of an ancestor on a coin of Blasio is the earliest of a series common from 90 B.C. The counterparts of such heads in marble and stone, generally carved in a hard, rather dry style with very precise personal details, mostly represent elderly persons and were presumably commissioned in old age or after death. It has been said that this class of portrait, which is typical of the first century B.C. but survives into the Empire, expressed a fundamental difference between the Roman and Greek traditions. This Roman likeness is a slice of life, a sculptured biography, a *cursus honorum* of the dead man, a record of his life.

Certainly *memoria* seems to have been the chief purpose of this essentially private portraiture; and the general style, which has been called 'veristic', may be defined as the attempt to give a true representation of the appearance to the senses of a person's features. Although we think of it as specifically Roman, it owes a great deal to late hellenistic taste for precise, almost clinical, studies of the characteristics of youth and old age in human beings. The image of the hard, bald-headed old republican dominates the early marble portraiture of Rome. The finish is rough, with obvious marks of the rasp. Rich modelling of the features is often combined with very sharp carving of incidentals – wrinkles, etc. One very striking head (No. 561a in the Ny Carlsberg Glyptotek in Copenhagen) makes the same kind of impact as do some of the better portraits on late Etruscan sarcophagi. Of the surviving heads of republicans some are obviously later copies; the Copenhagen Pompey (Plate 14) with its stark finish is a good example, having much in common with the cool, remote polish of the portraits of the early Empire. There are, indeed, a number of heads which at first glance look late republican but which, judging by the treatment of hair and flesh, are probably to be dated in the first century A.D. One interesting but not large group shows features very distinctly derived from death masks, and it seems clear that in a number of cases the portrait had such an origin. Heads with similar characteristics have been found in other parts of Italy, but the influence of the death mask was, generally speaking, short-lived.

There were statues in Rome of famous women of the old days – Tarpeia in the Porticus Metelli, Tanaquil, Cloelia on horseback by the Sacra Via. We know too that there was a publicly dedicated statue of Cornelia, the mother of the Gracchi, in the Porticus Metelli, but not when it was put up. Oddly, there do not seem to be any recorded portraits of women in the last century B.C., the great period of republican portraiture. Although there were at this time skilful studies of female old age and character, the women who accompany their stern husbands on Roman grave reliefs are far less interesting: on the fine relief from the Via Statilia in the Museo Capitolino (Plate 15), for instance, the man is a typical study of republican hardness and vigour, but the wife, dressed in hellenistic style and standing in the so-called Pudicitia pose, has gentle, regular, smoothed features, lacking expression except to embody, no doubt, the republican ideal

of dutiful womanhood. In some of the reliefs with busts the family likeness is stressed in male and female, but there is far less expression in the women's faces.

It is not until the Augustan era, it seems, that the grave reliefs include really interesting studies of females: the Vibius relief in the Vatican has a middle-aged wife, alert and intelligent, and a splendidly ornate stone in the British Museum has a most keenly observed study of female old age. In the late Republic all female portraits seem to have been funerary, and the 'idealism' must derive from a general hellenistic 'idealism' in female portraits. Children, too, first appear in the Augustan period, so far as we know. The traditions of the Republic are carried on into Augustan times: the first female coin-portraits are either vapid or ugly, and the portraiture of Livia has a severe simplicity, with her big eyes and composed expression, that seems wholly in keeping with the ideals of republican womanhood. The absence of severe Greek dress, and often a demure standing pose or a comfortable domestic sitting position, are part of the image; the women look pretty, neat, and clean. The choice in official art is for the matronly or the maidenly. But soon a more emancipated female society is reflected in the choice of a greater range of classical types and deviations, and the severe hairstyles give place to carefully arranged coiffures. The regular, idealized faces of late republican women, with their air of gentle resignation and very delicate features, are often combined with quite elaborate hairstyles, with the hair parted away from the forehead in a complex arrangement of plaits. There is a terracotta head of this type in Oslo, and a fine marble head of the same period in the Museo Nazionale Romano (Terme) (*R.M.*, XLIV, 1929, 167–79).

The 'veristic' type of portrait was not the only one prevailing in the first century B.C. On the coins a number of heads of kings and famous figures of early Roman history illustrate an idealizing style which has its counterpart in surviving portraits in the round. One of the most obvious links is between the coins of Titurius (Plate 13, G and H) and the well-known bronze head of Brutus (Plate 8) in the Conservatori Museum in Rome (cf. p. 11). This head, known since the sixteenth century, probably came from a statue; the original ivory and glass inlay of the eyes still survives. The style is distinctive: the features are enclosed in a firm outline, and the hair and beard worked out in delicate low relief so as not to break the enclosing contour. Superficially the contrast with later Greek portraits is very striking, although the delicacy of the surface treatment may be compared with the best Greek work. The Brutus has been classed with a number of other bronzes from Central Italy which share something of the same stereometric form and treatment of detail, and the group has been thought of as characteristically Central Italian and assigned to the fourth or third century B.C. In the case of the Brutus the argument is that it represents a Romano-Etruscan type of portraiture of some mythical hero of the early Republic executed in the fourth century, when imaginary portraits of such remote figures were particularly popular. But although the Brutus shares many characteristics, especially of general form, with earlier Etruscan heads, the treatment of detail favours the interpretation that we have here an archaizing work of the first century B.C.

The element of 'archaism' is always present in Roman art, at least from the fourth century, when it seems that there was a deliberate attempt to create types of the *prisci*

Latini, including the kings of Rome, in what would be recognizable as an 'old-fashioned' style. This is the style reflected in the coin portraits of the kings in the first century B.C. Archaizing features were always likely to be introduced into representations of men of the past; a fine example is the late Roman portrait of a priest, who is shown without a tunic in the manner of the *prisci Latini* and whose features follow archaic conventions. The archaic style was also admired for its dignity and simplicity, and republican Rome shared in the hellenistic 'archaic revival', as in the case of the archaizing Victories on the trophy base from the Capitol and on the frieze of the temple of Divus Julius. Other bronzes of the same group, for example the head from Bovianum, seem to be strongly influenced by the technique and style of late hellenistic portraiture. This interpretation of the Brutus head implies an awareness of the earlier Italic style on the part of the Roman sculptors in the last century B.C. A third trend in Roman portraiture of the last century, which we shall deal with in fuller detail later on, shows the more obvious influence of late hellenistic work both in modelling and in general style of representation. The influence of the portraiture of hellenistic rulers and famous philosophers and thinkers can be very clearly seen and was indeed consciously cultivated by the great men of the Republic. The Roman coinage has been used in attempts to provide a firm chronology for the various 'styles' during the first century B.C., but it is doubtful whether the sequences proposed have any real validity. Rome in the late Republic was open to many influences, and we find several cross-currents of style and technique operating at the same time.

Roman temple decoration, if often more elaborate, was fundamentally the same as Greek. Exterior friezes with figure composition were rare, but sculpture in the round, or more often in high relief, decorating the gables of temples, and acroteria with figures or rich ornament, were common. Scenes from early history and mythology seem to have been the commonest subjects. The pediment of the Augustan temple of Quirinus, known from a fragment of a historical relief, had appropriate scenes from Roman mythological history, revived and much embellished at the time, while a lively battle scene in hellenistic style on a building perhaps to be identified with the temple of Juno Regina could be interpreted as an episode from the Trojan War. The front of the temple of Mars Ultor in the forum of Augustus, appearing on the Ara Pietatis reliefs, seems to have had a gallery of divinities with Mars himself in the centre (cf. p. 62).

There are very few surviving actual fragments of sculpture from Roman temples. In the early Empire it seems to have been not uncommon to re-use Greek sculpture in prominent positions on a temple. We hear that statutes by Kalamis were particularly popular as acroteria in Augustan architectural decoration, and it is possible that the well-known group of the Niobids, which seem to be survivors from a Greek pedimental composition, were re-used in Rome in a new context. Outside Rome a few temple pediments are known; the Neronian temple of the Dioscuri in Naples had a collection of divinities represented on it, and the high-relief pediment of the Antonine temple at Tripoli (Oea) included a central figure of the City Tyche flanked by Apollo and Minerva and with the Dioscuri at the ends (cf. pp. 110, 120). (See P. Hommel, *Studien zu den römischen Figurengiebeln der Kaiserzeit*, Berlin, 1954.)

Another important aspect of the development of Roman art which lies behind the subject matter of the coinage is the development of commemorative relief sculpture largely in association with buildings – temples, altars, statue bases, then arches. The commemorative relief has, like Roman portraiture, been looked upon as something specifically Roman, but the antithesis between Greek and Roman in this context is only superficially valid. It is true that the great events of Greek history were generally represented by means of traditional allegories, but in later hellenistic times the taste for a more specific reference to historical events was becoming apparent. We have already looked at the earliest of the Roman historical friezes, that of the monument of Aemilius Paullus, where the style is very characteristically Greek and the representation of the battle somewhat generalized (cf. p. 13). From this time onwards the Romans provided a constant demand for representations of historical events, and we have examples in the coinage. But it should be noted that even here we see a number of different trends: some of the scenes, for example the voting scene referred to above, are shown in a down-to-earth style, while some of the battle illustrations are depicted in a grand hellenistic manner. At the same time the coins show the development of a specifically Roman allegorical language with the growing variety of semi-divine agencies such as Concordia, Pax, and Pietas who are to play a large role in the later history of Roman official art.

The stone reliefs of the last century B.C. are comparatively few. One of the most interesting survivals, although rather difficult to pin down in date, is the series of reliefs carved in blue-grey stone which were found in 1937 in the Piazza della Consolazione south of the Capitol (Plates 16 and 17). The proposed dates range from the second century B.C. down to the time of Sulla, and it is possible that the original monument may have been an honorific pillar not unlike the monument of Aemilius Paullus. The main fragments represent two Victories, one on either side of a shield which is carved with an eagle and thunderbolt. On either side of the two Victories are candelabra. A second fragment has trophies consisting of a greave, a cuirass, and a shield, and yet another has a chamfrein. In the same area as the fragments were found a number of inscriptions dedicated by various peoples and kings of Asia referring to friendships and alliances with the Roman people. Possibly the reliefs are related in some way to them, and it is interesting that the style, which is very Greek, has connections with second-century sculpture at Pergamon.

Two lesser monuments of Roman historical sculpture certainly belong to the first century B.C. The first is a base in the Villa Borghese showing a sacrifice by a Roman *togatus* to a collection of divinities including Venus; it has been argued that the Venus type is that created by Arkesilaos for Julius Caesar's temple of Venus Genetrix and, if that were so, the base would date from after 46 B.C. Most of the figure types are Greek in style, but the atmosphere of the scene is very Roman. This is true, too, of the second republican monument, the base now in the cathedral of Civita Castellana which also shows a sacrificial scene (Plate 18). Here a bearded hero is sacrificing to Mars, Venus, and Vulcan. The figures are in low relief, and the tall, graceful proportions give the impression of a rather self-conscious and formal classicism, strongly influenced by the contemporary revival of classical art in the hands of the neo-Attic school of

sculptors. The feeling of the scene is not unlike that of the idealized head of the so-called Brutus.

Probably the most famous sculptured monument of commemoration of the late Republic, and still a matter of considerable controversy, is the so-called Altar of Domitius Ahenobarbus. It consists of two main parts considered by the German archaeologist Furtwängler to have formed a single whole, approximately sixteen feet square. It is very unlikely to have been an altar; it may have been a statuary base for a group of some kind. The date and origin are much disputed. The monument consists of a series of three reliefs carved with a *thiasos* of sea deities and monsters whch is now in Munich (Plate 20); and a frieze now in the Louvre showing the Roman rite of the *suovetaurilia*: the sacrifice of a bull, a ram, and a pig in honour of the god Mars (Plate 19). Both sets of reliefs are carved in Pentelic marble. The two parts of the 'altar' are completely different in character: the Munich scene is purely hellenistic Greek, in style related to late hellenistic baroque carving from Asia Minor, whereas the one in the Louvre is carved in a factual and down-to-earth manner such as one finds in some of the coin reverses of the last century B.C. It shows an uncompromising indifference to the rules of classical relief sculpture; in the sacrifice scene there are curious inconsistencies of scale and awkwardness in the posing of the figures.

If these historical reliefs could be more firmly placed in the chronology of republican sculpture, we should have a clearer picture of the development of the type; but the arguments produced so far are unconvincing. The original site of the monument appears to have been in Piazza S. Salvatore, whence it was moved to Palazzo S. Croce in 1639. It may have come from a temple and could have served for a statuary group. As the scene is a *lustratio exercitus*, it must be interpreted as the sacrifice of closing the *lustrum*. It shows the censor at work, with the sacrifice as the final act, and the soldiers symbolizing the people assembled by centuries. The problem is whether a particular census is referred to or whether the scene is symbolic. The date of the work is equally difficult to establish and can only be argued on stylistic grounds. The style has been called 'neo-Attic', and some have argued that the reliefs are the work of sculptors from Athens who went to Italy after the city's destruction by Sulla in 80 B.C. Others have preferred a second-century date, and one as late as the Second Triumvirate period has also been proposed. The chief interest from our point of view is the purely Roman character of the monument as a whole, and at the same time the very striking contrast in style between the two parts, where we see on the one hand a hellenistic sculptor handling a traditional Greek theme, and on the other a much more tentative treatment of the historical episode by a sculptor who seems less familiar with the subject matter. But the whole monument is an ambitious attempt to commemorate a specific rite in sculptured form and lies at the beginning of the typical Roman tradition of historical relief sculpture.

The reliefs on a number of late Etruscan urns and sarcophagi of the hellenistic period refer specifically to the life or death of the deceased – the funeral procession culminating in a *dextrarum iunctio* of husband and wife, as on the sarcophagus of Hesti Afunei in Palermo (250 B.C.?); the journey of a magistrate to the underworld, his chariot accompanied by lictors and officials, on a Volterran urn (R. Lambrechts, *Essai sur les magistratures*

des républiques étrusques, Brussels, 1959, plate xxvi); on another Volterran urn a victory procession culminating in the figure of a magistrate shaking hands with the leader of the procession. Many details of these reliefs later became part of the symbolism of Roman propaganda sculpture.

There are other interesting historical reliefs which can be reasonably assigned to the first century B.C., but comparatively few historical paintings, which also are occasionally reflected in the coinage of the period. But enough survives to illustrate the different traditions of painting during this time. The well-known fragment of a historical picture found in a tomb on the Esquiline hill in Rome and now in the Museo Capitolino has a number of scenes of battle, siege, etc., arranged in tiers one above the other, presumably giving some sort of continuous account of the successive episodes in a campaign (cf. pp. 14–15). Here again the date is much disputed, but the second or first century seems most probable. Another painting, in the Terme Museum, also from a tomb on the Esquiline hill, appears to represent the battle by the Numicius between Trojans and Latins and Rutulians and the building of city-walls, presumably those of Castelgandolfo (Alba Longa) and Rome. It illustrates the developing interest in early Roman mythological history as a theme for art; and its style is full of verve and movement. Wholly hellenistic in spirit, it reflects the enormous antiquarian interest of the last century B.C. and the development of a characteristically Roman subject matter which again is mirrored in the coin series.

Despite the influx of foreign artists into Rome during this period much of the traditional Etrusco-Italic manner still survived. An interesting series of terracottas found in Via S. Gregorio once decorated the pediments of a temple built in the old Italic style. The date is about 100 B.C., and the scene represented was a sacrifice to Mars very similar in character to that shown on the Ahenobarbus frieze. The modelling of the figures illustrates the continued skill of Central Italian sculptors working in traditional materials. In Rome at this time there were many fine terracotta modellers capable of translating the style of late hellenistic sculpture into local media. A number of superb fragments, including the so-called Fortnum Head in the Ashmolean Museum, have survived from Rome. The persistence of the Etruscan style of painting is also an important factor. The painted scenes of the François Tomb at Vulci show episodes from Greek, Etruscan, and Roman history (cf. p. 15), and the elegant archaizing style of some of the pictures reminds us of the Brutus head in the Conservatori (cf. pp. 11, 18). While firmly rooted in the Etruscan tradition, the figures and the poses are evidence for the classical revival that is a feature of Roman art in this period.

DECORATIVE ARTS, ARTISTS, AND PATRONS IN THE LATE REPUBLIC

Interior Decoration

ONE of the clearer facts to emerge from a study of the Roman coinage is the deep-rooted taste for Greek art which had been developed since the Second Punic War. The coins illustrate the importance of art collections in creating the Roman style of the period. Occasionally we see direct copies of famous works such as Pomponius Musa's Muses or the famous Victory after a painting by Nikomachos on coins of Plancus. But more important than this, most of the newly created Roman allegories are adapted versions of traditional Greek divine figures. It is important to recognize how pervasive this passion for Greek art now becomes, and this can best be done by studying the Roman houses and their contents on the island of Delos, where during the second century and certainly down to 80 B.C. there existed a colony of prosperous Roman businessmen who chose to live in Greek surroundings and whose taste can be seen in the furnishings of their homes.

The type of house in which they lived was fundamentally Greek in origin and based on a smallish courtyard around which the principal rooms were grouped. These rooms were decorated with wall painting of a fairly standard variety imitating zones of masonry and generally consisting of a plinth, a range of orthostats, a narrow frieze or string course, and then a zone of masonry surmounted by a cornice. This basic scheme could be carried out in paint, by incision, by incision and paint, or in painted relief. The painted reliefs are of most interest, because this is the style that later took root in Italy. It is well illustrated by a number of rooms in the House of Dionysus. In one of these the orthostats are surmounted by two bands of frieze each framed by mouldings and each of different colour, while the masonry zone above has alternate courses again of different colours. It is not easy to restore the crowning parts of the design, and hardly any complete schemes survive. In the House of Dionysus one of the rooms had an order of Doric pilasters and a coffered ceiling shown in perspective, while a number of other rooms in Delian houses have produced relief columns, decorated mouldings, and other architectural details. Figured painting was only very rarely incorporated, but there is a battle scene in black and red from the House of Dionysus. For the schemes in general black and red are common and warm colours are favoured; yellow and a number of kinds of imitation marbling appear.

This type of wall painting in the wealthier houses was combined with the limited use of floor mosaics. Mosaic as a form of decoration in Greece appears in the fifth century B.C., the earliest examples consisting of small pebbles formed into quite ambitious figured and floral designs. The finest series of this type, made about 300, are in the Macedonian Palace at Pella. When and where this technique gave way to mosaic of

small cut cubes of stone is not certain, but it was perhaps in the third or second century and in Sicily. Mosaic of this kind was extensively used in some of the houses at Delos, for example the House of the Masks. This is a large house, combined with shops, in which the peristyle has simple pebble floors, but the principal rooms have tessellated ones. The main room has a pattern of perspective boxes covering a central area and flanked by bands of scroll pattern with masks. A smaller room has a white floor with a central panel, known as an *emblema*, with a picture of Pan and a Satyr executed in small tesserae. Yet another room has a central mosaic 'mat' decorated with a Panathenaic amphora and large rosettes. A fine mosaic picture of Dionysus on a cheetah is the main decoration of another apartment (Plate 21), which also has a little mosaic mat by the door.

These mosaic pictures are the main feature of the floor decoration at Delos. The detail is made up of very small tesserae of stone and glass in a wide range of colours which makes it possible to imitate the effects of the paintings from which most of the designs must have been copied. Mosaic *emblemata* were highly prized and sometimes lifted and moved from place to place; as they have only one good viewpoint, they tend to be carefully sited to give the maximum effect. The fashion spread over the whole hellenistic world, to Syria, where the technique of minute tesserae irregular and curved in shape – *opus vermiculatum*, as it is called – survived in later times, and to Egypt, which has produced several hellenistic examples, as well as to Greece and the West. The fashion reached Italy in the first century B.C., and there are several distinguished examples, including the famous Alexander mosaic, from Pompeii. The fashion for Nilotic scenes must have come through the work of Alexandrian mosaicists; one of the finest is the great carpet mosaic from the lower sanctuary of the temple of Fortuna Primigenia at Palestrina (Praeneste) which probably dates from *c.* 80 B.C.

All the paintings from hellenistic Egypt seem to come from tombs ranging in date from the third to the first century B.C. The mosaics come from a greater variety of sources and are of higher quality, in delicate *opus vermiculatum*, with a wide range of colours. One of the best is the mosaic from Thmuis signed by Sophilos with a central vermiculate panel of Alexandria (?) framed in guilloche, maeander, and crenellation pattern. The ornamental detail can be compared with examples in Pergamon and Delos. Crenellation is said to be a weaver's pattern. The Pergamene parallels seem to date from 197–*c.* 150; the epigraphy of Sophilos' signature suggests a late-third- to early-second-century date. If so, it is the earliest crenellated mosaic. Also from Alexandria is a tessellated floor in the manner of the pebble mosaics. Pebble technique was not apparently lost in the hellenistic period.

The sculptural contents of these houses of Roman businessmen were also in pure Greek style. In one house, the House of the Diadumenos, stood the figure of a Roman, his head carved in the portrait style of the period, his body the idealized body of a Greek statue. This type of statue, which the Romans called Achillea, had become very popular by this time, and adaptations of famous Greek masterpieces were used for the purpose. The figures were carved for Roman patrons by generations of highly skilled Greek sculptors; one such family, that of Dionysios and Timarchides, which was established on the island around 100 B.C. and made, among other things, the portrait of a

certain Ofellius Ferus, seems later to have emigrated to Rome, where its members were responsible for some religious sculpture. Many Greek artists must have followed the same sort of career, and they played a large role in the development of the Roman artistic tradition during the last century B.C. The work of the Greek portraitists on Delos, which is well evidenced by surviving heads, must have been an important factor in the development of the typical Roman portrait series.

The houses of these wealthy Romans on Delos were equipped with expensive furniture, although only the objects of more durable material have survived, including marble tables, basins, and candelabra and some garden furniture. At Delos these objects were comparatively simple in design, but they created a taste which was taken up in Italy and became very popular. Marble reliefs must have occasionally decorated the walls of these houses and the gardens and porticos.

The taste for ornate marble furniture continued throughout the first century A.D. The base of a candelabrum in the museum at Venice has relief figures of *kalathiskos* dancers in the style of the late fifth or fourth centuries B.C. Technically, the drilling of the swags and the deep undercutting of the drapery and the hair of some of the figures suggests the Flavian period. The curious Grimani 'altar' in the same museum (Plate 22) has figures in hellenistic style and ornamental mouldings that suggest a Julio-Claudian date. Many examples of such furniture now in museums are heavily restored; this is true of a number of very elaborate bases, vases, and candelabra said to have been found in Hadrian's villa, which clearly had many such pieces. The 'neo-Attic' carvers who created this tradition seem to have remained active until the Hadrianic period; after that time the fashion apparently declined.

The fashions which can be so clearly seen in the houses of Delos spread during the late second century to Italy. The wealthy Romans of the late Republic had their villas and town houses decorated with versions of hellenistic painted schemes, with mosaic *emblemata* and with marble and bronze statuary; and in response to this demand schools of decorative painters and sculptors were established both in Greece and in Italy. They were capable of decorating the house in the prevailing artistic fashion and to the taste of the patron, whether he be given to Egyptian designs or to classical Greek. A typical product of this period is the so-called neo-Attic school mentioned above, which probably flourished from about 130 B.C. and lasted, as we have seen, well into the Empire. This school concerned itself mainly with producing marble furniture, such as garden vases, or with herms or decorative marble reliefs. Some patrons preferred the simplicity of the archaic style, which had much in common with the traditions of early Etruscan sculpture; others favoured the cool classicism of the fifth century B.C. These sculptors operated from Athens and were much employed by wealthy Romans in the first century B.C.

Greek Artists and Roman Patrons

Sculptors from many places of origin set themselves up in Italy itself to be near the source of the demand. One such was Pasiteles, who was a very versatile artist and also wrote on the subject of art (cf. pp. 28, 60). He was perhaps a South Italian Greek given

franchise after the Social War, and his school specialized in eclectic works with a taste for the Greek severe style. The neo-Attics and the school of Pasiteles were but two of the artistic schools which functioned in this period.

There is a clearly recognizable Rhodian school of sculpture in late hellenistic times which is represented by surviving material from Rhodes and Cos. Much of it is on a small scale, and some is religious; but basically it caters for a developing taste for pretty, ornamental pieces in private contexts. Typical products are delicately carved stock figures of draped girls, semi-nude Nymphs, Satyrs in decorative reliefs, and so on. There are certain mannerisms in the handling of the proportions, for example the high-girded female with long loose robes, and characteristic tricks of drapery – the transparent overgarment, the archaic folds – which were obviously popular at the time.

It would be difficult to say how far-reaching the influence of this school became in the first centuries B.C. and A.D. The work of Rhodian sculptors, who gained a reputation as the 'followers of Lysippos', was well-known, and they certainly got big commissions in Rome: their archaizing style, which lacks the stiff formality of the neo-Attic, seems to have appealed to Roman patrons. Rhodian decorative work may have influenced the early development of Roman ornament, especially funerary ornament. Some of the neatly carved little altars which abound in Rhodes and Cos have naturalistic swags handled in a way that reminds one of objects in Rome.

The sculptors who worked for Roman patrons in the last two centuries B.C. seem to have established themselves first in the cities of the Greek world, but they were perfectly prepared to travel. There seem to have been strong family traditions among them, for following in the footsteps of the father and continuing the same workshop style. One family active in this period was that of Timarchides and Polykles. There were at least two of each: Timarchides I collaborated with his brother Timokles, who is known from several Greek inscriptions, and among their works was an Apollo Citharoedus in Rome (Pliny, *N.H.* 36, 35); Timarchides II (he is called νεώτερος, 'the Younger', in Athens, *I.G.*, II², 4302) worked with his uncle at Delos around 100 B.C. and made the marble statue of the Roman businessman, C. Ofellius Ferus (cf. pp. 24–5), in heroic Greek pose (J. Marcadé, *Recueil des signatures de sculpteurs grecs*: École Française d'Athènes, Paris, I, 1953; II, 1957). Another family, originating in Tyre, worked during the same period at Rhodes, in Athens, and in Asia Minor. Two of the recurring names are Artemidoros and Menodotos. Their origin is probably less significant than the fact that they had attached themselves to the late hellenistic Rhodian school, whose works were extremely popular in the late Republic and who continued to carve important sculptures in the first century A.D., to judge from the recent discoveries in the cave of Tiberius at Sperlonga. These men, like Pasiteles, were remarkably versatile – none more so, perhaps, than the Menodotos who collaborated with another Rhodian to 'forge' the famous bronze Apollo of Piombino and pass it off on a gullible Roman collector as a work of the late archaic period. The popularity of the archaic style in the late Republic, and especially in the Augustan period, produced a crop of archaizing works in most of the successful workshops. The charge against Menodotos depends on the dubious reading of the inscription on lead which the forgers put inside their work (*Antike Plastik*, VII, Berlin, 1967, 43 ff.).

The literary references to Alexandrian art are almost all equivocal and frequently mis-interpreted. A classic case is that of Demetrios the *topographos*, who was living in Rome in 164 B.C.; he had formerly lived in or visited Alexandria and had known Ptolemy VI Philometor. He sounds an important person, and some interpret *topographos* as a land-scape painter, although he could equally well have been a writer or a mapmaker. This was well before the popularity in Italy of the Nilotic landscape, which may or may not have been created in Alexandria. Bucolic painting was certainly popular there; but the argument that pictorial reliefs with bucolic subjects should be attributed to Alexandria is unacceptable (Schreiber, *Die Wiener Brunnen-Reliefs am Palazzo Grimani*, 1888; generally dated post-Augustan). Pliny's reference to a certain Antiphilos who worked in the time of Ptolemy I has also provoked much 'Alexandrianism'. He notes a picture of a boy with special effects of light; a picture of women spinning wool; and a grotesque of a certain Gryllos. But none of these themes is exclusively Alexandrian, and indeed Antiphilos was not a first-class painter. There is also a feeling that 'impressionism' was invented in Alexandria. Petronius mentions *compendiariae* from Egypt, by which he refers to speed in painting, apparently. Impressionism is widely used to refer princi-pally to a sketchy, unfinished technique, an 'abbreviated' use of plastic form, which might be called 'compendiary'. This is sometimes combined with colour impression-ism – showing the play of light and shade. There is also a 'momentary' style. None of this is much reflected in the extant painting.

It is important to understand the development of Roman taste which underlies the artistic output of this period. The subject can best be studied in the attitudes of Cicero, who is more or less typical of the cultivated society of the time. When Cicero withdrew, temporarily or permanently, from public life he hoped to create in his country estate an atmosphere suitable for the pursuit of *otium*. He wanted the interior of the house and the gardens to provide an atmosphere in which sculpture and painting played an essential part. None of Cicero's villas has survived with its furnishings, but we get some idea of the range of sculpture in such a villa from the so-called suburban villa at Herculaneum, where a whole series of heads of philosophers, poets, and others was found, together with copies of famous classical works of art of various periods. The contents of the villa are the counterpart of the kind of material that we know Cicero to have been looking for through his agent Atticus in Athens. He specifically refers to marble vases and herms, and a curious sidelight on this trade in works of art comes from the famous ancient wreck discovered off the Tunisian coast in 1908, which contained a mixed bag of all kinds of objects including herms, statuettes, architectural members, marble vases, and so on. Whether the find represents legitimate trade or loot of some kind it is very difficult to say.

A great change has now come over the Roman attitude to art. Instead of the rather uncritical taste of the generals of the second century, usually for rather ostentatious or technically very skilful hellenistic sculpture, we now have one based on consider-able knowledge of the history of art which could be used not only in beautifying one's private estate, but also in creating monuments of political and social propaganda. This taste is not based on deep understanding. Cicero does not set himself up as an expert on

Greek art, but he recognizes the qualities of the great artists of the past and wants to have their work around him. The development of knowledge comes from direct contact with the monuments of South Italy and mainland Greece as well as with imported works of art. It comes to a lesser extent from writings on ancient art which became more common in the hellenistic period (see below). We possess no ancient work of art criticism, but we know that, after Aristotle had provided them with a justification for imitative art, a number of writers produced works of art criticism (cf. pp. 59–60). Polykleitos in the fifth century had already written on his own work; others who followed him were Agatharchos and Euphranor. The art critic who seems to have been best known to the Romans of the late Republic was Xenokrates. He was a sculptor and writer in the early part of the third century B.C. who wrote on the fundamental qualities of art and discussed problems of representation which he used as the basis for a history of the painters. His work was certainly very influential, and others, including Duris of Samos, followed him, as did Pasiteles, the South Italian sculptor, who wrote a book, *Nobilia Opera*, about the great works of art of the world.

This body of criticism would have been well-known to Cicero, who, however much he may have disclaimed it, was reasonably well-informed and appreciative on the subject of ancient art. He was, after all, acquainted with a circle of artists, including Arkesilaos, the sculptor who worked for Julius Caesar and who was immensely successful in his day. He had been to Greece and had made a study of Greek works of art in Sicily. He obviously admired and respected the masterpieces, referring to their *sanctitas*. Great art he felt is essentially religious art, but he also developed a strong interest in what we should call antiques and acquired a good deal of know-how in the process. If he still occasionally hankers after the ignorance of Mummius and the simplicity of the old days and may think of himself as a moralist and a traditionalist, he is a very different person from his contemporary Varro, who is a pure *laudator temporis acti* and believes in *utilitas* rather than in *luxuria*. But Varro, too, had been to Athens for his higher education; he had a very considerable knowledge of ancient biography and portraiture, and he fully recognized the eminence of the great artists of the past.

The methods by which the taste of Cicero and his friends was satisfied created the technical background to the development of imperial art. The mechanical copying of classical masterpieces is one of the most important aspects of this. The practice of commissioning copies of classical sculpture goes back to the Attalid kings of Pergamon in hellenistic times, when it was common, but mechanical means were not apparently used. This is true of the copies from Pergamon and of those of the second century B.C. from the Heroon at Calydon, which has versions of a Meleager by Skopas and a Lysippic Hercules; and it was not until Roman times that mechanical copying was introduced on a large scale.

Mechanical reproduction is a response to a peculiarly Roman demand resulting from the age of looting in the early Roman imperialist era. In the first century B.C. the spread of Greek taste to a wider Roman public produced a market for copies which had to be supplied by the introduction of mechanical processes, especially the so-called pointing process, which is still used today; it is not certain when it was invented, but a statue from

Delos of Polykleitos' Diadumenos, which may date from before 69, has claims to be the earliest example. The use of the process, which involves making plaster casts of originals and then preparing stone or bronze copies, spread very widely. Athens was clearly an important centre, and other schools were quickly set up in Italy. Aphrodisias in Caria was another centre in the imperial period. Not all Roman patrons were content with straight copies, and some of the most successful 'schools' seem to have produced adaptations to suit the more eclectic taste. The Farnese Hercules from the baths of Caracalla, fit decoration for that gigantic building, is a version, signed by Glykon of Athens, of a work by Lysippos. Famous statues could also be adapted to suit particular contexts or settings. A copy of the Skopaic Meleager might be balanced by its mirror image in an opposing niche. Very common was the use of famous statues for portraits of men and women; the headless body of C. Ofellius is copied from a late-fifth-century original, and another Delian portrait statue derives from a work by Polykleitos.

Copies were made in different media. The famous sculptors of the classical period worked mainly in bronze, a material which could be used, with the aid of casts taken from the original, to make accurate reproductions: an impressive collection from the suburban villa at Herculaneum has already been referred to (p. 27). Full-size or reduced copies would also serve as candelabra supports or simply as ornaments, but bronze was an expensive medium and bronze copies would more normally be produced to order. The chief demand was for mass-produced marble versions, often from bronze originals, which needed the addition of some sort of support to make them stable. They vary in their effectiveness, but the best copyists went to great trouble to convey the effect of the original. A fine example now in the Side museum, probably taken from a fifth-century head of an athlete, by means of drilling and undercutting contrives to retain the sharp precision of detail that characterizes bronze work, the hair being a particularly masterly version of the bronze locks which in the prototype had been cast separately and joined on. The copies were not generally coloured to imitate the original but merely painted in accordance with the conventions of ancient marble sculpture, although it does seem that such a stone as green basalt owed its popularity to the fact that it approximated in colour to a patinated bronze. Later on a fairly wide variety of coloured marbles and combinations of white and coloured marbles came into general use.

Eclecticism, which was a characteristic both of the literature and of the philosophy of this century, found its artistic expression in the work of Pasiteles. We know directly only the works of his pupils, the best-known being an athlete by Stephanos in the Villa Albani, Rome, which combines a stiff, upright, 'severe-style' stance with a relaxed, pensive head. It was a popular figure, copied a good deal; although it is inspired by a number of different 'styles', it is coherent and effective. Other well-known Pasitelean works include a series of two-figure groups, among them the so-called 'Orestes and Electra' (Plate 23). Not all Pasiteleans followed the same style; Menelaos, a pupil of Stephanos, seems to have had little in common with his master. The learned founder of the school, Pasiteles himself, must have been a very influential figure in the history of late republican art; probably on the occasion of Q. Metellus Creticus' triumph in 62 B.C. he made a colossal ivory statue of Jupiter in collaboration with one Apollonios:

one wonders if this could be Apollonios, son of Nestor, who signed the famous Torso Belvedere, a fine example of the massive late hellenistic baroque style known to have been popular among Roman art patrons at this time.

Copies did not always maintain high standards of precise imitation, and as time goes on they reflect more and more the fashions of contemporary carving. A series from the Hadrianic Baths at Lepcis Magna, which seems to date from the Hadrianic and Antonine periods, shows the contemporary technique – shared with Antonine portraits – which combines highly polished flesh parts with rough and deeply drilled hair and beard. Copying on a large scale probably did not go on for long after the middle of the third century A.D., but some copies were produced after that date: the latest ones are usually a good deal removed from the original and show unsightly drill work or roughly executed drapery. But the importance of the series of copies in the history of Roman art is enormous. Not only do they provide our chief knowledge of Greek sculpture, but they reflect the important fact of the complete dependence of the sculpture of the Roman age on the classical tradition.

Another important aspect of copying was the manufacture of marble furniture of various kinds decorated with reliefs and figures based on classical originals. The most important of the 'schools' in this field were the neo-Attics, some of whose early productions, in response to Roman taste, show a dependence on hellenistic prototypes but who later worked mainly from archaic or classical models. Archaizing was particularly popular in the late Republic and early Empire, and one finds a whole series of decorative reliefs and articles of furniture with figures inspired by archaic Greek art. The later fifth century also provided a rich source of material. The neo-Attics made large wall panels decorated with figured scenes deriving from the shield and other parts of the Athena Parthenos, and marble ornaments for the Roman *horti marmorei* which Cicero was designing for his Tusculum villa. He specifically refers to wall reliefs, decorated well-heads, and marble herms which he is getting from Athens; and one catches something of the atmosphere that he was trying to create on a number of contemporary terracottas of the class known as Campana reliefs, which show colonnades decorated with various kinds of figure sculpture and vases.

A series of reliefs with landscape elements combined with figures of mythological or religious origin was studied by Schreiber under the heading of 'hellenistic landscape reliefs'. Many look rather like three-dimensional counterparts of some of the mythological panel pictures incorporated in Roman architectural decoration, and they often seem to have been used for a similar purpose. When coloured, as they no doubt were, they probably fitted into decorative designs in paint or applied marble (*crustae*) in public buildings and private villas; a rare survival *in situ* is the Telephus relief from a house at Herculaneum. The mythological reliefs of the Ara Pacis fall into the same class. The whole series probably ranges in date from the late hellenistic to the Hadrianic period, and there is no obvious homogeneity of style or technique. The sources of inspiration vary. In Athens the neo-Attic school employed fifth-century models. The Amazon groups copied from the shield of the Athena Parthenos are placed in simple landscape settings added to suit contemporary taste. The landscape is generally subsidiary to the

figures, and there is no attempt to create genuine organized backgrounds with systematic scale and perspective. However, buildings are generally shown in recession, and foreshortening and diminution of scale are also employed. The main interest is in the figure types, which are closely inspired by classical and hellenistic models like most of the decorative sculpture of the time.

Copying of paintings is a later phenomenon. In wealthy Roman houses of the last century B.C. sculpture seems to have dominated the decoration, combined with comparatively simple painted walls and rich mosaic floors; but as the century progressed painting came more and more into its own. Somewhere around the end of the second century B.C. hellenistic fashions of interior decoration, which are best known at Delos, had been adopted in Italy, where the general development of decorative painting can be followed at Pompeii; and the general framework for the study is still that established by Mau, with his 'four styles' of Pompeian wall painting.

Republican Wall Painting

Roman painting, as we know it from the interiors of houses, reflects the attitudes and beliefs of the Romans in general. What actually survives has, from time to time since the early eighteenth century, been greatly overpraised or equally badly underestimated; but no one can question the general truth of Goethe's dictum that the pictures reveal the artistic and pictorial taste of the Roman people. The models for many of them may be Greek, but their choice of subjects and their combinations are the product of Roman taste.

It is therefore particularly unfortunate that so much Campanian painting when first found was removed from its setting and taken to museums. Not only was much destroyed in the process, but a great deal of the meaning is lost when the pictures are out of context. The painting can only be understood in terms of the unity of the whole composition. The settings, from the very first, have a particularly strong Roman feel. The architectural 'second style', which begins at Pompeii about 80 B.C., and in Rome somewhat earlier, combines architecture with figure painting in a way which remains the basis of all subsequent 'styles'. Most students believe that this type of setting was inspired by Italic architecture of the first century B.C., but the spirit is completely Roman, whatever the source of motifs or details. One is on much less certain ground when one tries to establish the 'Roman' character of the content and style of individual pictures. The so-called illusionist style, which Wickhoff associated with the Pompeian fourth style, but which is now known to go back to the second, can scarcely be attributed to Roman native artists, if that is important to establish.

The Pompeian 'styles' are rooted in Italic culture of the late Republic, when Rome had become the pre-eminent artistic centre, developing its own versions of hellenistic architecture and art, and when private citizens decorated their villas like eastern kings, adopted Greek divinities as their patrons, and expressed their political and religious ideas through Greek art and literature. The choice of the kind of art that they wanted to have around them was always a meaningful one and not simply the result of a fashion in decorative taste. Changes in subject matter reflect changing attitudes rather than changing

taste, as for example when the mystery pictures and idyllic landscape of the second style give place to different mythological allegories; and the Greek models in general are not proof of Roman lack of imagination, but of the genuine assimilation of Greek culture into Roman. The basis of this assimilation is religious, and the State religion rests on a mythology and legend fundamentally Greek in origin. The achievements of Augustus are expressed through classical allegory and mythology in art, just as the poets of the age employed Greek literature. The difference between Greek and Roman art is perhaps that in the latter the religious ideas are expressed not so much in artistic form as in artistic symbolism. It is important, therefore, to establish the Roman attitude to the house as a factor in explaining the choice of themes.

The first important element is the development of the house as a gallery of works of art by men of the Republic who sought to express their political ambitions in terms of artistic schemes both in public and in private. Sculpture played an essential part, and a planned programme carefully arranged in a setting became a central idea in Roman artistic thought. Figures appropriate to villas, fountains, and baths are one of the persistent themes; one sees this for example in the baths of Faustina at Miletus, where the sculpture is chosen to illustrate the virtues of athletic prowess. When works of art were gathered together in temples, they were often arranged to stress the symbolic connections between them – a series of related myths, for example, to illustrate the same message. Later writers on Roman art often draw attention to the arrangement of pictures as pendants, as for example in the cycle of paintings described by Philostratus. The correlation of pictures in Pompeian wall schemes also makes this clear.

The Roman house, therefore, becomes a kind of art gallery. Collections of pictures (*pinacothecae*) had been made in public places and private houses from the second century B.C., and many of the major advances in planning had been made in private contexts. The best evidence for the appearance of the Roman picture gallery comes from the Farnesina House in Rome, and from the House of the Tragic Poet at Pompeii, where the pictures are arranged in sequence to illustrate work of different periods and styles. These galleries had, of course, a strongly religious content, because the house was a shrine and a place of sacrifice; and there were mythological and religious scenes appropriate to different rooms, such as the dining room and the bedroom. As time went on the domestic *lararia*, which had been in the *atrium*, were often moved into a garden setting. Bacchic subjects were particularly appropriate in the garden, which implied the idea of a sacred wood. Indeed religious themes appropriate to the beliefs of the residents became more common, especially illustrations of the mystery religions through the attributes of Bacchus, Venus and her daughters. There were also frequently symbols of piety – sacrificial instruments, candelabra, baskets, and incense burners. Especially popular were still-life pictures, which seem to be religious in origin and to represent objects offered in sacrifices. They occur as early as the second style, when triptychs appear in the principal part of the wall composition, and sometimes there are representations of objects hanging from the walls. Some of these offerings appear to be associated with particular divinities.

It is clear, therefore, that any simple decorative interpretation of Pompeian picture

is false: they are designed not only to decorate, but to express the religion, culture, and taste of the owners. Even in an age of religious scepticism, the old gods still survived and were a frequent subject in art. But perhaps the most important aspect of Roman thinking for the explanation of Pompeian pictures is the idea of the house as a sort of museum. Paintings and statues had been placed in domestic settings from an early period, originally perhaps to honour gods to whom they were, in a sense, dedicated. In the last century of the Republic such dedications were associated particularly with the Muses as a source of inspiration in thought and action. Varro had a sanctuary for the Muses in his park, and Cicero had an Academy which served the same purpose. One of Cicero's criticisms of Verres' looting was that he did not put what was stolen to fashionable use. The most famous example of a Roman *musaeum* is the villa of the Pisos at Herculaneum, where the range of sculpture is very wide. Probably at this time the Romans favoured sculpture in the round for this purpose, and this partly explains the enormous demand for copies of masterpieces. But painting increasingly took the place of sculpture, which was relegated to a subsidiary role in decoration. Already in the first century B.C., around 40, the villa of Boscoreale has a famous scene painted in the grand hellenistic style, which represents almost certainly the philosopher Menedemus: it is clearly an allegory of the virtues of philosophy as a source of inspiration to good rulers and administrators. The settings of the pictures were designed to create an atmosphere in which Roman humanism could flourish. It was perhaps rather too pretentious to survive in the later atmosphere of Roman decoration, existing only in the aspirations of such persons as Trimalchio, but it remains the key idea in the development of Roman painting, and it illustrates the striking contrast between ancient and modern collecting. Basically the objects were not acquired as objets d'art, but to express the religious and philosophical ideas of their owners.

The first style (Plate 24) is a style that reflects the taste of wealthier Roman houses and villas now lost. The inspiration was the palace of the hellenistic ruler with its massive peristyles, its marble incrustation and statuary, its rich mosaics. The Roman middle-class version combines an imitation in stucco and paint of coloured marble with mosaic floors in which the main decoration consists of pictures copied from celebrated classical and hellenistic painting. In the eastern hellenistic world there is nothing quite like this style of interior decoration as we know it, although it is absolutely clear that its various elements derive from hellenistic sources: the schemes of wall decoration, the types and subject matter of the mosaic floors, and other details have more or less precise parallels in Aegean domestic architecture of the last two centuries B.C.

The second style, on the other hand, is much more complex in character and origins, expressing, as it does, the tastes, the beliefs, the ideals of people in Italy at the time of the Civil Wars. It begins, quite simply, around 100 B.C., making use of hellenistic *trompe l'œil* to create basically architectural designs preserving the triple division of the wall used in the first style. The earliest and simplest is the wall of the House of the Griffins on the Palatine in Rome (*c.* 100 B.C.) (Plate 25), and the development can be seen in a series of villas at Rome and Pompeii. The developed style introduces a new world of ancient painting which makes use of technical discoveries to reveal the range of interests

of the Romans. In perhaps the most famous of second-style walls, in the Red Room of the Villa of the Mysteries (*c.* 60 B.C.), the figures taking part against a rich red background in the mystic initiation into the rites of Bacchus and in the mystic union of the human and divine are painted with a bold confidence expressive of the aspirations of the Romans towards immortality through the new mystery religions. Subjects are always chosen with care, although not always with deep symbolic meaning. Landscape is popular, but hardly ever for itself or in the fullest sense of landscape. In the famous scenes from the Odyssey (cf. p. 35) taken from a house of about 40 B.C. on Via Graziosa in Rome, it provides a setting for mythology and is varied and fundamentally naturalistic, with a good understanding of the use of linear and aerial perspective. The frieze is broken up by pilasters, but within each setting a number of different episodes, either contemporaneous or in close sequence, may be taking place; the figures do not dominate the landscape, and, as if to compensate for this, the painter writes in the names of the characters. (Plates 27 and 28). A little later in the Casa del Cryptoportico at Pompeii scenes from the Iliad decorate the frieze above the cornice of the *cryptoporticus*; the action moves in a continuous series of pictures against a background with some landscape features.

Landscape of another kind which creates an atmosphere of charming unreality – the so-called sacral-idyllic landscape – appears first in a subordinate role, in the *atrium* of the Villa of the Mysteries adorning the upper part of a simple masonry-style decoration. This is the landscape of fantasy with elements taken from Egyptian sources, and sometimes it uses tones of the same colour or unnatural colour schemes to heighten the effect of the imagery. The outstanding sacral-idyllic landscape, in a monochrome grisaille technique, decorated a room named after it in the house of Livia on the Palatine (30–25 B.C.). In the same house a series of sacral-idyllic landscapes form the main decoration on the walls of the *triclinium*. A little earlier (?40–30 B.C.) a *cubiculum* in the villa at Boscoreale had a second-style architectural scheme with large compositions of landscapes and buildings between columns; the designs must have been taken from hellenistic theatre-paintings.

A careful study of the themes used by the interior decorator throws light on every aspect of Roman thinking – the way in which classical mythology is used to express moral and political ideas, the hopes and aspirations through the mystery religions, the attitude to the gods. Towards the end of the Republic, and especially in the latest phases of the second style during the early years of Augustus, the wall designs become more formal, more museum-like; the horizontal frieze is broken up into framed panels in which large figure-compositions are arranged often as pendants, both with similar thematic or symbolic meaning. Soon a more direct copying of late classical masterpieces takes the place of the hellenistic taste of the late Republic, and we see much the same process of change as that already observed in the field of sculpture. The invention of still-life pictures is associated in our sources with the hellenistic period, in this case with a certain Peiraikos (third century B.C.: Pliny *N.H.* 35, 112). The evidence is that this type of subject appears in mosaics contemporary with the first style and is incorporated not infrequently into second-style compositions.

The last century of the Republic also saw the rapid development of stucco decoration

in Roman interiors. The vaults of three small *cubicula* in the Farnesina House contained the first surviving masterpieces of the technique – panels framed by mouldings and containing reliefs modelled with great delicacy, including landscape, Dionysiac scenes, floral ornament, and so forth. There is nothing in earlier work really comparable to the delicacy of the modelling in the Farnesina House, but something of the early development of the technique from the early first century B.C. can be followed in the surviving monuments. The early use of plaster in Greek interior decoration is confined to the imitation in relief of architectural elements which culminates in Italy in the Pompeian first style (see V. J. Bruno, 'Antecendents of the Pompeian First Style', *A.J.A.*, LXXIII, 1969, 305–17). Figured elements, modelled and coloured, come in at the beginning of the second style, for example in the Griffin figures in the lunettes of the House of Griffins on the Palatine (*c.* 80 B.C.), and by the time of the Casa del Cryptoportico (*c.* 40 B.C.) there are elaborately decorated vaults and friezes (e.g. with scenes from the Iliad) in low relief. The subjects include Cupids and figure scenes in the lunettes and on the vaults a rich variety of plant motifs, cult objects, armour of deities, and figure scenes. There is considerable refinement and variety in the reliefs (for this early development of stucco see R. J. Ling, 'Stucco Decoration in Pre-Augustan Italy', in *P.B.S.R.*, XL, 1972).

There are a number of problems concerning the relationship of the four Pompeian styles, but the following sequence seems to be generally acceptable. The first style appears around 200 B.C. and prevails until about 90 B.C.; the second style, apparently originating in Rome about 90 B.C., appears in Pompeii a few years later and continues until around 15 B.C., when the third style becomes popular in the capital. The fourth style comes to the fore under Tiberius but does not become general until the time of Claudius. It is generally said that there is no genuine third-style painting at Pompeii after the earthquake of 62–3.

The origin of the second style is one of the central problems of Roman art. There is no doubt that the painters of the hellenistic period had mastered all the techniques of illusionistic painting, and there are clear hellenistic prototypes for some of the elements in second-style decoration. The architectural schemes, of which a good example is the wall in the House of Obellius Firmus at Pompeii (Plate 26), seem to be imitations of Greek stage sets. They show a considerable understanding of the principles of perspective, although they do not introduce a single vanishing point. The famous frescoes found in 1848 on the Esquiline hill and now in the Vatican Museum introduce scenes from the Odyssey of Homer set in elaborate landscapes (cf. p. 34) (Plates 27 and 28). This is not landscape in the fullest sense of the word because there are inconsistencies in perspective and in the handling of light, but there is a genuine attempt to show objects in different tones of colour and a skilful use of perspective effects which create a very convincing atmosphere to suit the mythological events. Recent cleaning has shown that the painter used comparatively few colours to obtain his effects. The date of the Odyssey landscapes and the Obellius Firmus painting is around 50 B.C. Other contemporary second-style walls, such as the painted room from the Villa of the Mysteries, make use of hellenistic figured compositions.

Although we cannot follow out the development completely, it seems likely that the

second style, like the first, is of Greek origin and that it became particularly popular in Ita.y in the early part of the second century B.C. Certainly the sources of inspiration seem to be Greek, and the style as a whole can be considered as in the direct line of development of Greek painting. However, its adaptation, which produced the more obvious copying of classical masterpieces, does seem to be a Roman invention, and we shall discuss it in greater detail later on. Basically in this late form of the second style the frieze zone is broken up into a series of framed pictures, obviously inspired by the arrangement of a picture gallery; one famous scheme, that of the Farnesina House, even introduces imitations of picture hangings. From this time onwards there is a general taste for imitations of classical and hellenistic painting. These provide basic evidence for the lost masterpieces of antiquity, as do the copies of ancient sculpture, but they are a less reliable source because they are not produced mechanically in the same way: there is considerable variation between versions which obviously derive from the same original.

The copying of paintings is, then, inevitably much freer than that of sculpture because no mechanical method is available to produce exact replicas of the original. The degree of variation from copy to copy can be judged from the four versions of an Admetus and Alcestis picture in Naples: they differ considerably in style, in the posing of the figures, and in many of the details. A recent comment on the treatment of the table-like seat which appears in all four versions points out how it 'starts out like a firmly constructed piece of furniture with the principal receding lines of its extreme oblique construction all converging clearly. Step by step it is transformed into a clumsy concoction of warped planes and tilting and uneven members, receding from each other in disorganized divergence'. Apart from such details, one can distinguish peculiarities of style and technique among individual copyists by their brushwork and their modelling. Perhaps, too, one can see something of their personalities in the way in which they adapt the design or colour scheme of the picture to suit their own decorative conception.

The art of mosaic in the last century B.C. was also taken over by the Romans from the hellenistic world. *Opus vermiculatum*, which is typical of the houses of Delos (cf. p. 24), appears in Italy early in the century. At Palestrina (Praeneste) in part of the Great Sanctuary, which probably dates from the time of Sulla, there was a famous mosaic with Egyptian scenes in this characteristic technique of using minute tesserae in such a way as to achieve a remarkably close imitation of painting (cf. p. 24) (Plate 29). In the House of the Faun at Pompeii, when it was decorated in the second style, there were mosaics of typical hellenistic form, consisting of small *emblemata*. The most famous, which occupies an open *exedra* between two peristyles, represents Alexander at the Battle of Issus in a version clearly copied from a late classical painting (Plate 30) (cf. pp. 24 and 37).

There are many excellent hellenistic mosaics from Pompeii, generally *emblemata* with more or less elaborate frames. They include a fine roundel with a lion in landscape, framed by guilloche ornament, and a little composition of a putto riding a lion against a dark background within a frame of masks and swags which is very similar to examples from Delos. Best known is the little panel of street musicians and the one of birds drinking, both in elaborate frames; the colour schemes are muted, with much brown,

yellow, and black. In many ways the most attractive mosaics are the Nilotic scenes against a bright background, some of them from the House of the Faun which yielded the famous Alexander mosaic mentioned above (Plate 30). The colour scheme there is also muted, with a dominance of red, black, brown, and yellow, against which the figure of Alexander is isolated in rich colours. The inspiration is known to be a hellenistic painting, and the mosaicist contrives to give depth and movement to the figures, using subtle shades of colour in highlights. It is altogether a masterpiece of skill and certainly one of the finest surviving hellenistic mosaics. The picture is contained within a perspective frame.

As in painting, so in mosaic, famous *emblemata* were endlessly copied. The 'Unswept House' and the famous picture of doves drinking (cf. p. 36), both by a Pergamene mosaicist called Sosos, were two particularly fashionable subjects of which several replicas are known. These mosaic *emblemata* of hellenistic type, particularly popular in the last century B.C., seem to have gone out of fashion in the early Empire, although there was a revival of the art in the early second century A.D.

Opus signinum floors with patterns of tesserae, mainly white and forming maeanders, overlapping leaves, and so forth, are common also in early houses at Glanum (Saint-Rémy in Provence); *opus signinum* consisting of lumps of marble and stone, and even with some figured designs in lines of tesserae, is found in early contexts. Later, black marble mosaic, of a kind universal in the early Empire, superseded these early forms. The republican capitolium at Brescia seems to have had floors either of white tesserae or of *opus signinum* with marble fragments; the walls were decorated in the first style. At Ampurias in Spain the republican temple of Asklepios and Hygieia has simple geometric patterns of white tesserae in *opus signinum*, while the early houses of the *colonia* have mainly black and white geometric floors, incorporating scroll designs and a few figured motifs, such as dolphins. The *atrium* of House 2 however has a mosaic of white, purple, and black tesserae set with bits of such marbles as giallo, brescia, africano, pavonazzetto. A few *opus vermiculatum* medallions have been discovered.

THE TRANSITION TO THE EMPIRE AND AUGUSTUS
(31 B.C.–A.D. 14)

Art and the Dynasts

THE copying of sculpture, paintings, and mosaics was then the dominant theme of the last century B.C. The results can be looked at in one sense as a continuation of hellenistic art and in another as representing a specifically Roman taste which is characterized by a strong eclectic sense. But the outcome was to give a deep-rooted classical basis to the official art of the succeeding centuries. The process by which private taste is translated into public art can be seen in the class of objets d'art which may be called the miniatures of the Roman world: this is what archaeologists call gem carving in semi-precious stones, for example red cornelian or sardonyx, which may be hollowed out as seal stones (intaglio) or carved in relief (cameo). The carving of cameos in such layered stones as the Indian sardonyx is a hellenistic development taken over by wealthy Romans of the late Republic, who collected gems and commissioned engravers of Greek origin to work for them. It is worth noting that, while most painters and sculptors of the Roman period are anonymous, we have the signatures of no less than twenty-eight artists on gems and cameos from the late Republic and early Empire, and one is also mentioned by the ancient writers. Twenty-three of the names are Greek, and the five Romans sign their work in Greek letters. In view of this it is difficult to treat gem engraving as a 'minor art', and the same is true of other luxury crafts in the late Republic, such as that of the silversmiths, who made highly decorated relief-silver for wealthy Romans and often deserve to be considered as creative artists.

The cameos and intaglios throw a great deal of light on the development of Roman artistic taste both in subject matter and in style. The gems were often cut by the same men who prepared the coin dies for the late Republican moneyers, and there is frequently a striking similarity between the two media. In the Civil War period the sea monsters worked for Sextus Pompeius can be compared with coins and illustrate the taste of the time for the muscular contortions of late hellenistic baroque sculpture which are shown in such works as the Laocoon and the Farnese Bull. The creation of the taste for gems is attributed to Pompey the Great; and it is possible to follow the development down to the time of Augustus, when the best craftsmen were brought together to work on the vast output in this medium of imperial propaganda, including such highly skilful and impressive objects as the Gemma Augustea (Plate 31) and the Great Cameo of France.

Gem carving illustrates how a form of art which had obtained eminence in the hellenistic kingdoms was inherited by the wealthy Romans of the late Republic and later adopted as part of the official propaganda of the Empire. A similar chain of events took place in most other branches of art in the last century of the Republic. The activities

of the wealthy Romans created a classical taste; but the main transitional phase is that of the final struggle between the dynasts for control of the Roman State. The first of these powerful rulers was the dictator Sulla, who was honoured as a divinity in the States of Greece and who, during his dictatorship in Rome, carried out an unprecedentedly grand scheme of public building. He was the first man in Rome to blur the distinction between the human and the divine. By this time the statues of Roman gods had acquired the classic beauty of the Greeks, and this attribute was bestowed also on those of famous men, particularly Sulla, as an index to their divine gifts.

Pompey and Caesar inherited Sulla's mantle. Pompey controlled unprecedented wealth when he set out to adorn the city with suitable architectural and artistic memorials. In the Campus Martius in 54 B.C. he built the first stone theatre in Rome, which combined a public park and an open-air museum with its dramatic function. Into this complex of buildings he seems to have gathered a quite extraordinary collection of sculptural curiosities and other objets d'art. His taste, like that of many of his contemporaries, seems to have been for the highly skilful technical achievements of late hellenistic sculptors in creating an illusion of reality and testing their skills by the strangest choice of theme. The creation of a public museum of this kind was now very much part of Roman public life and was expected of those wealthy enough to undertake public building in the city. Pompey, although a man of no great taste, seems to have been typical of his time in that he was an ardent collector of works of art. We know that he built up a collection of gems and that he was an enthusiastic accumulator of silver plate. Many of the most skilful artist-craftsmen of the late Republic were working in his time.

Just as important as the creation of big public monuments was Pompey's creation of his own public image. Many generals before him had made use of the discoveries of hellenistic rulers in the field of idealized portraiture; in the late Republic this strong idealizing trend must be set against the realism that seems to have been popular in the early part of the first century B.C. Pompey had had an exceptional career, having been named Magnus at the age of twenty-five. At an early stage he likened himself to Alexander the Great, whose features and attributes were well-known and popular in Rome through portraits and paintings brought to the city: the characteristic set of his head, the sweep of hair on his forehead, and the 'melting gaze' were signs of Alexander's greatness, and other attributes marked his apotheosis. Pompey adopted many of these: in his triumph he had an elephant chariot; his coins carried Alexander attributes; and in his portraits, of which the best preserved seems to be a later copy of an original made between 55 and 50 B.C., the forehead hair is treated in the characteristic Alexander manner. The copy gives the head an air of caricature which may not have been shared by the original.

Pompey's activities in adorning the city of Rome and using artistic precedent for personal propaganda were far surpassed by those of Julius Caesar. From the time of the Gallic Wars, Caesar had unrivalled schemes for the adornment of the city and for the improvement of its practical amenities. As early as 54 B.C. he was planning the extension to the Forum Romanum which became the forum of Caesar, and he was using

marble for all the buildings that he planned. In the temple of Venus Genetrix the cult statue of Venus commissioned from the sculptor Arkesilaos, who had a high reputation at the time, was based on classical, perhaps late-fifth-century, Greek models. In all his buildings Caesar gathered together large public collections of pictures by master painters and of gems, silver, and other objects.

Caesar's portraiture, in its form, its material, and in the places where it was set up, further blurs the distinction between the human and the divine. Images of gods had played an active, as well as a passive, role in Roman public life. They were carried into the Circus and placed on the couches reserved for them, and they were borne in procession on a number of festival occasions. Caesar was honoured in much the same way when it was proposed to erect statues of him in the Comitium, on the Rostra, in the Curia, and on the Capitol, and it was also proposed to carry his image in triumphal costume from the temple of Jupiter to the Circus with the effigies of other gods. In a role of this kind Caesar was very much a living divinity, and his statue shared the cella of the temple of Jupiter with other divinities. Materials previously reserved for the gods, such as gold and ivory, were now used for human figures. The style was purely classical, generally combining an ideal body with a realistic head, and there was little in common with the traditions of earlier republican portraiture. The philhellenic taste of the Romans of the last century had transformed the Roman concept of ideal beauty.

The total effect of the artistic revolution was to set Roman art firmly on the classical path, not so much in the form of a revival, but simply as a continuation of an existing atmosphere. The gods of the State religion were now indistinguishable from Greek gods, and throughout the Empire Roman art continued to be very largely religious art. The portraits of great men were conceived in Greek form, and the attitudes of both patrons and artists owed much to Greek technique and Greek iconographical theory. The latter emerges much more clearly in the portraits of later emperors but is already quite evident at this time. In commemorative sculpture and painting, two of the most important fields of Roman art, classical allegories became acceptable, new allegories were invented and used to express Roman political ideas, and the realistic elements of the scene were treated with all the skill of Greek sculptural technique. There is a strong element of idealism in the treatment of figures who have no specific role to play in these scenes, just as there is an ideal type representing the Athenian people on the frieze of the Parthenon. The traditional themes of Roman mythology are now conceived in purely Greek terms and presented in ideal settings which owe much to the traditions of hellenistic landscape art.

The final transition from Republic to Empire took place in the period of the Second Triumvirate, and it is particularly unfortunate that so few monuments survive which can certainly be dated to this time. In the immediate post-Caesarean period and during the Second Triumvirate propaganda through the medium of art increased in intensity: this is particularly clear on the coinage, where the moneyers used the best Greek gem engravers to create types expressing their particular political convictions. The leaders of the period, Antony and Octavian, carry on Caesar's role. Antony adopts the extravagant artistic symbolism of Ptolemaic Egypt and appears with the symbols of the New Dio-

nysus; Octavian in Italy adopts the more cautious policy of stressing his connections with his adoptive father and completing his various building projects. Caesar is also commemorated with temples, altars, and statues which reflected glory on Octavian himself.

Late Republican Relief Sculpture

Very little of what was done during the Second Triumvirate has survived. In commemorative relief sculpture the so-called Ahenobarbus relief already discussed (cf. p. 21 and Plates 19 and 20) falls most naturally in this period because there is something very tentative about the manner of representing the *lustratio* scene, and the marine *thiasos* is very much to the taste of this particular time. One vitally significant undertaking was the erection of the temple of the deified Julius Caesar, begun in 42 B.C. and dedicated in 28. The building was of Luna marble and some fragments of its decoration survive, including a frieze of scrolls, Medusa heads, and archaistic winged figures which is very similar in design to some earlier Etruscan terracotta reliefs. But clearly in this case the workmanship is Greek, presumably because marble was unfamiliar to contemporary carvers in Rome. It is interesting that the design should have Etrusco-Italic origins, for the same background can be seen in the Campana decorative terracotta reliefs (cf. p. 30), which combine Greek motifs with Etruscan ones in a similar way: a particularly fine series, still with its rich painted details, has been found in what is believed to have been the house of Augustus on the Palatine.

Two other important groups of relief sculpture have been attributed to the immediately pre-imperial period, but neither is securely dated. The first is a frieze discovered in many small fragments inside the Basilica Aemilia in the Forum Romanum and now restored and set up in the Antiquarium of the Forum. The Basilica Aemilia was erected in 174 B.C. and subsequently underwent several restorations; those of 34 B.C. and 14 B.C. might have been associated with this particular frieze, and many scholars have favoured the former date. On the other hand there are good grounds for considering that the later reconstruction, when the building was ostensibly repaired by a surviving member of the Aemilian family, but paid for by Augustus, provides the more likely date. The frieze, a key monument for the history of Roman relief sculpture, depicts scenes from the early history, mythical and otherwise, of Rome. Although interest in such subject matter had developed in the late Republic, this work fits best in the Augustan revival, when the myths of Rome's foundation became a central theme of political propaganda. The scene here illustrated (Plate 32) shows the punishment of Tarpeia, the daughter of the governor of the Roman citadel, who opened the gates to the Sabines and was subsequently crushed to death under their shields. The relief tradition is a hellenistic one, with the same limited indication of setting and landscape. There is a classical simplicity about the arrangement of the figures, as in this scene with just two protagonists, one on either side, piling their shields on the unfortunate Tarpeia; although they are short and stocky and very solid, they are reminiscent of fifth-century Greek models both in features and in dress.

The second frieze which has been attributed to this period is that from the interior of the temple of Apollo near the theatre of Marcellus. The dating rests on the association with C. Sosius, who as consul in 32 B.C. fled to join Antony, but was later pardoned by Octavian. It is difficult to believe that the frieze can be as early as the 30s, and a much more likely date is around 20 because of the striking similarity between the details of the temple and those of the triumphal arch put up around the year 19 in the Forum Romanum in honour of Augustus. But whatever its date, it has the rather tentative quality which marks much of this early imperial sculpture. A triumphal procession is carved in a lively style on a rather small scale and in a somewhat detached, symbolic manner; another fragment of the frieze shows battle scenes apparently based on the traditional single combat of hellenistic relief sculpture and carried out in a rather similar style. Neither this frieze nor that from the Basilica Aemilia has yet the authority of fully developed imperial sculpture; and although they are probably a little later in date, they give a fairly good idea of the characteristics of Roman representational art in this transitional period.

After the victory over Antony, Augustus and his advisers were able to concentrate on a systematic programme for the rebuilding and adornment of Rome and on the creation of a convincing propaganda art which would express the new régime. This art was intended not only to convince those at home, but also to weld together a very heterogeneous Empire. It needed a vast amount of organizing, and it is now that the artistic background of those who were nearest the emperor becomes important. Agrippa, Augustus' general and constant adviser, was obviously a key figure until his death in 12 B.C.; and Maecenas and several others must have advised on official policy, which still had to tread very warily, seeming to sympathize with old traditions yet making full use of the fact that the Greek modes of artistic expression had penetrated deeply into the Roman way of life. The literary commemoration of the new régime was in the hands of brilliant poets – indeed, few régimes have been so well served – and there were equally brilliant artistic advisers.

The Ara Pacis Augustae

The monument which best shows the brilliance of the handling of the problems is the Ara Pacis Augustae, which is undeniably a masterpiece of political and social propaganda. It was put up between 13 and 9 B.C. to commemorate the return of Augustus from a long sojourn in the western provinces. The account of the excavation and reconstruction is something of an epic in itself (see G. Moretti, *Ara Pacis Augustae*, Rome, 1948). In its reassembled form the altar stands near the mausoleum of Augustus, but originally it occupied a site near the Via Lata (modern Corso), where now stands the Palazzo Ottoboni. The structure consists of a large rectangular – in fact almost square (11.63 by 10.62 metres) – enclosure with entrances to east and west, within which stood a raised monumental altar approached by steps. Both altar and enclosure – especially the latter – were richly decorated with sculpture of which parts had been found over a long period before the excavations of the 1930s; some of it is still dispersed in European museums, but

the restoration published in Moretti's lavish volume gives a satisfactory impression of the original.

The form of the altar seems to be basically Greek with elaborate scrollwork at either end, and it is generally believed that the enclosure also is derived from a Greek proto-type: the argument is that the closest parallel known to us, the fifth-century B.C. altar of Pity in the Agora at Athens, in the reconstruction by Homer Thompson also has decorated figure panels flanking the entrances. In the Roman monument these consist of scenes from the mythical history of Rome – on the back the Lupercal and the story of Aeneas and the Penates (Plate 34); on the front, which was towards the Via Lata, Tellus (Plate 33) and Roma. The two long sides of the enclosure wall had an upper frieze show-ing the procession of 13 B.C. when the site of the altar was consecrated (Plate 35); below was superbly carved ornament based on the acanthus scroll and incorporating a rich variety of naturalistic detail in the most delicate low relief (Plates 36 and 37). Inside, the frieze of garlands and bulls' skulls (*bucrania*) symbolizes sacrifice; the zone of ortho-stats below it perhaps represents some temporary structure erected before the comple-tion of the altar. The sacrificial frieze on the altar itself apparently commemorates the dedication procession of 9 B.C.

It is not unlikely that an Athenian design – so implicit in the sculpture – was indeed chosen for the altar, for it is undeniable that the buildings and art of classical Athens were greatly influential in the creation of the Augustan style. Although the frieze, for example that stretch of it which shows the emperor with his family and officials and priests (Plate 35), gives us a vivid portrayal of the individuals gathered for the celebra-tion, and in this sense differs utterly from the idealized representations of another famous procession, that on the frieze of the Parthenon, there is yet quite obvious classicism in the proportions, the drapery style, and the regularity of features in many of the subsidiary figures. It is quite certain that sculptors closely connected with the neo-Attic tradition worked on this frieze. They were aware, however, of developments which had taken place in earlier hellenistic relief sculpture, and made use of different planes of relief to create, in conjunction with paint, at least a rudimentary impression of depth. Their grouping of the figures is much more naturalistic than that on the classical frieze of the Parthenon.

Indeed, classical Athens does not seem to have been the only inspiration for the Ara Pacis: the delicate naturalism of the scrollwork (Plates 36 and 37) is very closely matched by reliefs from the temple of Athena at Pergamon, although the latter is more than a hundred years earlier in date. The detail is very obviously Pergamene, and it created a fashion for ornamental carving which became very characteristic of Roman sculpture. Another source of inspiration can be seen in the panels flanking the entrances. The most famous of them, and the best preserved, are first an elaborate allegory of the prosperity of the earth (Terra Mater) under Augustan rule; and second an episode from the life of Aeneas, who wears his toga drawn over his head and is about to sacrifice the white sow. Two *camilli* are in attendance and Achates is behind him. In the rustic shrine are the Penates brought from Troy and established at Lavinium before they were finally in-stalled in the Roman temple of Vesta. The origins of this type of relief, which belongs

43

to the Schreiber class, have already been discussed (cf. p. 30); such reliefs probably formed part of decorative schemes in the interior of public and private buildings as three-dimensional counterparts to panel pictures. The Ara Pacis panels are indeed fully in this tradition, but the series as a whole contains elements ranging widely in date.

The Ara Pacis demonstrates very clearly the way in which the best talent available was marshalled to serve an extremely successful and convincing programme of propagandist art, and it implies a firm directing hand. One would like to cast Agrippa in this role, because, through his succession of commands in the East, he had the opportunity to find the best craftsmen and build up his own staff, as we know he did in connection with his activities for the water supply of Rome. All one can say for certain is that many craftsmen from the eastern provinces were now employed on Roman enterprises, and many who had been chiefly engaged in producing for the private market were now brought into public service.

The Ara Pacis was a remarkable achievement, but by far the most impressive monument of the reign must have been the forum of Augustus, which was frankly designed, and successfully carried out, as a great dynastic showpiece using a very grand architectural design and the most expensive materials. It was begun very early in Augustus' reign, but for various reasons, chiefly of political caution, it was not finished until the early years of the first century A.D. Like the Ara Pacis, its design is a blend of Greek and Roman, a classic piece of the *communis ratiocinatio* which Vitruvius saw as the leitmotif of the architecture of the late Republic. Its chief interest here is in the way in which art and architecture were blended into the propaganda scene. The choice of decoration was very largely inspired by that of the buildings of classical Athens, the most obvious feature being the reduced Erechtheum caryatids which decorated the upper orders of the colonnades. These were careful mechanical copies, apparently produced in the workshops of a certain C. Vibius Rufus, yet clearly the work of Greek sculptors. But the imitation of classical buildings in Athens went much deeper than this, and there is a strong 'classical' element in the whole of the architectural detail.

As the chief dynastic monument of the reign, the forum also served as a kind of public *atrium* for the city, the counterpart of the private portrait galleries of influential patricians in the late Republic. Portraits of famous Romans, accompanied by accounts in verse (*elogia*) of the careers of men going right back to the foundation of the Roman State, were set up in the *exedrae*. It has been argued that the northern *exedra* celebrated the Julian *gens*, while the south side was devoted to the *summi viri* of the Republic. Unfortunately few fragments of the portraits seem to have survived, but they include examples of the different styles of portraiture in vogue in the late Republic; there is one fine hellenistic head, and another in the characteristically dry Republican style. A handsome idealized Apolline youth has been thought to represent Romulus, although Ricci preferred to call it a caryatid.

Augustan Portraiture

The importance of portraiture in the scheme of the forum of Augustus established a tradition which continued right through the Empire: there was now a new motivation to create an effective imperial image for the Julio-Claudian House. In the late Republic portraiture was commemorative or funerary; the latter showed a taste for the unvarnished truth, but in the former there was never in imperial times any question of realistic representation in the full sense of the word. The subject of portraiture had been treated in philosophical theory from the time of Aristotle, and certain basic tenets were widely accepted, one of which is put much later in the panegyric to the emperor Constantine: 'Nature endows great spirits with bodies worthy for them to dwell in and from a man's face and the beauty of his limbs we can see that the Divine Spirit has entered and dwells therein.' The phenomenon of Julio-Claudian dynastic portraiture is the creation of an idealized family image which became all-pervading. There was an enormous output of portraits of Augustus from his earliest youth, and those of members of the family were set up everywhere, so that numerically Julio-Claudian portraits far outweigh all others in most provinces. They were made for all kinds of purposes, ranging down from colossal examples which reflect the divinity of the emperor and have their precedents in divine images. To some extent their scale may be a matter of position; on the vast stage of a Roman theatre a figure must be suitably impressive and may even contain disproportions to correct optical effects. These portraits stood in public places of all kinds and were perhaps the most important organized aspect of imperial propaganda, carrying the message of the official idea of the reigning emperor, but also actually embodying the magical presence of the emperor himself. They were made in a great variety of media and in many forms: busts, herms, *imagines clipeatae* (portrait heads or busts on shields), and a wide range of statues.

The bust form had apparently originated in Italy and was especially connected with the dead, but although its use was extended later, emperors seem to have been only rarely so represented in public places or official contexts, as for example in the Augusteum of Cyrene. The portrait statue, by far the commonest form of likeness, literally represented the emperor; his statues would be removed if his memory were damned or if he fell into disfavour. An effective system of distribution had to be organized so that the appearance of a new emperor was known as soon and as widely as possible. Imperial statues could be cult figures, or they might decorate theatres and other public places; they could be found in military contexts or in private houses, where the worship of the Genius of the emperor took place in conjunction with that of the Lares.

The four chief types of imperial statues were the following: the figure in a toga; the statue in military uniform; the nude heroic figure; the equestrian statue. Of these the figure in a toga was, as we have seen (p. 11), typically Roman and goes back to Etruscan beginnings; the version in which the toga is drawn over the head (Plate 38) generally represents the emperor as chief priest and symbolizes the ideal of the pious ruler. The statue in military uniform is called by Pliny typically Roman, but there were plenty of Greek examples, and richly decorated hellenistic ones were well-known. The earliest

such statue of a Roman seems to be that of C. Billienus on Delos, and the oldest in Italy, a statue now in Munich, was found at Tusculum (cf. p. 14). The heroic statues of the nude emperor reflect particularly the divine aspects of the ruler and they, too, go back to earlier times; we know of an ideal portrait of Brutus in this manner, and of later ones of such men as Flamininus and the famous general from Tivoli whom some scholars have identified as the dictator Sulla (cf. p. 14: Plate 9). The use of *opera nobilia* for this purpose is certainly as early as the second century B.C.

Besides emperors, many other individuals had statues set up in their honour by Senate or emperor; Sejanus was voted one in Pompey's theatre and many others in the city, although none, however big, survived his death. Nero, after the suppression of the Pisonian conspiracy in A.D. 65, gave Cocceius Nerva and Tigellinus portraits on the Palatine as well as triumphal statues in the Forum Romanum. Domitian, we are told, granted triumphal statues to many who had never seen a camp or heard a trumpet. The forum of Trajan seems to have provided the grand setting for the commemoration of famous men of the Empire, and Commodus added to the collection by bringing in statues from elsewhere. The passion for portraits never died, and in the fourth century A.D. they gleamed with gold.

Augustus' own portraits have never been adequately studied. His artistic advisers handled the problems extremely well, because, while he seems to have been an impressive personality, he was certainly not a very pretentious figure. It is perhaps worth quoting the only description that we have of his physique, given us by Suetonius: 'He was negligent of his personal appearance; he cared so little about his hair that to save time he would have two or three barbers working on it together. . . . He always wore a serious expression. He had clear and bright eyes, teeth small and decayed, hair yellowish and rather curly. His eyebrows met above the nose, he had ears of normal size, a Roman nose and a complexion intermediate between dark and fair. He was 5 feet 7 inches tall but well proportioned.' The artistic advisers of the day skilfully played down his defects and stressed the qualities of his face: they made the eyes enormously large and impressive, arranged his hairstyle with care, and handled his features with great sensitivity. Two portraits illustrate what they achieved. The first, in the Museo Nazionale Romano, shows Augustus in his civil role, as chief priest, with his toga drawn over his head (Plate 38). His features are lean and ascetic and handled with fine sensitivity. The second (Plate 39), although facially of the same type, is very different in effect. This well-known statue, now in the Vatican, was found in 1863 at Prima Porta in a villa above the Tiber which seems to have belonged to Livia, Augustus' wife; it decorated part of a garden terrace standing against a wall and is generally believed to have been copied in marble from a bronze original erected in Rome. Damaged somewhat in antiquity and later repaired, it stands 2.08 metres high, and there are traces of painting and probably of gilding. We have no idea when it was made, but it is certainly later than 20 B.C., the date of the scene represented on the breastplate.

This statue represents Augustus in his military role, stressing his strength of character and of feature, and it produces an impression quite different from that of the togate figure. The pose is that of Polykleitos' famous Doryphoros, by far the most popular of

the Roman copies of classical statues. The breastplate is carved with low-relief decoration and figures representing the return of the standards captured by the Parthians on three occasions from the Romans, an event in which Augustus took especial pride and which was in many ways the major diplomatic success of his reign. The consummate skill of the best Greek carvers of the day in imitating a bronze original, or, if need be, of adapting it to a different medium, is strikingly in evidence.

How should the phenomenon of the idealized Augustan portrait be explained? V. Poulsen, a great student of Roman iconography, suggested that we should attribute it to the fact that Augustus came to power as a young, fresh-faced man at the end of an era 'dominated by choleric old men'. The earliest official portrait must have been erected in 31 B.C. or thereabouts, when Augustus was indeed very young, and some time before the definitive Prima Porta type was created. All the Augustus portraits are generic – over half belong to the Prima Porta type – and this remained the basic Julio-Claudian image until that image was broken by the humanity of Claudius and the vanity of Nero.

Just as important as the handling of Augustus' portrait was what may be called the creation of a dynastic type to represent members of the semi-divine imperial House. It is demonstrated best by the colossal portraits made of the Julio-Claudians, when the concept of the *domus divina* was established after the death of Augustus. In the provinces, whether in the hellenistic East or in the new world of the West, the emperor and his family were remote, larger than life, readily acceptable as divine beings in their own lifetime. These superhuman qualities can be seen for example in the collection of Julio-Claudians from the temple of Rome and Augustus at Lepcis Magna, which are overpowering in scale and exercise a very strong hypnotic effect on the observer. A direct line runs from these early portraits, which share certain strong and exaggerated family features, to the famous cult image of Constantine from the basilica of Constantine made some three centuries later. In the Augustan period a completely successful Julio-Claudian type was created – handsome, clean-shaven, compact, grave and serious, with hair simply arranged and always worn in a specific way. It has become notoriously difficult to tell the princes of the Julio-Claudian House one from another – their image was broken with only by Nero. The technique was invariable: it produced an economical and careful finish which clearly implies the use of colour and lacks the higher finish and contrasting surface treatments of later imperial portraiture and any striking sculptural effects.

The funerary portraiture of the early Empire remains closely linked with the traditions of the Republic. In tombs, the bust of the dead person may occupy a niche of the *columbarium*; outside, the whole family may appear in a series of such busts carved in the masonry wall. Statues of the dead may stand outside or inside the family mausoleum, which usually occupies part of a carefully planned and decorated funerary plot, sometimes laid out as a garden and furnished with seats for the passers-by. Something of the old style, too, survives: in the relief with the busts of two craftsmen in the British Museum, the younger has the rather absent look and typical features of the new portraiture, but the elder belongs to the tradition of the late republican funerary images.

It is probable, too, that some funerary portraits continued to be worked up from death masks, especially in parts of Italy and in the provinces. Several funerary portraits from Aquileia combine a very precise treatment of the facial surface, based perhaps on a cast, with very formal, unrealistic versions of ears and eyes, as though a death-mask had been converted into a portrait in the round. A symbolism of life after death developed in association with the portraits: the bust rising from a calyx of leaves implies rebirth, and other motifs suggest the triumph of life over death. These details can often be seen on posthumous imperial portraits.

Other Works of Augustan Commemorative Art

There is no simple way of characterizing the official art of the Augustan period except to say that it contrives to make the best use of the available talent for its own purposes. Apart from the Ara Pacis, very little Augustan commemorative sculpture has survived, either in Rome or in the provinces. One of the few survivals is the frieze from a building of the late Augustan period now in Mantua (Plate 40). Although a mere fragment, it represents a whole class of commemorative reliefs with military scenes which we know chiefly from later imperial examples, and it makes clear that, as in the case of the processional frieze, it was the Augustan period which set the fashion. The composition and the handling of the figures remind us of the later Trajanic frieze from the arch of Constantine. It is based, not on the realities of a Roman military engagement, but upon the traditional battle compositions of hellenistic art which are reflected in such works as the Alexander mosaic (Plate 30) and the relief panels of the monument of the Julii at Saint-Rémy (Plate 62). The figures are stock types applied in this case to an encounter between Romans and Gauls. It is not improbable that the Mantua frieze comes from some important temple in the city of Rome, erected or restored to commemorate a military victory. Fragments of other sculpture of this kind demonstrate that the type was well established in the reign of the first emperor. Presumably, too, commemorative painting was further developed but nothing has remained.

The Roman sacrificial altar is often decorated with relief sculpture. The earliest form used is Etruscan, rectangular with a heavy base and a crowning moulding of *cyma reversa* profile; but in the late Republic a form of Greek origin, rectangular with *pulvinus* scroll at the top, comes into fashion. The round altar, which is common on republican coins and perhaps specifically associated with certain divinities (e.g. Vesta), is also Greek, it seems. It is rare in the western provinces. The commonest form of decoration consists of *bucrania* with swags combined with various attributes or cult objects; the god or goddess may also be represented on scenes connected with the cult. The altar of the *Gens Augusta* found at Carthage in 1916 is decorated on all four sides with Roma, Aeneas with his father Anchises and Ascanius, sacrifice scene, Apollo. It has been argued that it is a replica of the great altar before the temple of Divus Augustus and that the Anchises–Aeneas group is copied from the group in the forum of Augustus, the Apollo from the Palatine library (cf. the Apollo of the Budapest relief, below). It would, indeed, be very interesting if we could be sure that this monument reflects the major Roman

artistic creations of the early Empire, but the connections are very tenuous (discussed in W. Hermann, *Römische Götteraltäre*, 1961, 126 ff.).

The victory of Actium must have been celebrated on many monuments. A fragmentary relief said to have been found at Avellino and now in Budapest (Hekler, *Catalogue*, 1928, no. 107) shows Apollo seated on a rock by his tripod with part of a ship's stern on the right and figures of a lictor, a *tubicen*, and another person on the left. Recently a fragment in Copenhagen, said to have come from Rome (*A.A.*, 1964, 823 ff.), showing the rock below Apollo with the coiled body of a snake, has been identified as belonging to the Avellino relief. It has something in common with scenes on the Ara Pacis, but its date is uncertain; it may be late Augustan, but if it is Tiberian, as seems possible, it could have decorated the temple of Divus Augustus, which is known to have had a rich collection of sculpture.

One further aspect of imperial propaganda, the development of a complex allegorical language to express imperial ideas, can be well seen in the medium of cameo carving in various layered stones. This subject has already been touched on, and, as so often, the Romans were merely inheriting a practice of hellenistic rulers. The Indian sardonyx and other similar stones had been used for hellenistic portraits and for large compositions such as the famous cup from the Farnese collection now in the Museo Nazionale in Naples. The Indian sardonyx used for portraits of Ptolemy II and Arsinoe in Vienna is said to have nine layers, and the subtlety of its tones was perhaps never surpassed by later Roman examples. But there are magnificent instances of this technique from Roman times which are inspired by the propaganda of the imperial House. Two of the finest are the Great Cameo of France and the Gemma Augustea (cf. p. 38) (Plate 31); the latter shows an allegory of the emperor Augustus symbolizing the prosperity of the new rule, combined with a scene connected with his successor Tiberius. The method of representing such scenes, and the allegorical figures used, developed in the late Republic, is later found in commemorative monuments of all kinds. Other branches of what are sometimes called the 'minor arts' became major vehicles of propaganda, as, for example, in the case of the silver cups with imperial scenes found in the villa at Boscoreale (Plates 43 and 44). They reflect major paintings and sculptures of the time.

Augustan Metalwork, Gems, Painting, and Mosaics

The age of the collector in the late Republic and early Empire produced many masterpieces in the 'minor arts', especially in metalwork, gem engraving, and glass. Silver vessels were ardently amassed, and in the late Republic some very fine craftsmen were producing for the Roman market. A pair of cups in the British Museum (Plates 41 and 42) is decorated with exquisite arabesque ornament in the manner of the Ara Pacis, carried out by *repoussé*; and another cup found with them has in high relief a scene taken from a lost play of Sophocles. The same cultured literary taste is catered for in other silver vessels, especially in decorated cups, found in Campanian hoards and ranging in date from the first century B.C. to A.D. 79. Some of the best silversmiths worked for the imperial Court, producing such works as the historical cups found in the Boscoreale

treasure (Plates 43 and 44) or the Aquileia dish (Plate 45), presents given away, it seems, on the occasion of imperial celebrations. Some scholars have identified less obvious examples of 'Court silver' with more or less oblique allusions to members of the imperial House.

In gem engraving the lively hellenistic themes of the last century B.C. give place to a courtly 'neo-classicism' attributed to the work of the Augustan official engravers, especially Dioskurides. Typical among a number of cameos and intaglios of the period which were marked by such strongly classical tendencies is the famous sardonyx portrait of Augustus in the British Museum. The cool remoteness and the superbly polished technique of such pieces show clearly the source of inspiration, and have persuaded many to the view that all the artists who worked for the first emperor must have come from the Greek world. Such works as the Ara Pacis remind one that the end product is in fact the creation of a Roman patron; but the man who made the Gemma Augustea (Plate 31) or the Portland Vase, both of which are in some sense typical of Augustan court art, must surely have been a Greek.

Although surviving monuments of public art are comparatively rare, we are fortunate in knowing a great deal about the private taste of the Augustan period through extant works associated with famous Romans of the day. We can get a fairly good idea of the best decorative painting and of the way in which Romans liked to furnish and decorate their houses, and this private taste, as in the late Republic, must be reflected in public monuments as well. Among the key monuments are the so-called house of Livia on the Palatine (Plate 49) and the new house of Augustus generally believed to have been the residence of the emperor himself; the villa of Livia at Prima Porta (Plates 47 and 48); and the so-called Farnesina House (Plate 46), which may well have been built by Agrippa in 25 B.C. as a residence for Marcellus and Julia and was perhaps decorated about 20 B.C., when he himself went to live in it. The villa at Boscotrecase is also associated with Agrippa and seems to have been occupied at some time by his son Agrippa Postumus.

Painting in general, however, declined in the early Empire. Pliny tells us that portrait painting, for example, became rare, and indeed that painting on panels had largely vanished by his own time. People continued to collect for their picture galleries and old masters were eagerly coveted, but there was very little creative work. On the other hand the taste for sculpture in domestic contexts obviously continued to be very strong, and some of the finest copies of old masterpieces probably belong to this period. We find many masterly examples of marble imitating bronze – for example, the Athena Farnese in the Museo Nazionale in Naples. The neo-Attic sculptors continued to work in their normal tradition and seem to have developed particularly a very subtle miniaturist style, which is seen on furniture and in some figured subjects.

There were, however, certain changes in taste during the period in the field of interior decoration. The early imperial development of painted decoration is clearly a phenomenon that took place under Roman patronage, whatever may have been the origins of the earlier Roman styles. Most characteristic is what Mau called the third style, which arises to some extent from earlier designs but finally assumes a very different character.

The majority of the houses associated with the imperial families belong to what might be called the last phase of the second style. Beyen divided the second style basically into two: (i) when the wall was essentially closed, down to *c.* 45 B.C., the best example being the House of the Griffins (Plate 25); and (ii) when architectural and landscape prospects were introduced, from approximately 45 B.C. onwards. The house of Livia on the Palatine and the Farnesina House represent a third phase, of which the Sala di Polifemo (*tablinum*) is the most developed example: the wall is broken up and the continuous arrangement of solid architectural forms gives way to a combination of large imitation panel paintings (*pinakes*) and a framing architecture which has already abandoned reality. This phase was apparently coming into fashion when Vitruvius wrote at the beginning of Augustus' reign; and he was highly critical of this abandonment of real form in favour of a decorative fancy (see p. 52). So far as we can judge the development was peculiarly Roman, and we can see it carried a stage further in the decoration of the Farnesina House, where the architectural schemes are broken down in this way to provide settings for imitation pictures, large and small (Plate 46).

The transition from the second to the third style is represented by the superb paintings in the Farnesina House of, say, *c.* 19 B.C. (J. Lessy and A. Mau, *Wand und Deckenschmuck*, 1891; H. G. Beyen, *Studia Vollgraff*, 1948). *Cubiculum* 2(B) has a scheme in which the architecture is beginning to take on an unreal character and serves to frame the pictures; it is already light and fanciful. This is the room with paintings in the 'old style', beautifully copied from masterpieces of the fifth century B.C. in strikingly accurate versions. Other rooms in the house are quite different in effect and intention; the black *oecus* provides an example of the use of strong colours which is a feature of the third style, especially in winter rooms. Here we have a bright, fanciful architectural painting on a strong background which creates a wonderful atmosphere, something like a Chinese print. The Egyptian room of the Casa del Frutteto at Pompeii, with its illustrations of Egyptian gods and other objects, is later Augustan and shows the continuing popularity of black decorative schemes. The change from the 'architectural' to the 'candelabrum' style seems to have taken place between 20 and 15 B.C.; this we know from old drawings of the interior of the Pyramid of Cestius in Rome (dated 12 B.C.) which was painted in this manner.

Although the style of these paintings seems to develop from Roman taste, the artists and much of the decorative detail are derived from foreign sources. The owner of the Farnesina House, who represents perhaps best of all the cultured and leisured class of the day, had wide-ranging tastes which included an interest in Alexandrian poetry and Egyptianizing detail, as well as an admiration for classical painting. His artists were versatile, capable of suiting all his tastes, and one of them, Seleukos, was clearly an Asiatic Greek and signed his work in Greek. The little pictures incorporated in the decorative schemes include exquisite imitations of early classical figure painting, and there are also a number of seascapes and landscapes, as well as the famous cycle of Egyptian scenes. The technique no doubt varied to some extent with the origins and the skill of the artists. Vitruvius lays down very precise formulae for Roman fresco painting, and the evidence suggests that these were sometimes followed, for example in the

tablinum of the house of Livia, where the Vitruvian requirements of three layers of lime, pozzolana, and sand and three layers of plaster (lime with chips of alabaster) have been observed. The technique here is fresco, and this is generally true of Roman wall painting, although elsewhere, especially at Pompeii, research has shown that paintings were often executed in tempera. It is also claimed that the binding material for the tempera was an emulsion of hydrated lime. Some colours would have been added later, the medium being liquid wax. An analysis of the paintings from Boscotrecase showed that a coat of marble dust lime was brushed into the semi-wet plaster and then rubbed and polished; this was followed by second and third coats of marble dust applied while the first was still wet and then polished by beating and rubbing so that the surface was so fine as not to need any varnish or wax to give it the characteristic shine of many Roman paintings. The colours used by Roman painters were generally earth minerals; there were five basic ones, and certain hues were more popular at certain periods – for example red and black were the dominant colours of the third style.

The main change in pattern in interior decoration during Augustus' reign seems to have taken place about 15 B.C., when the wall surface became completely 'closed', incorporating delicate architectural designs and small pictures, either miniatures or larger panel compositions, such as one sees in the *tablinum* of the Villa of the Mysteries at Pompeii. The third style, as it is called, has all the characteristics which Vitruvius found so distasteful: 'paintings of monstrosities rather than truthful representations . . . yet when people see these frauds they find no fault with them but on the contrary are delighted and do not care whether any of them exist or not'. Indeed the third style is probably the most successful Roman style of interior decoration, and includes among its finest achievements the paintings from the villa at Boscotrecase with its superb architectural fantasies and the handsome mythological and idyllic scenes which are incorporated into the decorative designs. However, the style seems to have been comparatively short-lived; later, architectural vistas were introduced to produce what is generally called the fourth style, combining big plain areas with limited landscape perspective. Pompeii provides many good examples of this compromise style, painted in the period between the earthquake and the eruption of A.D. 79. The *tablinum* of the House of Lucretius Fronto well represents the early stage of this development (Plate 65), and the House of the Vettii (Plate 66) has several rooms where the style is effectively applied, especially the *oecus* with the picture of Dirce, Pentheus, and Hercules, and the *triclinium*.

The decorators of Roman houses were neither renowned nor great. As Pliny the Elder tells us, only the painters of *tabulae* were famous; the work of the decorators is largely derivative, based in its styles and techniques on well-known masterpieces. However, there were many fine craftsmen. Exquisite drawing is often found in the best work, as for example the little paintings on marble from Campania, which include a most subtle and delicate picture from Herculaneum of a Centaur (Museo Nazionale, Naples, no. 9560) on a shiny slab of island marble, a masterpiece of delicate drawing with the most subtle shading, finer perhaps than the better-known knucklebone players (no. 9562), presumably a copy of a late-fifth-century piece. A few exceptional artists are known to us by name: Famulus made a great reputation as the decorator of the

Golden House (cf. pp. 69, 70, 100), and in the time of Augustus there was Studius, who painted landscapes and garden scenes such as those for Livia, the emperor's wife, in her villa at Prima Porta (Plates 47 and 48). Because Roman murals provide us with almost our only evidence for the later development of classical painting, enormous interest has been aroused in the various kinds of paintings incorporated in these decorative schemes. Since Wickhoff a central issue has been the question of the originality of some of the work from houses, for example landscape painting of various kinds.

The problems begin in the later phases of the second style, where the sources have been much discussed. The Odyssey scenes already mentioned (pp. 34-5: Plates 27 and 28) have series of landscapes with figures in which the artist, although chiefly concerned with the mythology, in fact gives more space than ever before to the setting and creates a fairyland atmosphere appropriate to mythical events by a most skilful use of colour and perspective. Completely opposing views have been advanced about the origins of this style: it is said (i) that such mythological landscape is impossible in Greek art, even in hellenistic times, and must be a special response to Roman taste; (ii) that this kind of painting was obviously developed by hellenistic artists. The problems can only be attacked in terms of probability, and the probability certainly is that this kind of landscape with figures, as in all cases where figure elements are incorporated in second-style schemes, has a hellenistic derivation. One thinks of the architectural vistas such as those from Boscoreale, which must go back to Greek stage paintings, or of the figure paintings from the Villa of the Mysteries or from Boscoreale, which clearly have very specific hellenistic prototypes.

But while the general hellenistic background of Roman decorative painting is clear enough, this does not exclude the possibility that some developments were made in Roman times. The iconography and style of Roman painting can now be best studied among the *disiecta membra* of Pompeian walls in the Museo Nazionale in Naples. The practice of cutting out the finest portions ended in the nineteenth century, but most of the best had already been removed by then. The whole range of Roman taste is illustrated there, including portraiture, genre scenes, religious pictures, landscapes, and mythological scenes of all kinds.

Among the outstanding pieces are the little architectural and landscape vignettes, including a tiny representation of a harbour from a villa at Stabiae, and the views of Campanian villas from Pompeii. Such scenes, especially popular in third-style pictures, belong to the general type known as the sacral-idyllic landscape which appears in Roman painting in the late second style (cf. p. 34). The outstanding early example is the grisaille frieze in brown and yellow from the *tablinum* of the house of Livia (Plate 49). This, like most pictures of its type, is painted with a characteristically sketchy brushwork aiming at colour impressions – very different from the modelling of classical painting. The colour schemes, either the monochrome of the house of Livia, or the hazy blues and greens which are popular at Pompeii, also produce a completely different atmosphere: they create a new land, clothed in the indistinct and airy hues of fantasy, representing a fine imaginative interpretation of the world of nature.

How much of a specifically Roman contribution there was to this tradition it is

difficult to judge. In general there seems to be a preference for hilly regions and wood-land, and the compositions and colours are based on nature, unless the choice of colour is deliberately limited or confined to a single shade. Depth is very well conveyed, and there is much use of aerial and linear perspective, although it is often rather arbitrary. One form of landscape which seems to have no earlier precedent is the villa landscape, in which buildings in Campania and other parts of the Italian coast are shown. Most other scenes probably originated elsewhere, particularly in Egypt.

Two types of mythological picture are found associated with second- and third-style schemes. In the first the figures are the main interest of the composition; the second gives more or less prominence to the setting. There is a marked contrast between the versions where the figures stand out prominently, and where the setting, even if it is carefully painted, looks remote and distant and is hardly ever genuinely integrated with the figures; and those particularly associated with the third style and studied in some detail by Dawson. The greater prominence given to landscape in the second type does seem to be a Roman development, as indeed may be the panel which makes use of 'continuous narration', that is, the representation within one single landscape setting of several successive episodes of the same myth. There was a suggestion of this in the Odyssey frieze, but the panel compositions of this type would seem to be Roman in inspiration.

The content of the pictures is always of paramount importance. The chief interest is in mythological scenes, especially those of retribution, punishment, and suffering. Two fine pendant panels of figures in a landscape from Pompeii (House RI, 7, 7) show Icarus and Andromeda; the heroes Hercules and Achilles are chosen as symbols of immortality. Mysteries of Bacchus and Isis increase in popularity, providing a foretaste of the rich eschatology of Roman funerary monuments of the second century A.D. The House of the Dioscuri at Pompeii has pictures of Achilles in the *tablinum*, together with subsidiary Bacchic subjects; Achilles, who gave up a life of luxury to become an immortal hero, had a particular attraction for the Romans of the day. The development of this ideology explains the latter-day success of the Roman sculptured sarcophagus.

Most of the big panel pictures associated with third- and fourth-style composition seem to be more or less direct copies of famous masterpieces, taken either from the paintings themselves or from cartoons available to the decorators. This is clear not only from literary references, but also from the pictures themselves, where the same scene can be recognized in a number of versions which, of course, vary considerably, since they were not made by the same mechanical processes as were the copies of sculpture. Copying of this kind does not preclude work of high quality or of considerable indi-viduality. A study of the paintings from the basilica of Herculaneum has revealed an artist of no little ability, the 'Herculaneum Master', who painted the well-known Hercu-les and Telephus scene and parts of other pictures in that building. The Theseus and the Minotaur (Plate 50) is by far the best version of a popular subject; a very banal version from the House of Gavius Rufus at Pompeii, now at Naples, is worth comparing. It is possible to follow the work of some of the better painters in a number of their commissions. One of the artists from Herculaneum seems also to have worked in the House of the Tragic Poet, the House of the Citharist, and the House of Mars and Venus

at Pompeii: his work can be recognized by brush technique and the handling of perspective and light and shade. A recent study of the paintings in the House of the Dioscuri produced similar results (L. Richardson, Jr, *Pompeii: the Casa dei Dioscuri and its Painters*, Rome, 1955).

There has been a tendency to consider Roman painting in isolation from other branches of interior decoration, and this has meant that the Roman taste as a whole has never been properly understood. Roman decorative painting should be studied in its context together with the use of mosaic, stucco, and other media. As Roman taste in painting was changing, so too were the fashions in mosaic. The flowering of the hellenistic picture mosaic in Italy belongs to the time of the first and early second styles of wall painting, and the examples that have been found at Pompeii are as fine as anything from the hellenistic East. The superb roundel with a lion in a rustic setting reminds one of some of the animal mosaics from Delos; but several examples surpass anything from the Greek islands. Apart from the *emblemata*, one or two examples of *opus vermiculatum* are laid out in long narrow friezes, for example a fine group of Nilotic scenes of animals and birds set against a bright background. Another big strip mosaic from Pompeii has a splendid series of theatrical masks combined with rich swags of fruit and flowers in typical hellenistic style. A wide variety of coloured stones and some bits of glass are employed to achieve special effects. It seems as though, in general, this type of *emblema* was going out of fashion when the richer schemes of second-style decoration were being developed. By this time mosaic had become a fairly common type of Roman flooring, but there was a tendency to keep the floor surface reasonably plain when the wall schemes were richer. The general development of specifically Italian styles of mosaic floor can be followed out in the Campanian cities and elsewhere. Ostia is perhaps the best place to follow the general development from late republican times; with its middle-class atmosphere it gives a good yardstick of taste.

The earliest Ostian floors tend to be made of red *opus signinum*, and there is hardly more than a scattering of tesserae in simple patterns or of irregular bits of coloured marble set in the cement. In the first century B.C. floors were also composed entirely of white tesserae, sometimes scattered with bits of coloured marble. The earliest floors at Ampurias in Spain, which probably date from about 80 B.C., have patterns of white tesserae including maeanders and network on red *signinum*. Somewhat later the houses of the *colonia* display more ambitious black-and-white designs, some of which remind one of medallions at Delos. The *atrium* of House II has a mosaic of white, purple, and black tesserae inset with irregular bits of coloured marbles. In the Augustan period at Ostia and elsewhere most of the mosaics are simple white-on-black or black designs sometimes incorporating fragments of coloured marbles. There was still a certain number of compositions in the *emblema* tradition, for example one or two, probably Augustan, from Aquileia, including a version of the famous 'Unswept House' (cf. p. 37) in a frame of guilloche and scrollwork which uses a certain number of glass tesserae. Early imperial taste in general was for plain floors, as can be seen in many houses at Pompeii and Herculaneum. The *atrium* of the Casa del Atrio a Mosaico at Herculaneum has big black-and-white rectangles with plain black scrollwork around the

impluvium, and the mosaics of the rest of the house too are all basically white-and-black. In the corridor of the peristyle they are white, with marble fragments which are basically black or grey or white. In the middle of the first century A.D. the general fashion is for black-and-white geometric patterns, with very little taste for polychrome effects. It seems that the rich polychrome *emblema*, which had combined so well with severe first-style wall schemes, had gone out of fashion in Italy. In other parts of the Empire, notably North Africa and Syria, the *emblema* and the use of *opus vermiculatum* continued; 'antique' mosaic *emblemata* were, no doubt, collected and there was certainly a revival of the *vermiculatum* technique in the second century A.D.

The typical first-century mosaics are all black-and-white geometric schemes with very limited use of colour, but a fashion grew for richer floors composed of cut marble segments, a technique known as *opus sectile*. From the Augustan period onwards a wide range of coloured marbles became available for this purpose, as demonstrated by floors from a number of houses in the Campanian cities, some of them appearing alongside floors composed of tesserae. *Opus sectile* was clearly becoming fashionable in the last days of Pompeii and Herculaneum, when the taste for polychromy in general was increasing. Some ambitious decorative schemes are known from late houses at Herculaneum, for example the House of the Stags, where the tessellated floors are still black-and-white.

Mosaic became one of the most characteristic forms of imperial decoration throughout the Roman world, and in any account of Roman art the mosaics bulk very large, although comparatively few deserve the name of art. The Roman word for floor is *pavimentum*, and for mosaic floors Vitruvius uses the words *pavimenta tessellata*. Pliny tells us that the picture floors of the early Roman period were superseded by what he calls *lithostrota* – which probably means the tessellated pavements with fragments of marble or those of *opus sectile* popular in his day. The technique always remains basically the same: Vitruvius and Pliny both describe the various layers consisting of the *statumen* (bed), the *rudus* consisting of broken stone and lime, and the *nucleus* of pounded tile and lime into which the floor was laid. In fact the composition and colour of the bed varies a good deal; if it is a very white floor, then lime and marble dust will have been used, but red mortar is also frequently found. In Roman mosaics generally there is a wide range of local and imported stones, but glass is comparatively rare in most places until the second and third centuries A.D.

In the provinces the development varies from place to place depending on the artistic background, but it is generally true that in the western provinces mosaic was rare in the first century A.D.; all the examples that have survived are comparatively simple white-on-black or black-on-white geometric designs. The earliest instances in the West usually come from exceptional buildings such as the palace at Fishbourne or the complex at Trier which was probably the headquarters of the procurator of Gallia Belgica. The later development of mosaic decoration in Italy and the provinces may be reserved for a later chapter.

There are many other important aspects of interior decoration which should be dealt with briefly here. *Opus sectile* was used for the decoration not only of floors but also of

the walls of rooms, especially the lower parts. This fashion also goes back to hellenistic times and was probably more common in palatial Roman houses and villas during the late Republic than the surviving evidence suggests. The sculptured reliefs already mentioned (p. 30) were no doubt combined with wall schemes of coloured marble. The early Empire provides a number of examples of figured *opus sectile* including some from Pompeii, among them a well-known figure of Venus in *giallo antico* on a black ground. *Giallo* was one of the most popular marbles for this purpose because of its attractive colouring. It is probable that throughout the first century A.D. the best rooms of palatial residences were paved with *opus sectile* rather than with *tessellatum*. Among the few surviving examples are the floor of the *nymphaeum* in the Domus Transitoria (cf. pp. 68–9) and the fine swinging pattern of the Aula Porticata under the Domus Flavia which is attributed to the Domus Aurea (cf. pp. 69–70).

Wall mosaic, which appeared as early as the first century B.C. and became very popular in the decorative schemes of the first century A.D., belongs to quite a separate tradition from that of floor mosaic. The Roman word for wall mosaic is *opus musivum*, and the art originated in the decoration of grottoes and *nymphaea* associated with rich Roman villas of the late Republic and early Empire. The earliest versions are chiefly composed of shells and pieces of coloured glass, but later on ornamental designs using large amounts of coloured glass became common. This type of decoration is especially associated with fountain buildings and ornamental grottoes, but in the first century A.D. it is also found combined with painted schemes in fountains and *lararia* at Pompeii. At this stage the designs, as may be seen, for example, in the House of Poseidon and Amphitrite at Herculaneum (Plate 51), are closely connected with painting. The figures stand in an elaborate architectural frame and, as on the earlier *opus vermiculatum*, are closely copied from painted originals by the use of a wide range of coloured glass. On either side of the figures are scrollwork and architectural elements related to second-style architecture, and over the scrolls is an ornamental canopy. In the House of Poseidon and Amphitrite on the adjacent wall of what appears to be a small *lararium* is a scheme in blue with animals, garlands, and a frieze of Griffins and bearded heads. Throughout its history this type of mosaic decoration was closely connected with painting, and in the wealthier houses whole wall schemes were carried out in this medium. Its connection with fountain buildings was continued later, when it became especially associated with the interior decoration of the big Roman baths, often in conjunction with various kinds of *opus sectile*.

Another branch of interior decoration which achieved a high standard in the better Roman houses and villas is stucco relief. This also goes back to hellenistic times, but the Greeks used it largely to imitate architecture, as in the first style of painting, and very little for figured decoration. In Italy during the late Republic however it was employed increasingly elaborately, for instance in vaulted ceilings such as those in the House of the Cryptoporticus at Pompeii (cf. p. 35); and in the early Augustan period there are some outstanding examples of very rich figure work in low relief decorating both walls and ceiling. The finest comes from the Farnesina House (Plates 52 and 53) where the stuccoes combine idyllic landscapes and figures with extremely delicate ornamental motifs derived

from very much the same repertoire as contemporary paintings. The uses of stucco relief and painting were always closely connected, and there are a number of examples from Pompeii and elsewhere of major schemes of wall decoration carried out partly in stucco relief and partly in paint. The famous example from Pompeii with architectural settings combined with Dionysiac figures is now in the Museo Nazionale in Naples.

In interior decoration, as in all branches of Roman art, the Augustan period was the chief creative epoch. It was then that the typically Roman styles were established, and only minor changes took place in subsequent periods. The decoration of Roman private houses provides us with the most direct evidence of the taste of Roman citizens at the time, and we can see that the inspiration came from widely different sources: one patron prefers Egyptianizing motifs, another copies classical prototypes, and yet another may decorate a room to imitate a garden. But whatever the source of inspiration, the choice derives from the patron and illustrates the knowledge of art and the importance given to it in everyday Roman life.

It is indeed worth considering, if only briefly, the general Roman attitude to artistic activity at this time. Cicero observed how rare artistic genius was, and this seems to have been true of the Roman period in particular, although we may not accept Cicero's explanation that Rome did not produce distinguished artists because not enough of the 'best' people put their hands to it. Neither Cicero nor Seneca was prepared to admit painting and sculpture among the liberal arts; the latter classifies all artists as *luxuriae ministri*, yet distinguishes between artists and artisans in the sense that the artist expresses himself, while the artisan works to meet a demand. But most Roman artists worked to meet a demand, and very few outstanding personalities emerged, so that the Romans continued to praise and to imitate the old masters of Greece, whose fame remained un-challenged throughout antiquity. Vitruvius, however, in a typical comment, remarks on the element of luck which accompanies such fame and lists a number of undistinguished artists who deserve a better fortune. The practices of the copyists were treated with scant respect by Quintilian, who dismisses them as the product of lazy minds.

This is not the place to say much about the attitudes of the Romans towards artists, but some comment on their general status is needed. The inferiority of the craftsman is a long-standing prejudice of the ancient world; but the Romans were more flexible. The prestige of artists was inevitably raised by the demand of the rich man to possess works of art of high technical merit. There was a general respect for fine craftsmanship, and in communities which supplied the ever-increasing market the artists could and did acquire dignity and independence. Families of sculptors and painters flourished (e.g. *Hesperia*, X, 1941, 351–61), and some were honoured in their own cities (*C.I.G.*, 2024) and made benefactions to their fellow citizens (*I.L.S.*, 5405). Artists were of all classes – slaves, freedmen, free Romans, or aliens. The majority certainly were from the eastern pro-vinces, as is shown by their names. Some worked independently, some were employed on the imperial staff or on the staffs of wealthy citizens. A certain Agrypnus (*C.I.L.*, VI, 4032) was a slave who first belonged to Maecenas and later became *a statuis* on Livia's staff. The Aphrodisians seem to have maintained their own workshops and their independence in Rome, as in other parts of the Empire.

Closely linked with the decoration of Roman houses is the development in the early imperial period of the art trade. Wealthy Romans employed connoisseurs who advised them on the appropriate kinds of sculpture and painting for their gardens and houses. These men understood Roman taste and cultivated it. Enormous prices were paid for works of art and even for sketches by the most famous painters. This inflation of art prices had begun in the late Republic, when, for example, the orator Hortensius bought a picture of the Argonauts by Kydias for 144,000 sesterces and built a special gallery in his Tusculum villa to house it. Collectors and dealers got to know a good deal about the technique of the old masters; and even if Pliny is right in saying that no one had the time to make systematic studies of the masterpieces housed in Roman collections, there were many who knew a good deal about the various styles of classical art. Fashions, of course, changed considerably, but the Romans always seem to have admired the virtuosity of hellenistic sculpture rather than the more severe qualities of classical art. The output of small- and large-scale sculpture in Pergamene and Rhodian styles for decorative contexts in Roman houses was enormous, and it was in the context of this domestic use that Roman taste was chiefly developed. Art served primarily decorative purposes. Statues adorned niches or garden vistas. In a house beneath Via Cavour in Rome there were two statues of the Pothos of Skopas in mirror image in balancing niches, and two corresponding Erotes after Lysippos flanked a statue of Aphrodite in a *nymphaeum* at Ostia.

The result of this was that art in Rome never achieved the respect which it was accorded in the Greek world, where it had succeeded in finding a place on the fringe of an ideal education, at least in the hands of the greatest artists such as Polykleitos or Pheidias. Art did not belong to the Roman concept of *humanitas*, and this attitude did not fundamentally change throughout the Empire, except perhaps at its very end. The names of painters were rarely recorded, and few Romans who practised art became famous. Under the Empire one or two emperors were to aspire to artistic achievement, especially those whose tastes lay in the Greek world: Nero and Hadrian are the two outstanding examples, and Hadrian seems to have been particularly versatile, if not particularly able. Marcus Aurelius was to take lessons in painting. It is worth noting that in the Greek world under the Empire the situation was always rather different. Art was an established subject in the instruction of the young, and there are references to ephebic competitions in the arts; so the practice of art by philhellene emperors can be readily understood. In the artistic centres of the Roman Empire such as Athens or Aphrodisias the artist could take pride in his work and the most successful among them were highly respected citizens.

It is worth discussing briefly the background of art criticism available to Roman connoisseurs (cf. pp. 27–8). Both Plato and Aristotle showed themselves well aware of the contemporary artistic scene, and after Aristotle's justification of imitative art his followers accepted art into education; Roman art criticism, such as it is, derives from this Aristotelian school. Greek artists, too, produced a considerable literature (cf. p. 28); Polykleitos had written on his ideal statue, and after Polykleitos many artists wrote about their work. Agatharchos, who seems to have been a pioneer of stage painting, and Euphranor, who

was a versatile sculptor and painter, both wrote on art. Most of what survives in Roman sources is fairly useless stuff with amusing anecdotes; but there were some works of genuine criticism. Xenokrates was a sculptor and writer of the Lysippic school at the beginning of the third century B.C. who laid down the fundamental qualities of art and discussed problems in optics, which he uses as a basis for a history of the painters. His work was very influential on Roman taste. It was he who described Apollodoros of Athens as the first painter and who praised the ideal proportions and rhythm of the great sculptors. Roman authorities included Pasiteles, who wrote on the great works of art and who epitomizes the eclectic taste of much Roman art.

The influence of writers on art was to increase enormously in the later Empire. Among them was the sophist Polemo, who was a friend of Hadrian and strongly influenced the emperor's thinking, especially in the matter of his own image and portraiture. Lucian, who wrote a great deal about art, claimed, although apparently without truth, that he came from a long line of sculptors, and the two Philostrati, of whom one constantly alludes to art in his life of Apollonius, while the other wrote the *Imagines*, belong to a period of greatly increased interest in artistic theory. The chief interest of the second Philostratus was, as one might expect of a sophist, in a description of painting as a form of literary art, but the whole approach implies a renewed respect for this branch of creative effort. The last phase of this revival in art criticism is represented, as we shall see, by the work of Plotinus, who offers new autonomy to artistic creation, and this played a big part in the development out of the Roman tradition of characteristically Byzantine modes of representation.

THE JULIO-CLAUDIANS (A.D. 14-68)

Relief Sculpture

THE traditions of State art established under Augustus developed slowly under his successor. Tiberius was no great builder, and few monuments were put up under his rule. Because the link between architecture and historical relief and decorative sculpture was so close, development in these fields also tended to be slow. There are comparatively few historical reliefs inspired by official policy; one of them, now in the Louvre, shows an emperor, probably Tiberius, sacrificing at a pair of altars. The design and treatment of the figures follows very closely that of the processional frieze of the Ara Pacis. The sculptors still render the background figures with the head frontal – a practice which was never a great success and later was abandoned. In general these heads tend to be in very low relief, which implies quite clearly the use of paint to strengthen the effects of depth at which the sculptor is aiming.

A rather different style of presentation can be seen on a frieze now in the Vatican (Plate 56) which was found together with the Flavian reliefs from the Cancelleria Palace discussed below (cf. pp. 75–6). The subject is a sacrificial procession of the *vicomagistri*, who were freedmen responsible for the worship of the Lares Compitales which was associated from 7 B.C. onwards with that of the Genius Augusti. A group on the left shows two *vicomagistri* carrying images of the Lares, and another with that of the emperor in a toga. There is a sharp contrast between the high-relief foreground figures, who are generally represented in frontal pose, and the low-relief profile heads of the background, and this style has been contrasted with the more graceful processional groups of the Ara Pacis. In particular, the frontal foreground figures, which are rather short and dumpy and perhaps remind one a little of the Ahenobarbus frieze, have been compared with those of a number of public monuments from Italian towns, especially in Central Italy, where classical traditions are much less obvious and the themes are represented with a directness which may have its roots in an Italic tradition (cf. p. 65).

However, the use of a frontal representation in State reliefs must not be considered in any way unclassical but rather as appropriate to certain types of scene. When the processional nature of the event is stressed, frontality is out of place; but in the case of the Ravenna reliefs (Plates 54 and 55), which are frankly a glorification of the imperial House and must date from Tiberian times or a little later, the deified emperor Augustus as Jupiter and Livia as Juno are in the company of living and dead members of the imperial family. The barriers between human rulers and gods have broken down, and imperial iconography is now based on the divinity of the emperor. These new ideas are very clearly expressed in some of the big cameos of the period, for example the Gemma Augustea (Plate 31), where the emperor enthroned with the eagle at his feet is

crowned by Oikoumene. This is an elaborate allegory standing at the beginning of a long line of such representations of famous events in Roman history, which always offered an alternative to the more factual versions preferred by some rulers. In the Ravenna relief the use of a basically frontal image is completely appropriate as an expression of the divine and semi-divine nature of the members of the ruling House.

The most important historical monument of the Julio-Claudian period is a monumental altar, apparently closely similar in design to the Ara Pacis, which was known as the Ara Pietatis (Plate 57). Begun under Tiberius in A.D. 22, having been voted by the Senate to commemorate the recovery of Livia from a serious illness, it was not completed until the reign of Claudius. It stood by the Via Flaminia near the modern church of S. Maria in Via Lata. A number of fragments of the altar, most of them now in the gardens of the Villa Medici, were first identified tentatively by Studniczka, after Sieveking had removed them from their earlier association with the Ara Pacis, to which some of them are similar in style. The identification is now widely accepted. There are a number of significant differences between the sacrificial and processional scenes from the two altars. The Ara Pietatis betrays a strong tendency to arrange the foreground figures in a more frontal pose, and the relationship between the foreground and background figures is less successful. However, the handling of the draperies and of the figures in general follows very closely the classical manner of the earlier monument. A new element is the introduction of buildings into the scene. In one relief, the temple of Magna Mater on the Palatine appears rather awkwardly and on a small scale that is in uncomfortable relation to the figures. Clearly the sculptor wanted the buildings to be prominent and recognizable, and therefore avoided placing them in the background, as they often were in hellenistic landscape reliefs and on contemporary coins (cf. p. 19). Other fragments of ornamental detail associated with this altar, especially some pieces of swags and scroll-work, also show that the Ara Pacis was the chief inspiration for the later building.

The development of an imperial representational art can be followed in the scenes shown on the coinage of the period; and to some extent the development of representational methods is reflected in the work of the die engravers. A coin of Caligula shows a sacrifice before a temple (*R.I.C.*, 1, 117 ff.) where for the first time the figures are effectively arranged against a temple front, and a sestertius of Nero sets a scene with tall graceful figures in front of a portico. A coin of Galba (*R.I.C.*, 1, 215) has complex groupings of figures shown in depth and gives much the same impression as the later panels of the arch of Titus. Experiments as well as accepted conventions in landscape and setting are represented, as on the Claudian views of the Praetorian Camp (*R.I.C.*, 1, 125) and of the harbour at Ostia (*R.I.C.*, 1, 151). All these features occur in later Roman sculpture but cannot be consistently followed in surviving works of art, apart from coins.

Portraiture

The history of Roman portraiture after Augustus is the history of a developing attitude towards the emperor. The problems of the Julio-Claudian portraiture, already touched upon (cf. p. 47), need to be treated more fully here. The systematic and scientific

study of Roman iconography, based on the imperial coinage, goes back to Bernoulli; since his day the coins have been put into a more generally convincing chronological sequence, and on this rests the identification of the portraits. Analogies can often be pushed too far, but normally it is possible to follow changes in fashion and taste during a particular reign. Portraits on gems are a subsidiary source of evidence, often of very high quality. There seems to be only one surviving painted portrait – that of the Severan family from Egypt, now in Berlin (cf. p. 134: Plate 184). Later on, in the third century, when sculptured portraits of emperors are very few and the coins our only means of identifying them, recognition can often be very subjective. It is also important to realize that portraits, especially of good emperors, were made or copied long after their deaths, and the date of the copies may make a considerable difference to the style. Other difficulties involve the identification of youthful emperors, and the problems of distribution, which was such an important factor in the spread of imperial iconography. It has been argued that marble versions were sent out from the main centres, especially from Rome, and copied in various parts of the Empire; alternatively it has been suggested that clay or plaster versions were used as a basis for the work of provincial sculptors (cf. p. 90). No doubt methods varied, as does our knowledge of imperial iconography; a *damnatio memoriae* may have left us comparatively few likenesses of some emperors because, as St Jerome tells us, 'when a tyrant is put to death his statues and images are thrown down, his head is removed and replaced by that of his victorious rival to be again removed in turn while the body remains untouched'.

Augustus, as we have seen, had been very successful in creating an imperial image, and for this reason the Julio-Claudians are notoriously difficult to identify, because they all subscribe to the basic formula. This is true even of Caligula, who was obsessed by his own appearance and was extremely self-conscious about it. Caligula was bald; he would not have anyone look at him from above, and tried every known remedy to recover his hair. In his portraits he simply follows the fashion of the Julio-Claudians, so that his hair-style is hardly distinguishable from that of the others, and there is no suggestion of any deficiency. The obsession with hair runs right through, because the physiognomical theorists had laid down that one's hair was just as important an indication of character as one's eyes.

The fascination and the pitfalls of the study of Roman portraiture are well illustrated by a detailed study of the portraits of Tiberius: the literary portraits are very thin, as indeed are all ancient literary portraits, since this genre is fundamentally modern; but we do get from Velleius Paterculus some impression of the personal impact of his stiff-necked and remote expression, and from Suetonius we have a brief description of his physical appearance. The coin portraits are particularly unsatisfactory: they fail to provide a sequence which might serve as a basis for identifying portraits in the round. There does seem to be some change in the official iconography, but it is often difficult to demonstrate clearly. The earliest coin portrait of Tiberius dates from A.D. 10; those of the mint of Lyon from A.D. 13 onwards first suggest a young man, but then settle down into rather nondescript and uniform likenesses generally showing his most obvious facial characteristics – aquiline nose, high brow, protruding upper lip, square head, and

typically Julio-Claudian hair-style. The variations make it difficult to believe that the same man is always represented; and perhaps this is appropriate in the case of one whose personality was little understood. Statues and portraits of Tiberius were erected from his youth onwards, but many were destroyed during the period of his disgrace in the last years of the first century B.C., for example by the inhabitants of Nîmes. Many imperial groups including Tiberius were put up under Augustus, and after his adoption these increased vastly. On an arch at Pavia he stood with Augustus and the rest of the imperial family. One of the most impressive examples of his portraiture during his reign must have been the group erected in front of the Venus Genetrix temple in A.D. 22–3 by the twelve cities of Asia, to which he gave relief after an earthquake; he appeared as a colossal equestrian figure in the company of the personified cities. These same cities appear in an exquisite hellenistic style on the base of a statue, now in the Museo Nazionale in Naples, which was put up in his honour at Pozzuoli (Puteoli) (Plate 59).

Tiberius himself seems to have had little regard for *statuae ac imagines*, and he resisted as far as possible the developing worship of the statues of reigning and dead emperors. Of surviving portraits one of the most remarkable (Plate 58) is that put up in his honour between A.D. 4 and 14 and found in 1929 in the Strategheion of Cyrene. The body, wearing Greek *chiton* and *himation*, seems to have been re-used, while the head of a youngish man, with aquiline nose, high forehead, and striking eyes, belongs to a hellenistic tradition and is not immediately recognizable as the future emperor. It illustrates the considerable differences that might exist in imperial portraits, especially in the East, where hellenistic traditions remained strong. The famous Augustus from Samos, which also follows the manner of hellenistic ruler portraits, offers a similar contrast with the official metropolitan likenesses of the first emperor. The early portraiture of Tiberius is never easy to recognize; and it remains one of the key problems in identifying the figures on the Ara Pacis. The figure that most probably represents him is that of a consul(?) standing near Augustus and looking towards him, but it has no relationship with Tiberius' portraits in general. The later pattern of his iconography seems to be based on a series of major statues created for significant events in his reign, for example for the dedication by the Asiatic cities. There were also many posthumous portraits, one of the best known belonging to the imperial group from the theatre at Cerveteri.

The first emperor to break with the established Augustan tradition was, as one might have expected, Nero, who openly, and very obviously in his portraits, favoured a return to the hellenistic ruler cult which Augustus had tried to avoid. He had his hair set in a row of curls on the forehead, and when he visited Greece let it grow long and hang down his back. Some modern scholars would read Nero's divine aspirations into this, but, curiously, Suetonius, who takes his cue from the Julio-Claudians, sums up by saying of him that 'he did not take the least trouble to look as an emperor should'. From the time of Nero onwards, Greek ideas were always likely to influence the portraits of a particular emperor, although some, as we shall see, might prefer to hark back to the older traditions of the republican past.

Provincial Art

The distribution of official portraiture in the provinces is one important aspect of the general spread to the Roman Empire, due partly to official policy and partly to the work of travelling artists, of the new official imperial art. Its precise effect varied from place to place, depending on the background of a particular province and the degree of Romanization. In Italy itself the spread was very rapid. Just off the forum at Pompeii, for example, in the time of Tiberius, the wealthy Numachia financed an impressive market building where the imperial overtones and the influence of the new style are very clear. On the wall of a structure facing towards the forum were niches containing statues of Aeneas, Romulus, Julius Caesar, and Augustus, a combination obviously inspired by the forum of Augustus. The door jambs on the forum side are exquisitely carved in marble with a version of the Roman scroll of the very highest quality, scarcely inferior to that of the Ara Pacis itself.

The development of new towns in Italy created an enormous demand for decorative art and statuary, and although this was sometimes met from local resources, the influence of the capital was obviously considerable through the work of migrant artists, who would come to carve a cycle of portraits for the basilica or a new capitolium; public buildings such as theatres were often built and decorated by architects from Rome, as at Verona, where the architectural detail is very close to that of the temple of Apollo in Rome. Municipal events were often celebrated by relief sculptures, and a particularly interesting series, dating from the late Republic to about A.D. 60, has been found in the region of Samnium. A relief from Amiternum found in 1879 represents the Roman *funus translaticium* (Plate 60), and those from a funerary monument now in the Chieti museum depict the processions and a gladiatorial show given by a *sevir Augustalis*. The style, especially the scale of the figures, the constant use of frontality, and the method of suggesting depth by superimposing the figures, has many unclassical features and serves for some students as an object lesson in 'plebeian', as opposed to official or courtly, art. They find evidence of a lively and unsophisticated manner largely uninfluenced by Greek fashions, but with its own simple and direct method of expression, which they believe to be intimately connected with the Italic and Etruscan background of Roman art (cf. p. 61). But generally speaking the provincial towns of Italy follow the fashions of Rome. For example the style of a relief from Aquileia which depicts the ceremony of the founding of a city is closely related to that of the State monuments of the capital; and this is also true of a number of fragmentary historical reliefs from other towns in Italy.

The spread of Roman styles to the Empire is more complicated. Broadly speaking the provinces may be divided into two groups: those which lack the background of Greek and hellenistic art; and the artistically creative areas of the eastern Mediterranean. In the West, the most interesting area is that of the old province of Narbonensis, where Roman traditions go back to the second century B.C. and where there was an enormous development of towns in the Augusto-Julio-Claudian period. Several of the surviving monuments show some evidence of independent artistic traditions: an outstanding

example is the monument of the Julii at Saint-Rémy (Glanum) (Plate 62), which has become one of the central works of Roman art, despite the fact that it cannot be securely dated and that its character and purpose are uncertain (cf. p. 48). However, it has hellenistic prototypes and could be acclimatized in Italy in the first century B.C.; and its architectural detail belongs generally to the Italian regional variant of hellenistic found during the same period. The sculptured panels which decorate the four sides show on the north a cavalry battle, on the west an infantry encounter, on the east a battle scene from mythology, and on the south the Calydonian boar hunt with related scenes. The style of the reliefs places them firmly in the late hellenistic tradition represented by the Alexander mosaic (cf. pp. 24, 37) or the sculpture of the Aemilius Paullus monument (cf. p. 13). The effect of the cavalry engagement is achieved by the virtuoso foreshortening which makes the horses and men disappear into the background or emerge out of it. The grand gestures of the foreground figures are offset by background figures in low relief, illustrating the ambitions of late hellenistic sculpture to conquer the problems of space. There is a marked contrast here with the State reliefs of the Augustan and Julio-Claudian periods in Rome and Italy, where the attempt to conquer space is abandoned in favour of a much more restrained and disciplined handling of figures. In the reliefs of the monument of the Julii the artistic language is hellenistic rather than Roman, and it illustrates the independence of the artistic tradition in Narbonensis.

Something of the same tradition can be seen in the reliefs on the arch at Orange (Plate 61), which was erected in the time of Tiberius. The design is an elaborate and richly decorated version of the new type of Roman triumphal arch, but the reliefs seem much closer to hellenistic battle-pieces than to Roman commemorative reliefs, although there is very little metropolitan work of the period with which they can be compared. No doubt the independent style of some of these early Roman monuments is due to the fact that, generally speaking, local materials were used. The only example of a large marble building was the capitolium at Narbonne, and in this case we know that the architectural elements in Luna marble were imported from Italy, and Italian sculptors must have worked on the decoration. Among surviving fragments associated with the decoration are some splendid panels with garlands supported by eagles and Jupiter's thunderbolt, veiled, in the field; this is work in the best Julio-Claudian style and technique. Another fine example is a panel in the Maison Carrée at Nîmes. On many other monuments in Provence, especially those put up under imperial patronage, the style follows very closely the new imperial manner. The fragments of the altar of Augustus at Lyon, erected in 12 B.C., illustrate a decorative style closely related to that of the Ara Pacis. The famous Maison Carrée temple, for which Agrippa seems to have been responsible, has a fine frieze decorated with the now inevitable Roman acanthus scroll (Plate 63).

In Spain, where there were also earlier republican traditions, the position is very much the same. The Augustan temple partly surviving in Barcelona is carved in local stone with a provincial version of Roman Corinthian detail which seems to owe something to republican forms; but in other cities, when a particularly grand architectural design was being contemplated, metropolitan artists seem to have been brought in. This

certainly happened under Tiberius when the people of Tarragona erected a temple to Augustus with the new emperor's permission, and fragments of sculpture in the museum show how closely the marble reliefs, which include heads of Jupiter Ammon in ornamental frames, are related to the forum of Augustus. It seems that craftsmen from the capital were available in considerable numbers during the lean years of Tiberius' reign. Other fragments from buildings at Tarragona also show a close connection with the best metropolitan work. The same is true of sculpture from Mérida, where there was an enormous building programme, largely inspired by Agrippa, on the establishment of the colony. A group of sculptures from Pancaliente includes panels with floral swags and historical reliefs in the full Augustan tradition.

The Spanish provinces also illustrate the success of Roman propaganda policy in the distribution of imperial portraits. The Julio-Claudians predominate, and the quality is by no means exceptional, but there is a good Augustus *capite velato* from Mérida and a colossal head of the emperor from Italica; if they were made in Spain they imply the presence of very competent official portraitists. Most of the official portraits come from the big towns – Mérida, Italica, and Tarragona. One series, mostly found in 1935, decorated the stage of the theatre at Mérida. They are all Julio-Claudian; and it is interesting that of the 180 Roman portraits known in 1949 from the three Spanish provinces, 55.5 per cent are of Julio-Claudian date, and of the sixty or so imperial portraits no less than forty are of members of the Julio-Claudian House. This fact alone illustrates the intensity of the early imperial campaign to make the person of the emperor and the members of his family known throughout the Empire.

In the East the spread of the Roman style took a different form. These provinces, especially Greece and Asia Minor, had been the chief source from which the imperial government drew its artists, and they were enormously influential in the creation of the official Roman art. In the East generally Roman policy was very cautious. The classic example of the government's political restraint in the field of art is the design of the little temple of Rome and Augustus which stood on the Acropolis by the Parthenon and was decorated in imitation of the architecture of the Erechtheum near by. Few massive monuments of imperial propaganda were erected in Greece and Asia Minor, and the Romans seem to have concentrated on portraits of members of the ruling House in countries where the divinity of the Roman emperor was readily acceptable; thus the Metroon at Olympia was converted into a shrine of the Augustan House, and statues of the emperor in heroic and divine dress were common. The usual commemoration of some great historical occasion such as Tiberius' benefaction to the cities of Asia was to erect a large statuary group in the hellenistic manner, and statues of the emperors in armour or in civilian garb were to be found everywhere. The Roman styles of decoration spread rapidly through the foundation of new towns and the erection of standard Roman public buildings; but the craftsmen of the eastern provinces developed their own techniques for carving Roman ornamental designs, and the difference between Italian and eastern styles becomes very marked later on, especially in the work of the sarcophagus carvers, which will be studied in a later chapter.

Sperlonga and Villa Decoration

The influence of the emperor's own tastes on the development of Roman art is particularly important in this period, but we know tantalizingly little about it. One of the outstanding surviving monuments in this context is the grotto associated with Tiberius' villa at Sperlonga, which was laid out as a summer banqueting hall incorporating the most lavish decoration in the contemporary manner, making considerable use of glass wall mosaics in a tradition which goes back to the grottoes and *nymphaea* of the late Republic. This provided a setting for a sculptured décor with colossal groups (Plate 64).

Since their discovery in such dramatic surroundings and in so sheltered a condition, the Sperlonga sculptures have been the subject of much discussion and argument among international scholars. It now seems, on the evidence of the sculptures themselves and the accompanying inscription of Faustinus, the friend of Martial, who owned a villa near by, that there were three groups representing scenes from the Odyssey – the blinding of Polyphemus, Scylla, and the destruction of Odysseus' last ship (*Acta ad Archaeologiam et Artium Historiam Pertinentia: Institutum Romanum Norvegiae*, II, 1965, 261–72). The surviving figures are supreme examples of the late hellenistic baroque style, superbly carved and totally appropriate to the intensely dramatic scenes. There is tremendous strength and life in the forms of the bodies and a fine sense of drama in the tortured faces and wild expressions. The sculptures were set up on bases in the pool of the grotto and in the walls of the grotto itself. The subjects were immensely difficult to achieve in the medium and to apply in such a context, and their presence has revealed the tremendous impact of this baroque, late hellenistic sculpture in late republican and early imperial Rome. One fragment bears the names of the three Rhodians, Athenodoros, Hagesander, and Polykles, mentioned by Pliny as the sculptors of the Laocoon. The grotto was that in which an attempt was made to murder Tiberius (Tacitus, *Ann.*, 4, 59).

The popularity of the *nymphaeum* in villa architecture continued at its height in the early Empire. Of the many such grottoes and shady retreats that there must have been in Nero's Golden House, one remains in the western courtyard wing of the surviving block. It had a basin once decorated with sculpture and mosaic on the vaults, including a representation of one of the most popular themes in such contexts – Ulysses offering the cup of wine to Polyphemus; the startling colours in which the figures are portrayed is also part of the effect (*M.E.F.R.*, LXXXII, 1970, 673). The so-called Ninfeo Bergantino on Lake Albano which may have formed part of Domitian's villa also combined mosaic and sculpture in its decorative design (*M.E.F.R.*, LXXIX, 1967, 421–502).

The Neronian barges from Lake Nemi belong in the same category as the grotto at Sperlonga. They, too, were most lavishly decorated with mosaic and sculpture and illustrate the elaboration of ornament in Roman villas and country houses which is epitomized by what we know of Nero's famous Golden House.

Before the fire of A.D. 64 Nero had already given expression to his taste for luxurious living in the so-called Domus Transitoria which he had built to link the imperial property on the Palatine with the suburban estates on the Esquiline. The best known fragment of this house is the handsome *nymphaeum* below the Domus Flavia on the

Palatine which has a fine, if restrained, decoration of *opus sectile*, using a rich variety of coloured marbles. Other fragments of the Domus Transitoria show the development of Nero's more imaginative architectural ideas which came to full fruition in the Domus Aurea which was built after the fire. In the last four years of his reign Nero gave full vent to his vanity. He had a colossal statue of the Sun erected with his own features; and he built the Domus Aurea.

The Golden House of Nero

The Golden House had a short life in antiquity. It is mentioned in ancient writers for its massive size and landscaping (cf. Suetonius, *Nero*, 31), the luxury of its decoration, the ingenuity of its construction and gadgetry, and the costliness of its materials. Apart from the 'architects' we know the name – Zenodoros – of the famous bronze-caster who made the colossus, and Pliny tells us the name of the painter responsible for the interior decoration – a certain Famulus, an austere fellow who always painted (or supervised, we must suppose) in a toga. None of it lasted long. The area of the gardens went back to public ownership, as did the works of art. Part of the area above was built over by Titus, and the rest, not sixty years after it was erected, by Trajan's baths. But some of the rooms filled with marble continued to support the structure above.

After that only the colossus, altered by Vespasian and moved by Hadrian, survived, and very little was known of the house. The first excavations in the area were in 1488. Further excavations to find statues were made in the early sixteenth century, when painted, stuccoed, and mosaic rooms were discovered on the Oppian and elsewhere nearer the *stagnum* (the lake replaced by the Colosseum). The subterranean rooms were explored several times in the eighteenth century, cleared, and some of them drawn in 1774 and later. More were discovered by Fea in 1819, including floors of glass and marble near the temple of Venus and Rome. Many Italian and foreign artists visited the rooms from the fifteenth century onwards and often left their names on the walls. Giovanni da Udine, who worked with Raphael on the Vatican Logge and elsewhere, was known to have visited the site with his master; and Michelangelo went there to study the paintings. Out of this came the term 'grotesques', from the paintings found in these underground 'grottoes'. The western rooms grouped round the courtyard became well-known; but the eastern rooms with the *exedra* were not dug out. They were visited by Weege and others in 1907 (F. Weege, 'Das Goldene Haus des Nero', in *J.d.A.I.*, XXVIII, 1913), and excavations to clear them began in 1912. The room in the centre of the recess in the façade has the so-called Volta Dorata, with an elaborate design of shallow square and rectangular panels framed with mouldings, with red and blue in the field and stucco relief figures forming mythological groups, all picked out with gold. Mythological pictures also adorn the walls of this room. The designs on the partly preserved ceiling in the long corridor below the eastern rooms are delicately painted with a light touch. Architectural elements when they occur are light and fanciful, with little substance. Favourite designs are arabesques with sphinxes. The scrolls and animal motifs are painted in delicate, precise silhouette, with reds and blues against a light background.

There are other ceiling designs of stucco and paint, as in Room 80 where Laocoon was found. Here too the combination of delicately painted walls and firm ceiling mouldings gives an attractive lightness. The panels are sometimes occupied by mythological scenes of which copies are to be found in many drawings preserved in European collections. But it is not easy to assess the style of the paintings until a full publication has appeared.

We have, however, on the Esquiline enough to confirm ancient literary accounts of the ingenious and extremely rich decoration of the new palace. In the rooms on the Oppian the walls and ceilings, discovered in the fifteenth century and enormously influential in the history of Renaissance art, provide what survives of the paintings to which Famulus devoted so much of his work. They are basically in what is known as the Pompeian fourth style (Plate 66), which seems to have originated in Nero's time and which combines the closed wall treatment of third-style paintings (Plate 65) with an attempt to open up vistas of architecture. In general rich colours are favoured, especially gold, and this choice is certainly due to the developing taste for vivid colour schemes, which is also clear from the contemporary popularity of glass mosaics. The Domus Aurea is particularly interesting for the survival of painted ceilings in this style. What remains of the famous Volta Dorata has just been described. Of the murals, the arabesques incorporate the marine creatures, Griffins, vases, and candelabra which had become part of the stock-in-trade of the Roman decorator. The general treatment often gives the impression of tapestry rather than of painting. In some of the rooms, for example the *cryptoporticus*, the same tapestry effect, in contrast with the more firm geometric shapes of the Volta Dorata, appears on ceilings, where the detail is drawn with very delicate brushwork on pale backgrounds. The panels incorporate classical figures, generally isolated motifs, and the architectural framework includes little Erotes and birds. The technique is sometimes the rather sketchy impressionistic one of some of the best landscapes found in Campania.

Perhaps there is something typical of Nero in the fourth style, in the rich architectural fantasies which often adorn the upper part of the walls. In the realm of figure painting it seems to herald something of a classical reaction, with the big picture, closely copied from late classical models, dominating the main surface. The style persists into Flavian times and is well illustrated by one of the few surviving interiors of a Roman public building – the basilica at Herculaneum – where statues of members of the imperial House in large niches appeared with other statues and a series of panels showing the Labours of Hercules and other heroic themes. The combination of painting and sculpture designed to glorify the ruling imperial House must have been particularly effective, and was probably used in many public buildings of this and later periods.

Nero's public works, in which his taste for lavish decoration must also have expressed itself, are lost to us. One of the most important would have been the baths of Nero in the Campus Martius, which seem to have been the first of the great public *thermae* in the fullest sense of the word. The creation of such enormous complexes designed to accommodate great numbers of people presented new problems in decoration and in the application of classical art to decorative purposes. One of the most obvious results was the

increasing use of colossal sculpture appropriate to the scale of these buildings. In the Museo Nazionale in Naples one may see the enormous Aphrodite from the baths of Caracalla, and the gigantic Farnese Bull (cf. pp. 38, 88) and the dominating Farnese Hercules (cf. p. 29), both of which also once decorated large architectural features in Roman baths. Colossal sculpture of this kind became a commonplace in the grandiloquent architecture of later Rome.

Together with this taste for the colossal, and arising partly from the increasingly lavish decoration of Roman interiors, goes the use of coloured marbles for statuary of various kinds. Coloured marble had already been used to a large extent in Augustan times, and we must suppose that its use increased enormously under the Julio-Claudians. Sometimes it simply served to simulate the effects of other materials, particularly popular being green stones to imitate bronze; but more complex colour schemes were also used. A figure of Isis may have green draperies combined with white skin; and the rich dress of a barbarian may be suggested by the use of variegated stones such as pavonazzetto, combined with black or white marble for the face and hands. Coloured marble was used with particular skill in the portrayal of animals, which were obviously popular decorative pieces in Roman interiors. There is a very finely carved leopard in Egyptian granite in the Farnese collection.

Funerary Art

The developing taste for lavish ornament can also be seen in the funerary monuments of the Julio-Claudian period. The Roman tombs are no more symbols of good taste than their modern counterparts. They were often vulgarly grand, like the mausoleum of the Julio-Claudians, ostentatiously vulgar, like some of the monuments at Pompeii, or strangely bizarre, like the tomb of the baker Eurysaces or the Pyramid of Cestius. The interiors, however, cannot be neglected in the study of Roman decoration, since, in order to recreate an atmosphere of life, some of the finest painting, mosaic, or stucco was employed, and the dead were buried in handsome marble urns or sarcophagi carved with scenes of funerary symbolism or with rich decoration. In some periods of Roman art funerary sculpture and painting provide the chief documentation; and whether it is good or bad in quality, it has the great value of expressing the ideas of individuals and is particularly important in a world dominated by official art, where personal taste may be difficult to recover.

In the Julio-Claudian period the chief interest centres on grave altars and cinerary urns which were the chief receptacles for the remains of the dead. At this time cremation was the main Roman burial rite, although inhumation was also practised. One of the few surviving coffins of this age is the splendid marble Caffarelli sarcophagus which dates from the time of Augustus and is carved with extremely delicate floral swags in the best Augustan tradition. Apart from this a number of reclining effigies have survived, especially from Julio-Claudian times; they certainly occupied a place in the interiors of tombs, but may have been associated with cremations as much as with inhumations. Their main interest is in the head, which is carved with great care and sensitivity.

Funerary altars and urns develop in increasing richness throughout the Julio-Claudian epoch. The commonest form is the altar, generally rectangular, although there are a few round ones. The size varies and they may be up to four feet high. The upper part is normally of scroll form, but there may be a roof. The lid is usually separate, and the recess for the ashes is generally sunk in the top of the main portion. There is an enormous variety of urns, from house-urns to stone vases. Decoration is also richly varied. The basic design is a series of swags supported by *bucrania* or animal heads combined with sacrificial implements, but a rich funerary symbolism appears in some of the more elaborate examples. Two of the most important series from the Julio-Claudian period are those found in 1885 on the Via Salaria belonging to the family of the Calpurnii Pisones, and the group from the Platorini tomb in Trastevere discovered in 1880 in a mausoleum constructed of brick and travertine. Of the monuments of the Pisones the earliest seems to be Augustan and the latest Hadrianic. One is the tomb of M. Licinius Crassus Frugi, consul in A.D. 27, who was put to death under Claudius. He had won triumphal honours in the campaign in Britain, and his tomb is a fine example of an early cinerary altar, decorated with Ammon heads and garlands and with eagles below. One of the Platorini urns is round and another rectangular, and both are decorated with *bucrania* and garlands of fruit and flowers carved in the highly decorative style of the Julio-Claudian age, when the delicate Augustan naturalism was giving place to a more deeply drilled and strongly sculptural technique, such as one finds fully developed in the architectural ornament of the Flavian period. The symbolism of the funerary reliefs is rich and varied, ranging from mythological subjects which serve as allegories of death, such as the stories of Meleager, Hippolytus, and Persephone, to traditional figures such as Nereids and Centaurs, who represent the bliss of the life after death.

THE FLAVIANS (A.D. 69–98)

THE new dynasty of the Flavians inherited an official art which bore the stamp of Nero's megalomania – his world of grandiose architectural schemes, of rich decoration, and of colossal statuary with new notions of the divinity of the emperor. The wealth of artistic talent and technical skill that seems to have been available was turned by the Flavians to the glorification of military success. The forum of Vespasian, the great dynastic monument, contained in its galleries the loot from Nero's Golden House and the spoils of Jerusalem. The Colosseum was built, with symbolic aptness, on the site of the lake in the grounds of the Domus Aurea.

The theme of victory which dominates the contemporary coinage was expressed also in a series of triumphal arches which had by now become great 'billboards' for propaganda sculpture. The only survivor, the arch of Titus, is scarcely typical, and the monuments of Domitian, which failed to survive the *damnatio memoriae* in A.D. 96, must have been richly adorned. The well-known Trophies of Marius, set up on the steps of the church of Ara Coeli by Sixtus V, apparently commemorate the Germanic campaigns and were probably erected in association with a statue of the victorious emperor. The reign, indeed, seems to have been the apogee of the cuirassed statue, and many of Domitian's torsos probably survived with changed portrait-heads. Trophies and Victories in fine hellenistic style are the prevailing themes of the reliefs. The concept of triumph again dominated the decoration of the main hall of the Domus Flavia. There were friezes of Victories and trophies and, no doubt, pilasters with masses of weapons and figured capitals incorporating captives, armour, and the like. The floral ornament on the cornices of this hall was extremely luxuriant (Plate 68).

The reigns of the Flavian emperors are indeed rich in monuments in Rome, Italy, and the provinces. Vespasian had to consolidate and reconstruct; Domitian was a notoriously megalomaniac builder. The destruction of Pompeii, which took place in A.D. 79, at the end of Vespasian's rule, tends to be thought of, wrongly, as the end of an era, since after that date we lack a continuous series of works to illustrate the history of Roman painting. But there is a sense in which the Flavian era is rightly thought of as the culmination of developments in early Roman art, although not perhaps to the extent that has been argued by some critics.

Relief Sculpture

One of the earliest surviving public buildings of this period is the temple of the deified Vespasian put up shortly after his death. Its richly carved entablature is deservedly famous and may be regarded as the finest example of the elaborate style of ornament which was developed in Julio-Claudian times. The delicate Augustan naturalism, with

its subtle low relief skilfully reinforced by the use of paint, had given way to a much more sculptural manner, with deep carving and crowded detail executed in a precise and elegant technique. This style lasted into Trajan's reign; and an equally fine example is the entablature of the rebuilt temple of Venus Genetrix, dedicated anew in A.D. 113. The acanthus scrollwork decorating the frieze had developed from the scrolls of the Ara Pacis and is still convincingly organic, but the carving is rich, baroque, and highly decorative. In the strong sunlight its patterns of black-and-white are clear and convincing. There is a confidence about the decorative sculpture of this period, as indeed in all its decorative art. Roman taste seems more assured than at any other time, whether it be in house interiors or on the sculptured exteriors of public buildings. The skill of the craftsmen was never surpassed. The style of the splendid series of putto reliefs, appropriate to their context, from the temple of Venus Genetrix (Plate 67) is that of the best hellenistic sculpture, but the handling of the theme is very much in the Roman spirit. The putto indeed, although his parentage lies in hellenistic art and his symbolic role was already a wide one, leaps to prominence in Roman art as a principal actor in many scenes of human activity and as a principal decorative motif.

The putto is, in fact, everywhere in Roman art. Born in the earlier hellenistic period, the chubby child ousts the adolescent Eros and joins the cortège of Bacchus; he can even represent the god himself. Sleeping or sad he symbolizes death in funerary art, or, in his more cheerful Bacchic role, the joyous spirits in the after-life. He comes to replace the Seasons and develops a rich and active life as charioteer, as athlete, and as participant in almost any kind of 'genre' scene. If nothing is purely decorative in Roman art, the putto often comes very close to being so when he carries garlands or plays amid rich arabesques of foliage. The sculptures of the temple of Venus Genetrix raise him to a new dignity and importance in art. Here he carries the arms of Mars and performs the role of servant to Venus. In the soffit panels he becomes the chief ornamental feature and, indeed, the main motif of the architectural decoration, almost in the way in which Victory was to become the chief theme of Trajan's forum. The sculptures of the temple are the works of highly talented artists, who achieved a masterly rendering of children unparallelled before in sculpture. Thereafter the putto retained his prominent role in Roman art, especially in the symbolism of the sarcophagi.

The political and military successes of the Flavians were commemorated in numerous public monuments, Domitian being a notorious arch-builder. Only one Flavian arch has survived: that of Titus on the Velia at the top of the Via Sacra. It is poorly preserved, having been built into later houses, and very largely reconstructed at the beginning of the nineteenth century. The dedication records that it was erected in honour of the deified Titus, presumably soon after his death in A.D. 81. The scale is modest and the design comparatively simple. The earlier, more complex essays, such as the arch of Augustus echoed in the arch at Orange, had now been reduced to an orthodox form with, in this case, a single passage flanked by an engaged order and surmounted by an attic to support a bronze statuary group of the emperor. The rich decoration is typical of Flavian work, as is the choice of the increasingly popular composite order. The soffit of the passage has a central panel showing the apotheosis of Titus – a now familiar

theme of imperial iconography – surrounded by coffering with rich architectural ornament.

Chief interest in the arch of Titus has always centred in the sculptured reliefs of the walls of the passage (Plates 69 and 70). At this stage in the development of the triumphal arch, the passage seems to have been the main area chosen for sculpture, and a theme of movement or action was particularly appropriate. The subject here was the triumph of Titus and Vespasian after the capture of Jerusalem in A.D. 70. One panel shows Titus riding in the triumph, the other a section of the procession carrying the booty of the Temple. Like the processional frieze in general, this particular theme was by now well established in the repertoire of Roman commemorative art. The earliest surviving example is the little frieze from the temple of Apollo in Campo (cf. p. 42), already a very confident, if modest, version of the event. The handling of the subject on the arch of Titus is quite ambitious in its attempt to create an illusion of life and movement, and its 'illusionistic' effects caused Wickhoff to distinguish between a 'Greek' and a 'Roman' approach. The architectural frame here acts as a sort of window through which the spectator views the action. By the simple expedient of showing the procession of the booty as passing through a triumphal arch in three-quarter view, the designer contrives to produce an impression of depth, which he sustains by skilful handling of the different levels: the foreground figures in higher relief cast their shadow on those behind, while the figures at the rear are in extremely low relief, so that the very background seems to disappear. The effectiveness of the illusion is not easy to judge in the discoloured marble, which lacks the original painted reinforcement of the sculpture; but, clearly, the artist's purpose, within the limit of his conventions and the scale of the figures, was to give an impression of a real event. The technique he used had been developed in Julio-Claudian times.

Not only a suspension of visual disbelief is required of the viewer, of course, but also the mental acceptance of an allegorical language which had been developed since republican times to express ideas of the State. Allegorical figures are now freely incorporated into the representation of imperial scenes, where the dividing line between human and divine is blurred. We see the convention at its simplest in the chariot scene of the arch of Titus, where the emperor's chariot is guided by the goddess Roma (or Virtus), while Victory crowns him with a wreath. There is also a whole language of gesture and composition associated with the developing imperial iconography in official art which shows up most clearly in the two reliefs found in 1938 beneath the papal Palazzo della Cancelleria.

The slabs were discovered near the tomb of Aulus Hirtius (consul in 43 B.C.); some of them were stacked against it, as if in a mason's yard. The two friezes were presumably intended to decorate a monument in honour of Domitian, but diverted after his death and *damnatio memoriae* to a new purpose, for on one of the friezes his likeness has been recarved as a portrait of Nerva. In the end, however, the slabs seem to have remained in store. Their original purpose is quite uncertain; they may have been designed for one of a number of buildings in the Campus Martius, which was involved in a very extensive building programme after A.D. 80.

There is some controversy about what the scenes are intended to represent. Frieze B (Plate 71) is best interpreted as the arrival (*adventus*) of Vespasian in A.D. 70, when he was welcomed by Domitian; the setting is Rome, as is shown by the figures of Roma, the Vestals, the Genius Senatus, and the Genius Populi Romani, although the event in fact took place at Benevento. The lictors, as is appropriate to an *adventus* scene, carry axes without fasces. The second frieze, A (Plate 72), is less clear, the basic problem being whether the scene is one of *adventus* or *profectio*. The figure of Domitian, recarved as Nerva, appears to be setting out, perhaps a little reluctantly, on a military campaign – possibly against the Chatti. The allegorical figures are much more explicitly involved in the action of guiding him than are the figures of frieze B, but the interpretation is not entirely clear.

The language of these scenes, although here not completely decipherable, was the product of a long development of certain set-piece compositions involving the emperor – *adlocutio, adventus,* and the like – which can be followed to some extent on coin reverses. These are designed with very careful use of allegory, combined with precise pose and gesture, and require no words to make their meaning clear. They are, as in the case of the Cancelleria reliefs, acceptable even to the unconditioned eye, because their reliance on the classical tradition is so obvious. The sculptors of the Cancelleria friezes had an academic background, and they handle the classical types with complete confidence. Their style and technique show some development from the purer classicism of the Ara Pacis frieze. The drill is much more obviously used in drapery – where deep parallel folds supersede the richer modelling of the earlier period – as also in hair and beards; and delicate naturalism gives way to effects of black-and-white, which, of course, became more obvious later on.

Interior Decoration and Portraiture

The Flavian palace on the Palatine was designed to provide a worthy public setting for the emperor, whose role had now become quite openly that of *dominus et deus*, and adequate private accommodation for the imperial family and the vast body of officials and retainers. The imposing character of the public apartments is expressed in the lavish use of marble inlays, of coloured sculpture, and of luxurious architectural ornament in characteristic Flavian style, which still combines organic naturalism with rich sculptural effects (e.g. Plate 68). At this time *opus tessellatum* seems to have been superseded in favour by *opus sectile*. Wall mosaic, on the other hand, apparently became increasingly popular in appropriate contexts – in grottoes, *nymphaea*, and the like. The Neronian wall of mosaic in a real third-style design from the Via XX Settembre, probably part of a peristyle in a wealthy house in one of Rome's garden suburbs, shows how ambitious the use of this technique could be, and it was clearly an essential part of the decoration of the more imposing Roman bath buildings at this time.

The grandeur of such Flavian interiors as the basilica and the *aula regia* of the Palatine, and the elaboration of contemporary theatre façades, where exquisite architectural detail and a variety of coloured marbles – especially *giallo, africano,* and *cipollino* – were accom-

panied by copious statuary, is reflected in the painted and stuccoed walls. The fourth style is, in many ways, the most successful mode of Roman interior decoration. Basically it combines the 'closed wall' system with the open vistas of the second style, which generally serve to relieve the monotony of plain surfaces rather than to open up views in order to create an illusion of space. High walls are dealt with particularly effectively by dint of breaking them up into two distinct zones, usually with a different basic colour scheme for each. Thus, in the famous *oecus* of the House of the Vettii, which contains the Dirce, Pentheus, and Hercules panels, the yellow ground below is relieved by little vistas, the major division is sharply marked, and above it is a predominantly white scheme which has the effect of breaking the monotony without destroying the intimacy of the main design. The decorators copied a whole range of pictures, and they were inspired also by the very elaborate architectural designs of the day. The sketchy brushwork and the choice of colours stress the unreal character of the décor. The use of gold, yellows, and white is characteristic of the fourth style. Closely related is the design of some of the stuccoes of this period. One wall of the peristyle of the Stabian baths at Pompeii had an elaborate fourth-style wall scheme in stucco relief and paint; and one of the finest examples of this manner, also from Pompeii, is the wall with Dionysiac figures now in the Museo Nazionale in Naples (inv. no. 9625) which combines figures and complex architectural settings. These integrated schemes are the continuation of the baroque use of sculpture which had been a characteristic of Roman interior decoration from republican times onwards.

The Roman decorative painter uses a variety of techniques to gain special effects. The copies of classical paintings are executed in bold classical chiaroscuro as regards colour and modelling, which sometimes gives them an almost sculptural effect, while the gentle, hazy landscapes of the little vignettes aim at impressions of light and colour which the painter seeks to achieve by sketchy brushwork and soft tones. Few of the figure painters are good at landscape. In the big compositions the main figures seem to stand against a backcloth rather than to be involved in their setting; and in those scenes in which landscape is more dominant the figures often lack conviction. The little landscapes and vistas are perhaps the most successful, in their subtle creation of a warm, unreal, and ethereal countryside. A high degree of technical competence is apparent in all the best work.

The diffusion of the Roman styles and the high popularity of interior decoration can be judged from surviving work in many parts of the Empire. The villa at Fishbourne, perhaps some kind of official residence, was richly decorated in this period. The mosaics are of the white-on-black or black-on-white variety, which was still the most popular type; the designs were geometric, although figure work of many kinds was becoming increasingly popular. In the villa as a whole considerable use was made of marble and stone inlays, and there was a good deal of the fashionable painted stucco. Among the few fragments of painting, part of a seaside landscape shows how closely the decoration of this house was linked with the taste of contemporary Italy.

On the other hand, a grand seaside villa at Zliten in Tripolitania illustrates how regional differences operate within common patterns of style, especially in areas where

creative artists, probably trained outside the centre, were able to exert their own influence on taste. The Zliten villa seems certainly to date from around A.D. 70. The mosaics show a much stronger taste for polychromy than does contemporary work in Italy; the picture showing the Four Seasons (Plate 73), for example, combines *opus sectile* with *opus vermiculatum* that makes use of a wide variety of coloured marble tesserae. The unquestioned masterpiece however is the floor of acanthus arabesques of a type mentioned elsewhere (p. 126). The handling of colour and of light and shade, with a range of yellow, white, black, purple, and grey tesserae, is extremely subtle and delicate, combining a wholly convincing naturalism with a highly successful decorative effect. The wall paintings of the villa belong to the now established traditions of Roman interior decoration. Their colours and scale are gentle and unobtrusive; there are no big, boldly modelled panels, but airy little compositions in delicate tones. The picture of a village near the sea is a classic piece of imaginative Roman landscape. The light, coming in from the right of the scene, casts strong shadows on the foreground buildings which are rendered in typically inconsistent perspective. The figures are ethereal silhouettes, and those in the background are done in lighter tones. The most distant buildings appear on an upper register with hazy ground-line, although the houses themselves are shown in horizontal perspective. The purple shades, especially in the distant figures, give a splendidly warm, unreal feeling to a delightful piece of escapist painting that seems to have been greatly to the taste of contemporary Romans (cf. p. 131).

It seems likely that the styles of decoration which are thought of as typically Flavian were largely developed in the reign of Nero, whose taste for richly ornate surroundings was, as we have seen, notorious. It is hard to believe that, if emperors personally influenced the course of taste, the first of the Flavians, Vespasian, would have found much to his liking in contemporary decoration. His public image represents something of a reaction to Nero's combination of features and attitudes influenced by the hellenistic ruler-cult (see above, p. 64). Early likenesses of Vespasian, if the chronology based on coin portraits can be accepted, have the direct, rather expressionless features of the Julio-Claudians. But his own predilection may have been for something more genuinely like himself; and there is one group of marble heads (Plate 74) which have a down-to-earth, heavy-featured, and rather strained look which brings to mind Suetonius' famous description of the emperor (Vespasian, 20): 'statura fuit quadrata . . . vultu velut nitentis'. The legacy of Vespasian's taste can be seen in some of the more revealing likenesses of his son Titus. Domitian, on the other hand, revived the concept of dynastic portraiture to suit the changing image of imperial power. The emperor's person was now projected by elaborate protocol, his presence surrounded by a massive setting, as in the great reception hall of the Palatine, and the creation of a suitable figurative image was a matter of the greatest official importance. Domitian himself must have influenced the decisions taken. He went bald early in life and seems to have taken it very hard, as others had (cf. p. 63); he considered it a personal insult if reference was made to bald men. In his portraits he always appears with a good head of hair, sometimes rather formally arranged, suggesting the wig that he in fact wore. The usual ancient aversion to baldness, which provides a sharp contrast to the attitude of republican Romans,

arose, as has been said, from the influence of Greek physiognomical theory, which expressed the view that hair and other facial details indicated character. Certainly those responsible for imperial portraiture were very much aware of these ideas and made use of them.

In the provinces, especially in the East, where there were few commemorative monuments of western type, the imperial image often took on a different character and portraiture was the chief reminder of imperial power. The cuirassed statue, with intricately modelled armour expressing the political and social ideas of the dynasty, was the commonest type of portrait, but members of the imperial family also appeared in heroic or divine guise both in temples and in public places. The features of the emperor came through official channels to the various provincial centres; but whatever the official prototype, there was a good deal of variety in the local versions. A good example is the colossal head of Domitian (or Titus) from the Flavian temple at Ephesus (Plate 75), a fine piece of that hellenistic baroque which provided constant inspiration to Asiatic sculptors. Also common is the exaggeration of certain features.

The course of official art, reflecting as it does the changing attitudes towards the emperor, absorbs our interest in Flavian times. Throughout, the survival of a thoroughgoing classicism is the obvious basis of the tradition. Religious sculpture is still purely Greek in inspiration. Cult statues and busts of gods continue to be skilful copies or adaptations of classical types, as are the frieze sculptures of the forum of Nerva, decorated in honour of the goddess Minerva. The taste of private individuals does not differ essentially from that of the patrons of State art, and their portraits cultivate an equal restraint and simplicity. The surface finish tends to become more polished than before, and there is a good deal of obvious drillwork in the hair and often a more self-conscious poise of the head. The female fashions of the court are closely followed by other women. From the simple coiffures of Julio-Claudian princesses develop the elaborate honeycomb arrangements and artificial settings of Flavian ladies. The hair fashions, which provide, on the evidence of coin likenesses, a fairly reliable indication of the date of a portrait, are the most interesting aspect of the iconography of imperial women. They were followed all over the Empire, although a few distinctive local fashions can be found in provincial portraits.

Funerary Art

How closely private taste is related to official works can best be seen however in funerary art. Urns show a similar increasingly rich symbolism and taste for elaborate ornament. A group of altars from the hypogeum of the freedmen of the Volusii on the Via Appia, dating from the latter half of the first century A.D., is rich in symbolic ornament and figured motifs. One in the Museo Chiaramonti of the Vatican (*C.I.L.*, VI, 29858) has a typical scheme of decoration. A Medusa head flanked by swans occupies some of the space under the inscription; the garlands are supported by rams' heads, and above the garlands, at the sides, are birds with nesting young to symbolize re-birth. Sphinxes guard the corners below, and between them are little figured scenes of sea monsters

and Erotes, referring to hopes of the after-life. Some altars, such as the massive example in the Terme Museum, simply show the taste for rich detail; the crowning cornice and the frame of the main panel are crowded with deep-cut decorative motifs in Flavian style. One feels that the urn or altar is ceasing to be an adequate vehicle for the ideas expressed in its decoration. Griffins and candelabra, sacrificial implements, Victories, the creations of fantasy, scenes from classical mythology – all have their parts in a rich funerary and religious symbolism which may be seen to reflect a more sanguine confidence in life after death in another world, an attitude which may have something to do with the change from cremation to inhumation which began to take place at the end of the first century A.D. (cf. p. 94). The symbolism of the early sarcophagi, which will be discussed later (pp. 102 ff.), is closely related to that of the altars and urns.

The reliefs from the tomb of the Haterii family on the other hand suggest elements of opposition to the official taste, which relied so completely on the classical tradition. They were found in 1848 on the Via Labicana, three miles from the Porta Maggiore, and are now in the Vatican Museum. The decorative detail is very rich, ranging from typical Flavian architectural ornament to examples in delicate low relief in the illusionistic manner that had its origins in Augustan times. The figured reliefs are of the greatest interest; the scenes are all connected with funerary practices – the construction of the splendidly ornate mausoleum to which all Romans aspired and the actual lying in state of a dead person surrounded by mourners and the trappings of mourning (Plates 76 and 77). The figure style should perhaps be characterized as homely; certainly it has very little in common with the classical manner of contemporary official art. The proportions are unclassical, the faces sometimes verging on caricature, and there is a directness and refreshing difference about them. Something of the same style can be seen in a few other, near-contemporary, funerary reliefs, for example one with a chariot. Some scholars have felt that the Haterii sculptures and others of a similar kind represent a positive reaction to classicism which is paralleled in some of the later official reliefs, of the late second century onwards. They would also link the style with that of provincial Italian reliefs, such as the ones from Samnium discussed above (p. 65). It is undoubtedly a deliberate choice and fundamentally unclassical, rather than an artisan variant on the classical, but whether or not its existence helps to explain the later Roman reaction to classicism in official circles is a matter that must be discussed further.

<p style="text-align:center">*</p>

The Flavian era in official Roman art represents the culmination of the Julio-Claudian tradition. Vespasian's role was one of consolidation after the excesses of Nero's reign, but much of what Nero had done was adapted rather than discarded. The Domus Aurea disappeared, but part of its vast area was utilized for public monuments of unprecedented splendour; the Capitolium was magnificently rebuilt. The new dynasty aimed to outdo the magnificence of Nero's schemes. Perhaps the most significant of Vespasianic buildings was the Forum Pacis, the last great public museum of the city, which housed not only the lootings from the Temple of Jerusalem but many of the splendid works of art which Nero had acquired and which now were made public

property. The Elder Pliny wrote at this time, and the lists he gives show us not only how rich in classical works the city now was, but also how they dominated Rome's thinking about art in general. The dynastic ideas of Vespasian's successor Domitian may seem at first sight very different from those of his predecessor, but they can be thought of as the natural outcome of a long process of development and were most effectively expressed in the art and architecture of the time. Flavian artists and craftsmen possessed a self-confidence and a discipline which were unsurpassed. Their work illustrates both the strength and the weakness of Roman official art – its lack of creative imagination as well as its high degree of technical skill and attention to detail.

A massive figure of Mars, 3.60 m. high, was found in the forum of Nerva, whose brief reign ushered in the next dynasty. Armoured to the teeth, the figure stands four-square, heavily posed, dominating, and in some sense personifying the might of Roman arms. It derives presumably from a cult statue and must have stood with other divine figures in the temple of Minerva. If most Roman religious sculpture was adapted from the Greek, this is an exception, presumably an original Roman work of the first century A.D. Sculptors continued to produce new types while relying heavily on traditional forms. Another typically Roman series of figures, also of Flavian date, are the basalt divinities now at Parma, found in early excavations of the Domus Flavia; a Hercules and a Dionysus, which once stood in the elaborate architectural settings of the *aula regia*, are two of the best preserved. The Hercules may well be an adaptation, but very much a Roman adaptation, of a classical prototype. Genuinely creative divine figures must have been very few, but they could and did occur as long as the classical remained a living source of inspiration. It is believed that two of the latest figures of this type are the well-known Dioscuri of the Monte Cavallo, which may have been made for the baths of Constantine and were 'improved' by inscriptions assigning them to Pheidias and Praxiteles.

TRAJAN (A.D. 98–117)

THE reign of Trajan provided the inspiration which lifted Roman official art to some of its greatest achievements. It is outstanding for the number and significance of the sculptured monuments put up to commemorate the period when the Roman Empire reached its maximum extent. Trajan was the last emperor to add to the series of imperial fora. His was a vast complex of buildings designed to extend the commercial and administrative area of the city and paid for out of the spoils of the Dacian campaigns. Against the Quirinal hill a massive series of market buildings was erected above the forum with its basilica, by far the largest of its kind; beyond it two libraries went up, one for Greek and one for Latin books, and in an open space between them stood a column of Parian marble 40 metres high and set on a square base. The epitomator of Dio Cassius tells us that the forum and a number of other buildings of Trajan in Rome, including a very splendid odeum and the baths, were the work of a certain Apollodoros of Damascus who, according to Procopius, built the famous bridge over the Danube. The construction of Trajan's market may well have required the kind of engineering skill which only Apollodoros possessed, but the other buildings belong to a tradition which had been developed in Rome. The forum is very similar in design to the forum of Augustus and in every sense fulfilled a similar function. It became a second National Portrait Gallery in the city and made use of the same rich decoration of coloured marbles and statuary, combined with restraint in architectural detail.

Trajan's Forum, Column, and 'Great Frieze'

Trajan's forum, that 'singularis sub omni caelo structura' (Ammianus Marcellinus, XVI, 10, 15), is the supreme illustration of the use of art and architecture as an instrument of imperial propaganda. Its dimensions are almost as great as those of the other imperial fora put together, and it was richer and grander than any of them. Begun after Trajan's triumph in A.D. 107, forum and basilica were dedicated in 112 and the column in May 113 (L. Vidmar, *Fasti Ostienses*, 1957, 20). The temple to Divus Traianus was founded in A.D. 121 (*C.I.L.*, VI, 966).

The basic design of the forum is very similar to that of Augustus' forum, but with the addition, as has been said, of a basilica and two very important libraries and the famous column of Trajan. The Dacian triumph was the theme of the decoration of the column – of the triumphal arch that formed its entrance as well as of the upper order of the colonnades, where the place of the classical caryatids of Augustus was taken by figures of captive Dacians. Many of these have been found since the Renaissance and still survive – massively powerful and quietly dignified, richly draped, striking in features, often

carved in coloured marbles, including *giallo*, *pavonazzetto*, and porphyry, with their heads and hands in white marble.

Both the architectural detail and the figured reliefs are superb and represent the best Roman decorative carving. A frieze with lion-Griffins, symbol of Rome's power, and another with Victories bringing animals to sacrifice and placing fillets and so forth on the *thymateria* once decorated the basilica. They embody traditional themes, splendidly carved. Sculpture dominated the forum. A relief in the Louvre (Plate 78) shows an *extispicium* (inspection of entrails), preliminary to a military campaign, taking place before the temple of Jupiter Capitolinus. The tall, dignified figures, active in different poses and gestures, are presented before the grand architectural setting of the triple-cella temple, which is no longer played down but given its rightful place in the scene. Above the heads of the figures hovers Victory with a *vexillum*. There is good reason to think that the frieze with Dacian scenes, of which fragments and slabs are known and which has been called the 'Great Trajanic Frieze', also comes from this complex. The forum, too, was rich in portraiture; the finds from excavations of the nineteen-thirties have not yet been published, but they included many military figures and *togati*, and some fine heads – for example Agrippina Minor and Nerva. Dominating all – 'in atrii medio' – was the great equestrian statue of the emperor surrounded by trophies and dead Dacians.

The column of Trajan (Plates 79–87) is dated A.D. 112–13 in an inscription which is not easy to interpret, but seems to refer to the constructional work carried out in association with the forum. Its main intention, however, was to commemorate the two campaigns against the Dacians, the first in A.D. 101 and the second in 105–6. Although it was apparently not destined for that purpose originally, the base later served as Trajan's tomb. The surface of the column is decorated with a spiral band of low-relief carving which is generally about three feet wide and winds twenty-three times around the shaft. It provides the chief record that we have of the two campaigns, the only literary accounts being a fragment of Dio Cassius and a line of Trajan's own diary. It is not, however, a pictorial history in the normal sense. The continuous spiral of reliefs depicts a series of episodes in chronological sequence, subject to definite and long-established artistic and propagandist conventions, yet rendered with a remarkable eye for detail. The position of the column in the context of Trajan's buildings was carefully determined; it stood between the two libraries and was itself designed to be 'read'. From the upper stories of the libraries one could perhaps have seen more than we can today, but, in a clear Roman light and with the reliefs reinforced with colour and metal attachments, the detail could have been made out reasonably well even from ground level. The base is richly decorated with trophies of arms rendered with the precise detail which is characteristic of all the military representations on the shaft.

The narrative method used is of considerable interest. The basic approach has been known as the continuous method or continuous style since it was characterized as such by Wickhoff, who wrote, 'If we ask what are the artistic devices which produce so keen an impression of our having seen an uninterrupted series of events, we shall find that it is again the continuous method of representation which alone can arouse this feeling. It

alone can make town, river, tent, forest, field, soldiers, horsemen, march etc. etc. glide into one another and masses of human creatures crowd together, condense, separate or break up; it alone knows how to interrupt the perpetual stream by letting the emperor appear periodically and thus help the spectator to consider and define the episodes regularly.'

It seems that there was at some stage a change of plan. The column was finished in A.D. 113 and dedicated on 12 May, when, as it appears on coins, it was crowned by a statue of Trajan; but an earlier coin, a sestertius in Vienna of A.D. 107 (COS [=consul] v), shows it surmounted by a bird – just possibly an owl, which, so Becatti suggests, as the bird of Athens, served to commemorate the erection of the two libraries: Athena always appears in libraries, and the column itself could be termed a book-roll, a *volumen* of the *res gestae* of Trajan. This seems a very involved and rather oblique reference to Athena and the library and I suspect the owl. (Is it an eagle or an owl? See Lehmann *versus* Strack in *Untersuchungen zur römischen Reichsprägung.*)

The search for models for Trajan's column and its frieze has been unprofitable. The tradition of narrative commemoration of historical events is a long one, especially in the East, but direct oriental models are lacking; nor does the West provide any source for the type of the column or for its sculpture. It cannot be argued that the 'roll' of the frieze is directly derived from an illustrated manuscript, although a roll of similar form could have been painted by the artists on the spot. The continuous style, in which successive events are narrated against an uninterrupted setting, actually has parallels in every art, although since Wickhoff it has often been thought of as a specifically Roman contribution, and there has been much discussion about its beginnings and early development. It seems to have originated in later Greek art; it is found fairly well developed in the Telephus frieze from the great altar at Pergamon. Its use may have been particularly common in the campaign pictures of the late Republic, but we have no direct evidence. One type of continuous narration which does seem to appear first in Roman times however is the panel picture with a single setting for a number of different events (cf. p. 54). On Trajan's column the form is comparatively simple. The episodes are separate, but the background provides a sense of continuity, and, just occasionally, makes the story a little more difficult to read than it would have been if the scenes had been completely isolated from each other. The extent to which the designer was influenced by earlier forms of campaign pictures or by contemporary illustrated rolls is a much discussed problem, as is the combination of bird's eye and horizontal perspective in the handling of landscape. But whatever the origins of the stylistic elements may be, the fact remains that no spiral figured frieze of this kind existed before Trajan's column, although there were plenty of spirally fluted columns, and some with floral motifs in spirals round the shaft, in earlier periods. The designer, whoever he may have been, must be credited with a basically original achievement.

The story is divided into two parts, the first ending with the treaty of A.D. 102 which is symbolized by a large figure of Victory, and the second with the capture of Sarmizegethusa and the annexation of Dacia. The frieze is in low relief, the figures generally a little over one half of the height of the band, the rest being filled out with figures at

higher levels or with landscape elements. The first war takes up scenes III to LXXVIII, about equal weight being given to the two years; in the second war, scenes LXXIX to C are devoted to the first year and CI onwards to the second. The whole employs what has been called the 'epic technique', with the twenty-two marching scenes forming the 'chorus'. Within the basic framework there are a series of clear patterns – council of war, sacrifice, *adlocutio*, then all the varied activities of the army, building of fortifications, and key episodes like the unsuccessful attack on a Roman fortification. The schemes of both wars are similar: the first campaign ends with a battle and a submission, and the pattern is repeated for the second. The concluding scenes are the most dramatically effective, describing the great march against Sarmizegethusa; we have the building of the siege works, the Dacians setting fire to their city and surrendering, and finally the pursuit of Decebalus and his suicide with the final evacuation of Dacia. It is often problematic on the other hand whether the formal set pieces, already mentioned, showing the emperor addressing his troops or sacrificing or receiving the surrender of barbarians, represent actual episodes or generalized statements. These different types of scene have been carefully analysed by scholars, and their origins and development in the Roman tradition have been traced. Even some of the 'realistic' scenes, such as the death of Decebalus (Plate 87), owe something to hellenistic narrative art. What is particularly striking about Trajan's column however is the subtle combination of artistic invention and an eye for detail. The *adlocutio*, which appears first in scene X, is a long established set piece, and however many times it appears on the column there is little variation in the pose of the emperor or in the symbolic gesture that he makes; but in contrast the figures of the soldiers are very precisely observed; the back view of the legionaries standing at ease and listening attentively is obviously based on many drawn studies of the actual events. The handling of the setting shows a similar contrast. Landscape in the reliefs fulfils many functions, from explicit topographical reference to mere punctuation for the story. Precise attention to detail comes out very clearly in the representation of Apollodoros' bridge over the Danube, built for the second campaign, while the treatment and setting in general is full of conventional detail and conventional methods of representation, with the high viewpoint used for a building or a river shown in plan and cutting through the flow of the narrative, or with a series of symbolic elements composing a landscape. Many of these formulae probably go back to the early Roman tradition of cartographic narrative, which seems to have been common in historical painting. On Trajan's column the relationship of figures to landscape is always conventional. The figures dominate the setting, and there is no perspective diminution even of distant figures.

It would be wrong to think of the frieze of Trajan's column as being 'photographically' factual (cf. p. 83). But it is the work of artists steeped in Roman traditions who closely followed the events, probably by preparing a series of remarkably unambiguous drawings; only very rarely, as for example in scene L, is the viewer in doubt as to the meaning, possibly because some explanatory diagram was misinterpreted. Despite the many hands who must have worked on the carving, style and technique are remarkably uniform. Generally speaking the sculptors gave up the attempt to create depth

and concentrated on effective surface modelling. The handling of figures and drapery is still firmly rooted in the classical tradition and ignores the emotional character of later Greek art as typified by baroque hellenistic compositions.

On account of its typically Roman character and its clarity, the relief sculpture of Trajan's column has been vastly influential in the history of art. It is completely successful in what it sets out to do, i.e. to provide an epic version of the wars, with the Roman army under its great leader in the role of hero. Carefully selected scenes of the army's activities are combined with set pieces of the emperor and fitted into a basically historical framework which highlights the main events of the campaign. The landscape and setting help to provide continuity by bridging individual episodes. They can also be used to separate and yet unite, as when two tall trees serve to divide the Dacians who are felling trees for their defences and the legionaries who are similarly employed on theirs. The battle scenes, while they have strong elements drawn from traditional pictures of encounters between Greeks and Gauls, are yet skilfully made to stress the order and discipline of the Roman legionaries and auxiliaries in contrast to the Dacians. The hopelessness of the barbarians' cause is brought out; but although little attention is devoted to them as individuals, an effort is made to represent them collectively as a worthy foe by means of dramatic set pieces, culminating in the death of Decebalus. Thus, although there is a complete lack of sentiment, the glorification of the Roman achievement is made possible by heroizing the defeated.

The conquest of Dacia inspired other monuments in honour of the emperor. One of these was a great frieze of which parts survive on the arch of Constantine and elsewhere. The arch, as is well known, re-uses sculpture from a large number of earlier buildings, and one series, which decorates both sides of the main passage and parts of the attic, clearly derives from some important Trajanic monument. Giuliano da Sangallo was the first to try to put the slabs together in a reconstructed drawing, and since then they have been generally thought to come from Trajan's forum. They certainly formed part of a much larger frieze of which fragments exist in the Louvre, the Villa Medici in Rome, and elsewhere. Although the forum of Trajan was, we know, indeed richly decorated with sculpture stressing the theme of the Roman conquests, much of it still unpublished, there are difficulties in attributing these particular reliefs to the building because we have the statement of Ammianus Marcellinus that the forum was intact in splendour in the time of Constantius II. But this might refer to its architecture only, not to its sculptural adornment, although Trajan's equestrian statue was still *in situ*. (Or could the frieze have come from the temple of Divus Traianus north-west of the column? JMCT)

Parts of the 'Great Trajanic Frieze' have been put together to give some idea of its original appearance; the height was just under 3 metres and the slabs are approximately 2.30 metres long. At the left end of the surviving section was a scene of the *adventus Augusti* (Plate 88) with Trajan being led into the city and crowned by Victory; the rest is occupied by episodes from the Dacian wars. The style is fundamentally different from that of Trajan's column, following generally the earlier traditions of Roman historical relief. The figures in the foreground are in high relief, while the secondary figures

appear in several receding planes, so that those in the background are merely traced on the flat surface. The principles of the composition are complex; in order to give an effect of mass and movement, the background heads are raised above those in front. Renaissance drawings help to reconstruct some of the most damaged parts, and show that in general the frieze has not deteriorated much since the fifteenth century. The fragment in the Louvre with the figure of a Dacian and buildings in the background demonstrates that some of the scenes were set in landscape not unlike that used on the column. Apart from the *adventus*, a second episode depicts a cavalry charge led by the emperor, perhaps the attack that concluded the campaign, and there were also *adlocutiones* and other set pieces. This frieze, more obviously than that of the column of Trajan, is a work of propaganda designed to appeal to the populace of Rome, so that the triumphal return of the emperor is shown, and the whole method of representation is less documentary and factual. In fact, the 'Great Trajanic Frieze' is the earliest example of triumphal sculpture on this scale from Rome, although it is obviously linked with traditions such as those of the arch of Tiberius at Orange (Plate 61) or the monument of the Julii at Saint-Rémy (Plate 62). The chief inspiration is unquestionably hellenistic, and the link with the battles of Alexander the Great and his successors, which show the same massing of figures and much the same inspiration in the types of figures employed, is very obvious. Very few examples illustrate the continuity of this tradition in Rome itself, but the line of descent from such rare survivals as the Mantua frieze (Plate 40) seems clear enough. The development of high relief gives a greater monumental quality to the best work. It also enables the important figures to be isolated and gives them greater prominence in that they seem to move in relation to the background figures as one passes from one side to the other. This is obviously connected with the intention to give the emperor a more commanding position. (The isolated scenes from the Dacian wars on panels from Adamklissi (Tropaeum Traiani) in Roumania are clearly the crude work of very unskilled army craftsmen but contain some highly realistic and precise details of both Roman and Dacian equipment and dress. If hardly deserving of the name of art, these panels are, at any rate, part of the sculptural documentation of the campaigns. JMCT)

The Arch at Benevento and Other Public Monuments

The triumphal arch of Trajan at Benevento (Plates 89–93) illustrates better than any other monument the changing attitudes to the representation of the emperor. It is the earliest survivor of a type richly decorated with figure sculpture in panels and friezes on both main faces; the arches of Claudius, Nero, and the Flavians (apart from that of Titus) have all disappeared. The arch at Benevento stood at the point where Trajan's new road to Brindisi left the Via Appia, and it was decorated with a propaganda programme which seemed appropriate to such a monument. The general belief is that the twelve reliefs on the side facing the country (Plate 89) and one in the passageway deal with the emperor's work in the provinces, while the other and those on the other side (Plate 90) refer to his work in Italy, although it is not always easy to maintain this

simple division. The subjects include an *alimenta* scene (Plate 93) and deputations, as well as a number of traditional set-piece themes. In general style the reliefs follow the traditions of the first century A.D., especially the two in the passageway, which are closely related to those of the arch of Titus; indeed the decoration as a whole is very similar. Architectural settings are little used, and the figures are generally allowed to stand alone. One fundamental change is demonstrated by the tendency to show the emperor on a larger scale than the subsidiary figures, for example in the scene where he is receiving a deputation of merchants. By this time the emperor was indeed becoming the *dominus* rather than the *princeps*; and this is reflected in the representations of him in relief sculpture. The age of Trajan seems on the one hand to represent the culmination of the first-century traditions and on the other to herald a number of significant changes in Roman representational art.

The monuments of Trajan's reign achieved a scale and a grandeur unsurpassed in the history of Roman art. Not only does the forum of Trajan exceed anything that has gone before, but his baths established for the first time the vast complex which became so typical of the later Roman Empire; so far as we know they were the earliest to combine the massive axially planned bath-block with the whole circuit of subsidiary buildings intended for various forms of entertainment and recreation. The decoration of this type of building created its own artistic problems. By this time the Romans were constructing vast internal spaces out of concrete to which they gave a veneer of classical architecture, and these huge areas required to be decorated on a very grand scale. The cross-vaulted halls were covered with enormous mosaic floors in a style appropriate to their size. The prevailing pattern was for big designs in black-and-white mosaic involving grandly conceived compositions of sea monsters or giants based on hellenistic traditions. Polychrome mosaic, whose use had generally been confined to small rooms, seemed inappropriate in such a setting. By contrast, the walls were richly decorated in the *opus sectile* technique with inlays of coloured marbles, of which by this time an enormous range, including some which were being exploited for the first time, was available to the Roman interior decorator. The marble veneer rose to the full height of the walls, and above that the concrete of the vaults was often decorated with rich polychrome mosaic, which was particularly suited to damp conditions and to reflecting the light shining from below. Indeed the whole tradition of wall mosaics had developed independently of that customary for floors, especially in the context of the decorations of grottoes and fountain buildings (cf. p. 57). It came into its own with the requirements of the big Roman *thermae* and eventually developed into an art form in its own right.

The scale of the Roman bath buildings also created new problems for the designer of sculpture appropriate to settings. By this time figure sculpture had become subordinate to architectural design, and the size of the *exedrae* demanded works on an appropriate scale. A number of sculptures in museum collections come from the decoration of Roman baths for which they were either designed or to which they were moved at some time. Taste naturally tended towards the enormous baroque compositions of the hellenistic tradition, the worst features of which are well illustrated by the Farnese Bull in Naples (cf. pp. 38, 71). The sculpture is too big and too complex to be set up in the

medium of stone; it has no really satisfactory viewpoint, although as a combination of shapes seen in an architectural setting it has a powerful decorative effect. The Farnese Bull comes from the later baths of Caracalla, as does the equally famous Farnese Hercules, which must also have been impressive in its setting and is admirable in its handling of the muscles and its surface finish. Glykon, who made it, was obviously a man of vast technical ability; he signs his work in a prominent place on the rock beside Hercules, which suggests that he was a man of consequence (cf. p. 29). Many colossal works from the setting of the big imperial baths were made of coloured marbles, which were often used to gain special effects as, for example, when *pavonazzetto*, a mottled stone, suggested rich oriental dress and dark-coloured marble imitated either bronze or the faces of negroes (Plate 94).

The forum of Caesar is known to have been restored in the time of Trajan; it was dedicated in the same year, A.D. 113 (cf. p. 83), as Trajan's column. The contrast could not be greater, especially in the architectural decoration, which follows the Flavian rather than the revived Augustan style of Trajan's forum itself. Whatever the explanations of the difference may be, and it has been suggested that the reconstruction was begun by Domitian and therefore by architects and craftsmen working in the Flavian tradition, the decoration of the forum of Caesar represents the culmination of the ornate Roman style which had been developing in the first century A.D. Some of the sculptured decoration is the best of its kind. The frieze of the temple of Venus Genetrix is a striking example of the 'Roman scroll' which had developed from the scroll of the Ara Pacis and still retains its strong organic quality, although it has become heavier, richer, more baroque, and generally more decorative. Seen in the strong Roman sunlight, the intricate patterns of black-and-white are extremely successful. Another fine series of reliefs from the temple and forum shows figures of putti (Plate 67), some of them in association with acanthus scrollwork and others performing tasks connected with their role as attendants of the goddess Venus. The putto already had a long history in classical and hellenistic art in every context (cf. p. 74), but there are few examples where he is treated with such confidence and effect as in these reliefs. They represent the high-water mark of Roman decorative carving.

Portraiture

The achievements of the Roman army under the emperor Trajan revived the strong sense of the glories of the Roman past. Trajan's forum, which was so closely based in design on the forum of Augustus, became, as has been said, a second National Portrait Gallery which surpassed the original Augustan creation. It was full of statues of famous men who had served Rome, and Trajan himself was represented in a number of magnificent figures. The changing attitude to the emperor is reflected in the coldness and remoteness of much of his official portraiture, as for example in the bust in the British Museum (Plate 95), which reminds us of the rather expressionless Julio-Claudian tradition, in which the features are simplified, ironed out, and rigidly controlled in form. One is indeed tempted to ask whether the portrait looked like the man. The question is

unanswerable, but gains particular interest when one considers the bronze *imago clipeata* in Ankara (Plate 96), which clearly represents an emperor, most probably Trajan. The features are very different from those of the British Museum head, a fact for which many explanations are possible, reminding us of the difficulties of distributing official portraiture throughout the Roman Empire. The likely practice seems to be that plaster casts sent out from Rome were used in the main art centres to make master copies which were then recopied further afield (cf. p. 63). It seems hardly necessary to stress the dangers inherent in this process; we need only quote the Younger Pliny: 'All I ask is that you find as accurate a painter as you can, for it is hard enough to make a likeness from life, but a portrait from a portrait is by far the most difficult of all. Please do not let the artist you choose depart from the original even to improve on it.' Another factor is the influence of Greek physiognomical theory, which is perhaps better studied in the context of the portraiture of the next emperor, Hadrian.

Art in the Provinces

Trajan was born at Italica in Baetica, the first Roman emperor from the provinces, and this fact is reflected in the increasing cosmopolitanism of Roman art during his reign. His architect Apollodoros came from Damascus in Syria, although the buildings for which he is said to have been responsible do not show any particularly strong Syrian influence. On the other hand, some of the architectural detail from the forum of Trajan is clearly the work of carvers from Asia Minor. The technique used on the column of Trajan by which the outlines of the figures are refined by grooving, is found much earlier in the sculpture of southern France and Spain, although there is no certainty that this is the source from which it came to Rome. In any case it is important from the time of Trajan onwards to have a real understanding of the artistic output of all the provinces which were to react and interact upon the Roman style. The early development of common imperial styles in these areas has already been briefly discussed, but something further must now be said about them. The major influence on their spread was the creation of the Roman *coloniae* and *municipia*, best observed in southern France and Spain, where there was already a strong hellenistic artistic background. Considerable sums were spent both by the governments of the cities and by the central authority to create Roman monuments in the new styles. What happened is well illustrated in the early Augustan period at Arles in Provence.

The theatre at Arles was built to the new orthodox design with the seating of the *cavea* built up from ground level. The decoration of the exterior arcade is unusual in that above the plain pilasters that flank the arches there is a rich entablature with a Doric frieze consisting of bull protomes alternating with sacrificial *paterae* in the metopes, surmounted by a continuous Ionic 'peopled scroll' frieze with animal protomes emerging from the wall (Plate 97). All the detail seems to belong to the Italic-hellenistic style which had spread from Italy to Gaul and the West during the Republic. The protomes are hellenistic in origin, and the scrollwork is of a type which antedates the typically Roman scroll.

Inside, the character was very different. The *scaenae frons* was orthodox Roman, intended as much as a work of propaganda as was any other Roman public building. It seems to have been designed under Augustus, and most of the decoration, which was carried out in the new materials – Carrara (Luna) and various coloured marbles – belongs to that period. The applied architectural ornamentation is closely related to that of buildings of the early Augustan period in Rome, and, indeed, the quality and execution seem to imply craftsmen trained in Italy. In the now established Roman manner, sculpture dominated the design, the central niche of the *scaenae frons* being occupied by a colossal figure of Augustus which was later found in two parts, the torso in 1750 and the head in 1834 during excavations in front of the *scaenae frons*. There were certainly other colossal statues, probably of other members of the Julio-Claudian family. The rest of the sculptural décor apparently consisted of copies and adaptations, generally of very fine quality, of classical masterpieces. Apart from the famous Venus of Arles, a fine fragment in island marble of a female head and shoulders after an original of the fourth century B.C. illustrates the very best techniques of copying bronze in stone with a very precise and carefully finished surface and a particularly masterly imitation of bronze hair, combining deep cutting with delicate engraving. The arrangement of the figures must have been firmly tied to the architectural design, a feature which, as we have already seen, had developed from the planned settings of republican villas. Here, two surviving Maenads carved in mirror-image were obviously designed to occupy corresponding niches in the façade.

Among the sculptures from the theatre at Arles are a number of very finely carved altars which are as good as any surviving religious sculpture of the period, including contemporary work in Rome. The best, a rectangular piece with a relief of Apollo seated at the tripod, flanked by pilasters decorated with laurels, with at the ends Marsyas bound and the Phrygian slave sharpening his knife, was found in 1822 centrally in front of the stage; the top is missing and also the head of Apollo, which had been carved separately and inset. The craftsmanship is of the best quality available; the modelling is delicate and naturalistic in the manner of Augustan work; and the decorated mouldings remind one of the Ara Pacis. On another piece, a small marble scroll altar decorated with cygnets holding up a garland (Plate 98), the modelling of the swans' down and of the garlands is very fine.

It is clear that in the western provinces the best craftsmen from Italy were made available to work on important projects, especially in the Augustan period. This initial impetus in the process of Romanization eventually produced a genuine synthesis of Roman and Celtic art forms. Local craftsmen working in local materials produced most of the finest work, including the decoration of the Roman arch at Cavaillon; only for the capitolium at Narbonne, the capital of the province of Narbonensis, did the Romans apparently attempt to use marble (in this case from Luna) on a large scale in Gaul, and the cost must have been prodigious, to judge by the size of some of the architectural members which were being transported, roughly shaped, when the vessel foundered in the Gulf of Saint-Tropez. One soon realizes that the term Gallo-Roman, when applied to art, does not simply describe a period but signifies a sense of national achievement;

the age of Roman rule is recognized as a vital stage in the development of France, and no aspect is more important than the success of artistic Romanization. The Gauls acquired a completely confident understanding of the classical representation of the human and animal worlds, which they used in expressing their own imaginative ideas of the gods and their great love of the grotesque, which is so obvious in much of their religious and funerary sculpture.

In some of the western provinces, and especially in certain parts of them, the local upper and middle classes genuinely accepted Roman art; a good example is provided by the coinage of the so-called Gallic emperors (Postumus etc. from 258 to 273), which is more Roman than the Roman. It is sometimes argued that in these provinces, even the ones that were not highly Romanized, there were cultural trends which inevitably reacted against classicism, searching for expressionism, stiffness, intensity, and for simple, formal patterns. Bianchi Bandinelli wants to see in all this an efflorescence of the 'plebeian' trend in art. Yet much of it is pretentious and pays lip service to classical art.

However, it seems unlikely that artists from these areas had much to do with the development of Roman art as a whole. In the East, on the other hand, the situation was different. From the first, Athens and the other hellenistic centres had developed important regional schools which played a very great part in the creation of Roman imperial art. Fundamentally the process of Romanization was different in the East. The Romans pursued a much more cautious policy. The triumphal arch, for example, as a vehicle for propaganda sculpture, is almost unknown. Instead, the medium of imperial propaganda is the imperial portrait statue in all its forms, especially those based on the traditions of classical religious sculpture. Groups of the Roman emperor and his family took the place of cult statues in temples and in public buildings.

Another contrast between East and West is demonstrated by the very obvious survival in the eastern provinces of elements of hellenistic style and technique. This can be seen particularly well in the field of portraiture – for example, in the Flavian portraits from the temple at Ephesus, which combine Roman iconography with an obvious taste for hellenistic baroque. In technique, too, the eastern provinces have their own distinctive methods. One school of sculptors whose work is particularly widespread in the later Empire is that of Aphrodisias in Caria; it goes back to early imperial days, and maintained itself successfully for several centuries. There were competitions amongst the sculptors, who obviously enjoyed a high social status in the community, and Aphrodisian artists worked in many provinces and acquired an international reputation. They and their colleagues in other cities of Asia Minor developed their own style of carving, which contrasts with the modelling of the classical tradition, preferring deep drillwork and angular shapes producing strong effects of black-and-white. As the Empire develops we can see the influence of this new technique in many places, in Rome already in the time of the Emperor Trajan.

Further east still the spread of the Roman style involves major problems arising from the fundamental clash between classical and oriental ideas and religious beliefs, which had not been resolved as a result of the spread of Alexander's rule in the eastern world. It is impossible to discuss this subject fully in a general account of Roman art, but we can

get some idea of the processes at work from a study of the surviving architecture and sculpture in the Roman colony of Baalbek in the Lebanon (Plate 99) and in the city of Palmyra in the Syrian desert (Plates 100–2). Baalbek, established in the time of Augustus, was adorned with typically Roman buildings. The most ambitious architectural scheme was the great temple of Jupiter Heliopolitanus, which seems to have been begun in Augustus' reign and finished in the second century A.D. The complex of buildings has a scale and grandeur which are scarcely surpassed anywhere in the Roman world. Design and detail, although indebted to western models, are characteristically Syrian. The carving combines the taste for strong black-and-white effects with a type of low relief which seems to be indebted as much to the delicate patterns of oriental fabric as to any sculptural model. The effect of the grand, often very 'baroque', forms is enhanced by a lavish use of sculptural decoration. The sanctuary was full of honorific statues carefully arranged in architectural settings.

While Baalbek is fundamentally a Roman foundation which shows some eastern characteristics in its art and architecture, Palmyra is much more an oriental city, and so the impact of western art can be more clearly sensed. The great temple of Bel is an oriental sanctuary in which the buildings are designed on occidental models. The art of Palmyra was subject to both hellenistic and eastern, especially Parthian, influences, and this can be seen in every aspect of its art. Among the best-known surviving sculptures are the series of portrait busts from tombs (Plate 100). Here the model is quite clearly that of the Roman funerary bust of the first century A.D., but interpreted in a distinctively eastern manner. The heads of these dead Palmyrenes often have a strikingly individual quality, but they are not portraits in the sense that many of their western counterparts seem to be. The same conventional details are repeated – the large almond-shaped eyes and the simple outline of the face – so that in many cases an almost identical face serves to represent different people. In relief sculpture, of which the earliest surviving example comes from the temple of Bel itself, the figures are often very clearly derived from classical models, but there is always a tendency to reduce natural form to pattern, especially in the handling of drapery. There is also a strong urge in this essentially religious sculpture to represent figures in a frontal aspect, as in the well-known reliefs illustrated here (Plates 101 and 102). This taste does not seem to be a long-standing convention of oriental art in general, and, indeed, in certain contexts it is common to the art of East and West. But early examples in the eastern Empire do seem to suggest that the sculptors and artists are expressing more directly and more strongly the oriental attitude towards divine beings, so that, when similar oriental ideas become part of the western attitude towards the emperor, frontality, which is such an obvious characteristic of late Roman imperial representations, comes into its own. It is not so much a question of direct influence on the West from eastern sources, but simply of a common attitude of mind requiring common means of expression.

In all the cities of the eastern Roman Empire sculpture and painting had an enormous role in public life. The sanctuaries were full of religious sculpture and dedications of various kinds, and the characteristically oriental colonnaded streets were often lined with statues of the famous men and magistrates of the cities – at Palmyra every column

has a bracket which once supported a bronze figure. Cycles of painting were an essential part of the interiors of temples, and dedications of costly tapestries were very common. Because so little of what once existed has survived it is very difficult to judge the eastern contribution to the art of the Roman world in general, but oriental influence can be seen in almost every field of Roman decorative art, as well as in the major arts of painting and sculpture and in architecture. It is from the time of the emperor Trajan that these influences began to flood in.

Sarcophagi

Perhaps one should attribute to eastern influence the taste for richly decorated sarcophagi which almost certainly began in the reign of Trajan. Up to that time the normal rite of burial in Rome had been cremation, and the normal types of monuments were the ash urns and altars which, as we have already seen, had developed quite an elaborate funerary symbolism, the most consistent motif being the garland supported in various ways. The front and sides of the earliest decorated sarcophagi likewise have garlands with different kinds of supports, and, in the spaces above, little sculptured vignettes of scenes from classical mythology, usually on a subject which could be interpreted in terms of funerary symbolism (Plate 103). There does not seem to be any obvious explanation, religious or otherwise, for the change from cremation to inhumation. The two rites existed side by side at least until the middle of the second century in Rome, and only of the third can it be said that inhumation was the normal practice. The funerary ideas expressed on the sarcophagi are not materially different from those of the urns, but it is worth noting that some scholars take the view that inhumation became customary because of the increased opportunities for rich sculptural decoration provided by the larger monument. Certainly some of the grandest and most pretentious funerary altars, for example the piece formerly in the Lateran, now in the Vatican (Plate 104), belong to the time of the emperor Trajan. The later development of the Roman sarcophagus is discussed below.

HADRIAN (A.D. 117–38)

Portraiture and Imperial Taste

'There were no campaigns of importance during [Hadrian's] reign, and the wars that he did wage were brought to a close almost without comment.' This is one of the passages from the life of the emperor in the *Historia Augusta* to set the stage for Hadrianic art, which produces quite a different atmosphere from that of the preceding period; in many ways it reflects Hadrian's own character, which was perhaps more influential than that of any other emperor on the art of his time. He was so deeply devoted to Greek studies that he acquired the nickname of 'Graeculus', and he was apparently no mean artist. His portraiture (Plate 106) completely transformed the Roman imperial tradition. His biographer in the *Historia Augusta* draws attention to the care which he took over his personal appearance, the way in which he combed his hair and let his beard grow – in order, so it is said, to cover the blemishes on his face. This explanation arises from a misunderstanding. It was no doubt a certain Polemo of Laodicea in Asia Minor, one of Hadrian's chief advisers and a leading figure in the history of Greek physiognomic theory, known to have delivered the oration when Hadrian dedicated the great temple of Olympian Zeus at Athens, who induced the emperor to wear a beard and to be so represented in his official portraiture. This element, new to Roman emperors, is not just a mark of Hadrian's philhellenism, although the general effect is to make him look rather like a Greek hero; it is rather the result of a great deal of learned, even metaphysical, controversy as to how a ruler should appear before his subjects. From Polemo himself we have a description of the emperor's eyes, which were said to reflect certain aspects of his character; and we may be sure that every detail of his official portraiture, including the cut of the beard and hair, was carefully thought out. From now on hair was to become a leading motif in the history of Roman iconography, and the merits and demerits of wearing long hair and beards were endlessly discussed by such men as Dio Chrysostom and Synesius of Cyrene.

The marking of the pupil and iris by engraving the outline of the former and hollowing out the highlight of the latter, a technique used much earlier in other media, especially in terracotta, appears in monumental stone portraits for the first time during Hadrian's reign. It marks an essential change in sculpture, freeing it partly from the dominance of colour. Details which formerly had been reinforced in paint – eyebrows, hair – and whose sculptured form had been played down are now more strongly indicated. Texture also is studied, more especially contrasts between the finish of the flesh parts and the roughness of the hair. The carver from now on will rely more on sculptural effects to achieve expression, a tendency which culminates in the often brutal technique of some of the portraits of emperors of the third century.

A recent book makes the portraiture of Sabina, Hadrian's wife, the central point of a discussion of Hadrian's supposed classicism. The empress had by then become an essential part of the imperial image, and the handling of her likeness had to be just as subtle, if not more so, as that of the emperor himself. The wife of his predecessor, Plotina, expresses in her portraits the virtues of the ideal empress which Pliny ascribes to her: 'modica cultu, parca comitatu, civilis incessu' – a living contrast with the intriguing females of the Julio-Claudian and Flavian era, whose ostentatious hairstyles seem to reflect their way of life. Sabina's earliest portraits, around A.D. 100, present us with the ideal Roman aristocrat, severe, and wearing a simple, neat, plaited hairstyle; a good example is the statue of her as Venus Genetrix from the building of the Augustales at Ostia. As Augusta, and part of the Court, she assumes a more regal air, with a stylized, more artificial coiffure. Later still, at the end of the reign, and as she appears in the scene of her apotheosis from the Arco di Portogallo, the empress is an idealized figure, with a diadem and a classical hairstyle which seem to transform her (Plates 105 and 111). The portrait changes as the need changes; she is by turns wife, Augusta, and personification of Empire. No single 'label' can characterize such a development.

The emperor's personal tastes are best illustrated by the architecture and decoration of his villa at Tivoli. To quote the *Historia Augusta* again, 'His villa at Tibur was marvellously constructed, and he actually gave the parts of it the names of provinces and places of great renown, calling them, for instance, Lyceum, Academia, Prytanium, Canopus, Poecile, and Tempe'; yet none of these seems actually to have been copied from the original, and in fact Hadrianic architecture at Tivoli constitutes a very imaginative advance on earlier work in its use of concrete and the planning of interior space in general. It is unfortunate that the vast amount of sculpture, painting, and mosaic from the site has never been properly collected, but enough is known to give a sound idea of the emperor's taste. The copying and adaptation of classical masterpieces flourished as never before, and vast quantities of imitations of famous Greek works have been found. Most recently the sculptural décor of the colonnades surrounding the Canopus has been revealed, and a series of copies of the caryatids from the Erechtheum at Athens (Plate 109) and other fifth-century masterpieces shows the continuing strength of the classical tradition in Roman art.

For reasons such as this the period of Hadrian has been characterized as one of classical revival, and this is true in the sense that it seems to have been the last era in which the classical tradition produced a genuinely creative response in Roman official art. Hadrian's consolidation of the Empire was expressed in artistic terms by such famous series of sculptures as the personifications of Roman provinces (cf. p. 98), which were established in a canonical form for the first time. A new classical concept of the goddess Athena was also created, and in all aspects of Hadrianic art the direct inspiration of the Greek world is very clear – nowhere more so than in the series of portrait statues and reliefs of the emperor's favourite Antinous, the Bithynian boy who was drowned in mysterious circumstances in the Nile in the year A.D. 130 and who was deified by the Greeks and commemorated everywhere at Hadrian's request. Some of these representations were not simply copies of famous classical works, as most figured portraits had been in the

past, but genuinely original creations by Greek or Asiatic sculptors, for example Antonianos, a member of the well-known Aphrodisian school (Plate 107). The statues of Antinous – for example the Antinous as Apollo from the Hadrianic baths at Lepcis Magna – illustrate what is perhaps the last original achievement of Roman art under the over-riding influence of classical form and style, before new techniques, new ideas, and different standards began to undermine the authority of the classical tradition in general.

The Delphi Antinous (Plate 108) is another good example. The technique is typically Hadrianic, contrasting a high surface finish with rougher work on the hair, and differing in a striking manner from that of the Greek sculpture of the Delphi Museum. The figure is very far removed, too, from the slim elegance of the Lysippic Agias displayed near by; both are ideal types, artists' creations, but the Antinous is based on the short, stocky, big-chested form that he must have had in life, whereas the Agias is the product of proportion and symmetry. They are worlds apart, the one trying to produce ideal form out of nature, the other to modify an ideal form by reference to the particular. The Hadrianic experiment had been made before – in the late hellenistic period for example – and would be again.

Relief Sculpture

The travels of Hadrian to all the provinces of the Empire produced a revival of art and architecture in many centres. At Athens there was a big architectural programme involving new and important buildings, and the same was true in a number of important cities in Asia Minor. This is nowhere clearer than at Ephesus, where the programme of glorification of the emperor and his House produced, about the time of his death, the 'Great Antonine Altar', the reliefs from which are now in Vienna. The monument, it seems, was modelled on the great altar of Zeus at Pergamon, and the sculptures were executed in much the same theatrical style, with highly dramatic battle scenes combined with groups of the imperial family (Plate 110). The reliefs have been described as a record of imperial glory, earthly and divine, in terms that represented a perfect fusion of hellenistic drama with the Roman sense of historical purpose. It is interesting too that the 'Great Antonine Altar' is the only imperial sculptured monument in the East which can be compared with the historical reliefs of the western tradition.

In Rome, the relief sculpture of Hadrian's reign has a monumental quality and a simplicity, especially in the handling of traditional scenes, which does seem to reflect a heightened classicism. This is particularly obvious in panel compositions where the figures in the foreground are modelled in classical proportions and stand out in the round so as to produce a stereoscopic effect in that the foreground figures appear to move with the eye in relation to the background. This feature can be seen in two panels, now in the Palazzo dei Conservatori, from the demolished Arco di Portogallo that once spanned the Corso in Rome; one scene shows the apotheosis of Sabina (Plate 111) (cf. p. 96) and the other an *adlocutio* (Plate 112). In the latter particularly, the relatively few figures stand out prominently in contrast with the crowded and more naturalistic versions of

the theme in earlier Roman sculpture. The comparison is not unreasonably made with Athenian grave reliefs. At the same time the simplification of the figures makes it possible for the sculptor to integrate them more successfully with the setting – a happier relationship which indeed is general among Hadrianic and early Antonine reliefs. In the so-called 'Anaglypha Traiani' now in the Curia in Rome (Plate 113), the action seems genuinely to be taking place in the Forum Romanum, where Hadrian is addressing the people from the Rostra in front of the temple of Divus Julius; to the right is a statue group of Trajan's *alimenta*. Although the interpretation of the buildings in this frieze is a very vexed question, this is perhaps the first time in a Roman monumental relief that the background and the figures seem to blend happily together. Later Antonine reliefs achieve even greater success in this field.

It would be wrong to think of any one particular Greek style as prevailing in the time of Hadrian; indeed the emperor's tastes and those of the Romans of the period seem to have been broadly based. An important group of Hadrianic reliefs is the roundels re-used in the arch of Constantine which commemorate the emperor's devotion, for which he was noted and indeed much criticized, to the pleasures of the hunt (Plates 114 and 115). They are in the direct line of the so-called hellenistic landscape reliefs in which a lively figure style is combined with careful rendering of the rustic setting. This series is unique in the history of Roman sculpture, and it is difficult to see what type of monument it may have come from.

The two most obvious developments in relief sculpture of this period – both of which demonstrate the strong influence of classical art – are the preference for the rectangular panel and the increased monumentality and high relief used in the rendering of the scenes. One of the chief characteristics of early Roman sculpture was the way in which low relief replaced sculpture in the round in a number of contexts, for example in the decoration of temple pediments; indeed the general uses to which sculpture was then put required a two-dimensional rather than a three-dimensional form. But it seems clear that under Hadrian figure sculpture was strongly revived not only in portraiture but also in the whole field of religious and semi-religious representation. Roman figure sculpture in general was often concerned with the creation of new types to represent divinities or virtues; and these might be either classical pieces converted to a new purpose, or copies or adaptations of older works, or specifically Roman creations based on Greek prototypes. In the time of Hadrian a whole new series of figure types was created to represent the provinces of the Empire, and versions of them in high relief were used to decorate part of the temple put up in Hadrian's honour after his ·death (Plates 116 and 117).

Another important innovation of the time which was to have enormous influence later was the cult image of the goddess Roma designed for Hadrian's temple of Venus and Rome. This severe classical figure seated with Victory and a sceptre is closely modelled on the goddess Athena, and the style harks back to the fifth century B.C., replacing the rather Amazonian figure of so many earlier Roman coins and historical reliefs.

Interior Decoration

The new architecture, which was beginning to transform the old classical tradition, and which as we have already seen was chiefly concerned with interior space, created new problems in interior decoration. Hadrian's architects carried the new methods a good deal further than their predecessors had done, and his villa represents a combination of the orthodox with daring innovations. The famous pumpkin domes and the complex central planning of buildings like the pavilion in the Piazza d'Oro posed entirely new decorative problems, as did the vast interior of the Pantheon. The effect of these architectural innovations was to cause the traditional media, especially wall painting and stucco work, to decline in favour of coloured marbles and mosaic. At Tivoli the use of wall and vault mosaic is widespread in the domes and vaulted interiors, especially in buildings such as the Serapeum. Marble inlay was the main decoration of the walls of the grander apartments, and for the Pantheon a rich multi-coloured scheme was devised. At Hadrian's villa there seems to have been a revival of floor mosaic, especially of the polychrome variety which had been fashionable a hundred years earlier.

In the intervening period most Roman floor mosaic had been based on geometric patterns in black-and-white with small figured panels and a very limited use of colour. At Hadrian's villa have been found a number of very fine mosaic *emblemata* in the old *opus vermiculatum* technique, with pictures apparently based on hellenistic originals (Plate 118). It has been argued that these are much older collector's pieces re-used in the decoration of the palace, but it may simply be that the old technique had become popular again. There was much fine stucco work associated with Hadrianic buildings, with a tendency to model figures in higher relief than in earlier periods; a number of very good examples have been found in Roman tombs of the Hadrianic period.

No wall painting of any importance has been traced so far at Hadrian's villa, and there seems little doubt that the art had become less popular. However, we do not have paintings from important public buildings from which to judge the quality of the best work. Those from the tomb of the Nasonii on the Via Latina are in a perfectly modelled academic classical style which many think is typical of the Hadrianic–Antonine period. Certainly many painters, especially copyists, will have contrived to work in this idiom. The wall of a tomb at Caivano (second half of the second century) is broken up into fields by heavy red bands, and in a lunette over the entrance can be seen an ethereal picture of Elysium with the figures and objects floating in space, a magical painting which still looks for inspiration to the earlier Roman idyllic landscapes, but introduces a new sense of order. The paintings of a house under Villa Negroni in Rome, dated by associated brick stamps to the Hadrianic period, are known only from coloured drawings of the eighteenth century which seem to show that the late Pompeian style continued in basically the same form. One wall here combines flat panels with huge picture panels, the whole included in a perspective architectural scheme. The architecture is light, without real structural form, but the perspective is effectively done. After the eruption of Vesuvius, the neat categories of style are no longer applicable to Roman painting; there is no fifth, sixth, seventh, or eighth style. The reasons are many: the

volume of material is far less, more scattered, and less easily subjected to systems; and attempts to associate style with ruler are unconvincing, except within the very broadest limits.

There is little doubt, too, that wall painting lost ground to other forms of interior decoration – marble incrustation, mosaic, and so forth; and fewer new designs and ideas were developed. It is true, however, that the Flavian fourth style was very successful, taking the best elements from earlier modes. There are a few elaborate architectural walls with figures, but the commonest type combined large panelled areas with light architectural vistas. Trojan paintings incorporated into these schemes may be executed in classical style or with the sketchy colour impressionism of, say, the Trojan Horse scene from Pompeii (now in Naples), a fine study of the effect of light and shade. For the variety of styles we may compare Pliny's remark about Atticus Priscus, a painter of the time of Vespasian, whose style was *antiquis similior*.

The role of Famulus (cf. pp. 52, 69) in creating an eclectic style is probably important. Most of the best work in the Golden House is the painting, in the lesser rooms and corridors, whereas the walls of the main rooms were adorned with marble or mosaic. The Golden House also has one of the elaborate two-storey architectural elevations which could be called fourth-style (Room 19). There are two types of ceiling decoration, one lighter and brighter like tapestry on a light ground, used in rooms with painted walls, the other with panels partly in stucco relief and partly with figure painting, which are combined with walls of stucco or marble. The Volta Dorata is the best example of the latter, most familiar from a watercolour of Francesco d'Olanda, dated 1538. The stucco was accompanied by gilding and glass and painting on a blue and red ground. The carpet style is only known from walls at Pompeii, although a few ceilings there are preserved.

The light, bright ceiling adorned with delicate decorative motifs occurs in a building in Via dei Cerchi (late Flavian?). On the other hand the villa of Domitian at Castelgandolfo, rebuilt after a fire in A.D. 90, had a stucco wall of *scaenae frons* type with little direct reference to structure. We have a Flavian stucco ceiling from the Palatine and, of course, a good deal from Hadrian's villa, again largely preserved in drawings and paintings, e.g. the Topham drawings at Eton College (*P.B.S.R.*, VII, 1914, 7 ff.). One wall with perspective columns, north of the hospital, looks rather second style, except for the naturalistic plant motifs. The designs in general in the villa seem to have been very simple panel compositions with strips or pilasters and stylized flowers. Between the pilasters were pictures of poets and the like, their names recorded on stucco *tabulae ansatae* above them (Wirth, figure 27). The style is generally an 'architekturlose Dekorationsart'. The ceilings are of stucco or mosaic or are painted. There are fine stucco ceilings in the large baths, some of them comparable with those in the Domus Aurea, but their component elements appear to be simpler geometric shapes. Some may, of course, be Antonine, or later still.

It is not easy to date figure paintings. The Marine Venus from under the church of SS. Giovanni e Paolo, forming part of a *nymphaeum*, is attributed by Wirth to *c.* 130/ 45, by others to the fourth century (cf. p. 156: Plate 214). It is very classical in taste, with

little expression – even rather wooden – and it reminds one of the base of the column of Antoninus Pius. In the main room of the Pancratii or Anicii tomb on the Via Latina (Antonine) simple wall painting with division into zones is combined with very elaborate ceiling and lunette decoration. The lunettes have a kind of *scaenae frons* architecture. There is a splendid cross-vaulted ceiling. A landscape from Roma Vecchia (villa of the Quintilii) in Villa Albani is assigned by Wirth to the Antonine period, and the same date is given to the tomb at Caivano, where, as we have seen (cf. p. 99), the lunette has an attractively ethereal landscape, while the white ground of the vault is divided into fields by fine red-brown lines. The beginnings of the linear style can be seen in the tomb of Clodius Hermes under the church of S. Sebastiano on the Via Appia near Rome.

Another source of evidence is the apartment houses at Ostia, which do not always yield high-quality work, although Ostia is the key to later development in Roman painting. The wall finish is much coarser than that at Pompeii, and true fresco is used comparatively rarely. Many of the walls are fairly closely dated, and the earliest of a worthwhile kind seem to be Hadrianic. A good example is the so-called House of the Muses, a trapezoidal courtyard structure in the quarter of the Case a Giardino, from which most of the paintings have been lifted and replaced on panels. The house belongs to a Hadrianic development of middle-class flats with gardens. There is perhaps little to connect the basic designs with Pompeii, although the same architectural schemes survive and the wall is still divided into the characteristic three zones. The architectural elements, however, become increasingly subordinate as time goes on. Reds and yellows are the prevailing colours, and the panels usually have single figures or mythological scenes floating in the background, often painted after the surface had dried. Room 5 of the House of the Muses (Plate 120) gives a good idea of the basic scheme and is fairly well preserved, although the upper margins are lost. The overall architecture and panel decoration is in fresco, but the figures were added later using lime water as a base. The wall has a black plinth and tall, slender columns rising to full height, with pilasters at the corners. A third of the way up the columns are tablets painted with floral decoration which appear to hold up the big panels painted in orange, yellow, and red. Between the columns and the panels are narrow strips with slender architecture in the background, not unlike the vistas of earlier Roman decoration. The figures in the panels, in this case the Muses, stand on little strips of ground. A Doric entablature divides the wall into two zones with the main columns continuing to the top. The upper zone uses rather different and quite subtle combinations of red and yellow. The whole scheme is unquestionably based on the fourth style of Pompeian painting, but its architecture is far less substantial, and it relies for its effect on colour rather than on architectural form.

From Ostia we also have a series of very closely dated mosaics. In the early period black-and-white was very common, but the big apartment houses have very little in the way of figured mosaics at all. In one of the earliest, from a set of baths built in the mid first century, the field is divided into squares, and the six forming the central panel are decorated with dolphins. At each end of the centrepiece are four squares with representations of Roman provinces and winds: Spain is a female head with an olive wreath; Sicily has a *triskeles*. In the second century black-and-white designs continue to dominate,

but there is a new taste for freer overall figure compositions, such as one finds in the baths of Neptune (Plate 119), where the mosaics have a very lively style and a very subtle and economical handling of the anatomy; they are probably Hadrianic, and may be compared with the very similar mosaics of sea monsters and so forth from the baths of Buticosus built under Trajan.

There is apparently very little Hadrianic polychrome mosaic from Ostia, although the earliest vault mosaic from the Seven Sages baths may date from that time. The very rich and famous floor from the baths of the Imperial Palace, now in the Vatican, seems to be Antonine. The design is in the full tradition of the later Roman polychrome geometric pavements which are so widespread throughout the Empire; they are unquestionably based on carpet patterns, and the developing taste for them seems to go with the decline in the art of wall painting.

Sarcophagi

The first garland sarcophagi probably belonged, as we have seen, to the time of Trajan, and there are a few earlier examples of richly sculptured coffins; but the main series, especially those with figured reliefs, seems to begin under Hadrian, and it was almost certainly during his reign that workshops were established in other parts of the Roman Empire. The typical Italian sarcophagus, which was made to be placed in a niche or against the wall of a tomb, is decorated on three sides with sculpture. The lid is usually in the form of a low-pitched roof with a kind of parapet along the front that is also decorated with sculpture and generally has masks or heads as corner acroteria. This remained the standard form, although there were changes as time went on: the box and the lid became taller, and one or two completely new shapes were evolved, for example the *lenos*, that is, the round-ended sarcophagus in the form of a wine vat which is especially associated with Dionysiac subjects. The arrangement of sarcophagi in the tombs may be studied, for example, in the tomb of the Egyptians from the Vatican cemetery. Of ten Dionysiac sarcophagi found in the tomb of the Calpurnii Pisones (cf. p. 72), two are in the Museo Nazionale Romano and seven in Baltimore (Plate 122).

Only the best sarcophagi interest the historian of art, although even some of the humbler ones have had their influence on later artists. Standard types such as the 'strigil-lated' sarcophagus, with the *imago* of the dead person and sometimes with stock figures of Seasons, Muses, marine creatures, etc., are found very generally in the West, pro-duced, it seems, in the workshops of Rome and Ostia with only the portraits carved locally by agents of the firms. In Sicily, where some one hundred sarcophagi are known, all the most important schools producing expensive figured versions are represented, the Asiatic by one of Sidamara type in the cathedral of Catania, the Attic by a fine Hippolytus at Agrigento, and Italian craftsmen by a good Amazonomachy of Antonine date. Such works were costly, and very few reached the further western provinces or North Africa.

Local schools are of no great artistic importance, although the subject matter that they employed is sometimes interesting and unusual. Garland sarcophagi are widespread in

the East and sometimes imitated in the West. Some western local forms seem to be inspired by eastern columnar types.

The Velletri sarcophagus (Plate 121), found in 1955 about 6 km. from Velletri with nine skeletons inside – seven of grown-ups and two of children – is a box of Parian marble with moulded base and gabled lid with acroteria and swags. The body of the box is divided into two zones: in the lower one atlantes support a shelf, in the upper one caryatids do likewise. Clearly the form is inspired by theatre buildings, especially the stage itself, supported by atlas figures, but it is not really architectural. The sarcophagus has been dated *c.* 190 and connected with Commodus/Hercules; but Andreae prefers to place it before the 'Stilwandel' of the later Antonine period (G. Rodenwaldt, 'Über den Stilwandel in der antoninischen Kunst', in *Abhandlungen Preuss. Akad. Wiss.*, 1935), and for this and other reasons he would attribute it to Hadrianic or early Antonine times. The reliefs are a remarkable collection of figures and themes inspired by Roman funerary symbolism – Hippodameia, Protesilaos, Hercules and Alcestis, and the whole cycle of the Labours of Hercules. In the lower registers is the Rape of Proserpina. Hercules is the dominating theme of Roman funerary art (Seneca, *Dial.*, 2, 2. 2.: 'Ulixen et Herculen . . . stoici nostri sapientes pronuntiaverunt, invictos laboribus et contemptores voluptatis et victores omnium terrarum'). His descent to Hell may be shown. The other world is indicated generally in symbols at the back – Charon, Sisyphus, Tantalus, the Danaides. The heavenly divinities are to be found in the gables – Caelus, Sol, Luna. The whole setting is the stage of life – σκηνὴ ὁ βίος:—

σκηνὴ πᾶς ὁ βίος καὶ παίγνιον. ἢ μάθε παίζειν
τὴν σπουδὴν μεταθείς, ἢ φέρε τὰς ὀδύνας

(Palladas: *Anthologia Palatina*, x, 72) ('Life is a stage and a play. Either learn to play putting gravity aside, or bear life's pains'). The Velletri sarcophagus is the most thorough and revealing document of the allegories of life and death in Rome, with its mythological scenes that tell of those who passed into the grave and returned, of the triumph of life, of the punishment of the wicked, of the bliss of the hereafter. It is an early, experimental, and untypical work of the most elaborate kind. Significantly, in its two registers and in some of its symbolic ideas, this piece, produced in a western workshop, has a great deal in common with the architectural sarcophagi of the Christian fourth century.

The garland sarcophagus is, indeed, overshadowed from Hadrian's time onwards by sarcophagi with figured reliefs, the scenes of which are generally, as on the Velletri piece, taken from classical mythology, often showing successive episodes of the same myth. Such subjects as those from the story of Orestes on the early sarcophagus of Plate 123 were, as has been said, interpreted by their patrons in terms of life and death; the earthly trials of Orestes symbolize the struggle of life and his eventual triumph and conquest of death. But scenes are also chosen for their decorative qualities, and the sculptors soon became obsessed with the elaborate tapestry of figures at their disposal, and allowed their imagination and technical skill to run riot. One of the most interesting questions concerning the early figured sarcophagi is that of their connection with the earlier central

Italian tradition. In South Etruria, especially in the territory of Tarquinia, sculptured sarcophagi with similar scenes from mythology had been common in the third and second centuries B.C., and they bear some striking resemblances to the Roman examples. Like later Roman ones, the Tarquinian sarcophagi may have an architectural lid, but the commonest type is a box with reliefs and a portrait of the deceased, usually a well-fed personage, reclining and facing the spectator. There also seems to be a group of effigies – usually flat and two-dimensional – without boxes, perhaps just lids from coffins cut in stone. The handling of the reliefs varies; they may be in a recessed panel, or flanked by architecture, or simply stand on a ground line. The style is usually vigorously hellenistic – battle scenes, Arimaspi, heraldic Griffins with shields, wild animals. The reclining figures often have splendidly casual poses and sometimes very lovely heads, especially the men. There is a good deal of colour.

The enormous demand for these sculptured coffins gave rise to a number of provincial workshops. The two chief centres – Athens and western Asia Minor – were associated with good marble supplies. The Attic sarcophagi (Plate 124), always of Pentelic marble, have decoration on all four sides, although the back is generally less carefully worked. The lid is either a roof with tiles or a *kline* (couch) with rich cushions on which the dead recline. The roofed type generally has mythological scenes; the couch type may also have simpler decoration in the form of strigillation. The subsidiary ornament is generally very rich. In the figured compositions mythological subjects predominate, Amazon scenes being especially popular; the sources are held to be classical paintings of the fifth century B.C. and later. There are said to be some 470 surviving examples, and their distribution is wide. Comparatively few have been found in Asia Minor, where the local school controlled the market, but they are more common in other parts of the Empire, especially in the western provinces. Attic sarcophagi generally have a very elegant, naturalistic figure style, and they preserved the classical tradition in the later centuries of the Roman Empire.

The Asiatic series, which also seems to begin in the time of Hadrian, probably comes from one or two main centres of manufacture. One of the best known varieties, with columns and figures, certainly has late classical and hellenistic prototypes and is represented by a number of very fine examples such as the well-known sarcophagus found near Melfi in South Italy (Plate 125). The Asiatic series, like the Attic, has reliefs on all four sides, but the style contrasts strongly with that of the more classicizing Attic workshops. From an early period the technical peculiarities of carving include deep drilling of the ornament and other details, and sharp modelling which produces strong effects of black-and-white. These sarcophagi were also widely exported to the Empire, although they are rare in Greece.

In Asia Minor the tradition of the massive sarcophagus is a long, although not always a continuous, one. Magnificently carved marble chests, like the Alexander sarcophagus with its rich mouldings and gabled roof, inspire the later Attic and Asiatic types. The Asiatic coffins are generally much larger than either the Attic or the western; the famous Sidamara sarcophagus is vast, the figures about three-quarters life-size and representing a remarkable tour de force of the sculptor's art.

New light has been thrown on the international sarcophagus trade by the recent dis-
covery of a number of wrecks that went down with heavy cargoes of stone coffins.
These were generally hollowed out and some of the decoration blocked in before ship-
ment. On arrival at their destination the sculptors who accompanied the cargoes would
prepare the finished monument, sometimes following, sometimes adapting, the origin-
ally intended design. Other sarcophagi were shipped in a more finished state, with
perhaps only the portraits or the more vulnerable parts of the relief work to be finished
off at their destination by local craftsmen. Such arrangements naturally helped to pro-
duce an international style, and we can see, for example, that the large-scale classical
style of the Attic workshops strongly influenced the biggest and best sarcophagi of
famous men in the third century.

<div align="center">*</div>

In conclusion, the art of the time of Hadrian does seem to have a distinctive character,
so that the idea of a single Hadrianic school is not unreasonable. The main characteristic
is what we might perhaps call a revival of form. Hadrian's imperialism was intensely
individual, and it was expressed by his personal interest in art; he was a painter and
liked painters, and he also modelled in various media. It would be very valuable to know
more of his taste, and this might be possible if the rich haul of finds from his villa could
be studied as a unity. The character of the Roman copies and their range would in itself
be very significant. It is a fallacy to think that Greek sculpture had by this time subsided
into sterile copying, because the choice of works of art as appropriate to particular set-
tings was important and significant.

The figure of Antinous is in every sense classical, however much new techniques,
such as the drilled hair and the plastic rendering of the eye, may intrude upon the purity
of classical form. There is a strength and firmness in the modelling which is revived also
in other branches of Hadrianic sculpture, and went with a renewed taste for sculpture
in general. A whole new series of plastically conceived personifications of the pro-
vinces is reflected in the contemporary coinage. In relief sculpture the portrayal of
figures standing out three-dimensionally against a neutral background gives a new
flavour reminiscent of Athenian art of the fifth century. Typical examples are the
Spada reliefs with mythological scenes which have so much in common with Athenian
grave reliefs of the fifth century B.C.

The imperial idea of Hadrian is finely expressed by the province series. In front of the
columns of the Olympieion at Athens stood statues of 'Colonies', and these personifi-
cations or allegorical figures had long been popular. A Roman province could be repre-
sented by an inhabitant – for example a trousered Parthian – but more common in
Greek and Roman art was the creation of an ideal figure such as had long been used to
express an abstract idea. The silver dish from the Boscoreale treasure depicts Africa
with a rich and very overloaded collection of attributes. In the Porticus ad Nationes
there were representations of various peoples, and the personifications of cities had
appeared on the Puteoli base (cf. p. 64). A number of personifications of provinces
feature on coins under Trajan, but the first creation of a complete set seems to be

Hadrianic (Plate 126, A–G). We know them only from coins, but their sculptural counterparts are the series of ideal figures in high relief from some part of the Hadrianeum, the temple of the deified Hadrian erected by his successor in 145 (cf. p. 98), which seem to typify the achievement of Hadrianic art. Their relaxed poses and uncomplicated detail are very classical in spirit, although in a rather vapid, stiff-necked way, with disturbing features like the carved eyes, the drilling of the hair, the grooving round the outlines of the figures: a rather fossilized classicism, one might say, with the seeds of change within it.

It is true to say that down to the time of Hadrian the classical tradition dominated the official art of Rome, and anything approaching a deliberately anti-classical trend was confined to sculpture outside that main stream, for example the reliefs of the Haterii monument (Plates 76 and 77). The reign of Hadrian, as we have seen, produced a revival of Greek taste, so that the earliest sarcophagi with figured reliefs use Greek subject matter, whether classical or hellenistic, or classical form with complete confidence. Under the Antonine emperors however there emerge clear indications of an altered outlook. The phenomenon is easier to recognize than it is to explain, but unquestionably its causes lie in the changing attitude of the Romans towards the classical ideal. Religious influences, political attitudes, provincial techniques, and many other factors are now at work on the received tradition, and it would be very surprising if major changes did not come about.

THE ANTONINES (A.D. 138–92)

The Base of Antoninus Pius' Column

THE changing attitudes of the Antonine period can best be seen in the considerably restored reliefs, rediscovered at the beginning of the eighteenth century, from the base of a vanished column in honour of Antoninus Pius, put up after his death in 161 by his sons Marcus Aurelius and Lucius Verus near the Ustrinum in the Campus Martius. It consisted of a marble pedestal and base, with a red granite shaft and a capital that carried a bronze statue of the deified emperor. Coins with the legend DIVO PIO depict it (Plate 126H). One of the scenes on the base, by then traditional, shows the apotheosis of Antoninus and Faustina (Plate 127); it is carved in a manner which is also traditional, packed with classical symbolism and in a full-bodied classical style. The emperor and his wife are ascending to heaven on the back of a winged Genius, while Roma in her now conventional guise and other allegorical figures wave them farewell. A Greek sculptor of an earlier period might find some of the detail rather harsh and the movement stiff and awkward, but the idiom is one which he would readily accept. What might strike him as the oddest feature is the extreme pomposity of the scene; and it is here perhaps that one can discern the most obvious seeds of decline in the classical tradition. The apotheosis relief seems to symbolize the confidence, perhaps the over-confidence, of the so-called golden age of the Roman Empire, which was not indeed to last very much longer. It is in striking contrast to the scenes carved on the other two sides of the base (Plate 128), which are very similar versions of the same event, known as a *decursio*, that is, a military parade held on the occasion of State funerals. The manner of representation is at first sight very strange. Seventeen horsemen ride anti-clockwise around a body of ten legionaries, who are shown in two groups of five standing two rows deep on a separate ground line and seen in horizontal perspective. The cavalry are shown in vertical perspective, with the horsemen that should be behind the foot-soldiers raised above them. Each of the horses has its hind legs grounded on its own patch of earth. The poses are repetitive, and the more distant horses are not shown in lower relief, although they appear to be slightly smaller in scale. It is an odd, although extremely effective, way of conveying what is going on. What chiefly surprises, however, is the dumpy and very unclassical proportions of the figures; one is inevitably reminded of those in a number of sculptures made during the first two centuries A.D., generally for private and unofficial purposes, of which perhaps the outstanding examples are the reliefs of the Haterii monument (Plates 76 and 77), although there are a number of other works in the same manner including a well-known circus relief now in the Vatican Museum.

It is quite clear then that the *decursio* scenes represent a very different tradition from

that of the apotheosis in the main scene, and it is at first sight surprising to find it in an official context at the end of a reign which seems to be characterized by a traditional, even academic, classicism. But, in fact, the same elements of change can be seen even in works of the period which seem most classical in conception.

The temple of Antoninus and Faustina in the Forum Romanum remains a severely orthodox structure, elegant in its proportions but uninspired. The entablature is rather plain, with a frieze of Griffins flanking candelabra (Plate 129), a traditional theme handled in a traditional, unimaginative way. The reign was not one of great military triumphs, and comparatively little sculpture survives, either in relief or in the round. There is however a fragmentary frieze in the Ludovisi Collection (Terme) which probably celebrated the *vicennalia* of the emperor in 158. The style is closely related to Hadrianic monuments, with the figures standing out in high relief. This type of processional frieze, with its own formal language, can now be employed to represent not only specific events but also symbolic acts such as the renewal of the *virtus* of the emperor, which was so vital to the well-being of the State. Antoninus himself did not participate in the campaigns of his reign.

Sarcophagi

The sarcophagi of this period tend to employ basically the same proportions and compositional principles as those of Hadrian's reign, but some technical and other details again suggest that the hitherto unchallenged classical tradition in Roman art is ending. Typical is the Alcestis sarcophagus in the Vatican (Plate 130), which probably dates from the end of Antoninus Pius' time. Subjects and actors are still closely based on classical models, but some of the proportions of the figures, especially the large heads, are strange, and there is awkwardness in the poses. It is typical of Antonine art that the principal actors in the scene, Admetus and Alcestis, should represent the dead man, Euhodus, and his wife Metilia Acte, for this was a period when funerary portraiture in the classical manner was especially popular. The well-known group of husband and wife as Mars and Venus illustrates the prevailing self-conscious and rather mannered classicism. At the same time, specific reference to the life of the dead man was introduced on the front. The composition of the sarcophagus from Via Collatina in the Museo delle Terme, which dates from this period, is taken from traditional representations of the sack of Troy, but here the prisoners are barbarians parading before the Roman victor, the scene flanked by captives and trophies. The combination of Greek and Roman subject matter inevitably results in changes in composition and style. On the Alcestis sarcophagus the episodes are given a strong central accent, and the arrangement of the figures is influenced by that of contemporary State reliefs. Some of the finest Antonine sarcophagi are still carved in pure Greek style, like that in the Vatican with the magnificent, Pergamene-inspired Gigantomachy (Plate 131).

Portraiture

The portraiture of Antoninus Pius has a confident, unchanging quality which seems to typify the untroubled confidence of his reign. The emperor, balanced and straightforward in life, found a simple formula and never changed it while he passed in age from 51 to 74. It was based on the manner and technique first applied to portraits of his predecessor. Since Hadrian, new sculptural qualities had developed which seem to make the use of paint less important and to give more scope to the carver's technique. The details of the eye are typical, with the deep lachrymal cavity and the grooved iris surrounding a circular indentation marking the pupil; part of the iris is always bounded by the upper lid. The contrast between the deeply modelled hair and the texture of the face is already quite marked in Hadrianic portraiture, but in Antonine heads the increasing use of the drill and the taste for a smoother surface finish accentuate this contrast. The dominance of hair, certainly under the influence of classical physiognomical theorizing, makes the age of the Antonines the 'age of the hairy emperors'.

Changes in technique are one very important aspect of stylistic change. The influence of provincial craftsmen was increasing. The sculptors who carved the Proconnesian marble entablatures of the temple of Venus and Rome at the end of Hadrian's reign must have come from Asia Minor, and their influence can be seen in a number of later buildings. The delicacy of classical modelling is giving place to strong effects of black-and-white in which organic forms tend to be broken down into patterns; a good example of this is a richly decorated pilaster with vine ornament in the Lateran Collection (now in the Vatican). The artistic atmosphere in the late Antonine period was very cosmopolitan, for it was a period when, as we shall see, big enterprises were being undertaken in many parts of the Empire and artists moved freely from centre to centre. The scale of work was unsurpassed.

Aurelian Relief Panels

The crisis of the Empire during Marcus' reign involved the emperor directly in the organization of military affairs. The theme of victory again becomes dominant in official art, and conquests are commemorated in all the chief centres of the Empire. In Rome, it seems, a number of triumphal arches were put up to celebrate the achievements of the emperor, and although none of them survives, sculpture perhaps from two (or more) of them has been preserved: the eight rectangular panels re-used on the attic of the arch of Constantine (Plates 134 and 135), and the three in the Palazzo dei Conservatori (Plates 132 and 133). Although the eleven reliefs are all of the same period and closely related, it has generally been thought that they do not come from a single monument. The problem then is to establish the date and design of the two arches. The most recent view is that the Conservatori panels come from the Capitol hill, where it is known that an arch was erected in A.D. 176, the inscription of which was copied by the Anonymous Einsiedeln in the eleventh century. If it was standing then, it cannot have been the source of the panels re-used on the arch of Constantine, and indeed the separation of the two groups is supported by stylistic evidence: the Conservatori reliefs seem

to be more classical in style, while those of the Constantinian arch have elements in common with the column of Marcus Aurelius. The conclusion would be that the Conservatori group belongs to the arch of A.D. 176 and the second group to an arch erected to celebrate the German and Sarmatian wars of 168–76, probably after Marcus' death. The connection of the Capitoline group with the triumph of 176 seems fairly clear, since the figure of Commodus has been erased from the triumph scene.

The Aurelian reliefs belong to a type which first came into fashion in the time of Hadrian. Comparatively few figures are used in the various episodes, which are framed by a heavy moulding, and there is a stiff and monumental quality which contrasts with the freedom and naturalness of earlier historical reliefs. The artists give much more attention to formal composition. The foreground figures are in such high relief that, as the eye travels across the scene, they actually seem to move in relation to the figures behind them and to the background. The arrangement of the setting is perhaps the most effective in the history of Roman relief sculpture, and much thought was given to the angle of viewpoint, as well as to the perspective of the buildings and other incidental features. Some of the compositions are very classical, but in the Constantinian arch series there are features alien to that tradition: many of the figures seem to have completely lost three-dimensionality, and the technical details, especially the use of the drill in outlining the contours of the forms, are derived from the methods of eastern and other provincial craftsmen. In many respects the purpose of these panels is different from that of earlier commemorative reliefs. They belong to what may be called the 'grand' Roman tradition, but, by simplifying the compositions and eliminating many of the incidentals, they concentrate on expressing the qualities, rather than the particular achievements, of the emperor; they are, as it were, a monument to his *virtus* and *pietas*.

Outside Rome the decoration of triumphal buildings concentrated on the theme of victory. On the four-way arch at Tripoli, for example, which is dated to the year A.D. 163 (Plates 136 and 137), the main theme is the celebration of Roman triumph by means of sculptured trophies and captives which are associated with the local divinities of the city of Oea (cf. pp. 19, 120). From Carthage come some magnificent fragments of the period showing Victories carrying trophies, and from Memphis in Egypt a single barbarian captive from another triumphal complex. In Marcus' reign, for the first time, the theme of victory appears also in private funerary sculpture, together with the celebration of specifically Roman virtues (Plate 138) (see below).

Sarcophagi

Antonine sarcophagi are generally rather taller in proportion than those of earlier periods, giving the sculptor the opportunity to create more complicated tapestries of figures in an infinite variety of poses. In this respect few can surpass the magnificent sarcophagus from the Via Tiburtina (Plate 139) now in the Museo delle Terme which clearly commemorates the successes against the barbarians of one of Marcus' generals. The lid and the two ends are also decorated with scenes of military campaigns. The twenty-five or so surviving battle sarcophagi, including a few from the Athenian work-

shops, all seem to have been made within the period *c.* 170–200, with the notable exception of the Ludovisi sarcophagus of the mid third century (Plate 140) (cf. p. 141). Although there are no two well preserved examples from the same workshop, similar figures and groups appear on most pieces – the barbarian falling from his horse, the mounted figure thrusting back at his enemy, the suicide of the barbarian chief (cf. the Decebalus of Trajan's column, Plate 87) – and they obviously come from a common source. The simplest and earliest designs are based on groups involving three or four figures, but in some of the later ones, including the remarkable example from the Via Tiburtina, a great massing of figures obscures the overall composition.

The inspiration comes from the Pergamenes' commemoration in the third and second centuries B.C. of their victories over the Gauls. The influence of this dramatic style runs right through the history of Roman sculpture; it is responsible alike for the complex figure groups and elaborate foreshortenings of the panels on the monument of the Julii at Saint-Rémy (Plate 62), the warriors on the Mantua relief (Plate 40), and the battle scenes on Trajanic monuments. It has been suggested that the individual figures and groups of the sarcophagi were taken, not from sculpture, but from paintings of Pergamene battles. Such a derivation would help to explain the very obvious influence of painting on so much Roman relief in its attempts to create an impression of depth and three-dimensionality. On the Roman sarcophagi, the scenes are 'updated' by the inclusion of Victories and trophies and by the Roman dress of the victors, but in modelling as well as in composition and feeling hellenistic art still dominates.

A number of sarcophagi of the mid to late second century depict a series of episodes in a man's life which express the particularly Roman virtues of *clementia*, *pietas*, and *concordia* (Plate 138). A general may be shown receiving the submission of barbarians, conducting a public sacrifice, or joining hands with his wife at the marriage ceremony. The scenes derive from the stock repertory of the Roman historical relief, and are still in a full-blooded classical style, with elegant static poses and controlled gestures. The deceased are private individuals who acquire the aura of immortality through imitation of the official iconographical language. The front of one sarcophagus in the Vatican is entirely devoted to the theme of *clementia*, as the Roman general crowned by Victory receives the submission of barbarians. The two ends of the scene are closed by splendid figures in fine hellenistic style of barbarians tied to trophies.

The Column of Marcus Aurelius

The great commemorative monument of this reign was the column of Marcus Aurelius (Plates 141–8) erected in the Campus Martius. Excluding its base and plinth, it stood 29.6 metres or 100 Roman feet high. Of the same general form as Trajan's column (Plate 79), it is much less well preserved; the original base is missing, although its design is known from old drawings, and there was a good deal of restoration at the end of the sixteenth century. The wars depicted are the German and Sarmatian campaigns; those against the Germans and others in 172–3 appear in scenes I–LV, while the campaigns of 174–5 are shown in LVI–CXVI. The narrative concludes with the events of 175, when the

rebellion of Avidius Cassius made it necessary for Marcus to resign the command to Commodus, who does not appear on the column at all. The monument was apparently begun at the end of Marcus' reign and finished after his death.

Nothing illustrates better the changing character of Roman art than the contrast between the column of Trajan and that of Marcus Aurelius, although the differences are often extremely subtle and difficult to assess. One fact is clear enough, however: the sculpture of the column of Marcus is much more effective as sculpture. The low relief of Trajan's column, although carved with extreme skill and clarity, does not stand out as do the more modelled forms and deeper shadows which one finds on the column of Marcus. Here they can be seen quite clearly right up to the top of the shaft, and if they lack the precision of detail, the repetitive character of many of the poses compensates for this. Whereas the reliefs of Trajan's column seem to demand the use of paint and other added details, those of Marcus' rely much more on the technique of the sculptor. It is possible, therefore, to think of some of the changes simply as improvements on the Trajanic method; the adoption of a more episodic treatment, and the use of fewer figures and higher relief, might fall into this category, although the result is a loss in the variety of the action, and a general lack of interest in the landscape setting and in the precise detail of military activities and historical events.

But there are also changes which imply a totally different attitude towards the purpose of artistic representation, and significant alterations too in style and technique. The increasing tendency in the set pieces for the emperor to be posed frontally above the soldiers (Plate 141) poses many problems. We have already seen that it is a common fea-ture of eastern religious art in the Roman period, and it seems as though it may express the growing veneration for the person and office of the emperor, and especially the concept of his divinity. We also find in the reliefs a quite new attitude towards the subject of war and human suffering in general. Instead of the factual reporting of Trajan's column, the reliefs of the column of Marcus seem often to evince more interest in the effect of an event on individuals than in the event itself. Moreover, while it is some-times not easy to understand exactly what is happening in the scene, as for example when barbarian prisoners are being thrust into a deep ravine, there is always a close attention to the detail of the faces even at the expense of the rest of the figures. The resulting decline in the representation of form seems almost inevitable, as indeed do the anomalies of scale and proportion, which do not seem to worry the sculptors at all. Technically, the most obvious characteristic is that which has already been seen to exert increasing influence on metropolitan Roman art in the second century: the use of the drill to achieve effects of chiaroscuro and to outline sharply the contours of the various forms.

Portraiture

The public image of the philosopher-emperor is skilfully handled by the sculptors of the day (Plates 149 and 151). Some of the portraits of Marcus, and indeed of his succes-sors, are occasionally difficult to distinguish from traditional heads of famous Greek philosophers. The technical changes are now more obvious, and there is generally a

very sharp contrast between the smooth finish of the flesh parts and the deeply drilled black-and-white of the hair. Marcus' portraiture is on the whole fairly consistent throughout his reign; the smooth skin and rich hair as signs of health, strength, and majesty are the result of the now established Greek theories of physiognomy, and Marcus' successors seem to have given a great deal of thought to such matters. Lucius Verus took such pride in his hair that he used to powder it with gold-dust, and he allowed his beard to grow very long 'almost in the style of the barbarians', in the words of his biographer. Commodus is said to have dyed and powdered his hair and to have had his beard singed because he was afraid of barbers. He changed his beard a great deal during his lifetime, as his portraits show. The conventions and technical tricks of Antonine portraiture are often so marked that very little of the personality of the emperor emerges, and some of the most masterly works from a technical point of view, such as the bust of Commodus as Hercules (Plate 150), are often the most pretentious. In general the private citizens of the age follow imperial fashions, and for the first time the portraits of women are often the more interesting: several ladies of the imperial House emerge much more clearly as individuals than do their male counterparts.

The survival of the bronze equestrian statue of Marcus Aurelius, which now stands in the Piazza del Campidoglio (Plate 151), reminds us how much of imperial portraiture has been lost, for in ancient Rome such figures were commonplace, both in public places and in association with imperial monuments. Portraits of emperors in almost all the available media were also to be seen. In the case of Marcus we have another very rare survival in the gold likeness found some years ago in Switzerland (Plate 149), a relic of those in gold and ivory and other costly substances once visible in many parts of the city, especially in the second and third centuries, when the divine status of the emperor was commonly accepted.

The equestrian figure was a popular form of monument in archaic Athens (from which several examples have survived), rare in the classical period, but employed widely again in hellenistic times for statues of Alexander and the Diadochi. Among the later hellenistic kings the normal form was a fairly high base or pillar with the rider either standing still or in full gallop. According to Pliny, the Romans derived such statues from the Greeks, whose coins show mounted kings as early as the fourth century B.C., and there were many in the second century. The earliest surviving Roman examples seem to be the fragmentary ones from Vigna Sforza at Lanuvium, perhaps dating from c. 50 B.C. (P.B.S.R., VII, 1914). There were many under the emperors, including the famous gilt-bronze *equus Traiani* of Trajan's forum showing the emperor in uniform; he appears fighting on horseback on coins and in other contexts. But the finest existing equestrian statue is certainly that of Marcus Aurelius, which Wegner thinks was put up in 164, when the emperor took the title Armeniacus. Before this there had been a continuous tradition of such honorific statues of magistrates in public contexts, including one in bronze by the arch near the forum at Pompeii, possibly of imperial date, and those of the Balbi at the entrance to the basilica at Herculaneum which honoured a benefactor of the town in the time of Nero. A wall painting in Naples shows three statues of horsemen between the columns of a *porticus*.

Art in the Provinces

The age of the Antonines is generally known as the golden age of the Roman Empire; it was a period of self-confidence in the institutions and way of life under Roman rule. The backbone of government was the middle class of the provincial cities, whose prosperity was as yet unaffected by the problems of maintaining the Empire against increasing barbarian pressure. In the time of the Antonines, big building enterprises involving expensive artistic programmes were the rule throughout the Empire. One sees this best in the cities of Greece and Asia Minor and in the activities of such men as Herodes Atticus, the great benefactor of Greek cities in the time of Marcus Aurelius.

Herodes Atticus put up monuments in almost all the principal cities of Greece. At Athens he built an *odeum* which still survives and a number of other important buildings. At Olympia he created a *nymphaeum* which had statues of various members of the imperial House from Trajan to Lucius Verus; and this type of monument – a combination of elaborate architecture and sculptural décor – is in many ways typical of the period. Another fine example of a similar scheme is the establishment of a courtyard at Perge in southern Asia Minor by the Plancii family, who were great benefactors of the city. It incorporated a sort of portrait gallery on the lines of the forum of Augustus, but in this case going back to Mopsus and Chalcas, the legendary founders of Perge, and continuing down to the time of the Plancii. The statuary is arranged, as so often in this period, in a kind of applied architecture creating a decorative façade. At Perge the greatest benefactor of all was Plancia Magna, who also dedicated statues of members of the imperial House.

In most of the wealthier cities of the Empire during this period traditional Roman buildings were either erected on a lavish scale or rebuilt in a more ornate manner with the use of costly materials. Most of the grand theatre façades of the eastern provinces were built at this time, as were many of the more elaborate *nymphaea* and numerous splendid bath buildings. One of the most interesting complexes, constructed in the reign of Marcus Aurelius, is the baths of Faustina at Miletus. At the end of a long hall is an apsed room which is very similar to a pair of rooms in the baths at Ephesus, where the basilica and the apsed room, used as a lecture room, appear to be described in an inscription as a *mouseion*. Traditionally the baths in eastern cities were associated with the gymnasium, which was the centre of the cities' educational systems, and the *mouseion* seems to have been a meeting place for scholars. Buildings of this kind from the time of the late Republic onwards had to be decorated with suitable sculpture, and here we find a series of Apollo and the Muses together with other figures appropriate to the setting. The statues are, as always, skilfully copied from famous classical and hellenistic works, although in most cases contemporary carving techniques are apparent, and rather less attention is paid to the modelling of the drapery than in earlier work.

In the 'baroque' architecture of the eastern Roman world the role of sculpture is vital. The established rhythms of architecture and sculpture had long been developed – figures in niches, on pedestals, and so forth – and in the façades of eastern buildings fulfilled a clear and consistent role. The Vedius gymnasium at Ephesus is typical both of the

lavish expenditure of the 'golden age' and of eastern architecture. The propylon was decorated with statuary, and the existing ornate 'Kaisersaal' (connected in some way with the imperial cult) had as its main feature an elaborate façade with reliefs and statues, including that of the benefactor Vedius himself. All the rooms of his bath were adorned with coloured marble and statuary. Another public building erected at Ephesus by a private benefactor was the library of Celsus with its typical two-storey columned elevation adorned with statuary groups and with figures symbolizing Celsus' virtues.

The Asiatic style of carved ornament was fully developed in the early second century A.D. and shows up well in the famous barley-sugar columns of St Peter's (Plate 152); similar columns in a fragmentary state have been found in Asia Minor, for example at Ephesus. The technique of the deeply carved foliage with undercutting to produce dark shadows, in contrast to a high surface finish on the figures and other details, is very different from contemporary work in the West, which seems to follow the earlier tradition of restrained classical modelling. But the work of the eastern carvers became increasingly popular in the West and generally dominated late Roman ornament. In Asia Minor the Pergamene style continued to be a strong influence on decorative sculpture: a series of half-scale warriors, falling, dying, dead, from the fountain of Pollio at Ephesus (A.D. 93) is taken from Pergamene originals, and in the second century the 'Great Antonine Altar' of Ephesus (cf. p. 97) is unquestionably inspired by its earlier counterpart at Pergamon.

There is not much to be said about the pictorial art of this period. Our evidence for the development of decorative painting is still very slight, and indeed there must have been little of the highest class associated with public monuments, but it seems clear that basically the same compositional design continued. Interior decoration is very largely concerned with the application of sculpture to polychrome marble and with glass vault mosaic. This is the heyday of the black-and-white technique for floors, but it seems that coloured designs based on richly decorated carpet patterns were becoming increasingly popular, so that in the third century they dominate the output of the mosaicists.

With the enormous increase in building and artistic schemes in the cities went a revival of local schools of sculpture throughout the Empire; Aphrodisias for one continued to flourish and extend its influence. In the Antonine period the techniques of Asiatic carvers can be seen on the North African coast as well as in the western provinces. This era also seems to have been, as we have seen, the finest and most successful for the manufacture of marble sarcophagi, both Attic and Asiatic; they were popular, especially those with garlands, all over the Mediterranean. In the realm of portraiture there was a revival everywhere, and statues of prominent citizens were set up in great numbers. In the western provinces some fine Antonine examples have been found in areas where little high-quality work existed previously – for example at the Roman villa at Lullingstone in Kent, or in the southern Pyrenees where a series was discovered that ranged in date from Hadrian to Caracalla.

To the same period may be attributed some of the best local work in the western provinces, including some of the finest Gallo-Roman sculpture. It is difficult to trace the rise of the Gallo-Roman style, which seems to have reached its highest point in the

second century. There are many superb carvings from sanctuaries of this period, among them the cult statue of a mother goddess from Naix, now in the museum at Bar-le-Duc, with its splendid, almost oriental drapery patterning, and the fine relief in the museum at Reims of the god Cernunnos seated in eastern majesty, bearded and with goat's horns, between two Graeco-Roman gods who act, as it were, as his attendants. Then there is the fine triple-headed god from Condat near Bordeaux, where the influence of Antonine sculpture seems quite clear in the luxuriant beards and hair and in the details of the faces and the drapery. The heads have a strikingly medieval look, stressing the continuity between the classical and medieval traditions in Roman Gaul. To move elsewhere in the Roman Empire, many of the best examples of Palmyrene sculpture were carved at this time, often showing strong Roman influence on the characteristic oriental stylizations of form and detail, and in Egypt the finest achievements of funerary painting also seem to belong to the age of the Antonines.

THE SEVERANS (A.D. 193–235)

THE Antonine age ended in wars and confusion, and that of the Severans really marks the beginning of the later Roman Empire. Despite all the attempts of Roman emperors from Severus onwards to found their dynasties on the traditions – including the artistic traditions – of the past, there seems to be a decisive break with classicism, and the best achievements look forward to the late antique and the Byzantine. This is the period when the earliest catacomb paintings were made and when the earliest Christian monuments of high quality appeared in the provinces. Christianity and the decline of paganism therefore become two of the predominant themes in the history of Roman art during the third century.

Relief Sculpture in Rome and North Africa

In A.D. 203 a triumphal arch was erected in the north-east corner of the Forum Romanum, perhaps to counterbalance the Parthian arch of Augustus which stood on the opposite side of the square. As a vehicle for imperial propaganda the arch of Septimius Severus was the biggest 'billboard' yet erected. A massive dedicatory inscription long-windedly proclaims its purpose, which is mainly to celebrate the Parthian victories and to establish the legitimacy of the new dynasty. It is a handsome arch with three passage-ways, probably incorporating features of design from lost Antonine examples, and providing us with the earliest surviving free-standing columns, although such columns had undoubtedly been used earlier. What does seem to be new is the form of the sculptural decoration (which is otherwise comparatively orthodox), especially the full, massive, historical panels, one above each of the side arches. Three different kinds of marble appear to have been used: Proconnesian from the island of Marmara, Pentelic from Attica, and Luna for the relief panels. Septimius Severus achieved power in A.D. 193; the arch was apparently voted to him as early as 195, but it was certainly not completed until 203.

The monument is lavishly decorated with Victories, with divinities connected with the Severan House, and with captives and other figures to produce a carefully con-trived propagandist scheme. The small frieze showing a triumphal procession was by now traditional on Roman arches. The chief interest, however, centres on the four big panel pictures (Plates 153 and 154), each apparently representing a major episode in Severus' eastern campaigns of 195 to 199. The historian Dio Cassius distinguishes two Parthian wars. The first was the campaign of 195 against the Osrhoeni, the Adiabeni, and the Arabians, when Septimius forced King Abgar to submit at Edessa and advanced to Nisibis, which thereupon became a Roman colony; as a result, Severus took the titles of Parthicus Arabicus and Parthicus Adiabenicus. The second campaign is divided into

two parts, the first against the Parthians in 197–8 and the second against Hatra in 198–9. In 197 Severus marched to Nisibis and lifted the Parthian siege and then, in the winter of 197–8, captured Seleucia, Babylon, and Ctesiphon and finally created the province of Mesopotamia with its capital at Nisibis. Although the history is fragmentary, it seems that each of the four panels has as its central theme an episode of the second war: the relief of Nisibis; the taking of Seleucia (Plate 153); the taking of Babylon; the taking of Ctesiphon. (But one of these pictures (Plate 154) looks remarkably like a rendering of two episodes in the unsuccessful siege of Hatra: G. Picard, in *Hommages à Marcel Renard*, III, 1969, 490–1 [J.M.C.T.].)

The character of these reliefs is very different from that of any earlier triumphal sculpture. There is no use of allegory or of the typical simplified compositions of submission and triumph. Each panel is 3.92 metres high by 4.72 metres wide, and the figures vary from 60 to 80 centimetres in height. This seems to be the first arch to be decorated with historical narrative, strongly influenced by the commemorative columns; earlier examples had been concerned with military triumph or with political propaganda. The essential difference from the column lies in the panel form, which makes some kind of unified composition both necessary and desirable. Each slab has a single landscape as the site of the episode, while the action is divided into zones by continuous ground lines. The historical progression follows that of the columns, i.e. it starts at the bottom left and concludes at the top right. The panel which seems to show the taking of Nisibis has three distinct registers, but preserves a kind of decorative unity through the flexibility of the ground lines. The Seleucia panel is rather more formal, while the others have only two registers and the scene is centred on a bird's eye view of the town.

The origin of this method of representation has been much discussed, and it is sometimes argued that the general form derives from campaign pictures of a kind which we know from Herodian to have been made for Severus. A supposed tradition of cartographic battle pictures has already been mentioned (p. 6), and some scholars have found close resemblance between the arrangement of the scenes and the design of Old Testament pictures in the synagogue at Dura Europos. Unfortunately, too little Roman painting has survived to confirm this hypothesis, but it is worth drawing attention to the well-known series of marble reliefs, the *tabulae Iliacae*, which depict events in the Trojan War grouped around a representation of the city seen from a high viewpoint. There are also reflections of this kind of composition in such later Roman mosaics as the famous hunt from Carthage, which has divisions of the individual scenes within an overall landscape composition. Although its origins are obscure, what can be said with certainty is that the design of a Severan panel combines a register composition with an attempt to produce a narrative flow and a temporal sequence like that used on the commemorative columns.

Consideration of the figure style and techniques of the panels has led some scholars to distinguish two masters, one attached to the style of the Antonine column, the other far less interested in form and modelling but delighting in the effects of drillwork, and prone to reduce a group of figures to a mass of scarcely differentiated heads. In the light of later developments in Roman art, the second master must be looked upon as the

more influential, for he seems to announce the new vision of late Roman representational art. His work highlights one of the problems already touched upon, for it appears to give weighty confirmation to the supporters of 'popular art' as the chief factor in the decline of the classical tradition. Some of the ugly disproportionate figures massed in little impersonal groups immediately remind one of provincial Italian sculptured reliefs and of others, generally of a funerary nature, from Rome which do not belong to the official stream – one of the best examples being the circus relief in the Vatican (no. 9556) (cf. pp. 65, 80).

Siting and design of the Severan arch are both characteristic of the artistic programme of the new dynasty. The design seems to be traditional, incorporating known elements from the arch of Trajan at Benevento and others perhaps from lost Antonine arches. The orthodoxy is in marked contrast with the elaborations and surprises of the contemporary Lepcis arch (see pp. 121–2), and the site was probably chosen with deliberation to stress the patriotism of the new rulers; for the Severan arch stands not on the Sacra Via but beside it, raised several feet above the Comitium and approached by steps, and diagonally opposite the Parthian arch of Augustus, balancing the arch of Tiberius. It may be thought of as completing the architectural scheme of the area.

Elsewhere in the city the Severans carried out very grandiose public schemes of restoration and new building, making rather ostentatious use of inscriptions; they vastly enlarged the private apartments of the Palatine; and Caracalla erected the most splendid baths yet.

One modest little monument to survive from this period is the arch or gate put up by the guild of silversmiths in honour of the imperial family in A.D. 204. The architectural ornament is very rich, in imitation of the Flavian type, although carved with far less precision and attention to detail; it is in a style popular in Severan Rome and found in the baths of Caracalla. The arch of Septimius in the Forum Romanum is much plainer, in dignified imitation of Trajanic and Hadrianic monuments. Although the arch of the Argentarii is not a work of any great pretension, some new light is thrown on contemporary artistic trends by its sculptural decoration, especially the panels of the passageway, one of which shows the emperor sacrificing, accompanied by Julia Domna; the figure of Geta was removed after his *damnatio memoriae*. There is an awkwardness about the composition (Plate 155) because the figures in the scene are turned towards the spectator, as though posing for a picture; this diminishes the action, although not the impact of the figures themselves. The pose is relevant to the changing position of the emperor in the Roman State: the divine ruler is himself an object of worship, and frontality, long accepted in religious contexts, as for example in eastern work (see p. 93), becomes an essential means of expression.

The chief interest of another Severan relief (Plate 156), now in Palazzo Sacchetti in Rome, is in the handling of the setting. Caracalla is being presented to the Senate, with the imperial group on the right of the scene and the senators approaching from the left; and the picture is, as it were, enclosed in a frame with an ornate entablature above pilasters in the background. Such use of architecture to provide an imposing setting and to give unity to the subject became increasingly popular in propaganda relief in the

late Empire: it is for example a feature of the reliefs of the arch of Constantine and of later monuments such as the base of the Theodosian obelisk in Istanbul (Plates 254 and 255), and it follows a long development in the use of landscape elements in historical reliefs. In the late republican and early imperial examples landscape appears to give continuity to the episodes, as it does in such hellenistic narrative reliefs as the Telephus frieze from Pergamon. It is then used in the first century A.D. to give explicit reference to an action, and any scene of complexity needs it, even though, as in Julio-Claudian historical reliefs, the buildings are not truly integrated with the figures. There is a subtle use of setting on Trajan's column, but it is not until we come to Hadrianic and Antonine reliefs that we find a highly confident use of background, so that the high-relief figures seem to move in front of the buildings which form the context of the scene. The next development, the Severan, where the setting encloses and defines the groups of figures or is arranged to give added effect to the composition, is part of the general move towards the more static and formal arrangement of figures so characteristic of later Roman sculpture and painting.

Severus was born at Lepcis Magna in Tripolitania, and during his reign the city was restored, enlarged, and embellished with a series of monuments of a character and scale appropriate to the birthplace of an emperor, including a magnificent new temple-forum-basilica complex. Much the same had been done by other emperors, for example by Hadrian at Italica, but never on such a scale. In the Antonine period at Lepcis, as in other towns of North Africa, there had been a great deal of rebuilding and adornment; the Hadrianic baths had been lavishly restored, the theatre rebuilt, and a number of temples given new façades. The atmosphere for artists was already very cosmopolitan, and the influence of east Greek sculptors can be seen, for example, in the reliefs and decoration of the Antonine arch at Tripoli (Oea) (cf. pp. 19, 110). But the demands of the new Severan programme and the decision to use Proconnesian and other eastern marbles meant that foreign artists were required on a scale that neither North Africa nor the official workshops of Rome could provide. The majority seem, in fact, to have come from centres in western Asia Minor, although there were obviously some from mainland Greece and perhaps from Italy.

The forum complex at Lepcis consists of an open area with arcaded colonnades. On one side, raised on a vast podium, is the temple of the imperial House, and on the other the basilica, a richly decorated hall divided into nave and aisles by columns of two orders. The rich sculptural decoration throughout gains its effects, in general, by deep carving with considerable use of the drill, which produces strong effects of black-and-white: the Medusa heads between the arcades of the forum are an object lesson in the effectiveness of the technique (Plate 157). Power and genuine monstrosity are achieved by the contrast of smooth surface modelling and deep drilling; it is very much a sculptor's technique, which does not require painted detail to strengthen it. The columns of the temple stand on rectangular plinths which were decorated with sculpture, a feature which seems to have been more general in the Greek East during Roman times than in the West. The carving illustrates the hurried nature of the Severan programme, for the bases were probably never finished, the mouldings being sometimes only marked out

or incomplete. The style of the reliefs, which depict battles between gods and giants, seems to derive from the hellenistic Pergamene tradition, but the best work, which is in Pentelic marble, may well be by Attic sculptors, since the technique seems to have much in common with that of the Attic sarcophagi of the period.

The interior of the basilica was spectacularly rich in sculptured detail. The apse at the north end was flanked by pairs of engaged pilasters carved on three sides with scrolls issuing from chalices; vine and acanthus leaves cover the scrolls, which interlock to form a series of roundels inhabited by animal and human figures (Plate 158). The motif of the fore-parts of an animal issuing from an acanthus whorl had long been part of the repertory of Roman decorative art, deriving from hellenistic sources; here, scenes from the Labours of Hercules and figures from the entourage of Bacchus on the pilasters of the south apse similarly emerge from whorls of foliage. It has been argued – although on no direct evidence – that the pilasters are Aphrodisian work; and indeed it does seem likely that the sculptors came from Asia Minor. The technique is rather different from what had gone before at Lepcis and may be contrasted with that of the acanthus ornament of the Antonine west gate, with its characteristically Flavian surface treatment of the heavy scrollwork. In the pilasters of the basilica the detail of the foliage is less organic, the influence of the drill and deep undercutting are very obvious, and the contrast of light marble and dark shadows gives a flatter, two-dimensional effect. The framing mouldings, too, are deeply drilled patterns rather than organic forms. This style of carving became increasingly popular in the Roman Empire in the third century, and there seems little doubt that its spread was due, as here at Lepcis, to the work of Asiatic craftsmen.

At the crossing of the *decumanus* and one of the other main streets of Lepcis, a commemorative four-way arch (Plates 159–63) was erected in honour of the emperor's victories; it is generally thought to have been dedicated in A.D. 203–4, or perhaps a little earlier, on the occasion of a visit by Septimius to his home town. The design makes a striking contrast with the orthodoxy of the arch in the Forum Romanum. Startlingly 'baroque' elements are the angled quarter-pediments on either side of the passageways, and the arrangement of the sculpture is also very different from that of the traditional Roman arches. Four big historical panels adorned the attic of the arch, and there were twenty-four figured panels on the inner faces of the piers, including one very battered and fragmentary example showing the siege of a city (Plate 162). The attic panels are approximately 7.20 m. by 1.17 m. high, and the scenes include sacrifice (Plate 160), procession (Plate 159), and *dextrarum iunctio*.

The style and the technique of the reliefs vary a good deal. Although the themes are those traditional to Roman imperial iconography, the composition and some elements of technique are strikingly different from those of earlier work. The tendency to show scenes frontally is a universal characteristic, but the degree to which it is developed varies. In some of the scenes from the piers the figures are arranged in basically frontal poses flanking a central axis and turn their heads rather awkwardly in the direction of the action. Elsewhere, frontality has acquired much more rigid application, notably in the processional triumph scene on one of the attic panels (Plate 159), where the figures of the

main chariot group, which include the emperor and his sons, are positioned facing the spectator, although the procession moves across from left to right. The main sacrificial scene (Plate 160) is handled in a similar way – a static arrangement of frontal figures with comparatively little variety in the poses; an upper register of half-figures serves to represent the people in the background of the scene. There is no uniform style or technique in the sculpture as a whole. The carving of the big sacrifice panel is already very late antique in effect. The drapery is so carved as to lose its organic quality, at least at close quarters, and to display instead a firm, incisive pattern of deeply drilled grooves. The surface finish is careless, and the loss of three-dimensional form, especially in the upper figures, is marked. Different hands can be detected: the sculptors who carved the *dextrarum iunctio* scene have outlined the figures with deep grooves (this is especially obvious in the figures on the right of the imperial group), but this detail does not appear in the sacrifice scene.

The effect of frontality on the arch at Lepcis is striking. In the processional scene there is bustle and movement from left to right, but the movement is arrested by the imperial group, to which all eyes seem to turn. In the more static composition of the sacrifice scene, the result is less convincing, but the portraits deserve close attention: heads in profile are generally stock types, but those shown facing the spectator or in three-quarter view are strongly individualized. We may note, too, that in the *dextrarum iunctio* scene the heads of Caracalla and Julia Domna are larger than the others, and rather awkwardly related to the body, with quite large roughly cut masses of marble behind them; it seems clear that what happened was that a block was left for the head which was later finished by another sculptor, presumably a specialist in portraiture. The technique often looks different from that of the rest (e.g. the Caracalla head); and in the case of Septimius the relationship between head and neck is not well thought out. Other portraits have unfinished patches, as in the triumphal procession.

The sculpture of the Severan arch at Lepcis provides very clear evidence of the new trends in Roman art, however they may be explained. The nude Victories which adorned the spandrels of the arch are still hellenistic figures with flowing locks and swirling drapery, but there are disturbing new elements of style and technique – the carefully modelled drapery is hard, the proportions are strange, the transitions awkward, and the hair shows the new taste for deep, harsh drillwork. This is also true of the figures of barbarian captives that flanked the passageways (Plate 163). It seems as though the ideals of Greek art have lost much of their meaning and that artists and patrons are moving away from the classical past as a source of inspiration, although the Graeco-Roman iconography still retains its significance.

Portraiture

The portraiture of Severus (Plates 164 and 165) is intensely interesting and still presents many unsolved problems. Septimius seems to have been obsessed with the creation of a satisfactory public image of himself. Antonine portraiture reflected the confidence of the age; that of the Severans the self-conscious striving to justify the usurpation of rule.

The new emperor was apparently a fine figure of a man, with a large, handsome face, a long beard, and grey curly hair – a face to command respect and, one would think, a good subject for successful portraiture. But, in fact, the emperor and his advisers never seem to have been satisfied. At first he appears as a rugged soldier; then he pays lip-service to the Antonine image by trying to look like Antoninus Pius (Plate 164) and Marcus Aurelius; and finally, or almost finally, he settles for the hair and beard of the god Serapis, his patron deity (Plate 165). Few emperors had tried so hard, and none had gone so blatantly for a divine model, but both these characteristics are typical of the changing attitude towards the emperor, who is now plainly accepted as a divine being in his lifetime.

Even so we find the emperor's son Caracalla reacting violently to this kind of representation. His portraits (Plate 166) seem to be an attempt to re-create the simple, down-to-earth soldier type, but when one looks in closer detail, one sees that there are obvious attempts to link his likeness with that of Alexander the Great, whose appearance he is known to have cultivated. The last of the Severans, Alexander Severus, who ruled from 222 to 235, is depicted in quite a different tradition (Plate 167), one that combines an almost republican simplicity of detail with a remoteness which seems appropriate to the idea of a god-emperor. He is the last of the emperors for some time whose portraiture shows a clear-cut imperial policy. In the years of anarchy to follow many short-lived rulers devised different solutions, as we shall see, and it was not until the time of the Tetrarchs that confidence was again established.

Sarcophagi

In the time of the Severan emperors the regional schools of sarcophagus carving were probably at their most flourishing and the demand was never greater. Some of the finest Asiatic columnar types, including the famous Sidamara sarcophagus (Plate 168), belong to this period, and some of the best Athenian products can also be dated by their portraiture to this time. The trade was now highly organized throughout the Empire, and the leading workshops had agents in various provincial centres. It seems as though the sarcophagi were often mass-produced, with only the portraits left unfinished; it was intended that these should be carved where the order was required, but frequently, as we can see, the commission was never completed. Presumably the coffins were often bought during the lifetime of the purchaser and had to be adapted when they were put into use. It has been pointed out that some of the blocks intended for male portraits were used for women, and *vice versa*. Children's coffins often have the portrait left unfinished.

In western products some new elements appear firmly established in Severan times. There is a tendency for the body of the sarcophagus to gain in height and to be carved with tall figures. The so-called *lenos* shape, which seems to be derived from the form of the Dionysiac wine vat (cf. p. 102), was particularly popular. One of the finest surviving sarcophagi of this period is that formerly at Badminton and now in the Metropolitan Museum, New York (Plate 169). The subject of the reliefs is one of the most favoured

in the funerary symbolism of the later Empire, that of the four Seasons, here depicted as youthful male figures in the company of members of the Bacchic *thiasos*. Increasingly, the sarcophagi concentrate on themes involving the after-life: two of the most popular are the Seasons, and sea monsters, Nereids, and the like, who seem to signify a happy existence in the Isles of the Blessed. The marine sarcophagi often have a portrait of the deceased framed in a large seashell on the front.

The Badminton sarcophagus and a number of other contemporary examples show very clearly some of the technical developments common to many branches of Roman sculpture at this time. The bodies of the Seasons are highly finished, but lack the firm modelling and proportions of classical figures. The faces are ugly, especially because of the lack of proportion in the main features, and there is a striking contrast between the finish of the body and the deeply drilled, unruly hair. These technical developments have already been seen in contemporary portrait sculpture and seem to be the result of the work of foreign craftsmen.

Interior Decoration

The period of the Severans provides a good opportunity to review the developments in Roman interior decoration, especially painting and mosaic. Unfortunately, it is not easy to get a clear picture of the imperial taste because the key monuments have not been published in detail; this is true of the Severan private apartments on the Palatine, which are known to have been full of daring and ingenious architectural designs. The emperors continued to use Hadrian's villa as a country residence, but it is not clear what innovations and developments belong to their period. In public building the baths of Caracalla were outstandingly the grandest of the imperial *thermae* erected up to then, but they, too, lack full and adequate publication.

Some general idea of the decorative schemes of the baths of Caracalla can, however, be given. It seems as if the black-and-white style of floor mosaic was widely adopted for the bigger areas, and that the themes were generally the traditional ones of marine monsters and the like. At the same time polychrome mosaic with figured panels was adopted in many rooms. On the wall surfaces, in association with a rich and very grand architectural design, there was considerable use of *opus sectile*; and the vaults appear to have been covered with bright mosaics making extensive use of glass tesserae. The architecture itself was extremely ornate and carved in a kind of imitation of Flavian decoration which has inspired some scholars to describe it as Flavian revival (cf. p. 119). The technique is a good deal rougher than that of the prototype, but there are some outstanding ornamental details, including the famous figured capitals with the representation of Hercules. Statuary was used on a very considerable scale, especially colossal statuary, which was appropriate to the size of the massive building.

As far as one can see decorative wall painting had declined, and in general there is very little of high quality from late-second- and early-third-century houses in Italy, although walls at Ostia have yielded competent figure painting in the classical manner; the late-second-century murals of Artemis and other divinities from the Horrea dell'

Artemide (Plate 170), for example, are in the full Romano-hellenistic tradition, with fine, well proportioned figures modelled in classical style. At the same time some painters preferred the more impressionistic style which had come into its own in the later first century A.D. Wall schemes in general were much simpler; for instance the Caseggiato dell'Ercole, behind the forum baths at Ostia, has an architectural scheme made up of a series of large panels decorated with foliate Griffins (Plate 170). The style is frail and sketchy, but pleasant and restful, and this example and a number of others with white grounds and fine lines of decoration are said to belong to the Severan period. The prevailing style can be seen in one of the rooms of the villa below the church of S. Sebastiano by the Via Appia, where one finds patterns of red and green lines on a white ground following the main features of the architecture and dividing the wall up into large areas or compartments, some of which are decorated with simple figured motifs sketched in a rather racy style.

Early Christian Painting

The oldest Christian paintings (Beckwith, 8 ff.) belong to the period around A.D. 200 and come from the Roman catacombs. The earliest are those of the catacomb of Domitilla and of the crypt of Lucina in the catacomb of St Calixtus (Plate 171). Elsewhere in the Roman Empire there is little painting of the same period, although the frescoes of the baptistery at Dura Europos were executed c. 240 (cf. p. 126). The decorative schemes found on the walls and vaults of the catacombs are very similar to those of contemporary interior decoration, where the circle is divided up into various geometric shapes by fairly fine lines. The execution is often rather poor, and the chief interest centres on the iconography. There are generally subjects which symbolize the triumph of the Christian soul, for example, Lazarus, Noah, and Daniel; and sometimes there are more complex images which are not always to be readily explained, as in the case of the fine paintings from the so-called hypogeum of the Aurelii. Another popular theme is that of divine intervention on behalf of humans; and Christ appears in a number of allegorical images, for example as the Good Shepherd or the Philosopher accompanied by praying figures. Later on we get the miracles and episodes from the life of Jesus. The subject matter of the earliest paintings is basically the same as that of the oldest Christian sarcophagi. Contemporary pagan sarcophagus scenes stress the theme of death through such figures as Meleager or Endymion, or the blessed life after death; Christian iconography on the other hand appears to concentrate on the triumph over death. Hercules bridges the gap between Christian and pagan as the good man who achieves immortality (cf. p. 141), and he sometimes finds a place in Christian contexts, as in the series of fourth-century paintings from the new catacomb on Via Latina (Plate 172). Indeed Christian artists do not hesitate to use pagan iconography in this way, and the style of the earliest painting can often be very classical in spirit. There are some superb details from the hypogeum of the Aurelii (Plate 173), where, whatever the precise beliefs of those buried there may have been, there seems to be a strong Christian element.

It is unfortunate that almost nothing has survived from Christian cult building of

this early period. The only exception is the baptistery at Dura Europos, which may give some idea of what has been lost. The subjects of the cycle of pictures which covered the walls are, however, different from those employed in the West, as for example in the case of the Resurrection (Plate 174). It has been noted that in the Dura pictures there is a tendency towards elaborate descriptive composition, while in the Roman catacombs the imagery tends to be rather abbreviated. The common theme, however, is salvation. The style at Dura, too, is very different from that in the West; there is much less classical detail and a strong tendency to follow some of the compositional features which we have noted in east Roman art in general.

It is worth saying at this point that a great deal of Christian imagery was obviously taken over in the third century from the art of the Roman State. There was no deliberate reaction against pagan artistic conventions, so that, for example, the gesture of the orant and the general use of putti in catacomb pictures are derived from Roman proto-types. Most obvious of these borrowings is, perhaps, the apotheosis scene of imperial iconography which is adapted to represent the Ascension. Pagan pastoral imagery domin-ates the Good Shepherd scenes. We shall return to this theme and the development of the early Christian style later on.

Mosaics in Italy and the Provinces

The decline in wall painting seems to have coincided with a rapid development of floor mosaic (Beckwith, 8 ff.). We have already seen that black-and-white geometric mosaic was the commonest form in the first century A.D., whereas the hellenistic poly-chrome picture floors, of which many significant late republican examples survive, seem to have given way, except perhaps in limited areas in the eastern provinces, to *opus sectile*. Elaborate schemes of wall decoration flourished, however, and in the early second century there was a revival of the mosaic picture in the West (cf. p. 99), at a time when at Antioch-on-the-Orontes in the East the big picture floor in a geometric setting seems to have been well established.

Rome must originally have led the way in the development of distinctively Roman mosaic types, and Rome is the best place to follow the early history of the medium. To recapitulate – the simple patterns of tesserae in cement give place by the end of the first century B.C. to all-over geometric designs in black-and-white which prevail throughout the first century A.D. Polychromy develops both in mosaic alone and in combination with *opus sectile*, but chiefly on walls. Some of the finest black-and-white mosaic comes from Hadrian's villa, especially the splendid floral arabesques and scroll-work. Geometric designs remain fairly simple, and curvilinear ones are rare. In the first half of the second century richer forms, more polychromy, and more varied curvilinear patterns are introduced, especially centralized ones based on early designs. In the second century the black-and-white silhouette style for big figured compositions, especially in bath buildings, seems to have been most popular, but by now the polychrome floors with their rich borders incorporated a variety of figured motifs taken from classical mythology and religion.

By the end of the second century A.D. the styles of mosaic had spead widely in the Empire. Many schools flourished in the Severan period, but in Rome itself there was very little good or interesting work: what survives from the Severan additions to the Palatine is severe black-and-white, and the same is largely true of the grandest building enterprises, such as the baths of Caracalla (211–16), where the colour derives from *opus sectile* and polychrome vault mosaic. Polychrome figured floor mosaics are confined to certain areas of the complex, for instance the apses of the *palaestrae*, where the famous series of panels with figures and busts of athletes deserves respect for the fine technique and the effective way in which the artists have characterized the different types.

The picture of a decline in mosaic floors in favour of other forms of decoration during the third century may be a somewhat false one. Few wealthy villas of the time around Rome have been excavated systematically; and the fragments in museums, often of uncertain provenance or heavily restored, suggest that there was, in fact, a good deal of fine work. But undeniably the chief interest in this period lies in the provincial schools. Later on Rome shared in the revival of floor mosaic; the gladiator mosaic of the Villa Borghese provides a fine example of the big overall figured compositions which were characteristic of the late third and fourth centuries.

Towards the end of the first century A.D. black-and-white geometric mosaic was, as we have seen, giving place to more elaborate polychrome themes often based upon carpet designs, or in centrally planned buildings echoing the divisions of ceiling decorations. This combination of the revived picture mosaic and the polychrome geometric floor schemes based on straight and curvilinear motifs was typical for the later Roman Empire.

In the second century the big black-and-white mosaic pictures seem to have maintained their popularity, but there was an increasing taste for polychromy, which achieved its best results in the early third century. Certain stock decorative motifs occur on floors everywhere because designs and artists passed from province to province. Italy may have dominated the early evolution, but later on regional schools developed, and one is often struck by the originality and independence of centres quite close to one another, as in North Africa, where Timgad for example developed the style combining splendid floral detail with geometric shapes which prevailed there in the late second century.

Floor mosaics are found in private houses, in public buildings, especially in *thermae*, and in temples. They range from the plain to the highly decorated. In houses the mosaics of the vestibule are often quite simple, whereas rich carpet patterns may decorate the peristyle, and the most elaborate schemes, including figure panels, are reserved for the *triclinium* and other important rooms. The repertory is fairly wide-ranging, although there is a tendency for stock subjects to be repeated: Dionysus, Nereids and sea monsters, and the Seasons seem to be standard because they typify the beliefs and attitudes of Roman people in the late Empire. Roman mosaics are not often of high artistic quality, but there are many examples of extremely high skill and virtuosity. The earliest try, as we saw, to emulate the effects of painting, and some achieved their aim very successfully by the use of small and very varied tesserae of glass as well as of stone. But later on the limitations

of the mosaicists' technique are accepted, and as the tesserae become larger the subtle effects of colour modelling tend to be abandoned in favour of a stronger, more expressive style, with exaggerated detail. This is very obvious in a number of mosaics made around A.D. 200, where the heavier and stiffer forms of the body seem to reflect the general trend of Roman art. One of the most valuable features of the medium is the fact that, because it is so durable, examples have been found all over the Empire, so that we can get an indication of regional styles, although much remains to be done before full use can be made of this source of information.

The study of a defined geographical area such as the Rhineland gives a good idea of the development of the craft in the provinces and the way in which surviving mosaics can be divided into groups on the basis of design, colour, ornamental detail, and, to a lesser extent, technique. The series from Trier (Plates 175–6) ranges from the first to the fourth century, the earliest coming from a complex of buildings which was probably the headquarters of the procurator of Gallia Belgica. The date is around A.D. 70 and the mosaics are all in black-and-white and based on geometric patterns – pelta ornament, black-and-white squares, and squares divided into triangles and framed by maeander patterns. The later group of the early second century is still all in black-and-white, but has a larger repertoire of motifs and a little figured decoration. It is fairly widespread in the Rhineland both in the country villas and in the towns. From a villa near Fliessem, where most of the floors seem to belong to the first half of the second century A.D., comes a very fine black-and-white geometric series of which one is very like a mosaic from the palace of Trier, with a central rosette framed with guilloche surrounded by firm geometric shapes.

Some fragmentary picture mosaics from Trier date from about the end of the second century, but the main series probably does not begin until the time of the Severans: one also from Trier with a circus theme, with four large octagonal pictures of chariots around a head of Victory (Plate 175), seems to date from early in this era. The commonest type now is the polychrome mosaic composed as a series of geometrically framed panels enclosing figured scenes, heads, and so on. There are many different styles, some deriving from the various workshop traditions and some from the character of the originals from which the mosaics are copied. The designs can still be quite simple, as in the case of a floor from Trier with busts of the Nine Muses in square frames surrounded by maeander patterns and divided from one another by bands of guilloche (Plate 176). The effect, and perhaps the inspiration, is that of a coffered ceiling; and ceiling design was obviously a strong influence in general. A much more complicated geometric arrangement occurs on mosaics found close to the one just mentioned, where there are interlocking guilloche frames arranged to form an eight-pointed star, each point enclosing a figured motif. The technically finest and artistically most elaborate piece of work of about this time is the gladiators and wild beasts mosaic from the villa at Nennig (Plate 177), one of the richest and most handsome in the area. The whole floor measures 15.65 by 10.30 metres, and the elaborate network of framed geometric shapes gives an impression of a richly patterned carpet, where the figured panels contrast with the overall density of the design and so stand out effectively to the eye. The modelling

of the figures is vivid and lively, with skilfully worked highlights and shadows. The date is probably *c.* 230.

In Switzerland, another area where the development of mosaic has been studied, the picture is similar. There seem to be no first-century examples, even in the big towns. In the early second century black-and-white geometric is the rule; the polychrome floor is a development of the later second century, when centralized designs occur with figured panels in geometric frames. Gaulish centres seem to provide the chief inspiration, and the finest work appears to belong to the Severan period. (One of the very few dated Roman mosaics, from Aventicum, has an inscription with the names of the consuls of A.D. 209; *Inv. Gaule*, 1389.) The colours are now augmented by glass, including gold glass, and foreign marbles. Wall mosaic (*opus musivum*) is used for private baths, especially blue mosaic, mirroring the water of basins on niche and ceiling. The figured designs generally try to imitate the modelling of painting, and occasionally the artist–craftsman signs his work. On the fine Severan floor from Orbe illustrating the days of the week a series of octagonal pictures in heavy frames form the main 'carpet', surrounded by a narrow frieze of running animals. Venus occupies the central panel.

In Britain the few surviving early mosaics are black-and-white geometric. There are comparatively few floors of the second century A.D., and none of outstanding quality. The great period was the later third and fourth centuries, when the Romano-British villas were at their most thriving.

In other provinces there is much yet to be learnt about the history of mosaic. The eastern Mediterranean, especially Syria, provides some of the most illustratively rich material: big pictures are found on floors from the first century A.D. to late antiquity, when Antioch, one of the four metropoleis of the Empire, was a specially important artistic centre. The sources of the city's mosaic designs and compositions seem to be wide-ranging. The so-called rainbow style (which is also found in the Piazza d'Oro of Hadrian's villa) produces an iridescent effect, and appears to imitate the work of woven fabrics; textile patterns were indeed one very obvious source of inspiration. The chief sources of the big pictures were the classical and hellenistic paintings which had formerly inspired wall painters, and it would be interesting to know how these designs were transmitted from one place to another. The early-third-century Dionysus and Ariadne from Room 1 of the House of Dionysus and Ariadne (Plate 178) has a scheme of architectural framing which seems to be pure late-second style, combined with a rectangle of black-and-white geometric mosaic of a simple perspective type, all framed in a simple rainbow pattern. The total effect is of a page from a pattern book illustrating suitable combinations of floor and wall designs; but whether anything of the kind actually existed, we cannot say.

★

The end of the Severan age is a good moment at which to assess the development of Roman art. It was also the end of an era, because never again in the Roman Empire were the cities on which the Empire depended so prosperous and confident. The end of the

golden age is symbolized by the Severan building programme at Lepcis – a grandiose scheme which had very little basis in local prosperity and was, in fact, followed by a decline in the fortunes of the place. The Severan age is also one of changing attitudes, especially towards the emperor. The ruler of Rome is now master of the world-Empire and acquires, by virtue of his office, the qualities of a divine being; and this is clearly reflected in the art of the period. Severus was himself a provincial with strong oriental connections. He spent much time in the eastern Empire and married a Syrian wife; and one notices in many branches of the art of his time a strong affinity with oriental ideas. But there is also a much more cosmopolitan atmosphere generally, and one might say that the art of Rome had by now developed into the art of the Roman world.

Roman art as such had always been held together by the classical current which created a broad uniformity of intention, if not of achievement, over widely scattered parts of the Roman world. The Graeco-Roman artistic tradition admits of great differences in style and technique, even at its centre; on the periphery of the tradition, and of the Empire, one can see from an early period alien influences at work which exert subtle but positive pressures. In the West, Celtic art absorbs much from the common classical language, without in general providing a disciplined interpretation of its own. In some cases, as we saw (pp. 115–16), the taste for pattern-making, for intricacy, for flowing movement and formal simplicity came to the fore, producing what seems to be a genuine synthesis between classical and Celtic ideas. The Romano-Celtic tradition is at its best when the Celtic imagination allows itself to be restrained by classical form. In Roman Britain examples of a genuine artistic synthesis are very rare. In sculpture, a few heads like the Antenociticus from Benwell (Plate 179) and the very arresting head from the Bon Marché site at Gloucester are truly memorable; and the Gorgon pediment from Bath and the famous figured capital from Cirencester illustrate the best achievements of Celtic imagination expressed through classical conventions. But in other branches of art, for example painting, there seems to have been very little creative response in the western provinces, and the fashions of Italy and the capital were simply followed with more or less success everywhere.

Art in the Provinces

A fine provincial school of sculptors was centred on the Moselle valley, where a number of notable tomb-monuments in local stone were decorated with figure work of very high quality. The reliefs from Neumagen and Trier belong to the tombs of wealthy businessmen and merchants and represent scenes from their life. One good example is the Neumagen school relief (Plate 180) with its vivid realism and immensely delicate modelling, especially in the ornament, which has the soft, velvety quality of a flock wallpaper. Precise detail, rendered with consummate skill, characterizes the reliefs; the stone was generally covered with white lime plaster and painted in a wide range of colours. Banquet scenes dwell on the details of the food and drink, domestic scenes include precisely accurate versions of metal utensils, mirrors, and other objects. Many of

the panels illustrate everyday life, but sometimes the traditional themes of Graeco-Roman art are excellently rendered. One example is the battle between Romans and barbarians executed in a fine baroque manner and with remarkable command of the powerful anatomy; at the end of the slab is a scene of parley between a general and a barbarian. The relief is made to stand out by deep grooving round the outlines of the figures; the whole was stuccoed and painted. This school of sculpture owes little to local taste but is in full command of the best Graeco-Roman techniques and adopts the latest fashions in the Empire, as some of the portraits show.

There are good examples of Roman domestic painting from most of the northern provinces, the best belonging, it seems, to the second century A.D., when versions of what may be called the fourth style still prevailed. A good specimen is the 'Green Wall' from the Palastplatz at Trier which has been reconstructed in the form of a pair of *aediculae* with entablatures and a panel depicting Jason and Medea, a competent piece of classical painting in the academic tradition; the modelling of the flesh and the drapery is skilfully handled. The impressionistic late Pompeian style is superbly represented by the pictures from the villa at Zliten in Tripolitania (cf. p. 78). The strange columns and slashing highlights in the scene showing people and houses give the picture a splendidly ghostly quality; the artists at Zliten love eerie, unnatural colours (S. Aurigemma, *Tripolitania: le pitture d'età romana*, 1962, plates 29, 30). The date of the paintings is disputed, as is that of the brilliantly successful mosaic pictures from the same villa.

So modest was the real success of the classical tradition in the West that it is tempting to write off all western Roman art as more or less derivative and 'provincial'. The bronze workers who produced the Colchester Claudius or the Hadrian from the Thames are competent, but poor relations of the best metropolitan sculptors. But if this is generally true of the West, the same cannot be said of the eastern Roman world. Without the eastern provinces Roman art as we understand it would not have existed; artists from mainland Greece and the Ionian area created the Graeco-Roman tradition and kept it alive for several centuries of the Empire. Up to the time of the Severans Greece and Asia Minor continued to exert the decisive influence on the development of Roman art, and the appearance of many new ideas and techniques can be directly traced to these centres. A more complex problem concerns the role of Asia Minor as the transmitter of artistic ideas from the eastern periphery of the Roman world, where a mixed oriental Greek art had been germinating since the conquests of Alexander the Great. The failure of Alexander's great dream of a cosmopolitan Greek world is surely reflected in the art of the eastern satrapies, which followed either oriental or Greek models but scarcely ever show a combination of the two. For their propaganda art these rulers seem to have favoured Greek style, and some genuine masterpieces of later Greek portraiture were produced to their order, especially in the strongly hellenized Bactrian kingdom.

But in the first century B.C. in Syria and in the western parts of the Parthian Empire something like a consistent style began to emerge which can be followed to some extent in the coinage of the Parthian kings. The heads of Mithridates I (171–138 B.C.) are in pure Greek style and contrast very strongly with the linear, very dry technique of the coins of Phraates IV and the patterned formalism of the heads of his successors in the first

century A.D. To call these new elements Parthian is merely to recognize that Parthia was the chief political power on the eastern frontiers of the Empire; and in fact the characteristics of this new Graeco-oriental art are best studied in the art of Palmyra, where some reliefs from beneath the precincts of the temple of Bel illustrate its early development. There is a strong tendency to formal pattern-making in the handling of the drapery and towards frontality in the posing of the figures. A little later, reliefs from the peristyle of the temple of Bel (c. A.D. 32) show groups of oriental divinities arranged in strictly frontal and static poses, although they are engaged in the vigorous action of a battle against giants. Soon in Palmyra and a number of other western areas of the Parthian Empire this frontality became a dominant feature of the composition.

In the second century A.D. cult reliefs from Hatra invariably show the divinity and often the worshippers in frontal pose, and it is reasonable to argue that the general adoption of this artistic convention is designed to bring the divinity into more direct and personal contact with the spectator. At the same time one can see the prevailing tendency towards formal symmetry and regularity, which often give the figures an archaic look – the faces in particular tend to become simplified shapes and patterns, especially the details of the hair and the eyes. This is outstandingly true of a series of Palmyrene funerary busts which were otherwise obviously inspired by the Roman practice of placing busts on tombstones and in *columbaria*. They were presumably designed to contain the Genius of the dead, but are too conventional to be considered genuine portraits, although they may include details directly drawn from the individuals whom they represent and can often be very life-like and vivid, like many archaic Greek statues. In contrast to the generalized character of many of the portraits, there is a great interest in the minutiae of embroidered clothes or expensive jewellery, or in the various attributes that serve to explain the individual's trade or business (cf. p. 93).

Art at Dura Europos

Dura Europos on the Euphrates was a Macedonian colony founded by Seleucus I c. 300 B.C. It fell to the Parthians c. 113 B.C. and remained a Parthian town until A.D. 165, when it was occupied by Lucius Verus and given a Roman garrison. The place held out against the Sassanians until 256, when it was captured and abandoned to the desert. In life, religion, and art Dura combined Greek and oriental and Roman elements into something like a local idiom. The art of Dura cannot have been a very significant influence outside its own boundaries, but the city remains a vital type-site for the kind of intermingling of ideas which affects the whole of the art of the later Roman Empire and has, therefore, assumed an important place in discussions of the period.

Dura was laid out like a hellenistic city, but its architecture became predominantly oriental in the years that followed. The gods, generally Graeco-oriental syncretisms, were worshipped in temples of oriental type, and the houses derive from Mesopotamian traditions. After 165 however a number of characteristically Roman buildings were erected – baths, garrison buildings, and so forth; Mithraea, a synagogue, temples

of other pagan cults, all seem to have been built to satisfy the needs of a very cosmo-
politan military population. Around 240 a private house was converted for Christian
use and its baptistery decorated with paintings (cf. pp. 126, 143).

A lot of painting and sculpture has survived from the Roman period. The murals
come mostly from religious buildings. Although few examples are firmly dated, it
seems that most of the survivors belong to the last fifty years of Dura's history. The
earliest paintings seem to have been those in the *naos* of the temple of Bel (temple of the
Palmyrene gods), known from photographs, but now largely destroyed; the end wall
was dominated by a massive frontal figure of the god of which only fragments remained.
On the side walls were worshippers in registers, including on the south the well-known
group of Konon, the donor, sacrificing, painted against an elaborate architectural
background (Plate 181). This group demonstrates the basic characteristics of Durene
representational art: a solemn, still frontality accentuated by an essentially two-dimen-
sional technique with very little colour modelling. There are echoes perhaps of western
painting in the elaborate settings. The date is second century A.D. Another scene of
sacrifice, this time in the *pronaos*, is more crowded in composition, with the figures
arranged in two rows (Plate 182). Here Julius Terentius, tribune of the twentieth
Palmyrene cohort *c.* A.D. 239, stands facing the spectator while his men line up behind
him, rendered as complete figures in the lower register and as half-figures and heads in
those above. Military standards and statues of divinities are shown, together with the
personifications of Dura and Palmyra, based on the famous Tyche of Antioch by Euty-
chides.

The paintings of the temple of Zeus Theos were obviously very like those of the
temple of Bel, although again only fragments are preserved, and a late redecoration
of the Mithraeum, not long before the destruction of the city, produced some lively
work, with a fine sense of movement in a vigorous hunting episode. The subjects of the
elaborate scenes from the Old and New Testaments in the baptistery of the house-
church have much in common with those of the catacombs, as we have seen, but the
outline and flat wash technique is different from the impressionism of the western
painters. A very elaborate programme decorates the famous synagogue now rebuilt in
the museum of Damascus. Round the base of the wall runs a marble dado, and above
that are three registers of figure paintings taken from the Old Testament and later Jewish
writings. The narrative scenes are very static, the figures being arranged with a strong
frontal emphasis and lacking expression and movement. The total effect is of a rich
patchwork (cf. pp. 143–4).

Like the paintings, stone sculptures are almost entirely religious at Dura, with a rich
variety of deities represented. They consist of cult reliefs, statues, and statuettes. The
elements of style are not difficult to establish. There is no effort to model realistically,
but the best work has a crisp precision and intensity based on simplicity of form and
bold carving, which sometimes exaggerates the size of individual features and achieves
thereby a strikingly expressive, if concentrated, effect. The drapery, even when modelled
on a Greek prototype, is forced into strict patterns. Gods are usually shown in rigid
frontal pose, in low relief, and with little depth to represent a third dimension. The relief

of Zeus Kyrios (A.D. 31) (Plate 183) and the splendid one of Aphlad (A.D. 54?) in the National Museum, Damascus, are excellent examples of the general style, combined with a most skilful rendering of detail. Many of the sculptures reveal Greek or Roman prototypes or influence but always subordinated to Durene style and technique.

<p style="text-align:center">*</p>

The Durene style in sculpture and painting has many features which can be compared with late Roman art throughout the Empire: the schematic figures with accentuated features; the almost universal frontality and lack of interest in three-dimensionality; the arrangement of figures without precise regard to their actions in relation to one another. Parthia, Mesopotamia, Palmyra, Greece, and Rome all seem to have played some part in the creation of this hybrid art. Some of the same elements become dominant in late Roman art, too, and it seems true to say that they are fundamentally Asiatic.

It is easy to describe in general terms the characteristics of this western Parthian art which also spread to the Far East and influenced the art of Gandhara. It seems to represent a genuine response to hellenistic art in which the artists draw inspiration from Greek sources but confine their interests within a series of formulae, both religious and aesthetic, and so preserve a distinctively oriental flavour. From the point of view of Roman art as defined in this book the real problem is to discover the effects of this tradition in the Empire as a whole. Frontality, pattern-making, the use of repetitive formulae, which are all elements of this eastern art, intrude into the Graeco-Roman tradition of the West and eventually transform classical art. Some of these features, especially technical ones, demonstrably originate from the work of craftsmen from the eastern provinces, but in the case of artistic concepts such as the frontal pose the picture is less clear. There is always a tendency towards frontality in Roman art; it is not an early oriental characteristic, although it becomes general in religious sculpture in the East before it does in the West. Its spread is presumably to be explained by the increasing cosmopolitanism of Roman art, and especially by the development of oriental ideas regarding the status and position of the emperor in the second and third centuries A.D. As one might expect, it is in the age of the Severans in the West that this new attitude becomes very clear, and it brings out the close connection between artistic conventions and political and religious ideas.

At the same time the Severan age illustrates the conservatism of Roman art, especially in the emperor's search for a public image based on sound Roman precedent. The same attitude is reflected in the constant imitations of earlier decorative forms in architecture. There is always a tendency towards archaism, and one sees it particularly clearly in Severan times, when it is not so much an artistic convention as an element of propaganda. But the main characteristic of Severan rule is the more blatant glorification of the imperial family. A rare survival in Roman art is the painted roundel of the emperor and his wife and children found in Egypt and now in Berlin (Plate 184) (cf. p. 63). They are strictly frontal, almost hieratic, and one receives as much the impression of a

<p style="text-align:center">134</p>

religious icon as of a portrait. There is something of the same character in the few surviving examples of portrait cameos belonging to this age. The art of cameo carving, which seems to have gone into something of a decline since the Julio-Claudian achievements, appears to have been revived around this time and was to become an important aspect of imperial propaganda in the late Empire. Much the same iconography and symbolism is used as on the earlier examples, but the changing attitudes to the emperor can be seen in the method of presenting the portraits and some of the scenes.

THE THIRD CENTURY (A.D. 238–84)

THE years from 238 to 284 saw an age of anarchy in Roman history, not only in a political sense but also in that of a great ferment of ideas and a search for new values. The reflection of this tumult in the art of the period, however, is very much obscured by the lack of surviving monuments. Many of the cities of the Empire suffered severe set-backs, and few of them undertook ambitious building programmes, so that there is very little architectural sculpture. The age of anarchy seems to interrupt completely the logical development of Roman art, as may be seen very clearly in portraiture. The reaction of the portraits of Alexander Severus against those of Septimius in an attempt to re-establish the concept of an imperial image is reversed in the third century, when many short-lived emperors were faced with the problems of presenting themselves to the Roman public. The results make a fascinating study. Literary descriptions are virtually useless for identification, so that the coinage is the only real source – but even that sometimes fails us, as when two emperors strike almost indistinguishable portrait types.

Portraiture

These imperial characters, often remarkable in their own right, lived in a remarkable period – of murder, ruthless fighting, and general anarchy; and it is not therefore surprising that, although their portraits are often strikingly individual, there is usually a common factor derived from the spirit of the age. Alexander Severus (Plate 167) is represented with a Julio-Claudian simplicity and regularity, except for the sketchy technique used to indicate the hair, and the treatment of the eyes with the engraved iris and twin-lobed pupil. The portraits are courtly, flattering, and remote. The succeeding style is best expressed in the image of Maximinus, vicious, ruthless, and hated for his barbaric cruelty, who was declared emperor at Mainz in 235. The head now in the Ny Carlsberg Glyptotek at Copenhagen (Plate 185) survived a comprehensive *damnatio*. The coins of Maximinus present him in several different ways, but one group in a startlingly uncompromising style deliberately gives him a frightening physiognomy: what seems to be intended and achieved is a brutal characterization of strength and stark ruthlessness. Several of these third-century emperors seem to have found inspiration in the portraiture of the late republican period and in that of the Julio-Claudians. Of the Gordians, Gordian I is said in our literary sources to have had the looks and voice of Augustus, Gordian II is compared to Pompey the Great, although said to have been not so fat, and Gordian III was apparently a re-incarnation of Scipio Asiaticus. On their coins, in fact, they all look very much alike, and there is some doubt about the identification of portrait busts in the round; a head at Castle Howard has been tentatively identified as Gordian I.

Another side of contemporary life is represented by the reclining effigy supposed to be that of the eloquent, high-living, and very short-lived emperor Balbinus on a sarcophagus in the catacomb of Praetextatus (Plate 186). The scenes on the front, symbolic of the virtues of the dead man, belong to the tradition of the Antonine emperors. The main figures are a husband and wife in the *dextrarum iunctio* pose; the prosperous patrician shown here holding an eagle-topped sceptre which suggests an imperial personage seems particularly appropriate to Balbinus' character. The bold, large-scale carving of the figures is typical of the best contemporary sarcophagi, and equal to that of the monumental sculpture from buildings which one is accustomed to in earlier periods but of which there are no surviving examples in the age of anarchy. Sarcophagi, indeed, replace architectural reliefs as our chief source of knowledge for the history of sculpture at this time. On the Balbinus monument, portrait and reliefs seem to be by different hands, no doubt because the portrait was carved later, possibly after the emperor's death. Another typical sarcophagus, probably connected with an emperor, is the one found at Acilia (Plate 189). The best preserved part shows a young man with the Genius Senatus on one end, and his parents, it seems, in the centre of the front. The young man is thought to represent Gordian III, and the sarcophagus is perhaps that of his father, Gordian II. The head of the youth is worked by another hand; it is not highly polished like the other figures and shows much less use of the drill. The profile is not unlike coin portraits of Gordian III.

Philip the Arab and Trajan Decius are two of the lost souls of this era whose likenesses are known to us. The latter survives in a bust in the Capitoline Museum (Plate 187) identified – although by no means certainly – on the basis of coins. It is a striking example of the expressive portraiture of the age. The hair and beard are typically without volume and executed in a technique making use of gouges and punches which seems to have come in around A.D. 230. The portrait could only belong to this period of Roman art and is, indeed, an object lesson in its aims and achievements. The style is non-plastic and concerned with visual effects, and some scholars have found it typically Roman and unclassical. It stresses realistic detail and exaggerates a momentary expression. Such likenesses, which often lack the controlled simplicity of earlier portraiture, seem to be the products of a period of instability, and both sitter and artist appear concerned to express the sufferings and doubts of human beings in such an age. This type is utterly opposed to the ideal and eternal imperial image which earlier emperors tried to achieve.

The portraiture of Gallienus represents a reaction to this style which some scholars have glorified into a 'renaissance'. This man, who succeeded the emperor Valerian, embarked on an unremitting struggle to defend the bounds of the Empire, and his success in organizing the frontier defences permitted him a more stable rule than many of his contemporaries. He was associated with governing the Empire from 253 to 268, during which time the Empire of the Gauls was set up. Gallienus' reign produced a coinage rich in likenesses which can to some extent be classified into groups. Among the portraits in the round some sort of chronological divisions can be achieved; a well-known head in Berlin, for example (Plate 188), is certainly early. In general Gallienus'

portraiture seems to derive inspiration from that of the emperor Hadrian, and the eyes and the set of the head often recall the Alexander iconography. The technique is much more plastic than is usual earlier in the third century, and critics generally find that it has much in common with the cold classicism of the Augustan age. The portraits of a number of subsequent emperors, especially of men of the old school such as Tacitus, show the influence of this revived classicism.

It is difficult to judge the influence of third-century philosophical thought on the art of the period. The chief figure is Plotinus, father of neo-Platonism, who was important at the court of Gallienus. He advocated ideas which are opposed to those of classical culture: the artist can achieve a statement of the ideal without imitation, and may produce an expression of the inner man through external appearance. These concepts, which seem typical of the age, probably gave rise to the developing tendency to express spiritual values rather than physical form. A portrait from Ostia (Plate 190) of a bearded, balding man, which seems to have a new serenity, the serenity of intellectual contemplation, strikingly opposed to the tortured faces of the 'involved', like the emperor Decius, has been thought of as a likeness of Plotinus, the greatest philospher of the late Empire; it is certainly an expression of one trend in the art of the day that seems to prevail in later antiquity. Nothing could be more different from the portraits of the emperors, every one of whom was an army commander, serving for a short while, and whose energy and vital qualities are stressed. The Plotinus is the head of a philosopher of the Greek world. It is all technique and form; and (apparently uniquely for a philosopher) it survives in a number of replicas, three of them from Ostia. The probable date of the original – 260–70 – suggests that the identification is indeed valid. In any case it is an excellent example of a late Roman philosopher-portrait, inspired by those of the past but with a fine intensity of expression, intellectual, and foreshadowing the remote detachment from life which characterizes so many of the portraits of the *spirituales* of the next century; it particularly suits this strange, inspired man. At this time begins the series of sarcophagi with the wise man, scroll in hand, talking to his pupils which later became part of the Christian tradition of representing Christ and his Apostles. One of the Ostia portraits seems to have been recovered from a room which may be interpreted as an assembly hall for students. It is argued that late Roman art was strongly influenced by the neo-Platonic doctrine of Plotinus (Grabar, *Cahiers Archéologiques: fin de l'antiquité, etc.*, I, 1945, 15–34; V, 1951, 15–30, and G. Mathew, *Byzantine Aesthetics*, London, 1963). Yet the basic theory – that images open the mind to realities beyond – seems rarely to have been put into practice: rather, literature stresses the lifelike quality of contemporary art. The model is presumed to be like the image (as Constantius II was like his image). But Byzantine writers draw no distinction between their own art, which we think of as abstract, and that of the classical world.

The history of frontal representation occupies a span much longer than that of this book, but it is highlighted at the end of our period by being applied as an invariable law to certain themes, as it continues to be later. Its development can be seen from the late second century A.D. onwards. It is used in imperial groups and in representations of the chariot of Sol and of the triumphal emperor. Chariots had often been shown head-on in

archaic Greek art with the horses' heads turned sideways, but the practice lapsed until the third century A.D., when it was revived in a form in which the horses are divided into two pairs turned outwards and the chariot wheels are shown side on. It is argued that its earliest occurrence in the West derived from the East (Palmyra: *Syria*, XVIII, 1937, 43–51, and *East and West*, VI, 1955, 9–25) in the later third century, the oldest coin example belonging to the time of Probus. The manner is artificial and symbolic, beginning with the chariot of Sol and becoming a standard form for imperial triumph, with the emperor making a grand gesture with his right hand, as Constantius II does on a fine gold medallion (see H. P. L'Orange, *Studies in the Iconography of Cosmic Kingship*, 1953, 144, figure 101 d, e).

Villa Decoration

We know nothing about the development of painting and mosaic in this age. But in the third century, in villas, gardens, and public places, many colonnades as much as 1000 feet long were erected. The inspiration seems to have come from oriental streets (where the columns were likewise often decorated with statues). Inside were paintings or figured mosaics. The Severans and the emperors up to Aurelian seem to have been particularly fond of these long, richly decorated covered porticoes (S.H.A., *Septimius Severus*, XXI, 12; *Gordian I*, XXXII; *Gallienus*, XVIII, 5; *Aurelianus*, XLIX). It would be fascinating to know what kind of pictures the barbarous Maximinus sent to Rome to be set up before the Senate House to exalt his German victories. Certainly he, of all people, must have hated the conventions of the Roman triumphal tradition. And indeed, by contrast, what kind of *imagines* were revealed in the cabinets of the old Romans when they were opened to celebrate the appointment of Tacitus to the purple? Such political and social events must have greatly influenced the course of Roman art.

Coin Types

In a period when there were very few public monuments, the coinage is our main source for tracing the development of imperial art. The handling of traditional themes shows the change in attitude towards the ruling emperor, especially in the period immediately before the establishment of the Tetrarchy. The theme of *adlocutio* is handled very differently on coins of Numerian and Carinus (284) from the representations to which one has become accustomed; the massive emperors dominate their legionaries much more obviously than did their predecessors. In some versions, as on the coins of the Gallic Postumus, the emperor is shown high up in the centre in strictly frontal pose, with the soldiers lined up below him. On a medallion struck in 281–2 Probus acquires an even more hieratic position, raised on a central dais, with soldiers on either side and a suppliant barbarian below. In renderings of triumphal processions, for example on coins of Probus from the mint of Lyon, the chariot is shown frontal with the horses dividing to left and right. Often the emperor appears in splendid isolation, for instance in

the battle scenes of the later third century, where he dominates by scale as well as by position. Many of the features shown on the coins appear as established conventions in the State reliefs of the late third and fourth centuries.

The Classical Tradition

Despite the new ideas and new methods of representation, the classical tradition remained a major source of inspiration throughout most of the third century. The Roman élite cherished the old ideals: they decorated their houses and country estates with works of classical art and created the sort of atmosphere that Cicero had aimed at in the last years of the Republic. The concept of *otium liberale* continued to guide their lives. As a result, the copying of Greek sculpture – which was probably the main factor in the classical survival – went on during most of this period, but it is instructive to compare the technique with that of earlier periods. In the copy of Myron's Athena in island marble in the museum at Hamburg, which is probably eastern Roman work of the third century, the surface is dead and lacks precision; the detail is lost, and there is no longer any attempt to achieve an accurate imitation of bronze. The drillwork in the drapery folds is particularly obvious. Compared with the classic replica in Frankfurt, the decline is clear enough. It seems generally agreed that copying on a large scale probably came to an end around 260; one of the latest sets of sculpture to be made for a specific context is that from Miletus. However, there were clearly a number of copyists active in the later third century and indeed in the fourth.

The traditional classical figures, or adaptations of them, continued to be found in portrait sculpture. A number of the emperors of the third century were depicted as heroic nude figures, and sometimes the contrast between the body and the face is extremely incongruous. It seems likely that this type of portraiture was more popular in the eastern provinces than in the West. The other traditional imperial types, especially the cuirassed statue, are found throughout the period. At this time all aristocratic Romans, especially those with a taste for the traditional in classical art, aspired to be buried in a large marble sarcophagus. Particularly popular were the works of the eastern schools of Attica and Asia Minor. The Attic sarcophagi preserve a monumental classical style in versions of popular Greek myths, while the commonest Asiatic form is the columnar sarcophagus, usually decorated with stately classical figures. The style of the eastern schools had a strong influence on the products of the western workshops, where the finest examples have much the same grand monumental quality.

But, while many Romans clung to the old values, important changes can be seen to be taking place. The classical tradition became more and more divorced from reality, and allegories tended to lose their meaning or to be very differently interpreted, for they no longer expressed the religious and philosophical ideas in which many Romans were taking refuge from the times. Rome had by now absorbed many foreign cults and had transformed a lot of them. Soon Christianity was to replace rational classical thought with a personal and emotional philosophy. Hercules, the last hero of pagan religion, who had been a popular theme on sarcophagi, in painting, and in other branches of art,

is perhaps the nearest approach that the pagan world achieved to a Redeemer (cf. p. 125): hence the attempts of several emperors to identify themselves with his figure and to derive their power from him. But although Hercules was replaced by other Saviour figures, the traditional mythological framework, encouraged by official policy, continued to prevail, and so to preserve the basically Greek structure of late Roman art. What one sees, therefore, in the third century is not a violent artistic revolution but a slow process of significant change.

Sarcophagi

This process can be seen very clearly in the new ideas expressed on the finest of the third-century sarcophagi: the battle sarcophagus from the Ludovisi Collection (Plate 140), now in the Museo delle Terme. It dates from about 250 and is a revival of a type popular in the late second century (Plate 139) (cf. pp. 110–11). The composition is basically similar – a massed battle of Romans and barbarians covering the whole field in an elaborate tapestry – but the figures are fewer and the design simpler. The scene is dominated by the Roman general riding in the upper part of the relief. In style there are many contrasts with the earlier work: the faces are strikingly unclassical, and the technique of deep drilling is particularly obvious in the manes of the horses and the shaggy hair of the barbarians. But the main difference is in the symbolism. The barbarians all seem frozen in the moment before disaster and death overwhelm them; their attitudes are highly theatrical but none the less immensely expressive. The most striking figure is, of course, the general, who, unlike his Antonine predecessors, is not actually involved in the battle; instead he makes a gesture with his hand which is difficult to interpret but seems to be one of farewell. The main theme is no longer the glorification of military prowess but that of transcending the struggle, presumably conveying the notion of triumph over death. It cannot be denied that the twisting bodies of the Ludovisi sarcophagus are direct descendants of the Pergamene frieze, but there is nothing of epic quality in the tortured faces of the barbarians now: mobility, perhaps, but no heroics. The ugliness of pain and suffering is stressed by the dishevelled hair, the tormented eyes, the twisted mouth. Some of this effect must be won at the expense of organic form and rational relationship between figures.

Many of the finest sarcophagi, such as the fragmentary example with scenes from the life of a consul, hark back to Antonine designs, but the figures have a more monumental character. Similar ideas can be seen in the well-known lion-hunt series, the finest examples of which seem to belong to the second half of the third century. The hunt motif expresses the *virtus* of the dead man, which guarantees him immortality. Rather different ideas, although again stressing the theme of life after death, are embodied in the sarcophagi which show the deceased as a philosopher in the company of the Muses. In this series the persistent Roman aspirations towards the cultured life have become symbolic of the life of bliss in the next world.

Christian and Jewish Art

The ideas conveyed in these series of pagan sarcophagi are the result of the religious ferment of the age of anarchy. By contrast, the earliest Christian examples are generally very modest works, smaller in size and simpler in the relief work. Like the contemporary pagan versions they stress the theme of resurrection and life after death by means of themes taken predominantly from the Old Testament; popular subjects, which are also very common in contemporary catacomb painting (Plates 191 and 192), are the Good Shepherd, Daniel, Jonah, and the Three Youths in the Fiery Furnace.

The catacombs derive their name from the zone between the second and third milestones of the Via Appia. They are mostly situated along roads, generally for the first three miles from Rome, and are cut into the tufa. They vary greatly in size, but all consist essentially of a series of subterranean corridors with *loculi* for bodies cut in the sides and closed off by slabs; the body or coffin may also be placed in an arched opening known as an *arcosolium*. The corridors open out in places into chambers and galleries resembling the *hypogea* of pagan underground tombs. The catacombs were still in use in the fourth century, but after 400 became places of veneration of martyrs.

Artistically their importance is as an illustration of developing iconography. Painting is generally confined to limited spaces and is the work of modest artisans. The earliest paintings are to be found in the Calixtus, Domitilla, and Priscilla catacombs, some of the latest in the new catacomb on the Via Latina (see pp. 160–1). Sculptured coffins of the later third century have also been discovered. One of the earliest with a Christian theme, now in the Vatican (Plate 193), comes from a site on the Via Salaria, near the mausoleum of Licinius Paetus. It is a low box measuring 0.75 by 2.40 metres, with the Good Shepherd in the centre, seated philosopher figures on the left and a seated woman on the right with an orant and attendants. At the ends are two kneeling rams. The style is strictly classical, even closely inspired by Greek types of the fourth century B.C. The date is generally thought to be 250–75. Another contemporary sarcophagus (Plate 194) in the chapel of S. Maria Antiqua in the Forum Romanum, found in 1901, has for its central figure the dead man seated reading with an orant before him; his face has not been carved. On the right are a Good Shepherd and St John baptizing Christ; on the left is Jonah washed ashore, having been disgorged by a very classical *ketos*. The scene is broken up by trees, and the style is again inspired by classical models, with good use of the nude in the figure of Jonah.

In the late third century a number of sarcophagi of rather grander form were made in the West by craftsmen with close affinities to eastern workshops (Rodenwaldt, *Gnomon*, I, 1925, 123). One or two have Christian connections, but they seem to be chiefly pagan. One example in Villa Ada on the Via Salaria (*Repertorium*, no. 918) has husband and wife in the central niche, with a Genius in attendance, and other male and female figures in the side niches. The ornament is carved in the characteristic Asiatic technique.

Christian painting throughout the third century is generally rather humble in Rome, normally associated with simple architectural schemes, and usually confined to a single

chamber or to part of a chamber, especially the *arcosolium* above a sarcophagus. It is all funerary in character, and none is associated with places of worship (apart from that at Dura: cf. pp. 126, 133). Its general character can be studied in a series of approximately dated catacombs. The catacomb of Priscilla, originally separate but later joined to others, belongs to the early third century; the basis here is a simple design of architectural frames with little paintings, not predominantly Christian, subordinated to a pattern of geometric lines. As in house interiors, the artist seems to be mainly concerned with decorative effects, the creamy white ground being criss-crossed with thin red and green lines. The religious scenes in the catacomb of Praetextatus (the crypt of S. Gennaro) are among the best, on the favourite Old Testament themes. The latest paintings before the Peace of the Church, from that part of the cemetery of St Calixtus which is precisely dated to the period 308–9, belong to the earlier tradition of Roman decorative painting; in the *cubiculum* of the Five Saints is a series of orant figures arranged in floral settings.

There is not a great deal to be said about the style of early catacomb paintings. It can range from skilful classical modelling to a very inept and summary technique. In general there is a tendency to paint in the more racy and impressionistic style which had come into fashion in the later first century A.D. Unfortunately one is not always looking at work of high quality.

There are almost no Christian wall mosaics of this period to continue the series begun by one of the tombs in the Vatican cemetery (mausoleum of the Julii). On the vault is what is thought to be the figure of Christ with the attributes of the god Helios, the arrangement of the rays of the nimbus being an obvious allusion to the Cross (Plate 195). Christ is represented frontally in a chariot and framed by decorative, two-dimensional vine scrolls against a bright yellow background. There were other mosaics with Christian subjects on the walls of the same mausoleum, but this is the only well-preserved survivor of what must have been an increasingly popular method of decoration in Christian contexts.

One factor which comes out clearly in early Christian painting is that there was no fundamental conflict between Christian and pagan art: the only problem was the aesthetic one of adapting classical forms to works of the new order. It did not seem to the earliest Christian painters that any new style was needed. However, in the fourth century, as we shall see, there was a quite different attempt to express Christian ideology, especially the divinity of Christ. Wide-open eyes in a schematic design, an indifference to modelling and colour, a preference for surface effects produce a conceptual, rather than a visual, Christian imagery.

It is in this context that third-century developments in eastern art seem particularly relevant to the history of Roman art in general. We have already followed the early evolution of the Parthian style in painting and sculpture, and if there is no evidence that the East was a decisive influence on the development of the Roman tradition, at least we know that many artists from the oriental world came to the West and also that Roman artists were active in the Sassanian Courts. The synagogue at Dura Europos, excavated between 1932 and 1935, was rebuilt around 245. Its cycle of Old Testament paintings

(Plate 196) (cf. p. 133) has always been thought to foreshadow many characteristic elements of Byzantine art, and large claims have been made for Syria as the chief inspiration for the Byzantine development. This would obviously over-simplify the problem, but there is no reason to play down these eastern paintings as inferior provincialism; theirs is an assured style, of which the way the figures are presented is the most obvious feature – arranged, as it were, outside space, their positions defined strictly by their importance in the scene and by their moral rather than physical relationships. Colour is used principally to achieve emotional effects, and line is strongly marked at the expense of modelling. Perspective disappears altogether, and the classical figure types are strictly of the pattern-book variety, where a stock personage is used in several contexts. Spatial relationships disappear in favour of a two-dimensional structure. The handling of the figures in general has been called 'negative relief'.

When these characteristics are found expressed in such an unequivocal way, there can be little doubt that one must look to the East as one of the main influences on the development of late Roman art. But it has to be remembered that this evolution took place in the West, where other influences were equally strong, and also that it is to some extent common to other parts of the Empire. The mummy portraits of the Fayyum in Egypt may be taken as an example (Plates 197 and 198). As with the funerary art of Palmyra, the inspiration for a number of Egyptian centres seems to have been Roman, for none of the portraits is earlier than the conquest (although Pharaonic examples may lie in the background), and there are close similarities in style between the earliest examples of the first century A.D. and contemporary portraits in Pompeii. The mummy portraits range from the first to the fourth century and are generally painted in tempera or encaustic on wood or canvas. The stylistic range runs from what may be called the psychological realism of Campanian portraiture, which makes use of classical modelling and handles colour delicately, to the wide-eyed and hieratic expressionism of the latest examples, which directly face the spectator, very much as in an early Christian icon. The painting is dominated by line, and there is very little colour modelling, so that one seems to see in the Dura pictures and in the Fayyum portraits the same basic evolutions of artistic style. There is often a striking similarity between late Egyptian portraits and those of dead Palmyrenes.

THE TETRARCHS (A.D. 293–311)

The Imperial Image

THE Tetrarchy was established by Diocletian in 293, ten years after his own accession, in an attempt to bring order to the chaos of the Roman world; and nothing symbolizes its character more completely than the portraiture of the Tetrarchs themselves. It pulls together the whole history of the genre, which had always involved a search for a simple, straightforward imperial image, a search that gained momentum with the development of the imperial cult. The emperor had become an aloof, semi-divine figure, as much a symbol of the office as a human being. By his very nature he was identified with the virtues and superhuman powers on which the survival of the State depended. The quest for a single imperial formula has its roots in the cult of the *imagines*, and Augustus had come close to accomplishing it; but, as we have seen, later rulers, from Nero onwards, were side-tracked by Greek theory and sometimes by the more blatant aspects of hellenistic ruler-worship. Some emperors had resort to the features of their predecessors, and in the third century archaism was deliberately cultivated. Although the portraits on the earliest coins of his reign show markedly individual features (cf. p. 155), Diocletian and his advisers saw the need for a revived imperial image, and this gave birth to what is perhaps the most remarkable phenomenon in the history of Roman portraiture: the creation of a de-personalized formula – an imperial cult image achieved at the expense of personal identity.

In the portraits of the Augusti and Caesars of the Tetrarchy one type serves for all; its intention is to symbolize the simple, direct solidarity of Tetrarchic rule. On coins, the typical four-square cubistic heads sometimes look firmly forward and have all the appearance of a religious icon. Indeed, the famous *similitudo* of Diocletian and Maximianus, which makes it impossible to tell one Tetrarch from the other, is based on their shared divine essence. Very few Tetrarchic portraits, whether from the eastern provinces or the western, are great artistic achievements, but they represent the basis on which the imperial style of the fourth century was created. Then, the cult image was an established phenomenon.

It is often said that the portraiture of the emperors from 235 to 251 (Maximinus Thrax, Pupienus, Philip the Arab, Decius) represents a naturalistic or realistic reaction to that of late Severan times. The summary treatment of the hair and beard, the concentration on the eyes, the momentary expression, the intensity are almost Flavian. The style is found in Greece among the *kosmetai* at Athens (one dated 238–43) and on sarcophagi in Rome and Athens. The later portraiture of Gallienus introduces mannerisms based on earlier ones, especially in the treatment of hair and beard, and this, too, is seen in Greece and Italy. After Gallienus' death in 268 until the Tetrarchy the development

is a little obscure, which has led to some very complex theorizing; those who make the porphyry statues and heads the starting point for their assessment of the Tetrarchic style think of them as heralding a striking new direction, a kind of abstract symmetry with exaggeration of certain features, under the influence of oriental art. There seems to be a contemporary western manner which has some of the same features, especially the symmetrical form, but dwells much more on facial detail. The same contrast appears in the coinage, especially when the western mints before the establishment of the Tetrarchy are compared with those of the East. Can one distinguish phases in western Tetrarchic portraiture? It seems very difficult to do so at present.

Characteristic of post-Gallienic portraiture throughout the Empire is a tendency towards controlled form and strongly frontal pose, although there may be considerable modelling and detail in the features. The Tetrarchic formula survived into the fourth century, and it was not until Theodosius that a new image was evolved, typified by the lean, aristocratic, refined faces of Theodosius and his sons on the Madrid *missorium* (cf. p. 167) or the precise features of their portraits in the round. Sharp and precise, smooth and refined is an excellent group of Theodosian portraits, including one of Valentinian II, wearing elegantly draped tunic and toga, from the baths of Aphrodisias (Plate 258).

Public Monuments

Although Diocletian was only once in Rome as emperor, in 303, when he celebrated his *vicennalia* and his delayed Persian triumph, there was a great revival of public building during his rule. A remarkably long list of structures restored or erected by Diocletian in Rome includes the baths on the Viminal, a new building, and the Basilica Julia, a major reconstruction. The popular types of amenity building, *porticus* and *nymphaea*, were also put up. At the same time an enormous programme was undertaken at Nicomedia, where Diocletian himself lived, including a new palace complex; and he presented many new buildings to the city of Antioch.

A pair of bases now in the Boboli Gardens in Florence has been thought to come from Diocletian's triumphal arch, but some scholars have preferred to assign them to the time of Aurelian. The style has much in common with that of a number of third-century sarcophagi, and it would be hard to date the bases on such grounds; with their figures of Victories and captives, they are of a type long traditional for this kind of monument. A definite Diocletianic survivor is the so-called *decennalia* base found in 1547 not far from the Rostra in the Forum Romanum. It shows Victories and a shield, and on the other side the sacrifice of the *suovetaurilia*. The sculpture is of no particular interest, but the monument from which it comes must have been typical of the imperial commemorative art created by the Tetrarchs. This monument seems to have been the one erected by Diocletian behind the Rostra after the fire of 284 had destroyed one end of the Forum Romanum, and from it too apparently came a base discovered some fifty years earlier and another found in 1509. It is generally thought that there were five of these bases; as shown in the representation on the *oratio* relief of the arch of Constantine,

the monument had five columns with Jupiter in the centre flanked by figures of the Tetrarchs (Plate 199).

The statues were of porphyry, now one of the chief media for imperial sculpture. Its use in imperial art seems to have begun during Trajan's reign, to which a series of figures of captive Dacians has been attributed (cf. Plate 94). The earliest porphyry statues of men in Roman military uniform seem also to belong to this period or to the Hadrianic. The heads of classical figures such as the Athena at Bagshot House are in the same material, but it was more common at first, as in the case of the seated Apollo in Naples, the Dacians, and the Roman generals, for the faces and other flesh parts to be in white marble. This exotic stone seems to have acquired a special imperial significance in the time of the Tetrarchs; it was much used in architectural decoration at Split and in Rome (e.g. the Curia, the temple of Venus and Roma) and for imperial figures, which were now completely carved in it (cf. p. 151). The precise arrangement of the five statues on the Diocletianic monument is not clear, but it is suggested that the Tetrarchs stood in a line, with Jupiter in the centre, larger and nearer to the Capitol. The choice of a site in the very heart and core of Rome associated the new dynasty with the most venerable relics of the city and, except for the equestrian statue of Constantine put up in 334, gave the Forum Romanum its final shape.

The Tetrarchic monument belongs to a type which became increasingly popular in Constantinople from the time of Constantine onwards. The statue on a column had always been a Roman commemorative type, and in the late Empire it seems to have been revived, for there are many references to statues of emperors on shafts of porphyry or of marble elaborately decorated with coloured stone. These portraits were generally colossal and frequently of precious metal or stone combined with bronze; often members of the emperor's family accompanied him on adjacent columns – an arrangement that reflects the vastly increased formality of the relations between the ruler and his subjects, and perhaps also his growing remoteness from their everyday lives. In a similar way, a series of bases of appropriately different heights once supported statues of Diocletian and the members of his family on the façade of the palace at Split, at the entrance known as the Porta Aurea.

The revival of public building in Rome saw the creation of the baths of Diocletian on the Esquiline, the largest in the city, bigger even than those of Caracalla. Unfortunately, little is recorded about the lavish decoration of their vast halls, although it is known that there was a great deal of mosaic on the vaults as well as on the elaborate floors. Some of the many colossal statues were probably taken from other parts of the city – a practice that became common with the decline of classical sculpture and was general in the fourth century. Decorative *opus sectile* also seems to have come to the fore; walls covered with coloured marbles must have pleased the late Roman interior decorator. The best surviving examples seem to belong to the fourth century. For buildings, especially sculptured architecture, the stark black-and-white style had by now almost entirely superseded the organic decoration of earlier periods. The sculptors made extensive use of the drill, and there is a roughness and sometimes a carelessness in the execution, but, in the mass, the style can be very effective.

Art in the Provinces

The Tetrarchy was also responsible for an extensive revival of art in the provinces, largely owing to the creation of new imperial residences. The Augustus of the West lived at Trier after Diocletian's reforms in 286–7, in 287 Maximian celebrated his first consulate in the city, and after 293 Constantius Chlorus resided there as Caesar. As a result, a large number of public buildings and palaces were erected, and, although few have survived, what remains of the art of this period suggests that many craftsmen were attracted from all over the Roman world; for example one of the patterns of a very fine fragmentary geometric mosaic, found in 1935, which was probably made in this context, is almost exactly the same as one on a villa mosaic at Woodchester in Britain. One is reminded of the passage in the panegyric to Constantius Chlorus which refers to craftsmen being brought from Britain for the building of Autun.

Another imperial capital came into being at Salonika, where Galerius, the Caesar of the East, who had originally chosen Sirmium, spent much of his time. He erected a very impressive complex of buildings including a palace about which very little is known from historical sources but whose plan is being slowly established by recent studies. One partially surviving element of this great architectural scheme is a four-way triumphal arch, built in 296, from which a wide processional way flanked by colonnades ran northwards up to a great rotunda; to the south lay the palace and the imperial hippodrome.

The reliefs of the arch dealt with the Persian wars of the Tetrarchs. Only two of its four piers have survived; the north-east pier, which deals with the conquest of Assyria, and the south-west one, which is concerned with Armenia. Originally they bore statues of the Tetrarchs – Maximianus, Constantius Chlorus, Diocletian, and Galerius. The original arrangement of the sculptured scenes is problematic, but the following reconstruction has some logical probability: the impressive scene glorifying the

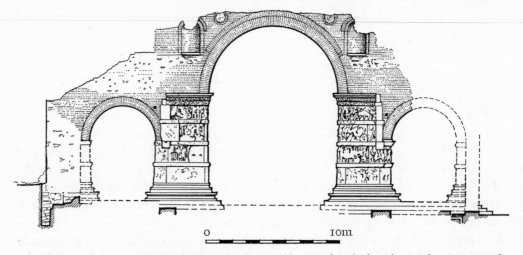

o 10m

Reconstruction of the arch of Galerius, Salonika, 296 (drawing by Sheila Gibson, after *Byzantinische Zeitschrift*, XXXVII, 1937, BSB B. G. Teubner Verlagsgesellschaft, Leipzig)

Tetrarchs might well have been on the right as one approached on the Asiatic side, and on the other side the Armenian campaigns on the right, with the lesser campaigns against Assyria on the left. The arrangement of the reliefs on the piers looks very strange at first sight and has little in common with that of Roman triumphal arches: they are superimposed, each depicting some significant event in battle or triumph and divided from its neighbour by a heavy decorative moulding (Plate 201). One wonders why this type of frieze, rather than the more traditional panel compositions, was chosen; the most likely answer seems to be that the sculpture belonged to the eastern hellenistic tradition. Indeed the reliefs sometimes look rather like a series of superimposed sarcophagi, although the elements of the iconography appear to derive from many different sources. In some cases one sees a method of representation which is closely related to the developments already noted in the coinage of the third century. The top register of the south-east face of the south-west pier is centrally organized, with the dominating figure of the Tetrarch in the middle and two registers of little figures offsetting the main group (Plate 200). In some cases, and especially in the battle scenes, the motifs seem to be taken directly from hellenistic battle pictures. The most likely explanation of the variety of styles is that artists were brought in from many different sources.

One of the most remarkable monuments in the whole of the Roman world is the fortress-palace which Diocletian built for his retirement at Split in Dalmatia, not far from the Roman city of Salona where he was born. The chief interest lies in the architecture: the artistic finds have been very disappointing. However, from the surviving remains it can be deduced that sculpture, mosaic, and painting all played their part in the creation of a setting for a remote and semi-divine figure. We have to remember that Diocletian, however down-to-earth in his political policies, was the first emperor to wear gems on his clothes and shoes and to surround himself with extremely elaborate protocol. The whole architectural design of Split reflects this. The formidable decoration of the Porta Aurea with its sculptured portraits in an elaborate architectural setting has already been mentioned. Inside the gates the approach to the palace is flanked by massive arcaded columns, and the entrance to the palace itself is dominated by a huge pedimented porch giving access to a domed vestibule in which mosaic and painting must have played a prominent part. The state reception rooms have not been preserved, but one can perhaps imagine the effects through what has survived of the decoration of imperial buildings at Trier and elsewhere.

Piazza Armerina

A complete contrast with Split is provided by the vast villa at Piazza Armerina in Sicily, which has been called imperial and attributed to the period of the Tetrarchs. Piazza Armerina obviously belonged to an important, wealthy man, and there now seems to be reasonably positive evidence for a date in the first half of the fourth century. H. P. L'Orange (*Symbolae Osloenses*, XXIX (2), 52, 114–25) has argued that it was built for or used by Maximian in retirement after 305, and his hypothesis is attractive. The villa certainly has groups of palatial apartments ceremonially arranged, and the magnificent

mosaics include some scenes which could be interpreted as referring to an emperor and even specifically to Maximian – the 'imperial group' in the corridor of the 'Great Hunt' (Plate 202), the *adventus* in the vestibule leading to the great court, the sacrifice after the hunt from the *diaeta* of the 'Little Hunt', and the whole cycle of the Labours of Hercules in the *triclinium* (Plate 203). A colossal head of Hercules was found in the excavations as well as a fragmentary inscription which might refer to Maximian.

The villa is loosely planned with three main blocks of buildings linked together and has much in common with the atmosphere of Hadrian's villa. Set in attractive surroundings, it seems to typify the ambitions of the late Roman upper class to possess 'a country estate, a house, gardens watered by clear streams, the soft glow of marble in contrasting shades'. To live in this atmosphere, as a late Roman epigram tells us, helps one to a quiet old age spent in turning over the learned writings of ancient masters. This had always been the ideal of the Roman aristocrat from Cicero onwards. The villa is outstanding for its mosaics, but because of the uncertainty of the dating they are still not securely placed in the history of Roman art: the only evidence seems to be a coin of Maximian in the mortar below the threshold of the baths. It seems probable that the floors were laid over a fairly long period, ranging from, say, 300 to 350. There are said to be 3,500 square metres of mosaic, most of it of very high quality. Three areas deserve special attention: the famous hunting scenes occupying the full length of the corridor of the 'Great Hunt', the Labours of Hercules in the 'trilobate hall', and the fine series of animal heads in the great courtyard.

The mosaics of Piazza Armerina gave a new status to the art in the Roman world, which it retained for most of the Byzantine period. Earlier floor mosaic, however technically excellent, had been largely derivative from painting, but here the medium itself seems to express directly the aims of the craftsman. The freedom with which the figures are distributed in the whole field of the 'Great Hunt' shows how the artists have broken with conventional restraints. Technique and style vary a good deal; in general line is combined with colour, but there is also modelling in shades of colour. On the whole, however, the mosaicists prefer a two-dimensional approach, combined with a modelling technique more appropriate to the medium than the use of very subtle tones. They constantly make use of foreshortening and perspective, sometimes to the point of caricature. It seems likely that they were from North Africa, where, as we have seen (cf. pp. 77–8, 127), a number of flourishing schools of polychrome mosaic had been established in the second and third centuries. There are striking parallels between some of the simpler work at Piazza Armerina and pavements in North Africa. This connection, and the subjects of some of the mosaics, have led scholars to suppose that the owner of the Sicilian villa was, in some way, connected with the trade in wild animals that flourished in the late Empire.

Of all the mosaic areas that of Africa Proconsularis in the third and fourth centuries seems to have harboured the most talented artists. Much of their work is, of course, derivative and based on standard patterns, but no one can deny the creativity of the man responsible for the floor with geometric motifs and Berber heads. Some North African designs seem to have become popular elsewhere – the rich foliate wreaths enclosing

heads, and so forth; others, such as the wild beast hunt with a rainbow frame, are surely copied from carpets. They have been compared with the fifth-century diptych of Adam in Florence (Bargello) for the way in which the figures are distributed, but seem to belong to the late fourth century.

Porphyry Sculpture

The official art of the Tetrarchs had a decisive influence. Its achievement is particularly clear in the realm of sculptured portraiture, where, at the expense of individuality, it contrives to bring order to the chaotic variety of nature by creating a firm generic shape so obvious that it has been called cubistic. The figures of two pairs of embracing emperors in porphyry at the corner of St Mark's looking towards the Doge's Palace (Plate 204) are known to come from Istanbul because of the discovery of a foot backed by a column that belongs to the group. Apparently they stood on corbels and seem to represent the Tetrarchs, but which? – the first or the third (Galerius/Licinius/Constantius/Maximinus Daia)? The style has been compared with that of coins of the East, especially those of Maximinus Daia from Alexandria. The red porphyry certainly comes from Egypt, and a striking parallel in the same material is the bust, a little over life-size, from Athribis in the Cairo Museum (Plate 205).

Even stranger are the two pairs of little figures attached to two columns in the Vatican Library (Plate 206), quaint, dwarf-like creatures in military dress, each with one arm flung round his companion and a globe in the other hand. There is no majesty here, but there is strength enough in some of the best Tetrarchic sculpture and a power which is generated by the very simplicity and directness of the style. The porphyry bust from Egypt with its sharp, precise, compact forms, its stern, clear-eyed intensity – the counterpart of the 'cubist' coin images – is a remarkable expression of the austere, uncompromising manner of the coins of the Tetrarchs. There is a fanaticism about some of the portraiture, as for example in the head of a Tetrarch in the Ny Carlsberg Glyptotek at Copenhagen or the Diocletian from Pestone in Sofia, which is prepared to reject the whole achievement of classical art even at the risk of occasionally falling into caricature. Inevitably its achievements, involving the deliberate choice of an imperial propaganda machine, were short-lived, but its influence can be seen in other branches of art.

Many people, as we saw, like to think of Roman art as giving way before abstract tendencies derived from the eastern provinces, and they even see the destruction of Palmyra in 273 as a key event in this process, pointing to the essentially anti-classical attitudes of Palmyrene sculpture. This interpretation is surely much too simple. In Roman portraiture, for example, there is always a tendency (except in the last decade of the Republic and under the early soldier-emperors of the third century A.D.: cf. pp. 17ff., 136-7) to stress the generic at the expense of the particular, and it merely becomes especially obvious at the time of the Tetrarchs. But there was also certainly a rejection of classical form and modelling which, although comparatively short-lived, can be seen in other branches of art, for example in the catacomb painting of the

cemetery of Priscilla. Here the figures are frontally rendered in a hard, linear style without classical form, and the main interest is in the faces, which, as in the group of Christ and the Apostles in the contemporary cemetery of the Iordani, have lively expressions firmly controlled within a simple organic form.

S. Costanza

Before Constantine Christian art is mainly interesting for its iconography. After Constantine it has greater variety, subtlety, and quality. The mosaicists transformed a decorative medium into a genuine art form expressing their faith. The mosaics of S. Costanza are still pagan in context – putti vintaging (Plate 207), roundels with heads, branches and utensils (Beckwith, 12, 13, plates 11–13). Those of the dome are lost, but the painting by Francesco da Olanda shows that the upper part of S. Costanza, probably built between 337 and 354, illustrated a new concept of decoration – just how new the dome would have revealed, with its river scene with putti fishing, below scenes from the Old and New Testaments in twelve panels separated by female figures and acanthus.

CONSTANTINE THE GREAT (A.D. 311–37)

THE reign of Constantine the Great is unquestionably the most complex in the history of Roman art. The legacy of the Tetrarchs, the interlude of Maxentius, the circumstances of Constantine's rise to power, the new official attitude towards Christianity, the creation of a capital at Constantinople (Beckwith, 33–4) – these are perhaps the key factors in the situation which can only be very partially understood from surviving works. There is still a good deal of controversy about dating in this period and indeed throughout the fourth century, and attempts to create simple artistic sequences on stylistic evidence have been singularly unsuccessful.

The arch of Constantine, designed shortly after the series of victories by which he overcame his rivals, is the key monument of the early part of the reign. The short rule of Maxentius was notable for a great deal of building activity, including the reconstruction of the temple of Venus and Rome and the erection near by of a vast new basilica designed like the *frigidarium* of one of the great imperial *thermae*. Maxentius, if he stood for anything, stood for the old Roman values, the traditional religion and way of life, and the reconstruction of the temple, with the rededication of the great Hadrianic cult statue, was a symbol. The confidence in the new order of the Tetrarchs was past; Constantine's attitude, like that of so many of his predecessors, combined a strong conservatism with an attempt to found his own new order, and the arch of Constantine is its embodiment.

The Arch of Constantine

Late antique art is often thought to begin with the arch of Constantine erected by the Senate in honour of the emperor between 313 and 315, and the monument is full of the strange contradictions that characterize the period. It is a highly successful architectural achievement, perhaps the best of the surviving Roman triumphal arches, and it has been much admired since the Renaissance for its harmonious design – particularly by painters, who often depicted it. This is the more remarkable because it incorporates the remains of at least three earlier monuments, and most of the architecture was also re-used. The use of older sculpture for new purposes was by now well established – statues of earlier emperors had been adapted by recarving or simply re-used *in toto* with a new inscription – but this was the first building so far as we know to cannibalize earlier monuments. It is important to understand the motives. One element is certainly the feeling that there were not available in Rome artists who could compare with earlier sculptors; but there is much more to it than this. The choice of monuments had to be appropriate to the image that the emperor wished to create, and it is not therefore surprising that he selected the 'Great Trajanic Frieze', perhaps from the forum of Trajan,

the roundels from some monument of Hadrian, and the panels from a triumphal arch of Marcus Aurelius; sometimes the heads of the emperors were recarved to portray Constantine, and the subsidiary figures also brought up to date.

The contrast between these earlier works and the Constantinian contribution is very marked. Some of the details, for example the roundels depicting Sol (Plate 209) and Luna on the short sides, are carved in imitation of the borrowed sculpture; and traditional also are the Victories and captives and soldiers on the plinths of the columns. Other imitative elements are the Victories in the spandrels of the central archway and the reclining divinities in those of the lateral passages. The main inscription over the central passage is on a large scale and beautifully legible. Only the narrow friezes beneath the Constantinian roundel on the short sides of the arch and above the lateral arches on both faces refer specifically to events in Constantine's career, and they are unquestionably the least conspicuous of all the sculptured details. The style, however, is distinctive and strikingly different from that of the rest of the sculpture. The best known scene is Constantine's *oratio* to the people from the Rostra. This long, narrow frieze shows the emperor surrounded by his entourage addressing the assembled Romans, who are strung out in two rows on either side of the central group. A rigid frontality dominates the scene, and the figures themselves, especially those of the audience, are utterly unclassical in feeling: the bodies are scarcely formed and the heads are vastly large in proportion. The method of representation is basically two-dimensional, so that the background figures are shown above those in front as a series of bigger disembodied heads. There is much the same feeling about the scene of *largitio* above the other arch on the same face (Plate 208). Here the emperor sits enthroned in the centre flanked by members of his staff, and adored by a group of larger figures. On either side the scene is divided into two registers by a strong horizontal line: above, within an architectural framework, officials distribute largesse, while below the assembled Romans, strung out in a line, look up towards them. Nothing could be less classical than the style and technique of the sculpture; but there is something very effective about it as a means of conveying the character of the occasion in each case. The battle and siege scenes on the other face of the arch are far less effective and by no means as convincing as the friezes of the arch of Galerius.

The style of the Constantinian reliefs from the arch of Constantine is generally believed to derive from that of the Tetrarchic period: there is the same disregard for classical proportions, and the same concentration of interest in the heads, which have the same simple stereotyped forms. The problem of the origin of this style has been much discussed. The heads re-cut on the Hadrianic roundels and on the 'Great Trajanic Frieze' – the earliest surviving portraits of Constantine in the round – also share with Tetrarchic sculpture the very dry modelling, simple structure, and especially big expressive eyes. On early coins, when he was Caesar, Constantine is shown as a rather thin-faced youth. When he became Augustus he began to look more like his father, with short hair, rather longer at the nape of the neck. His latest images are massive, remote, and impersonal. The coins are used to interpret the portrait in the round, yielding the traditional picture, with those on the arch representing him as young, and

the general development culminating in the colossal head (Plate 210) from the Maxentius/Constantine basilica, although the late date of the latter is by no means universally accepted (see *J.d.A.I.*, LXVII, 1952, 10–30).

The Imperial Image

The portraiture of Constantine is, of course, a subject riddled with controversy, and its problems are intimately linked with those of the portraiture of the Tetrarchs. Some of Constantine's early coins show him as very like the eastern Tetrarchs, with the features simplified and a rather exaggerated expression. But even under the Tetrarchs this style had not been universal; a coin of Diocletian struck in Rome in 393 seems to show the stern, relentless features of this soldier-emperor to the life, whereas a contemporary coin of Antioch has all the characteristics of a generic simplicity which seems to be a feature of eastern portraits; and certainly this style had spread to the western mints by the time of Maxentius. It is best seen in the long-nosed, big-eyed profile of Maximinus Daia from Antioch. Most scholars have seen the three-dimensional counterparts of this coin style in the porphyry figures in Venice and in the curious column-figures in the Vatican, with their generic form, minimum detail, and staring, intense expressions (see above, p. 151), and they believe that it is an eastern phenomenon which exerts its influence also in the West.

The general picture that we have of Constantinian portraiture is of a steady revival of interest in the individual, together with a more varied technique. As a result, many examples in a style which might seem more appropriate to the Trajanic or Antonine periods have been attributed, especially in the East, to a Constantinian revival. However, it is on the whole true that the Tetrarchic style tends to disappear in favour of a technique which involves skilful modelling and a much more sympathetic understanding of individual features. This is particularly clear in the heads of Constantine wearing a diadem, which he adopted after 326, where the artist dwells on the emperor's aquiline nose, jutting chin, and other well-known characteristics.

Certainly one of the most remarkable of all Constantinian portraits is the colossal seated figure (the head of which has been already mentioned) found in fragments in the apse of the basilica of Maxentius/Constantine (Plate 210) and now in the Palazzo dei Conservatori. It must have been set up in 313, when the basilica, built by Maxentius, was rededicated in the name of the new emperor. The problem is that the superhuman grandeur of the skilfully modelled head corresponds better with the concept of the emperor expressed in his later coins and seems to have little in common with the art of the Tetrarchs (cf. pp. 154–5). It is difficult, however, to compare these colossal heads with anything on a much smaller scale. Colossal statues had always approximated more to the cult image; the Julio-Claudian portraits from the temple of Rome and Augustus at Lepcis Magna (cf. p. 47) have much the same qualities as this enormously expressive head of the first Christian emperor. The Constantine is an experience; it is almost overpowering to come close up to one of the massive, fractured limbs in the courtyard of the Conservatori. The head, of course, is the most striking feature, its steady, frontal aspect

animated by a straight turn of the eyes to the right as though something had just caught its stern, unwavering attention. It is scarcely necessary to argue, as some have done, that it could be identified as Constantius II, or indeed that it is a later replacement, the original having been a rather hurried adaptation of an appropriated statue of some earlier emperor.

Painting and Mosaics

The colossal portrait of Constantine illustrates one most important aspect of official Constantinian art – the revival of grandeur and monumentality. This can be seen equally well in painting. One striking survival is the so-called 'Roma Barberini' (Plate 211), which seems to have been part of a group of Constantine and his sons painted for the Lateran palace. The picture has now been restored to show the rich colours of the drapery of the majestic figure of the goddess, who sits in solemn splendour; she is perhaps a version of the great cult statue in the temple of Venus and Roma which had been restored by Maxentius and was rededicated by Constantine in 314. The 'Roma Barberini' fits well into the scheme of Constantinian painting, which has been more clearly understood following discoveries at Trier beneath the double basilica erected about 326 on the site of what is now the cathedral, in a room which apparently formed part of the imperial palace. Panels with fragmentary paintings of female busts and figures of putti (Plates 212 and 213) can be reconstructed as a coffered ceiling. The three women, richly dressed and with haloes, have been interpreted both as portraits and as ideal representations. The style is classical, finely drawn and richly modelled in colour – comparable with that of the contemporary mythological wall painting in the Casa Celimontana in Rome (cf. p. 100: Plate 214) – and the figures are contained within a solidly painted architectural scheme. From other fragments it seems that the wall design was also architectural, with figures standing between columns.

The revival of a strongly painted architectural style in which the elements stand out boldly in line and colour and the subtleties of modelling are ignored seems to be typical of this period. The main paintings of the Casa Celimontana illustrate it most clearly (G. di S. Stanislao, *La Casa Celimontana dei S.S. Martiri Giovanni e Paolo*, Rome, 1894). The domed dining room has a strong architectural base, an ashlar wall with a series of pedimented frames, a frieze of acanthus above, a strongly defined coffered ceiling, and paintings of figures and decorative motifs both pagan and Christian. On one of the walls are an orant and other figures in frames. Although it occasionally uses earlier models, this is not really an illusionistic style but very much a style of 'painted architecture'; there are imitations of coloured marble, for example, without any intention to convey an illusion of reality. We have examples of such painting from all over the Roman world, including apparently Aquileia (the Constantinian basilica), Ephesus, and in Britain in the Kentish Roman villa at Lullingstone, where the famous figures of orants stand between painted columns. In the murals of the late second and third centuries, as we have seen, architectural structure had given place to a linear style that only vaguely recalls the structural forms of earlier favourites; now, under Constantine, both

in painting and in mosaic there was a revival of architectural form which gave new strength and control to figure painting, and often provided a literally monumental quality.

The decoration of the villa under S. Sebastiano on the Via Appia is typical of the linear style of the third century, based on the old proportions but now only delineated in greens and browns. It is closely matched by the walls of the *cubiculum* of the Good Shepherd in the Domitilla catacomb and strongly contrasts with later architectonic styles. Also interesting are the fourth-century paintings at Silistra on the right bank of the Danube in Lower Moesia (Plate 216): the *trompe l'œil* architecture, although meaningless, is powerfully presented, the figures are contained in firm frames, and the painted coffering preserves its architectural form.

It is sometimes argued that the revival of figured *opus sectile* is a symptom of a new attitude towards representational art. Coloured marble revetment had for some time been the chief medium for important interior decoration, as in the basilica at Trier, built between 305 and 312 when Constantine was there as Caesar, which also has mosaics above. In brightly lit interiors such as this the effect must have been very striking. But since the first century A.D. there had been, it seems, very little figured *opus sectile*: the few examples from Pompeii show figures often in *giallo antico* for the attractions of the yellow-brown flesh tints against a black ground (cf. p. 57). Its revival produced some of the most famous instances of the technique, the best known from the basilica of Junius Bassus on the Esquiline, which seems to have been put up in 330 as a kind of reception hall by a man who had been consul in 317. Its decoration is known from numerous Renaissance drawings and from some surviving fragments. In one picture (Plate 215), the consul appears in a chariot which faces the spectator in a manner now established in late antique art; he is accompanied by four horsemen in the garb of the four circus factions. There are also two splendidly effective scenes of a tigress attacking a calf and a lively classical mythological representation of the Rape of Hylas, which is handled with a fine vigorous touch. The decorative detail stands out strongly and precisely.

Scholars who take the view that the basic change in late antique art is from a three-dimensional 'classical' approach to a two-dimensional 'medieval' one find the style of this *opus sectile* and contemporary wall mosaic symptomatic. The development is closely linked with the new concept of internal space, on which Roman architects had concentrated since the mid second century; some of their most daring innovations were in the field of centrally planned buildings. The purpose of interior decoration is not to fill space but to adorn it, and we find mosaic and *opus sectile* enhancing the complicated shapes developed by the use of concrete. The outstanding examples of vault mosaic from this period are those on the central rotunda and the barrel-vaults of S. Costanza, which seems to have been the mausoleum of Constantina, the daughter of Constantine (cf. p. 152). The former were Christian, the latter derived from pagan symbolism, especially associated with the god Dionysus. Wall/vault and floor mosaic had had a very different history, as we have seen, but in the Constantinian period the two seem to have come together, and there is a striking similarity between the mosaics of S. Costanza and floors of the same time, except perhaps that the walls and vaults continue to be richer in

their colour schemes, with greater use of coloured glass. What is common to both is a new firmness of design. This is particularly clear in the basilica at Aquileia built by Bishop Theodore after the Edict of Milan (Plate 217), where the simple and consistent figures contrast strongly with some of the decadent classical forms on contemporary and earlier floor mosaics. At Aquileia, for example in the great fishing scene, there is little attempt to represent a third dimension, but the distribution of the figures over the surface is completely coherent and confident. The same characteristics can be seen in the vault decoration of S. Costanza, where the designs seem to be derived from such earlier mosaics as the 'Unswept House' of Sosos (cf. p. 37); but there is again no attempt to show depth or to create an illusion. The forms are strictly two-dimensional and the richness and subtlety is all in the brilliance of the colour.

A very fine floor of this period is a large (7 by 5.15 metres) composition of vine branches with the Punishment of Lycurgus in its centre (Plate 218), now in the museum of Vienne: it was found at Saint Romain-en-Gaul early in this century. The decorative effect of the rich black-and-brown leaves and stems against a green background is most successful, and the strength of the design, as in all the best all-over late Roman mosaics, derives from firm outlines and skilful use of colour.

It must be remembered that there is no common Constantinian style throughout the Roman Empire in mosaics, or indeed in any other artistic medium, but there does seem to be a genuine artistic revival in many of the chief art centres. No contrast could be greater than that between the mosaics at Aquileia and those from the near-contemporary villa at Daphni by Antioch which were excavated in 1935 and are now in the Louvre. Here we have an elegant, flowing hellenistic style with a rich naturalism of detail contained in a strong architectural framework, rather like that of the Constantinian paintings from Trier. A number of other Antioch pavements show the same revived sense of architectural form.

Christian Sarcophagi

After the Peace of the Church, the opportunity for the creation of ambitious works of sculpture with Christian subjects developed rapidly. A fine sarcophagus (Plate 219), transitional between pieces of the third and of the fourth century and now in the Vatican, carries large-scale episodes from the story of Jonah, with other biblical scenes on a miniature scale fitted into the interstices. A number of more pretentious sarcophagi of the first half of the fourth century following a kind of mixed pagan/Christian tradition are decorated with narrow superimposed rows of figures enacting scenes from the Old and New Testaments. One example, on a fragment in the Villa Doria Pamfili, shows in the right-hand half of the central group a consul being married according to the pagan rite with Juno Pronuba/Concordia presiding (Plate 220). The figure of the bride, once on the left, is lost; and the group has been wrongly restored as a sacrifice with altar and patera (R.M., LXV, 1958, 100 ff.). On either side of this central group were biblical scenes in two superimposed rows in the characteristic figure style that is shared with the narrow friezes of the arch of Constantine. Another well-known example, now in the

Vatican, shows a husband and wife in a roundel and two registers of figures in a very positively and no doubt purposely ugly style, which reminds one of that on Tetrarchic public monuments. The handling of the nude figure is particularly unpleasing, and there seems little doubt that Christian sculptors were deliberately reacting against the canons of classical art.

On a splendid fourth-century sarcophagus in the Vatican (Plate 221) three representations of the Good Shepherd motif stand on decorated bases, one at the centre and one at each end; the rest of the field is occupied by putti vintaging. The short sides are divided into two zones with the seasons illustrated by various rustic activities. Most of the twin-zone sarcophagi seem to belong to the fourth century; one in the Vatican (*Repertorium*, no. 39: cf. above) with its ugly heads must be among the earliest, while the much more plastic example in high relief and with fine proportions should be later (330–60?); it comes from the cemetery by S. Paolo fuori le Mura and was for some time below the altar of the tribune of the church. Columnar sarcophagi were also produced throughout the fourth century, their architecture usually quite ornate and precisely dividing the scenes. The more imaginative settings of the end of the fourth century were perhaps inspired by Roman historical reliefs, since the various versions of the Egyptian army in the Red Sea (Plate 223) remind one of Maxentius' troops engulfed at the Milvian Bridge on Constantine's arch (Plate 222). Strigillated sarcophagi often have orants or Good Shepherd figures. They are sometimes designed in two registers.

The grandest of the architectural sarcophagi, here with the two registers of figures, found beneath the high altar of St Peter's in 1595, has an inscription reading IUN BASSUS V(*ir*) C(*larissimus*) QUI VIXIT ANNIS XLII MEN II IN IPSA PRAEFECTURA URBI NEOFITUS IIT AD DEUM VIII KAL SEPT EUSEBIO ET YPATIO COSS (A.D. 359). The figures appear in a magnificently rich *scaenae frons* with decorated and fluted columns (Plate 224). A youthful Christ sits in the centre of the upper register with *caelus* personified below the vault of heaven. The rest of the scenes are from the Old and New Testaments. At the sides, the two zones again have Seasons/putti engaged in various rustic activities. A number of other sarcophagi show a similar taste for rich and solid architectural form.

The earliest Christian columnar sarcophagi appear around A.D. 300 with the double-register variety (cf. Junius Bassus, which is rather later). The 'city gate' form has a series of gates, walls, and towers forming the background above the heads of the figures. One of the best-known examples, in S. Ambrogio in Milan (Plate 225), has on front and back scenes of Christ flanked by the Apostles. It is carved on all four sides and on its gabled lid.

It is generally true that there is a close relation at this time between pagan and Christian monuments. The iconography of Constantinian art was much concerned with the political activities of the emperor, and when official workshops took over Christian themes it was inevitable that they should adopt the same kind of artistic language to represent Christ on the throne or Christ confiding the scrolls of his laws to St Peter (*traditio legis*). Some subjects can be matched on pagan triumphal monuments; for example the Entry into Jerusalem is related to the *adventus* of the emperor, and the

Magi of the Adoration may be inspired by figures of barbarians submitting or presenting gifts. Christian art is also very strongly influenced by imperial portraiture. Roman official iconography had always concentrated on the type, and Tetrarchic artists, as we have seen, tended to neglect personal characteristics and to concentrate on the formulae; the individual was much less important than what we may call his 'emperorship'. Now, imperial effigies were used as Christian models, and a number of ideal types for Christ and the Apostles were based on pagan portraits of the period.

Thus the imagery and the artistic repertoire of Christian art in general continued to be closely linked with those of pagan narrative art. Representations of the childhood of Christ were connected with Dionysiac imagery, and various other themes were appropriated. Only when the artist attempted to express dogma through the medium of classical art was he much less successful: the Trinity is not well symbolized by three separate, but identical, figures of classical inspiration, and different images are not always effectively juxtaposed.

Catacomb Painting

No painting from early Christian basilicas has survived, and we are still dependent on the catacombs and a few provincial works in trying to assess the development of early Christian iconography. The paintings of the *cubicula* of the Coemeterium Maius and of the catacomb of SS. Peter and Marcellinus belong to the period. The Mother and Child of the Coemeterium Maius (Plates 226 and 227) are still fully modelled in the classical manner, but there is a new and very powerful expressiveness in the features which must derive from contemporary monumental Christian work. Also outstanding in this style is the praying woman from the catacomb of Thraso, with her huge, intense eyes and mysterious expression, that seems to introduce a completely new atmosphere (Plates 228 and 229). By contrast, other contemporary work is closely inspired by pagan art. In the recently discovered catacomb by the Via Latina the subjects and the symbolism combine pagan and Christian themes. A number of pictures show Labours etc. of Hercules – one room is entirely devoted to him (Plate 230) – and there is also the famous scene that is best called the 'Medical Class' (Plate 231) but has also been interpreted as Aristotle receiving a demonstration of the immortality of the soul. Some of the biblical subjects (Plates 232 and 233) come from the developing repertoire which possibly derives from contemporary manuscript illumination, and these, too, are closely connected with models from classical literature and mythology. The Crossing of the Red Sea (Plate 232) and the Raising of Lazarus have affinities with pictures in the earlier of the two Virgil manuscripts (cf. p. 165).

The Via Latina catacomb, found in 1955, is very regularly planned, especially its western section, where a series of chambers and galleries open out from one another. Some of the *cubicula* have a massive architectural frame (e.g. the columns in the corners of B, D, I, and N), but the predominant impression is that of the painting which covers almost every wall, giving the effect of 'una pinacotheca cristiana del secolo iv'. There is originality in the subjects chosen and a strength which is largely derived from the firm

architectural framework. Most of the pictures are frescoes in mineral colours, some shades being added in a double layer of plaster. The ornament is brownish-red, yellow, and green. The architectural frame is mainly quite solid, with some good imitations of coffered ceilings containing figure motifs, but the old fine line style also survives. One quite new scene is that of the Sermon on the Mount (Plate 233) in *cubiculum* A, in which all heads are turned three-quarters towards the spectator, and the right arms are raised in a gesture of adoration. Jesus, with arm outstretched, addresses the crowd from a rock above (cf. the *adlocutio*). The Egyptians in the Red Sea appear as Roman soldiers. The repertoire is very rich, and the designs are much more ambitious than in the other catacombs. Sala N in the western part is in many ways the most interesting. It is rectangular, with four columns at its corners, and has a richly coffered vault and *arcosolia*. Its subjects are completely pagan, a whole cycle of Labours etc. of Hercules. In *cubiculum* O next door is Abundantia symbolizing fruitful love. About 410 is the lower limit for burials in catacombs; but this one was somewhat earlier. It was probably a private burial place for a small group of families, perhaps some pagan and others Christian.

The range of biblical themes is most important. Old subjects are the Sacrifice of Isaac, the Fiery Furnace, Adam and Eve, and Lazarus. Some of the new ones had appeared on sarcophagi, for instance Lot, Bethel, the Crossing of the Red Sea, and the Sermon on the Mount, and the others presumably came from the developing repertoire of church painting, as we know it from St Ambrose and St Paulinus of Nola. Did the pictures possibly derive from an illustrated *codex* of the scriptures? No such *codices* of the fourth century have survived.

Constantinople

It seems clear that the period of Constantine was full of contradictory influences. There was certainly a revival of classicism which showed itself from the very first and culminated after 328, when the emperor attempted to create what was literally to be a New Rome in Constantinople. For this purpose statues and other works of art were brought from many places, and buildings with Roman names were erected throughout the city and appropriately decorated. Classical statues were adapted as portraits of the emperor. But if the classical traditions were still a vital influence on the development of art, certain unclassical trends continued to evolve and can be seen especially in the catacomb paintings and Christian funerary sculpture.

From 323 Constantine reigned supreme, and on 11 May 330 he dedicated his new capital of Constantinople (Beckwith, 33–4). The Tetrarchies had been administered from a number of places in the Empire – Trier, Milan, Sirmium, and Nicomedia; but none was adequate to serve a single emperor. That emperor was now an oriental despot, and his chief problems, as well as his chief support, lay in the East. The choice of Constantinople fulfilled his requirements.

In his new capital Constantine determined, as has been said, to create a New Rome; he divided the city into fourteen regions and put up buildings which bore the same names as those in the West. Unfortunately, we do not know very much about

Constantinian art in Constantinople. We hear of triumphal paintings placed over the gate of his palace, we are told of his statues with their characteristic heavenward gaze, of a mosaic of the Cross in the palace hall, and of portraits of Christ and the Apostles which were by no means universally approved. After 328 Constantine completed the hippodrome and adorned it with bronzes. In his new forum stood a porphyry column with a figure of himself as Apollo. The shaft survives in a badly damaged condition, and the base appears in a drawing by M. Lorich in the Freshfield Album which portrays strictly symmetrical scenes with Victories carrying trophies and leading in captive barbarians on either side. An *imago clipeata* of the emperor appears in the field above, and what seems to be a figure of Constantinople is seated below. There is some doubt about the reliability of this drawing, although the artist was normally a 'faithful delineator' (see *J.d.A.I.*, LXXX, 1965). Constantine put up a number of buildings in association with his forum, calling them Senatus, Regia, etc., although they do not seem to have been imitations of the famous Roman originals.

Almost nothing of these Constantinian works has survived. Brief descriptions of some of them include Eusebius' account in his Life of Constantine of statues of the emperor over the entrances to palaces which showed him gazing heavenward and stretching out his arms in prayer. There are possibly one or two surviving fragments, for example the mannered relief with a figure of Victory from the Hunter's Gate in Istanbul, its drapery folds close set and rather stiff, which has been compared with contemporary work in Rome and attributed to metropolitan craftsmen. Constantine must indeed have recruited many sculptors from the West, just as he brought works of art from all over the Empire to adorn his new capital. His edict to the praetorian prefect in 334 asks him to encourage men 'who are about eighteen years old and have a taste for the arts' by offering immunity from taxes to them and their parents. A further edict of 337 offers wide exemption from public service to those learning the arts and crafts. All the public places were richly decorated with sculpture and painting: a famous statue of the Good Shepherd adorned the fountain of a public square, and all the new architectural designs made considerable use of figure sculpture. We hear, too, of works of art designed for specific purposes, as for example the gilt wooden statue of Constantine which was made to be paraded round the city on the emperor's birthday.

THE FOURTH CENTURY AFTER CONSTANTINE
THE GREAT

THE century after Constantine forms the epilogue to the study of Roman art and at the same time the prelude to the Byzantine age. Historically, it is marked by the wave of Germanic invasion which resulted in the ultimate downfall of the western Empire. Internally, the history of the Roman State is dominated by that of the Church, especially by attempts to defend its unity against heresy. Only one emperor, Julian (361–3), was a non-Christian; the rest frequently intervened in matters of religious controversy, so that those issues became political ones as well. It was Constantine who convened the Council of Nicaea in 325; later on Constantius II supported the Arians and Julian proclaimed equality for all religious creeds, thereby putting pressure on the Christians, which did much to close their ranks. After Julian the Empire was divided, with Valentinian ruling in the West and Valens in the East. In 378 Valens died and Theodosius I succeeded, and orthodoxy finally prevailed at the Council of Constantinople in A.D. 381. In 410 the Goths, who had been halted on the outskirts of Constantinople some years before, sacked the city of Rome.

The main interest in the study of Roman art in the fourth century centres on the development of Christian themes in sculpture and painting; the evolution of a courtly art reflecting the new attitudes towards imperial majesty; and the attempts, especially amongst the aristocracy of Rome and the East, to preserve pagan thought and art in the face of change. In religious art we move much closer to a Byzantine conception. The old Christian repertoire of pastoral scenes, with vignettes of the Good Shepherd in essentially Graeco-Roman ornamental settings, proved inadequate, and the wider biblical field was entered. The most significant innovation is the practice of displaying portraits of saints to which a special sacredness became attached – i.e., the introduction of the icon. In the realm of Court art the changing attitude to the emperor is seen in the rigidly hieratic arrangement of figures in ceremonial scenes, and in the increasingly remote and formal imperial portraiture of the late fourth century. The continuation of pagan traditions is best studied in the luxury crafts, especially in ivory carvings, silver work, and illustrated manuscripts, which in technical ability and artistic creativity surpass the work of earlier periods, and reflect the struggle put up by the aristocracy of Rome to defend its ideas and beliefs in a Christian Empire dominated by the military and by the presence of the emperor. This attitude of mind – demonstrated also in the wealthy villas of Gaul and Britain – was alien to some of the eastern emperors. The accession of Valentinian in 365 was a particularly significant event; the old aristocracy was repugnant to him, and his reign was darkened by murder and intrigue. Although he never visited Rome, he did try to save the public buildings of the city from looting by its own inhabitants.

Classicism

Any attempt to label the phases of artistic development during the fourth century is bound to be unsuccessful. There are certain general trends in Court art which can be clearly followed; but the styles which involve more or less imitation of earlier periods do not fall into any sequence or pattern: one object may show obviously classical features, whereas a contemporary work has all the characteristics of later Roman formalism. Nor is it easy to distinguish between the output of the eastern and the western provinces. Constantinople was, generally speaking, the main creative centre, but the western capitals probably dominated the field of the luxury arts, producing the finest ivories, silverware, engraved gems, and so on.

The problems of defining stylistic periods are well illustrated by the study of a number of works of art which reflect the kind of mannered classicism that has been associated with the period of Constantius II. It appears on coins and in bronze-engraving and can be related to sculpture and other objects, but it is difficult to be sure that this identity of style implies that the various works are contemporary. A coin minted at Aquileia shows a lively Constantius in vigorous movement grabbing the hair of a diminutive barbarian; his rich drapery swirls about him, and he moves with genuine life, although his head is far too large for his body and his body for his legs. The barbarian lady who kneels before him is the very image of a hellenistic Nymph. There is a good deal of this style in the famous Seasons sarcophagus now in Dumbarton Oaks (Plate 234), which has deservedly been the subject of a long monograph. It is the monument of a husband and wife of the old Roman aristocracy who still had a taste for rich classical modelling and for decorative prettiness; and the sculpture achieves a certain elegance which is found in much earlier work. It is possible to make comparisons between this style of the time of Constantius II and, for example, the mosaics of Piazza Armerina, especially the one with the scene of the children hunting, or the splendid agricultural mosaic at Cherchel. But the work at Piazza Armerina seems to be dated on archaeological grounds to a somewhat earlier period, and the date of the Cherchel floor is highly controversial. It seems likely therefore that this rather mannered classical style could have been employed at any time during the fourth century, and no attempt at precise dating can be made.

Before considering the development of official art and of Christian themes, it may be best to look at a number of media which demonstrate the persistence of classical iconography and style. The famous calendar of the year 354, although we know it only at third hand from a seventeenth-century copy of a Carolingian version, provides vivid proof of the survival of pagan festivals and consequently of pagan beliefs and artistic representations. The calendar was a New Year's gift to a Roman named Valentinus, and the original scribe was a certain Dionysius Filocalus. Pagan allegory is used throughout to illustrate the months and the days, and there is an elaborate title page with personifications of the four main cities of the Empire. The pictures are usually arranged in rich classical architectural settings of the kind which later became an essential part of courtly representation. In the calendar, although the figures are generally shown in

frontal pose, there is none of the rigidity of later imperial images, and the classical inspiration continues to be strong. The main feature, however, is the living force of the pagan imagery, which a hundred years later would largely have lost its meaning.

Luxury Crafts

The whole field of ancient book illustration opens in the fourth century, revealing glimpses of a long earlier tradition (Beckwith, 17–18). The codex had by now largely superseded the roll, but the illustrated book remained something that few could afford. That several examples have survived is explained by the fact that this was an age of luxury. The so-called Vatican Virgil (Cod. Vat. Lat. 3225) has forty-one miniatures of the Aeneid by at least two hands (Plate 235) (J. de Wit, *Die Miniaturen das Vergilius Vaticanus*, Amsterdam, 1959). The ten pictures of the *Vergilius Romanus* (Cod. Vat. Lat. 3867) (Plate 236) are very different in style – strikingly unclassical in their stiff figures – and were perhaps painted outside Rome. The *Ilias Ambrosiana*, which has been dated to *c.* 500, has fifty-eight miniatures (Plates 238 and 239), presumably all by the same hand, but inspired by originals of very different schools. The influence of Roman triumphal art and of hellenistic pictures is obvious in some of the scenes (R. Bianchi Bandinelli, *Hellenistic-Byzantine Miniatures of the Iliad*, Olten, 1955). The earliest Christian miniatures, those of the Quedlinburg Old Testament (Plate 237), which are painted in fine ornamental classical style, date from the fourth century (H. Degering and A. Boeckler, *Die Quedlinburger Italafragmente*, Berlin, 1932).

Luxury craftsmanship, whether in the service of individuals or of the Church, consistently illustrates this marriage of pagan and Christian. The superb quality of many works of the 'minor arts' raises them to the status of primary artistic documents. Ivory carving is especially characteristic of the time (Beckwith, 20–1). One of the finest and earliest Christian ivories is the so-called Brescia casket (Plate 240), an oblong box richly carved with figures in relief in a delicate miniaturist technique. On the lid are episodes from the Passion and from the Old and New Testaments, and heads of the Apostles; the religious scenes on the main body of the box are very finely carved with a keen narrative sense and a fine command of composition. The casket was probably made in Milan, and the basic style of the figures is classical, elegant and simple, if rather lacking in punch. The Apostles are stern and noble figures with classically symmetrical features.

The series of consular diptychs begins about the same time, the finest being carved in ivory or wood. The use of ivory and gilt was forbidden to anyone except consuls by a law of 354, which gave them the sole right, generally exercised on the occasion of their entry into office, to give 'names and portraits engraved on gilt tablets of ivory as presents to provinces, cities, Senate, magistrates, and people'. The finest of the diptychs were presented to the emperor himself. One of the earliest with figures of the donor is that of Stilicho and his family (Plate 241), richly draped and portrayed in a graceful, if rather elongated, manner within an architectural frame; the faces are serene and expressionless and firmly confront the spectator. It has been suggested that the style is an east-Roman one.

The commemorative diptych gave the great pagan families of Rome the opportunity to express their beliefs (Beckwith, 35–7). The reliefs of one believed to have been made to commemorate a dynastic marriage between the two great families of the Nicomachi and the Symmachi, elegantly carved in hellenistic style, show women sacrificing at rustic altars (Plates 242 and 243). One of the panels is in the Cluny Museum in Paris, the other in the Victoria and Albert Museum in London. The Cluny piece, although less well preserved, is particularly fine. The consular diptych of Probus (A.D. 406) (Plate 244) has figures of the emperor Honorius in military costume, obviously copied from statuary. A very fine leaf from a diptych in Milan, probably of *c.* 400, is carved with a religious subject (Plate 245): above is the Holy Sepulchre with the soldiers falling down in fear; below are a seated man and adoring women at the door of the Sepulchre. The modelling is subtle and sensitive, and the figures in general reproduce late classical models; the ornamental detail is very Greek in spirit and execution. A typical scene occurs on another leaf of a diptych in Brescia: a magistrate presides at the Circus in a stiff, hieratic frontal pose over a race of *quadrigae* with big men and little horses in a curiously contrived slanting perspective. It is often very difficult to date these ivories with any precision, especially those which copy, or are inspired by, older themes like the apotheosis shown on a diptych of the middle of the fourth century.

Grand cameos were much prized among Roman imperial families, who gave them as presents to each other and to friends and high officials (Plate 246). They have, from the first, their own iconography, full of references to the divinity and status of the emperor, celebrating especially imperial marriages, the prosperity of each new rule, the emperor's victory, his godhead. Constantius II for example appears with his wife on the Rothschild Cameo in the Rothschild collection in Paris (E. Coche de la Ferté, *La camée Rothschild*, Paris, 1957; Beckwith, plate 62). There are striking analogies in form and subject with the dynastic cameos of the hellenistic ancient world. This art, which had flourished in the early Empire, received a new lease of life in late antiquity.

The earliest contorniates, medallions in a framed border, were struck around 360 and are of high quality and skill. They were probably made for the wealthy families of Rome, as were silver dishes and the diptychs (A. Alföldi, *Die Kontorniaten*, Leipzig, 1943). The later ones are cheap, mass-produced objects. Some of the early ones have obverse heads of Alexander, others have Roman emperors going back to Nero. Later we get philosophers and poets, among them Homer. Larger contorniates are also found. In the fifth century they seem to have become imperial medallions. The reverse types include Alexander scenes, religious pictures, especially gods and goddesses, mythology and legend, romantic references to Rome's past history, and circus and amphitheatre and other games.

The glass Lycurgus cup in the British Museum is a rare example of the 'cage cup' (*diatreta*) technique with figured decoration (Plate 247). The story is that of the wild king of a wild Thracian tribe who persecuted Dionysus and was destroyed after being entangled in the branches of a sprouting vine (cf. p. 158). It is, no doubt, a subject that had been popular in sculpture and painting for a long time, but it seems to have been particularly so in the late Empire and to have acquired a specific symbolism. The figures

here stand out in high relief and are deeply undercut. There is a splendidly confident disregard for classical proportion, but a wonderfully lively presentation of figures in action and a fine expressiveness about the faces – the tortured, frustrated Lycurgus, the stern, implacable Dionysus, the gaily abandoned Pan and Satyr. It shares with so many other works of the period in ivory, semi-precious stones, and silver a quality of technique, and at the same time a feeling for the subject, which raise it into the category of an artistic masterpiece.

In the atmosphere of the fourth century the luxury craft of the silversmith produced masterpieces of the highest quality (Beckwith, 21–2). Silver had long been a medium for artistic representation; and now the Roman treasures of the fourth and fifth centuries were endowed with some of the finest examples of the art ever made. Silver plate was often given by Roman emperors to officials and friends on the occasion of imperial anniversaries, and some of the best pieces must have been made in the Court workshops for this purpose. The treasure found on the Esquiline hill in Rome throws light on the relationship between pagan art and Christian beliefs at the time; for although the owners were Christian, the subject matter is almost entirely pagan. The casket of Projecta (Plate 248), which illustrates scenes of her toilet as a bride, is decorated in fine repoussé, a technique which had largely gone out of fashion, but was now most successfully revived. Projecta's cosmetic box is decorated with figures of Muses, and in general the ornament derives from classical prototypes. In other treasures there are magnificent examples of the use of gilding and niello combined with engraving to produce pictures on plate, the inspiration for which seems to have been the hellenistic style. The Corbridge *lanx* (Plate 249), an enormous picture dish with scenes from the worship of the god Apollo, has been associated, perhaps with insufficient reason, with the pagan revival of the period of Julian. Another early example of richly decorated plate with pagan scenes is the jugs from the treasure of Traprain. Scenes from the Old and New Testaments are often represented, and figures of Christ and the Apostles occur frequently.

Perhaps the most famous piece of fourth-century Roman silver (Plate 250), the big dish now in Madrid which was made for the *decennalia* of Theodosius I in 388, illustrates the direction taken by official art in the late fourth century (cf. p. 146) (Beckwith, 34). The emperor is shown in a rich architectural setting together with his sons Arcadius and Valentinian III. The serenely classical figures appear in strict hieratic frontality, the formality also being stressed by the sharp, linear style of the drapery and the manner of wearing the toga. The main features are precisely outlined, the eyes are big and open, and the hair is almost archaic in its simplicity. The extravagance of late Roman silver outshines that of all earlier periods. The rectangular *lanx* (Plate 251) found at Kaiseraugst in Switzerland in 1962 is an outstanding example of its exquisite technical virtuosity and cultivated richness; openwork frame, niello figure work, gilding, and engraving produce rather surprisingly a satisfyingly splendid ornamental piece. The treasure to which this belonged, which dates from the middle of the fourth century, contained many other fine examples of late Roman silver (R. Laur-Belart, *Der spätromische Silberschatz von Kaiseraugst*, Basel, 1963).

Imperial Portraiture

The figures on the silver dish of Theodosius I have their counterpart in sculpture in the round; and these later-fourth-century portraits are among the finest achievements of the period. Sculpture had been the art of the old pagan world and now had little place in church architecture, but the conditions of commemorative and funerary portraiture continued. There was now an increasing tendency for certain features – the eyebrow ridge or the eyes – to be simplified or accentuated in order to increase the impact or expressiveness of the face, and for the drapery to be formal or rigidly patterned. Personality does sometimes shine through, as in the portraits of the emperor Julian, and there is a splendid clarity and strength about, for instance, the Arcadius from Istanbul wearing a diadem of pearl. Some emperors seem to have aped earlier styles; Julian wore a beard, and his likenesses often hark back to the bearded emperors of the second century. On the other hand Valentinian I on his coins has an impersonal image, which also serves for Valentinian II and Valens; and although it is usually possible to identify a fourth-century portrait as an emperor, it is often very difficult to decide which one, as in the case of the bronze colossus from Barletta. In 390 a marble statue of Valentinian II was set up in the Hadrianic baths at Aphrodisias (Plate 258) (cf. p. 146) with a pendant of Arcadius. Valentinian has a severely classical pose and rich, formal drapery, the head is precise and symmetrical, and the whole feeling recalls Greece in the fifth century B.C.

The essential character of imperial portraiture in this period may be judged from a coin of Valentinian I and Valens, emperors of the West and the East respectively, which was struck at Trier (367–75). They are enthroned side by side, identical in dress, gazing like icons straight before them, their hands joined on a globe above which hovers the figure of Victory. The big, staring eyes and the repeated drapery patterns stress the symbolic character of the figures and their relationship to one another. The style and method of representation are created deliberately for the purpose of expressing the majesty which surrounds the figures of the emperors; but it is a style appropriate only to official art and generally confined to those contexts. An elaborate architectural setting is designed to stress the solemn formality of the scene, as we have already seen in such works as the Stilicho diptych.

Christian Sarcophagi

Little is known about the sculpture from commemorative monuments erected in Constantinople until the end of the century. The best carving in Rome and the West is the series of Christian sarcophagi discussed in the previous chapter. Members of the imperial family were buried in massive coffins of porphyry, for instance the two magnificent examples in the Sala a Croce Greca of the Vatican Museum, one with battle scenes between Romans and barbarians from the mausoleum of Helena on the Via Casalina (Plate 252), the other, decorated with acanthus scrollwork and putti, from the mausoleum of Constantina (S. Costanza) on the Via Nomentana (Plate 253). The method of carving is adapted to the nature of the material; figures stand out almost in the round,

and there is no attempt to create an illusion of space or depth. On the first piece the element of triumph is stressed with the victorious Romans dominating the scene and the barbarians, falling or fallen, below. Two female busts survey the scene, one from either end, and there are putti and swags together with other figures on the lid. The second is again carved in high relief; the big acanthus and vine scrolls, with their vintaging putti, have a richly organic form. The repertoire of both belongs to the world of pagan art.

The ten, if not more, porphyry sarcophagi of the fourth and early fifth centuries from the church of the Holy Apostles in Constantinople have been supposed – on no certain evidence – to have belonged to emperors; most of them have been found, in whole or in part (R. Delbrück, *Antike Porphyrwerke*, Berlin and Leipzig, 1932, 222 ff.; *D.O.P.*, IV, 1948; *D.O.P.*, XVI, 1962). It has been argued that a fragment with scroll-work and putti, related to examples in Rome, comes from Constantine's sarcophagus (no. 806), and a very large one with curved ends and corner columns was long thought to be Julian's. The monuments are mostly plain, but one has a chi-rho in relief in the gable. Porphyry does not seem to have been used later in Constantinople; the tombs of the Sicilian kings were apparently modelled after ancient porphyry baths in Rome, which was the source of most of the stone (J. Dur, *The Dynastic Porphyry Tombs of the Norman Period in Sicily*, Dumbarton Oaks Studies, V, 1959).

New Rome

We know almost nothing about sculpture in Constantinople until the time of Theodosius I (379–95), with whom the policy of 'New Rome' culminated. The principal monument of the new forum that he built was a column with spiral reliefs imitating the column of Trajan, by whose memory he seems in fact to have been inspired; another was an equestrian statue of himself on a base with episodes from his victories over Maximus and his campaigns against the Scythians in Thrace. In 390 Theodosius also set up an obelisk in the hippodrome on a base decorated with sculptured scenes. His son Arcadius built another forum, with a spiral column begun in 402 and finished by Theodosius II, who crowned it with the emperor's statue.

The reliefs of the Theodosian obelisk illustrate the ceremonial style of the period. The base is carved on all four sides with ceremonial groups in attendance at the hippodrome (Plates 254 and 255). On the side with the Latin inscriptions, the central figure stands tall and rigidly frontal above all the rest, who gaze towards some distant event, looking slightly inward – except for a few in the background, who look away. Less successful is the lower register of this scene, which consists of a monotonous row of disembodied heads. On the western side the central group is set beneath a wide arch and again off-set by soldiers, whose slightly inward look stresses the absolute hieratic frontality of the main figures. The ceremonial is portrayed in a very similar way on the other two sides and makes a striking contrast with the lively little scenes on the lower base, which include a representation of the setting up of the obelisk in the hippodrome. All four sides of the base seem to show the emperor in the *kathisma* or royal box of the circus; most of the figures can be identified by dress and other details, and differences in

the rendering of the architecture are generally attributed to 'artistic licence' (G. Bruns, *Der Obelisk und seine Basis auf dem Hippodrom zu Konstantinopel*, Istanbul, 1935; Kollwitz, in *Gnomon*, XIII, 1937, 423–7). The front (AI in Bruns' numbering) has musicians and dancers in the lower register, the back (BI) depicts barbarians bringing offerings to the emperor, and the two sides (left B2 and right A2) are almost identical, with the arch and steps leading up to the *kathisma* flanked by standing figures and attendants. The treatment of the architecture differs radically on AI, suggesting to Bruns a different setting.

The column of Theodosius, which was surmounted by a statue of the emperor, was vowed in 386, finished when the forum was inaugurated in 393, and demolished early in the sixteenth century. The design seems to have been almost identical with that of the column of Trajan and the reliefs of the spirals were concerned with events in the emperor's life. Now only a few miserable fragments survive, although enough to show that the style was closely related to that of the base of the obelisk; one may compare especially the repetitive gestures of some of the figures, the classic regularity of the features, and the intensity of the expressions. It seems likely that some of the reliefs are represented in a drawing in the Louvre which shows a procession against a spacious background of buildings and landscape, apparently those of Constantinople and its environs: the style may be truly described as picturesque. Indeed this period obviously saw a revival of interest in landscape and setting – a main feature of Trajan's column eliminated in that of Marcus Aurelius. It is still uncertain what scenes were depicted; arguments have been put forward for the triumph over the Goths in the lower part of the column and the campaign against Maximus above. None of the earlier columns had given so much space to a triumphal procession, and this development reflects the changing attitudes towards the emperor, to whom homage is paid with typical oriental ceremonial as the bringer of victory.

Arcadius' column is described by Byzantine writers, and a series of drawings in the Freshfield Album (Plates 256 and 257), now in Trinity College, Cambridge, made in 1574 when the column was already much damaged, provide an almost complete record of the spiral frieze, except for the north side, of which the drawings are lost. The style is fairly accurate and does not embellish the reliefs, but it is rather naïve. The shaft and the base in the form of an altar were very similar to those of Trajan's column, but there were only thirteen relief spirals. The theme is the war against Gainas the Goth, who had campaigned on the side of the Empire, but imposed a reign of terror in the absence of other imperial forces from Constantinople. The events are vividly described by Synesius of Cyrene. A popular uprising brought about the departure of the Goths, and the ensuing campaign against Gainas resulted in his defeat and death.

The early scenes provide a rich panorama of the buildings and monuments of Constantinople. The story seems to have begun with the departure of the Goths, which was attributed to divine intervention, and they are followed through the suburbs and beyond. The action is punctuated by scenes showing the emperor Arcadius and members of his staff generally in the same sort of ceremonial arrangement as one finds on other contemporary monuments. There are also episodes of marching and of battles on sea and

land, and the sequence finishes with scenes of triumph. The design of the base is also known from the drawings; each side was divided into four registers, and groups of figures and other compositions were arranged in strict heraldic symmetry on either side of the central axis. The south side had four allegorical scenes of triumph, and the east a similar one – Victories and trophies at the bottom, then a crowd of civilians (?), then groups of soldiers, and above a Christian cross in a panel supported by Victories or angels (Plate 257). The submission of barbarians was shown in the first and second registers of the west side, and soldiers in two long lines flanked the two commanders, presumably Arcadius and Honorius, in the third. Only one very small fragment of the reliefs survives in the Istanbul Archaeological Museum.

The theme of triumph is central to the design of these later columns, because it was now essential to the *divina maiestas* of the emperor. It was apparently the sole concern of the column of Theodosius and – repetitively – of the base of that of Arcadius. The emperor does not really take part in the events but appears in solemn splendour here and there; his very presence implies victory. In his detachment he belongs more to the world of the diptychs or of the ceremonial scenes of the base of the Theodosian obelisk. Another feature which should be noted is the taste for picturesque landscape (cf. p. 170), which seems to be shared with painting and mosaic during the period. As far as the style of the sculpture is concerned, one cannot fail to be struck by the solemn simplicity and formality, the almost classical idealism of the heads and figures. There are no disturbing elements in the technique, and very little use is made of the drill; nor are there the many deformations which are so characteristic of earlier-fourth-century sculpture. It is as though the Court art of Constantinople had renewed its contacts with the classical world in its attempt to express human and divine majesty.

Private Portraiture

The statue of Valentinian II from the Hadrianic baths at Aphrodisias (Plate 258) (cf. pp. 146, 168) shows him young, wearing dalmatic, toga, and *calcei* with a diadem of precious stones; he once carried a sceptre and a *mappa*, marking him as consul. Two bases, one for Arcadius and one for Valentinian II, were found near the statue, and the two portraits were probably put up together between 387 and 390 (see J. Kollwitz, *Oströmische Plastik der theodosianischen Zeit*, Berlin, 1941, 81–3). A remarkable colossus of this period from Ephesus, now in Vienna, is strongly characterized, but has the same simple hairstyle, the same sharp, precise features and big, expressive eyes. The Valentinian and the private portraits both have great sensitivity and delicacy created by the simple clarity of the modelling. We have a fine series of heads of the late Roman period from the Tetrarchies to the fifth century, and it can be noted that the Theodosian style is very delicate, quite unlike that of the earlier fourth century with its richer modelling. It was short-lived, however; the early fifth century seems to revert to a more richly modelled style with strongly marked features and richly drilled hair, as in the case of the older magistrate and the man in tunic and toga from Aphrodisias.

A number of portraits which seem to belong to the period of Arcadius and Honorius

represent what has been called the 'subtle style', an easily recognizable and rather mannered development of the classical Theodosian mode with its idealized faces and long, simple forms. It is characterized – as can be seen so well from a head in the Museo Nazionale Romano (set on a toga-statue: see *Die Antike*, II, 1926, 55 ff.) – by the precise sharpness of the finely drawn features and the subtlety of the modelling in such details as the hair. A pair of busts, a man and a woman, in Salonika have the same delicacy and ageless, smoothed-out features as the western examples (*Antike Kunst*, IV, 1961, 68–79); the woman's splendidly elaborate hairstyle, which superseded the fourth-century 'turban', is also seen on the small marble portrait of an empress in the Cabinet des Médailles (Plate 259) (*Aréthuse*, V, 1925, 163 ff.). The 'subtle style' precedes the radical naturalism of such portraits as those of the Aphrodisian officials.

It is worth summarizing briefly the late Roman developments in the art of portraiture and the way in which they reflect new ideas. The ideal of detachment from the body, the search for new abstract meaning in physical events, even mythological events, produced also a new image of man. This seems to be the theme of Roman portraiture, from the intensely realistic likenesses of the early soldier-emperors, such as Maximinus Thrax, through the restless, tortured faces of Decius and Philip the Arab, which convey processes of thought and particular moods. The abstract tendencies of Tetrarchic and Constantinian representation develop in the first half of the fourth century into a kind of mask, intense or serene, which aims to be an image of the soul. The effect is achieved by the cold precision of carving, simplification of form, and the concentration of expression in the eyes. There are, of course, breaks in this process of development, but it created the mask-like abstractions of the Byzantine age.

Mosaics

The fifth-century mosaics of Hagios Georgios at Salonika (Plates 262 and 263) (Beckwith, 13–14, plate 17) are the successors in religious art of the Court painting and sculpture of the Theodosian era. The church had been built as a mausoleum by Galerius and turned into a chapel some time in the fifth century, when the mosaics were added to the dome. Superb figures of saints, serene and majestic against a rich, sparkling golden background, stand in an architectural framework of quite magnificent elaboration. The faces have the same tranquil and remote expressions as one finds in Court productions of the time. In fact we have moved unequivocally into the realm of Byzantine art; and it is important to bear in mind that this kind of representation was created for certain specific imperial and religious purposes. If one turns to the floor mosaics of the imperial palace (see below), one finds a totally different style. The figures are richly modelled forms which make use of subtle shading to give an impression of three-dimensionality. The old classical traditions of painting were not forgotten, but they did not harmonize with the more formal character of official art. It is not that the Byzantine method represents new artistic theory or that the artists were striving for some kind of truth which lay beyond nature but could be grasped as it were intuitively: rather they are concerned to express the super-human character of God and Man, and they achieve this through a rigid canon which

rejects certain aspects of three-dimensional representation in favour of a more direct expression of ideas.

The floor mosaics found in the peristyle of the imperial palace at Constantinople serve to illustrate the complexity of the chronological problems of late antique art (Plates 260 and 261) (Beckwith, 74-5, plate 143). Proposed dates have ranged from the fourth to the seventh century: the first excavation report put the date around 410, in the reign of Theodosius II, on the basis of the iconography, the second preferred the late fifth century, while pottery found below the floors points to the sixth. However the stratigraphical evidence does not seem to be decisive, and a stylistic dating is inevitably subjective. The use of richly modelled forms against a neutral background is the chief characteristic. The figures are certainly derived from an older tradition, and their arrangement in the field often reminds one of tapestry or carpet design. (For a recent discussion with bibliography of the palace mosaics see *Contributi dell' Istituto di Archeologia* (*Milan*), II, 99–109.)

Byzantine art did not develop in any simple way from late Roman art (Beckwith, *passim*); some elements can be seen to derive from that source, but others may come from the imitation of classical, hellenistic, and oriental prototypes. Many people have argued in favour of especially strong influences from one area or another – Alexandria or Syria, for example. But the truth is that in the late Roman Empire artists were open to all kinds of ideas and could choose their inspiration from a wide variety of sources.

*

It is difficult to know at what point one should conclude a general study of Roman art. There are certain moments which might seem decisive, such as the sack of Rome by the Goths in 410, or the year 435, when Theodosius II banned sacrifices in surviving pagan temples, but none of them in fact marks a final break with tradition. At Antioch in a poor villa built in 400 there was a collection of portraits and classical sculpture which must have survived until the Arab conquest. Some late houses at Ostia were adorned with a whole range of classical works of art, and the collecting of pagan sculpture seems to have gone on right up to the time of Justinian. The Pheidian Zeus of Olympia and the Aphrodite of Knidos were to be seen in Constantinople and survived until the late fifth century. In the western provinces wealthy landowners kept alive the classical tradition in the interior decoration of their villas, and floor mosaic often had scenes from classical authors, possibly derived from illuminated manuscripts.

'Graecia capta ferum victorem cepit'

Our story ends in some ways very much as it began. For despite her efforts to break the bonds of classical tutelage and to evolve, almost aggressively, from time to time a rude, uncouth, and non-naturalistic iconographic style, despite her development of many new, unhellenic themes in numerous fields of art, Rome remained captive to the spell of Greece whom she acknowledged as her conqueror and mistress for as long as her rule endured.

BIBLIOGRAPHY

The author left at the time of his death virtually no footnotes and not much in the way of bibliography. These lists have therefore been compiled by another student of Roman art to include such works as the author did cite and other books and articles that seemed to the compiler to be relevant, both in general and in particular, to the contents of the book. It is hoped that the lists, together with the not inconsiderable number of references incorporated by the author in the text, will equip the book with reasonably adequate documentation. For the errors and omissions in the lists which readers will probably detect the responsibility of course lies, not with the author, but with the compiler.

The material is arranged as follows:

A. ART: GENERAL

ANDREAE, B. *Studien zur römischen Grabkunst.* Heidelberg, 1963.

ANDREAE, B. *Römische Kunst.* 1972.

BECATTI, G. *Arti e gusto negli scrittori latini.* Florence, 1951.

BECKWITH, J. *Early Christian and Byzantine Art* (Pelican History of Art). Harmondsworth, 1970.

BIANCHI BANDINELLI, R. *Rome, the Centre of Power: Roman Art to A.D. 200.* London, 1970.

BIANCHI BANDINELLI, R. *Rome, the Late Empire: Roman Art A.D. 200 to 400.* London, 1971.

BLANCKENHAGEN, P. H. VON. *Flavische Architektur und ihre Dekoration.* Berlin, 1940.

BOURGUET, P. DU. *Early Christian Art.* London, 1972.

BRENDEL, O. 'Prolegomena to a Book on Roman Art', *M.A.A.R.*, XXI (1953), 9–73.

BRILLIANT, R. *Gesture and Rank in Roman Art.* New Haven, 1963.

BURFORD, A. *Craftsmen in Greek and Roman Society.* London, 1972.

BYVANCK, A. W. *L'art de Constantinople, 330–658.* 1965.

CALABI-LIMENTANI, I. *Studi sulla società romana: il lavoro artistico.* Milan, 1958.

CHARBONNEAUX, J. *L'art au siècle d'Auguste.* Paris, 1948.

DUCATI, P. *L'arte in Roma dalle origini al sec. viii.* Bologna, 1938.

ENGEMANN, J. *Untersuchungen zur Sepulkralsymbolik der späteren römischen Kaiserzeit.* Münster, 1973.

FRANCHI, L. 'Ricerche sull'arte di età severiana in Roma', *Studi Miscellanei*, IV (1960–1 [1964]).

FROVA, A. *L'arte di Roma e del mondo romano.* Turin, 1961 (with detailed bibliography).

GARCÍA Y BELLIDO, A. *Arte Romano* (Enciclopedia Classica, I), 2nd ed. Madrid, 1972 (with detailed bibliography).

GERKE, F. *Spätantike und frühes Christentum.* Baden-Baden, 1967.

GHIRSHMAN, R. *Iran: Parthians and Sassanians.* London, 1962.

GIGLIOLI, G. Q. *L'arte etrusca.* Milan, 1935.

GOETHERT, F. W. *Zur Kunst der römischen Republik.* Berlin, 1931.

GOUGH, M. *The Origins of Christian Art.* London, 1973.

GRABAR, A. *Byzantium from the Death of Theodosius to the Rise of Islam.* London, 1966.

GRABAR, A. *The Beginnings of Christian Art: 200 to 395.* London, 1967.

BIBLIOGRAPHY

HAMBERG, P. G. *Studies in Roman Imperial Art.* Uppsala, 1945.

HANFMANN, G. M. A. *Roman Art.* London, 1964.

HEINTZE, H. VON. *Römische Kunst.* Stuttgart, 1969.

JEX-BLAKE, K., and SELLERS, E. *The Elder Pliny's Chapters on the History of Art.* London, 1896.

JUCKER, H. *Vom Verhältnis der Römer zur bildenden Kunst der Griecher.* Frankfurt am Main, 1950.

KÄHLER, H. *Rome and her Empire.* London, 1963.

KRAUS, T. (ed.). *Das römische Weltreich.* Berlin, 1967.

LEVI, D. 'L'arte romana', *Annuario della Scuola Archeologica di Atene*, XXIV–XXVI (1950), 229–303.

L'ORANGE, H. P. *Art Forms and Civic Life in the Late Roman Empire.* Princeton, 1965.

MANGO, C. *The Art of the Byzantine Empire 312 to 1453: Sources and Documents.* Englewood Cliffs, N.J., 1972.

MATHEW, G. *Byzantine Aesthetics.* London, 1963.

MEER, F. VAN DER, and MOHRMAN, C. *Atlas of the Early Christian World.* Edinburgh and London, 1958.

MEER, F. VAN DER. *Early Christian Art.* London, 1967.

PERKINS, A. *The Art of Dura-Europos.* Oxford, 1973.

PICARD, G. C. *L'art romain.* Paris, 1962.

PICARD, G. C. 'L'art flavien', *Revue des Études Latines*, XLII (1964 [1965]), 514–28.

PICARD, G. C. 'Problèmes de l'art sévérien', *Hommages à Marcel Renard*, III, 485–96. Brussels, 1969.

POBÉ, M., and ROUBIER, J. *The Art of Roman Gaul.* London, 1961.

RICE, D. T. *The Beginnings of Christian Art.* London, 1957.

RICHARDSON, E. H. 'The Etruscan Origins of Early Roman Sculpture', *M.A.A.R.*, XXI (1953), 77–124.

RICHTER, G. M. A. *Ancient Italy.* Ann Arbor, 1955.

RICHTER, G. M. A. *Perspective in Greek and Roman Art.* London and New York, 1970.

RIEGL, A. *Spätrömische Kunstindustrie.* Vienna, 1927.

ROSTOVTZEFF, M. *Dura-Europos and its Art.* Oxford, 1938.

RYBERG, I. S. *Rites of the State Religion in Roman Art.* Rome, 1955.

SCHLUMBERGER, D. *L'orient hellénisé.* Paris, 1970.

SCHOPPA, H. *Die Kunst der Römerzeit in Gallien, Germanien und Britannien.* Munich, 1957.

STRONG, D. E. 'Roman Museums', in D. E. Strong (ed.), *Archaeological Theory and Practice*, 248–64. London, 1973.

STRONG, E. *Art in Ancient Rome.* London, 1929.

STUVERAS, R. *Le putto dans l'art romain.* Brussels, 1969.

TOYNBEE, J. M. C. *The Hadrianic School.* Cambridge, 1934.

TOYNBEE, J. M. C. *Some Notes on Artists in the Roman World* (Collection Latomus, VI). Brussels, 1951.

TOYNBEE, J. M. C. *Art in Roman Britain*, 2nd ed. London, 1963.

TOYNBEE, J. M. C. *The Art of the Romans.* London, 1965.

TURCAN, R. 'Les guirlandes dans l'antiquité classique', *Jahrbuch für Antike und Christentum*, XIV (1971), 92–139.

VERMEULE, C. C. 'Greek Sculpture and Roman Taste', *Bulletin of the Museum of Fine Arts, Boston*, LXV (1967), 175–92.

VERMEULE, C. C. 'Graeco-Roman Statues: Purpose and Setting, i, ii', *Burlington Magazine*, CX (1968), 545–58; 607–13.

VERMEULE, C. C. *Roman Imperial Art in Greece and Asia Minor.* Cambridge, Mass., 1968.

VESSBERG, O. *Studien zur Kunstgeschichte der römischen Republik.* Lund and Leipzig, 1941.

VOLBACH, F. W., and HIRMER, M. *Early Christian Art.* London, 1961.

WARD-PERKINS, J. B. 'The Art of the Severan Age', *Proceedings of the British Academy*, XXXVII (1951), 269–304.

WHEELER, R. E. M. *Roman Art and Architecture.* London, 1964.

WICKHOFF, F., in E. Strong (ed.). *Roman Art.* London, 1900.

B. SCULPTURE: GENERAL

ALTMANN, W. *Die römischen Grabaltäre der Kaiserzeit.* Berlin, 1905.

ANDRÉN, A. *Architectural Terracottas from Etrusco-Italic Temples.* Lund and Leipzig, 1940.

BORDA, M. *La scuola di Pasiteles*. Bari, 1953.

DELBRÜCK, R. *Antike Porphyrwerke*. Berlin and Leipzig, 1932.

DOHRN, T. *Der Arringatore*. Berlin, 1968.

ESPÉRANDIEU, E., and LANTIER, R. *Recueil général des bas-reliefs, statues et bustes de la Gaule romaine*, Paris, 1907–66, with an additional volume on *La Germanie romaine*, Paris, 1951.

GULLINI, G. *La scultura romana*. 1970.

HAMPE, R. *Sperlonga und Vergil*. Mainz, 1972.

HOMMEL, P. *Studien zu den römischen Figuren-giebeln der Kaiserzeit*. Berlin, 1954.

KOLLWITZ, J. *Oströmische Plastik der theodosiani-schen Zeit*. Berlin, 1941.

KOLLWITZ, J. 'Probleme der theodosianischen Kunst', *Rivista di Archeologia Cristiana*, XXXIX (1963), 191–233.

KRAUS, T. *Die Ranken der Ara Pacis*. Berlin, 1953.

LAUTER, H. 'Zur Datierung der Skulpturen von Sperlonga', *R.M.*, LXXVI (1969), 162–73.

LAVIOSA, C. *Scultura tardo-etrusca di Volterra*. Milan, 1965.

LIPPOLD, G. *Kopien und Umbildungen griechischer Statuen*. Munich, 1923.

L'ORANGE, H. P. 'Ein tetrarchisches Ehrendenk-mal auf dem Forum Romanum', *R.M.*, LIII (1938), 1–34.

L'ORANGE, H. P. 'Osservazioni sui ritrovamenti di Sperlonga', *Acta ad Archaeologiam et Artium Historiam Pertinentia: Institutum Romanum Norvegiae*, II (1965), 261–72.

MANGO, C. 'Antique Statuary and the Byzantine Beholder', *D.O.P.*, XVII (1963), 55–75.

MARCADÉ, J. *Recueil des signatures de sculpteurs grecs*, I and II. Paris, 1953 and 1957.

MERCKLEN, E. VON. *Antike Figuralkapitelle*. Berlin, 1962.

MUTHMANN, F. *Statuenstützen und dekoratives Beiwerk an griechischen und römischen Bildwerken*. Heidelberg, 1951.

POINSSOT, L. *L'autel de la Gens Augusta à Carthage*. Tunis, 1929.

REUTERSWÄRD, P. *Studien zu Polychromie der Plastik: Griechenland und Rom*. Stockholm, 1960.

SÄFLUND, C. *The Polyphemus and Scylla Groups at Sperlonga*. Stockholm, 1972.

SQUARCIAPINO, M. F. *La scuola di Afrodisia*. Rome, 1943.

STRONG, D. E. *Roman Imperial Sculpture*. London, 1961 (with detailed sculptural bibliography).

STRONG, E. *La scultura romana*, I and II. Florence, 1923 and 1926.

WILL, E. *Le relief cultuel gréco-romain*. Paris, 1955.

C. PORTRAITS

BERNOUILLI, J. J. *Römische Ikonographie*. Stuttgart, 1882–94.

BRENDEL, O. *Ikonographie des Kaisers Augustus*. Nuremberg, 1931.

BUDDE, L. *Jugendbildnisse des Caracalla und Geta*. Münster, 1951.

CALZA, R. 'Sui ritratti ostiensi del supposto Plotino', *B.d.A.*, XXXVIII (1953), 203–10.

CALZA, R. *Scavi di Ostia*, V: *i ritratti* (to *c.* A.D. 160). Rome, 1964.

CALZA, R. *Iconografia romana imperiale: da Carausio a Giuliano (287–363)*. Rome, 1972.

CLAIRMONT, C. W. *Die Bildnisse des Antinous*. Rome, 1966.

DELBRÜCK, R. *Spätantike Kaiserporträts*. Berlin and Leipzig, 1933.

FELLETTI-MAJ, B. M. *Iconografia romana imperiale da Severo Alessandro a M. Aurelio Carino (222–285)*. Rome, 1958.

GROSS, W. H. *Bildnisse Traians*. Berlin, 1940.

HARRISON, E. B. *The Athenian Agora*, I: *Portrait Sculpture*. Princeton, 1953.

HARRISON, E. B. 'The Constantinian Portrait', *D.O.P.*, XXI (1967), 81–96.

HEINTZE, H. VON. *Römische Porträtplastik aus sieben Jahrhunderten*. Stuttgart, 1961.

HEINTZE, H. VON. *Römische Porträts*. Darmstadt, 1974.

INAN, J., and ROSENBAUM, E. *Roman and Early Byzantine Portrait Sculpture in Asia Minor*. London, 1966.

JOHANSEN, F. S. 'Antichi ritratti di Caio Giulio Cesare nella scultura', *Analecta Romana Instituti Danici*, IV (1967), 7–68.

JUCKER, H. *Das Bildnis in Blätterkelch*. Lausanne and Freiburg, 1961.

KÄHLER, H. *Die Augustusstatue von Primaporta*. Cologne, 1959.

KASCHNITZ VON WEINBERG, G. *Römische Bildnisse*. Berlin, 1965.

BIBLIOGRAPHY

L'ORANGE, H. P. *Studien zur Geschichte des spätantiken Porträts*. Oslo, 1933.

L'ORANGE, H. P. *Apotheosis in Ancient Portraiture*. Oslo, 1947.

L'ORANGE, H. P. *Likeness and Icon*. Odense, 1973.

MANCINI, G. *Le statue loricate imperiale*. Rome, 1966.

McCANN, A. M. *The Portraits of Septimius Severus*. Rome, 1968.

MICHEL, D. *Alexander als Vorbild für Pompeius, Caesar und Marcus Antonius*. Brussels, 1967.

PARLASCA, K. *Mumienporträts und verwandte Denkmäler*. Wiesbaden, 1966.

PEKÁRY, J. 'Goldene Statuen der Kaiserzeit', *R.M.*, LXXV (1968), 144–8.

POLACCO, L. *Il volto di Tiberio*. Padua, 1955.

POULSEN, V. 'Portraits of Caligula', *Acta Archaeologica*, XXIX (1958), 175–90.

POULSEN, V. *Les portraits romains*. Copenhagen, 1962 and 1974.

RAGONA, A. *I tetrarchi dei gruppi porfirei di S. Marco in Venezia*. Caltagirone, 1963.

RICHTER, G. M. A. 'How were the Roman Copies of Greek Portraits made?', *R.M.*, LXIX (1962), 52–8.

RICHTER, G. M. A. *The Portraits of the Greeks*, III. London, 1965.

ROSENBAUM, E. *Cyrenaican Portrait Sculpture*. London, 1960.

SCHWEITZER, B. *Die Bildniskunst der römischen Republik*. Leipzig, 1948.

SCOTT, K. 'The Significance of Statues in Precious Metals in Emperor Worship', *Transactions of the American Philological Association*, LXII (1931), 101–23.

SHORE, A. F. *Portrait Painting from Roman Egypt*. London, 1962.

WEGNER, M. *Die Herrscherbildnisse in antoninischer Zeit*. Berlin, 1939.

WEGNER, M. *Das römische Herrscherbild: Hadrian, etc.* Berlin, 1956.

WEGNER, M., etc. *Das römische Herrscherbild: Caracalla, Geta, Plautilla, Macrinus bis Balbinus*. Berlin, 1971.

WEGNER, M. *Das römische Herrscherbild: Die Flavier*. Berlin, 1966.

WEST, R. *Römische Porträtplastik*, I and II. Munich, 1933 and 1941.

ZADOKS-JOSEPHUS JITTA, A. N. *Ancestral Portraiture in Rome*. Amsterdam, 1932.

D. HISTORICAL RELIEFS
(arranged chronologically)

KÄHLER, H. *Der Fries vom Reiterdenkmal des Aemilius Paullus in Delphi*. Berlin, 1965.

PICARD, G. C. 'Les fouilles de la Via del Mare et les débuts de l'art triomphal romain', *M.E.F.R.*, LXXI (1959), 263–79.

BARTOLI, A. 'Il fregio della Basilica Aemilia', *B.d.A.*, XXXV (1950), 289–94.

FURUHAGEN, H. 'Some Remarks on the Sculptured Frieze of the Basilica Aemilia in Rome', *Opuscula Romana*, III (1961), 139–55.

CASTAGNOLI, F. 'Il problema dell'Ara di Domizio Enobarbo', *Arti Figurative*, I (1945), 181–96.

KÄHLER, H. *Seethiasos und Census: die Reliefs aus dem Palazzo Santa Croce in Rom*. Berlin, 1966.

GARGER, E. 'Die kunstgeschichtliche Stellung der Reliefs am Julierdenkmal von St Rémy', *R.M.*, LII (1937), 1–43.

MORETTI, G. *Ara Pacis Augustae*. Rome, 1948.

TOYNBEE, J. M. C. 'The Ara Pacis Reconsidered and Historical Art in Roman Italy', *Proceedings of the British Academy*, XXXIX (1953).

HANELL, K. 'Das Opfer des Augustus an der Ara Pacis', *Opuscula Romana*, II (1960), 33–123.

SIMON, E. *Ara Pacis Augustae*. Tübingen, 1967.

AMY, R., etc. *L'arc d'Orange*. Paris, 1962.

BLOCH, R. 'L'ara pietatis Augustae', *M.E.F.R.*, LVI (1939), 81–120.

RYBERG, I. S. 'The Altar of Pietas', *A.J.A.*, LVIII (1954), 149.

MAGI, F. *I rilievi flavi del Palazzo della Cancelleria*. Rome, 1945.

TOYNBEE, J. M. C. *The Flavian Reliefs from the Palazzo della Cancelleria in Rome*. Newcastle upon Tyne, 1957.

McCANN, A. M. 'A Re-dating of the Reliefs from the Cancelleria', *R.M.*, LXXIX (1972), 249–76; cf. *ibid.*, LXXX (1973), 289–91.

CICHORIUS, C. *Die Reliefs der Trajanssäule*. Berlin, 1896–1900.

LEHMANN-HARTLEBEN, K. *Die Trajanssäule*. Berlin and Leipzig, 1926.

BIBLIOGRAPHY

RICHMOND, I. A. 'Trajan's Army on Trajan's Column', *P.B.S.R.*, XIII (1935), 1–40.

FLORESCU, F. B. *Die Trajanssäule, I: Grundfragen und Tafeln*. Bucharest, 1969.

ROSSI, L. *Trajan's Column and the Dacian Wars*. London, 1971.

BECATTI, G. *La colonna coclide istoriata*. Rome, 1960.

FLORESCU, F. B. *Monumental de la Adamklissi: Tropaeum Traiani*. 2nd ed. Bucharest, 1961.

RICHMOND, I. A. 'Adamklissi', *P.B.S.R.*, XXXV (1967), 29–39.

ROSSI, L. 'A Historiographic Re-assessment of the Metopes of the Tropaeum Traiani at Adamklissi', *Archaeological Journal*, CXXIX (1972), 56–68.

PIETRANGELI, C. *L'arco di Traiano a Benevento* (Documento Fotografico Athenaeum). Novara, 1943.

HASSEL, F. J. *Der Trajansbogen in Benevent*. Mainz, 1966.

FITTSCHEN, K. 'Das Bildprogramm des Trajansbogens zu Benevent', *A.A.*, LXXXVII (1972 [1973]), 742–88.

ROTILI, M. *L'arco di Traiano a Benevento*. Rome, 1972.

LORENZ, T. *Leben und Regierung Trajans auf dem Bogen in Benevent*. Amsterdam, 1973.

PALLOTTINO, M. 'Il grande fregio di Traiano', *Bullettino della Commissione archeologica comunale di Roma*, LXVI (1938).

SESTON, W. 'Les "Anaglypha Traiani" du Forum Romanum', *M.E.F.R.*, XLIV (1927), 154–83.

HAMMOND, M. 'A Statue of Trajan Represented on the "Anaglypha Traiani"', *M.A.A.R.*, XXI (1953), 127–83.

LORENZ, F. VON, in *R.M.*, XLVIII (1933), 309–10 (Ephesus relief).

EICHLER, F. 'Zum Partherdenkmal von Ephesos', *Jahreshefte des Österreichischen Archäologischen Institutes*, XLIX, Beiheft II (1971).

VOGEL, L. *The Column of Antoninus Pius*. Cambridge, Mass., 1973.

RYBERG, I. S. *Panel Reliefs of Marcus Aurelius*. New York, 1967.

DOMASZEWSKI, A. VON, etc. *Die Marcus-Säule*. Munich, 1896.

CAPRINO, C., etc. *La colonna di Marco Aurelio*. Rome, 1955.

BECATTI, G. *La colonna di Marco Aurelio*. Milan, 1957.

BRILLIANT, R. *The Arch of Septimius Severus in the Roman Forum*. Rome, 1967.

HAYNES, D. E. L., and HIRST, P. E. D. *Porta Argentariorum*. London, 1939.

PALLOTTINO, M. *L'arco degli argentari*. Rome, 1946.

BARTOCINI, B. 'L'arco quadrifronte dei Severi a Lepcis', *Africa Italiana*, IV (1931), 32–152.

BUDDE, L. *Severisches Relief in Palazzo Sacchetti*. Berlin, 1955.

KÄHLER, H. *Zwei Sockel eines Triumphbogens im Boboligarten zu Florenz*. Berlin, 1936.

KÄHLER, H. *Das Fünfsäulendenkmal für die Tetrarchen auf dem Forum Romanum*. Cologne, 1964.

KINCH, K. F. *L'arc de triomphe de Salonique*. Paris, 1890.

SCHÖNEBECK, H. VON. 'Die zyklische Ordnung der Triumphalreliefs am Galeriusbogen in Saloniki', *Byzantinische Zeitschrift*, XXXVII (1937), 361–71.

L'ORANGE, H. P., and GERKAN, A. VON. *Der spätantike Bildschmuck des Konstantinsbogens*. Berlin, 1939.

GIULIANO, A. *L'arco di Costantino*. Milan, 1955.

BERENSON, B. *The Arch of Constantine or the Decline of Form*. London, 1954.

BRUNS, G. *Obelisk und seine Basis auf dem Hippodrom zu Konstantinopel*. Istanbul, 1935.

GIGLIOLI, G. Q. *La colonna di Arcadio a Costantinopoli*. Naples, 1952.

FRESHFIELD, E. H. 'Notes on a Vellum Album Containing some Original Sketches of Public Buildings and Monuments, drawn by a German Artist who visited Constantinople in 1574', *Archaeologia*, LXXII (1921–2), 87–104.

E. SARCOPHAGI

ANDREAE, B. *Motivgeschichtliche Untersuchungen zu den römischen Schlachtsarkophagen*. Berlin, 1956.

ANDREAE, B. 'Zur Sarkophagchronologie im 3. Jahrhundert nach Christus', *Jahrbuch für Antike und Christentum*, XIII (1970), 83–8.

BIANCHI BANDINELLI, R. 'Sarcofago di Acilia con la designazione di Gordiano III', *B.d.A.*, XXXIX (1954), 200–20.

BOVINI, G. *I sarcofagi paleocristiani della Spagna*. Vatican City, 1954.

CHÉHAB, M. H. 'Sarcophages à reliefs de Tyr', *Bulletin du Musée de Beyrouth*, XXI (1968), 7–93.

DEICHMANN, F. W., and KLAUSER, T. *Frühchristliche Sarkophage in Bild und Wort*. Olten, 1966.

DEICHMANN, F. W., etc. *Repertorium der christlich-antiken Sarkophage*, I: *Rom und Ostia*. Wiesbaden, 1967.

FERRARI, G. *Il commercio dei sarcofagi asiatici*. Rome, 1966.

GABELMANN, H. *Die Werkstattgruppen der oberitalischen Sarkophage*. Bonn, 1973.

GAERTNER, J. A. 'Zur Deutung des Junius Bassus-Sarkophages', *J.d.A.I.*, LXXXIII (1968), 240–64.

GERKE, F. *Der Sarkophag des Iunius Bassus*. Berlin, 1936.

GERKE, F. *Die christlichen Sarkophage der vorkonstantinischen Zeit*. Berlin, 1940.

GIULIANO, A. *Il commercio dei sarcofagi attici*. Rome, 1962.

GÜTSCHOW, M. 'Das Museum der Praetextatus Katakombe', *Atti della Pontificia Accademia*, serie III: *Memorie*, IV, 2 (1938), 29–268.

HANFMANN, G. M. A. *The Season Sarcophagus in Dumbarton Oaks*. Cambridge, Mass., 1951.

HERBIG, R. *Die jüngeretruskischen Steinsarcophage*. Berlin, 1952.

HIMMELMAN-WILDSCHÜTZ, N. *Typologische Untersuchungen an römischen Sarkophagreliefs des 3 und 4 Jahrhunderts n. Chr.* Mainz, 1973.

KOLLWITZ, J. *Die Sarkophage Ravennas*. Freiburg, 1956.

LAWRENCE, M. 'City-Gate Sarcophagi', *Art Bulletin*, X (1927), 1–45.

LAWRENCE, M. 'Columnar Sarcophagi in the Latin West', *Art Bulletin*, XIV (1932), 103–85.

LAWRENCE, M. *The Sarcophagi of Ravenna*. New York, 1945.

LAWRENCE, M. 'The Velletri Sarcophagus', *A.J.A.*, LXIX (1965), 207–22.

LEHMANN-HARTLEBEN, K., and OLSEN, E. C. *Dionysiac Sarcophagi in Baltimore*. Baltimore, 1942.

MATZ, F. *Ein römisches Meisterwerk: der Jahreszeitensarkophag Badminton-New York*. Berlin, 1958.

MATZ, F. *Die dionysischen Sarkophage*. Berlin, 1968–9.

MOREY, C. R. *The Sarcophagus of Claudia Antonia Sabina and the Asiatic Sarcophagi* (=*Sardis* v, i). Princeton, 1924.

RIZZARDI, C. *I sarcofagi paleocristiani con rappresentazione del passaggio del Mare Rosso*. Faenza, 1970.

ROBERT, C., etc. *Die antiken Sarkophagreliefs*. 1890–1966.

RODENWALDT, G. *Der Sarkophag Caffarelli*. Berlin, 1925.

RODENWALDT, G. 'Der Klinensarkophag von S. Lorenzo', *J.d.A.I.*, XLV (1930), 116–89.

SAGGIORATO, A. *I sarcofagi paleocristiani con scene di passione*. Bologna, 1968.

SANSONI, P. *I sarcofagi paleocristiani a porte di città*. Bologna, 1969.

SICHTERMANN, H. *Späte Endymion-Sarkophage*. Baden-Baden, 1966.

SICHTERMANN, H. 'Der Niobiden-Sarkophag in Providence', *J.d.A.I.*, LXXXIII (1968), 180–220.

SICHTERMANN, H. 'Deutung und Interpretation der Meerwesensarkophage', *J.d.A.I.*, LXXXV (1970), 224–38.

SICHTERMANN, H. 'Beiträge zu den Meerwesensarkophagen', *A.A.* (1970/1), 214–41.

SOPER, A. C. 'The Latin Style on Christian Sarcophagi of the Fourth Century', *Art Bulletin*, XIX (1937), 148–202.

STROCKA, V. M. 'Zum Neapler Konsulssarkophag', *J.d.A.I.*, LXXXIII (1968), 221–39.

WEGNER, M. *Die Musensarkophage*. Berlin, 1966.

WILPERT, J. *I sarcofagi cristiani antichi*. Rome, 1929–36.

F. PAINTING

ANDREAE, B. 'Der Zyklus der Odyseefresken im Vatikan', *R.M.*, LXIX (1962), 106–17.

AUGUSTI, S. *La technique de la peinture pompéienne*. Naples, 1957.

BARBEL, A. *La peinture murale romaine*. 1971.

BEYEN, H. G. *Die pompejanische Wanddekoration vom zweiten bis zum vierten Stil*. The Hague, 1938, 1960.

BIANCHI BANDINELLI, R. *Hellenistic-Byzantine Miniatures of the Iliad (Ilias Ambrosiana)*. Olten, 1955.

BLANCKENHAGEN, P. H. VON. 'The Odyssey Frieze', *R.M.*, LXX (1963), 100–46.

BORDA, M. *La pittura romana*. Milan, 1958.

BOURGUET, P. DU. *Early Christian Painting*. London, 1965.

BOYCE, G. K. 'Corpus of the *lararia* of Pompeii', *M.A.A.R.*, XIV (1937).

BRENDEL, O. 'Der grosse Fries in der Villa dei Misteri', *J.d.A.I.*, LXXXI (1966), 206–60.

BROWN, B. R. *Ptolemaic Paintings and Mosaics and the Alexandrian Style*. Cambridge, Mass., 1957.

BULARD, M. *La réligion domestique dans la colonie italienne de Délos, d'après les peintures murales et les autels historiés*. Paris, 1926.

CALDERINI, A., etc. *Ilias Ambrosiana* (facsimile edition in colour). New York, 1953.

CROISILLE, J. M. *Les natures mortes campaniennes*. Brussels-Berchem, 1965.

CURTIUS, L. *Die Wandmalerei Pompejis*. Leipzig, 1929.

DAWSON, C. M. *Romano-Campanian Mythological Landscape Painting* (Yale Classical Studies, IX). New Haven, 1944.

DEGERING, H., and BOECKLER, A. *Die Quedlinburger Italafragmente*. Berlin, 1932.

DORIGO, W. *Late Roman Painting*. London, 1971 (with detailed bibliography).

ELIA, O. *Pitture di Stabia*. Naples, 1957.

FERRUA, A. *Le pitture della nuova catacomba di Via Latina*. Città del Vaticano, 1960.

Fragmenta et picturae Vergiliana Codicis Vaticani Latini 3225, 3rd ed. Città del Vaticano, 1945.

FROVA, A. *Pittura romana in Bulgaria*. Rome, 1943.

GABRIEL, M. M. *Livia's Garden Room at Prima Porta*. New York, 1955.

GALLINA, A. 'Le pitture con paesaggi dell'Odissea dall'Esquilino', *Studi Miscellanei*, VI (1960–1 [1964]).

GOODENOUGH, E. R. 'Catacomb Art', *Journal of Biblical Literature*, LXXXI (1962), 113–42.

GULLINI, G. *La pittura romana*. 1969.

HINKS, R. P. *Catalogue of Greek, Etruscan and Roman Paintings and Mosaics in the British Museum*. London, 1933.

KINKERT, W. 'Bemerkungen zur Technik der pompejanischen Wanddekoration', *R.M.*, LXIV (1957), 111–48.

KRAELING, C. H. *The Excavations at Dura-Europos: Final Report*, VIII, 1, *The Synagogue*. New Haven, 1956.

KRAELING, C. H. *The Excavations at Dura-Europos: Final Report*, VIII, 2, *The Christian Building*. New Haven, 1967.

LEHMANN, P. W. *Roman Wall Paintings from Boscoreale in the Metropolitan Museum of Art*. Cambridge, Mass., 1953.

LITTLE, A. M. G. *Roman Perspective Painting and the Ancient Stage*. Wheaton, Minnesota, 1971.

MAIURI, A. *La Villa dei Misteri*. Rome, 1931.

MAIURI, A. *Roman Painting*. Geneva, 1953.

MEIGGS, R. *Roman Ostia*, 2nd ed., 436–46 (wall paintings). Oxford, 1973.

PETERS, W. J. T. *Landscape in Romano-Campanian Mural Painting*. Assen, 1963.

PICARD, G. C. *Roman Painting*. London, 1970.

Picturae, ornamenta, complura scripturae specimina Codicis Vaticani 3867. 1902.

RICHARDSON, L., Jr. *Pompeii: the Casa dei Dioscuri and its Painters*. Rome, 1955.

RIZZO, G. E. *La pittura ellenistico-romana*. Milan, 1929.

RIZZO, G. E. *Le pitture della 'Casa dei Grifi'* (*Palatino*). Rome, 1936.

ROBERTSON, M. 'The Boscoreale Figure-Paintings', *Journal of Roman Studies*, XLV (1955), 58–67.

SEIDER, R. *Römische Malerei*. Königstein im Taunus, 1968.

WIRTH, F. *Römische Wandmalerei*. Berlin, 1934.

WIT, J. DE. *Die Miniaturen des Vergilius Vaticanus*. Amsterdam, 1959.

WOERMANN, K. *Die antiken Odyseelandschaften*. Munich, 1876.

G. MOSAIC

ANDREAE, B. *Das Alexandermosaik*. Bremen, 1959.

AURIGEMMA, S. *I mosaici di Zliten*. Rome, 1926.

AURIGEMMA, S. *Tripolitania: i mosaici*. Rome, 1960.

BECATTI, G. *Scavi di Ostia: mosaici e pavimenti marmorei*. Rome, 1961.

BLAKE, M. E., in *M.A.A.R.*, VIII (1930), XIII (1936), XVII (1940).

BOVINI, G. *Ravenna Mosaics*. London, 1957.

BIBLIOGRAPHY

BOVINI, G. *Mosaici paleocristiani di Roma, sec. iii–vi.* Bologna, 1971.

BRETT, G., etc. *The Great Palace of the Byzantine Emperors: Report I.* London, 1947.

BUDDE, L. *Antike Mosaiken in Kilikien,* I and II. Recklinghausen, 1969 and 1972.

CARANDINI, A. 'Ricerche sullo stile e la cronologia dei mosaici della villa di Piazza Armerina', *Studi Miscellanei,* VII (1961–2 [1964]).

CATTANI, P. *La rotonda e i mosaici di San Giorgio a Salonica.* Bologna, 1972.

CHÉHAB, M. *Mosaïques de Liban.* Paris, 1960.

DEICHMANN, F. W. *Frühchristliche Bauten und Mosaiken von Ravenna.* Wiesbaden, 1958 (= plates) and 1969 (=text).

Délos, XIV (1933): 'Les mosaïques de la Maison des Masques'.

DOHRN, T. 'Crustae', *R.M.,* LXXII (1965), 127–41.

DORIGO, W. *Late Roman Painting.* London, 1971 (with detailed bibliography).

FISCHER, P. *Mosaic: History and Technique.* London, 1971.

GENTILI, G. V. *La villa erculia di Piazza Armerina: mosaici figurati.* Rome, 1959.

GERMAIN, S. *Les mosaïques de Timgad.* Paris, 1969.

GONZENBACH, V. VON. *Die römischen Mosaiken der Schweiz.* Basel, 1961.

GRABAR, A. 'Apropos des mosaïques de la coupole de Saint-Georges à Salonique', *Cahiers Archéologiques: Fin de l'Antiquité et Moyen Âge,* XVII (1967), 59–81.

GULLINI, G. *I mosaici di Palestrina.* Rome, 1956.

HINKS, R. P. *Catalogue of Greek, Etruscan and Roman Paintings and Mosaics in the British Museum.* London, 1933.

HODDINOTT, R. F. *Early Byzantine Churches in Macedonia and Southern Serbia.* London, 1963.

Inventaire des mosaïques de la Gaule et de l'Afrique. Paris, 1909–25.

KÄHLER, H. *Die Villa des Maxentius bei Piazza Armerina.* Berlin, 1973.

KISS, A. *Roman Mosaics in Hungary.* Budapest, 1973.

La mosaïque gréco-romaine (Colloque Internationale de la Mosaïque Gréco-Romaine, Paris, 1963). Paris, 1965.

LAVIN, I. 'The Hunting Mosaics of Antioch and their Sources', *D.O.P.,* XVII (1963), 179–286.

LEVI, D. *Antioch Mosaic Pavements.* Princeton, 1947.

L'ORANGE, H. P. 'Nuovo contributo alla studia del Palazzo Erculio di Piazza Armerina', *Acta ad Archaeologiam et Artium Historiam Pertinentia (Institutum Romanum Norvegiae),* II (1965), 65–104.

L'ORANGE, H. P., and NORDHAGEN, P. J. *Mosaics from Antiquity to the Early Middle Ages.* London, 1966.

MENIS, G. C. *I mosaici cristiani di Aquileia.* Udine, 1965.

PACE, B. *I mosaici di Piazza Armerina.* Rome, 1955.

PARLASCA, K. *Die römischen Mosaiken in Deutschland.* Berlin, 1959.

PERLER, O. *Die Mosaiken der Juliergruft im Vatican.* Freiburg (Switzerland), 1953.

RICE, D. T. *The Great Palace of the Byzantine Emperors: Report II.* Edinburgh, 1958.

ROBERTSON, C. M. 'Greek Mosaics', *Journal of Hellenic Studies,* LXXXV (1965), 72–89.

ROBINSON, D. M. *Excavations at Olynthus,* II, V, and VIII. Baltimore, 1930, 1933, and 1938.

STERN, H. *Recueil général des mosaïques de la Gaule.* Paris, 1957–.

VICKERS, M. 'The Date of the Mosaics of the Rotunda at Thessaloniki', *P.B.S.R.,* XXXVIII (1970), 183–7.

WINTER, F., and PERNICE, E. *Die hellenistische Kunst in Pompeji,* VI: *Pavimente e figürliche Mosaiken.* Berlin, 1930.

H. STUCCO WORK

SPINAZZOLA, V. *Pompei alla luce degli scavi nuovi di Via dell'Abbondanza (anni 1910–23),* II, 869–901 ('Casa Omerica' or 'del Sacello Iliaco'). Rome, 1953.

TOYNBEE, J. M. C., and WARD-PERKINS, J. B. *The Shrine of St Peter and the Vatican Excavations,* 80–8. London, 1956.

WADSWORTH, E. L. 'Stucco Reliefs of the First and Second Centuries still Extant in Rome', *M.A.A.R.,* IV (1924), 9–102.

I. BRONZE ENGRAVING

DOHRN, T. *Die ficoronische Cista.* Berlin, 1972.

BIBLIOGRAPHY

J. PLATE

ALFÖLDI, A. 'Die Silberschale von Parabiago', *Atlantis*, II (1949), 68–73.

ARIAS, P. E. 'Il piatto argento di Cesena', *Annuario della Scuola Archeologica di Atene*, XXIV–XXVI (1950), 309–44.

BEBELON, E. *Le trésor d'argenterie de Berthouville près Bernay*. Paris, 1916.

BRAILSFORD, J. W. *The Mildenhall Treasure: A Handbook*, 2nd ed. London, 1955.

BRENDEL, O. 'The Corbridge Lanx', *Journal of Roman Studies*, XXXI (1941), 100–27.

CORBETT, P., and STRONG, D. E. 'Three Roman Silver Cups', *British Museum Quarterly*, XXIII (1961), 68–83.

CURLE, A. O. *The Treasure of Traprain*. Edinburgh, 1923.

GEHRIG, U. *Hildesheimer Silberfund*. Berlin, 1967.

HAFNER, G. 'Der Silberteller von Aquileia: kein "Historisches Relief"', *A.A.* (1967), 213–19.

INSTINSKY, H. U. *Der spätrömische Silberschatzfund von Kaiseraugst*. Mainz, 1971.

JOHANSEN, K. F. 'Hoby-Fundet', *Nordiske Fortidsminder*, II (1911–35), 119–64.

LAUR-BELART, R. *Der spätrömische Silberschatz von Kaiseraugst: Katalog*. Basel, 1963.

MAIURI, A. *La casa del Menandro e il suo tesoro di argenteria*. Rome, 1933.

PAINTER, K. S. 'The Mildenhall Treasure: A Reconsideration', *British Museum Quarterly*, XXXVII (1973), 154–80.

PERNICE, E., and WINTER, F. *Der Hildesheimer Silberfund*. Berlin, 1901.

STRONG, D. E. *Greek and Roman Gold and Silver Plate*. London, 1966.

VILLEFOSSE, H. DE. 'Le trésor de Boscoreale', *Monuments Piot*, V (1899), 7–290.

K. IVORIES

DELBRÜCK, R. *Die Consulardiptychen*. Berlin, 1926–9.

DELBRÜCK, R. *Probleme der Lipsanothek in Brescia*. Bonn, 1952.

KOLLWITZ, J. *Die Lipsanothek von Brescia*. Berlin, 1933.

NATANSON, J. *Early Christian Ivories*. London, 1953.

VOLBACH, W. F. *Elfenbeinarbeiten der Spätantike und des frühen Mittelalters*. Mainz, 1952.

L. GLASS

ASHMOLE, B. 'A New Interpretation of the Portland Vase', *Journal of Hellenic Studies*, LXXXVII (1967), 1–17.

HARDEN, D. B., and TOYNBEE, J. M. C. 'The Rothschild Lycurgus Cup', *Archaeologia*, XCVII (1959), 179–212.

HAYNES, D. E. L. *The Portland Vase*. London, 1964.

HAYNES, D. E. L. 'The Portland Vase Again', *Journal of Hellenic Studies*, XXXVIII (1968), 58–72.

KISA, A. *Das Glas im Altertume*. Leipzig, 1908.

MOREY, C. R. *The Gold Glass Collection of the Vatican Library*. Città del Vaticano, 1959.

M. CAMEOS AND GEMS

BRUNS, G. *Staatskameen des vierten Jahrhunderts nach Christi Geburt*. Berlin, 1948.

FERTÉ, C. DE LA. *La camée Rothschild: un chef d'œuvre du 4e siècle après J.C.* Paris, 1957.

FURTWÄNGLER, A. *Die antiken Gemmen*. Leipzig, 1900.

KÄHLER, H. *Gemma Augustea*. Berlin, 1968.

RICHTER, G. M. A. *Engraved Gems of the Romans*. London, 1971.

SIMON, E. 'Beobachtungen zum Grand Camée de France', *Kölner Jahrbuch für Vor- und Frühgeschichte*, IX (1967–8), 16–22.

VOLLENWEIDER, M. L. *Die Steinschneidekunst und ihre Künstler in spätrepublikanischer und augusteischer Zeit*. Baden-Baden, 1966.

VOLLENWEIDER, M. L. *Die Porträtgemmen der römischen Republik*. Mainz, 1972.

N. COINS AND MEDALLIONS

ALFÖLDI, A. *Die Kontorniaten*. Budapest, 1942, 1943.

BREGLIA, L. *Roman Imperial Coins: Their Art and Technique*. London, 1968.

BIBLIOGRAPHY

CRAWFORD, M. H. *Studies in the Roman Republican Coinage.* Cambridge, 1975.

GNECCHI, F. *I medaglioni romani.* Milan, 1912.

LANCKOROŃSKA, L. M. *Das römische Bildnis in Meisterwerken der Münzkunst.* Amsterdam, 1944.

MATTINGLY, H., etc. *Coins of the Roman Empire in the British Museum.* London, 1922–62.

MATTINGLY, H., and SYDENHAM, E. A., etc. *The Roman Imperial Coinage.* London, 1923–67.

MATTINGLY, H. *Roman Coins,* 2nd ed. London, 1960.

SYDENHAM, E. A. *The Coinage of the Roman Republic.* London, 1952.

TOYNBEE, J. M. C. *Roman Medallions.* New York, 1944.

THE PLATES

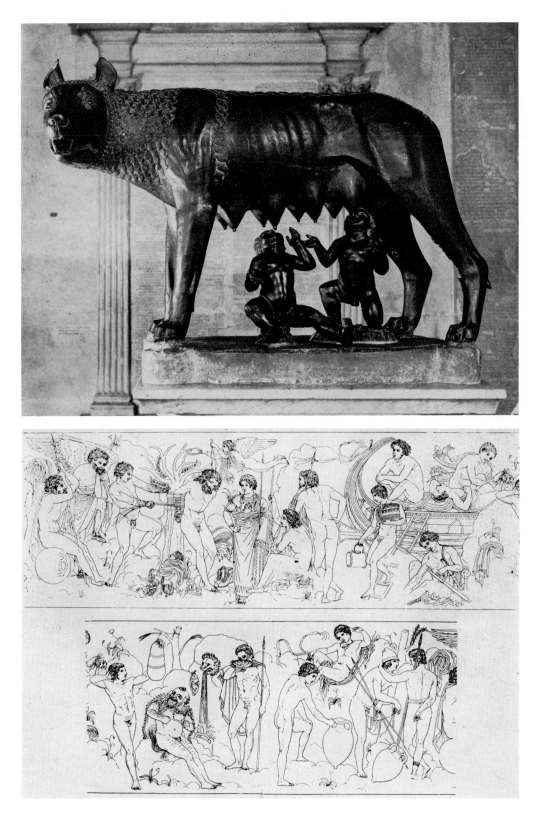

1. Lupa Romana, fifth century B.C. Bronze. *Rome, Palazzo dei Conservatori*

2. Scenes from the story of the Argonauts (drawing) on the circular Ficoroni cista, fifth–fourth century B.C. Bronze. *Rome, Villa Giulia*

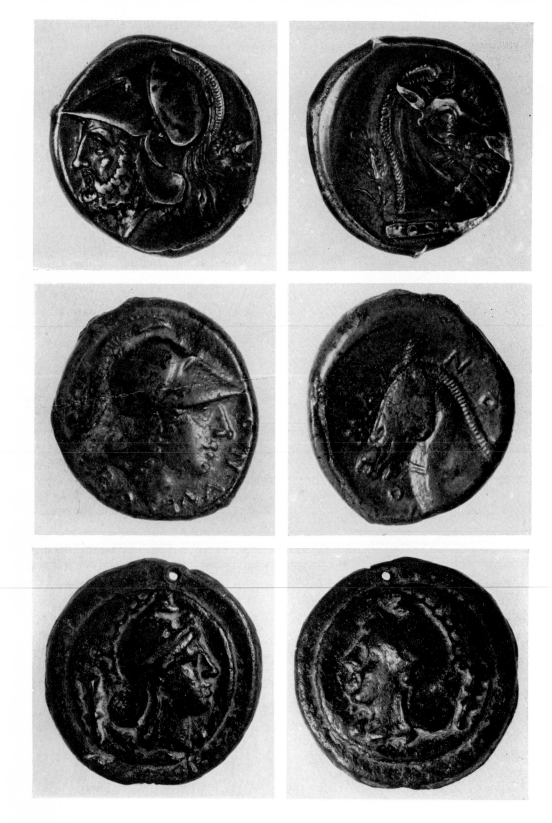

3 (A)–(F). Coins. (A) and (B) obverse (Mars) and reverse (horse) of a silver drachma struck in South Italy, 269–*c.* 242 B.C.; (C) and (D) obverse (Minerva) and reverse (horse) of a bronze half-litra struck in South Italy, 269–*c.* 242 B.C.; (E) and (F) obverse (Diana) and reverse (Diana) of heavy bronze (*aes grave*) struck in South Italy, *c.* 241–222 B.C.

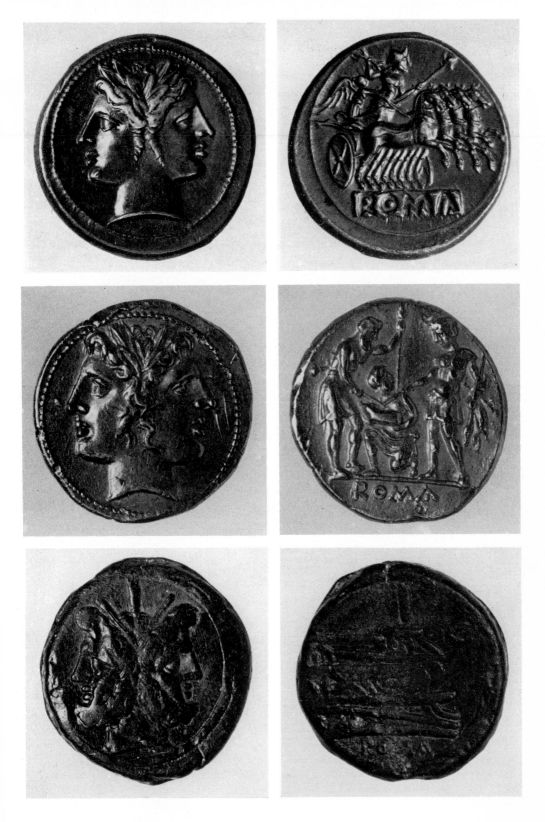

3 (G)–(L). Coins. (G) and (H) obverse (Janus) and reverse (Jupiter in quadriga) of a silver drachma (quadrigatus) struck in South Italy, *c.* 222–205 B.C.; (I) and (J) obverse (Janus) and reverse (oath-taking scene) of a gold stater struck in South Italy, *c.* 218–217 B.C.; (K) and (L) obverse (Janus) and reverse (prow) of bronze as struck in South Italy, *c.* 187–175 B.C.

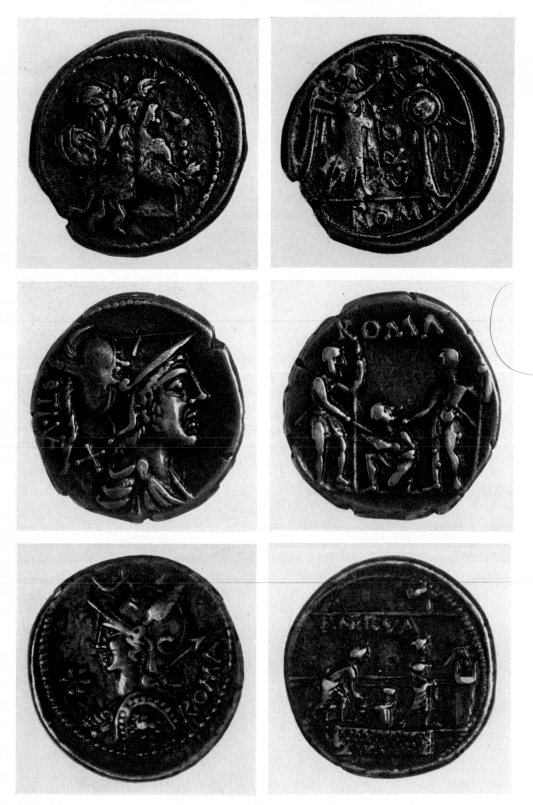

3 (M)–(R). Coins. (M) and (N) obverse (Jupiter) and reverse (Victory crowning a trophy) of a silver victoriatus struck in South Italy, *c.* 205–195 B.C.; (O) and (P) obverse (Mars) and reverse (oath-taking scene) of a silver denarius struck in Central Italy, *c.* 110–108 B.C.; (Q) and (R) obverse (Roma) and reverse (voting scene) of a silver denarius struck in Italy, *c.* 106 B.C. *London, British Museum*

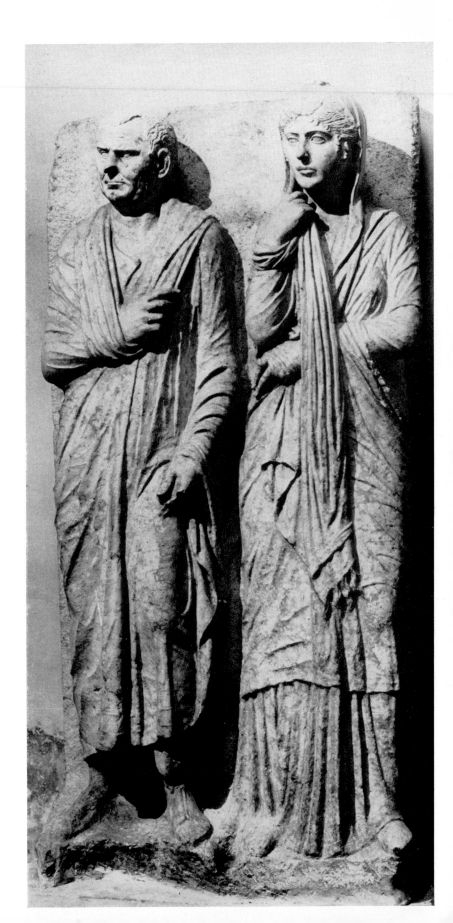

15. Husband and wife,
from the Via Statilia,
Rome, first century B.C.
Rome, Museo Capitolino

16 and 17. Relief fragments from the Piazza della Consolazione, Rome, first century B.C.(?). Stone. *Rome, Museo Capitolino*

18. Scene of sacrifice on a circular basis, first century B.C. *Civita Castellana Cathedral*

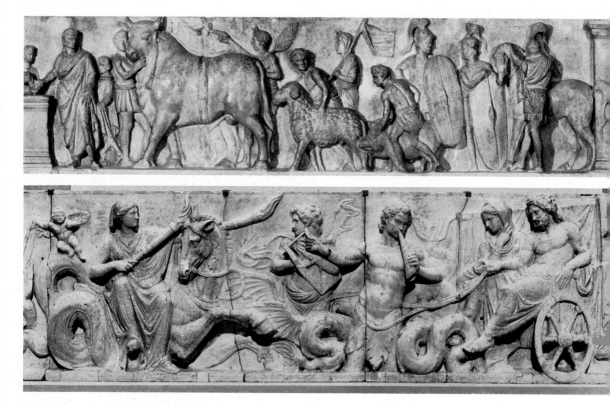

19. Census ceremonies, relief from the 'altar of Domitius Ahenobarbus', Rome, first century B.C. *Paris, Louvre*

20. Marine procession, relief from the 'altar of Domitius Ahenobarbus', Rome, first century B.C. *Munich, Staatliche Antikensammlung*

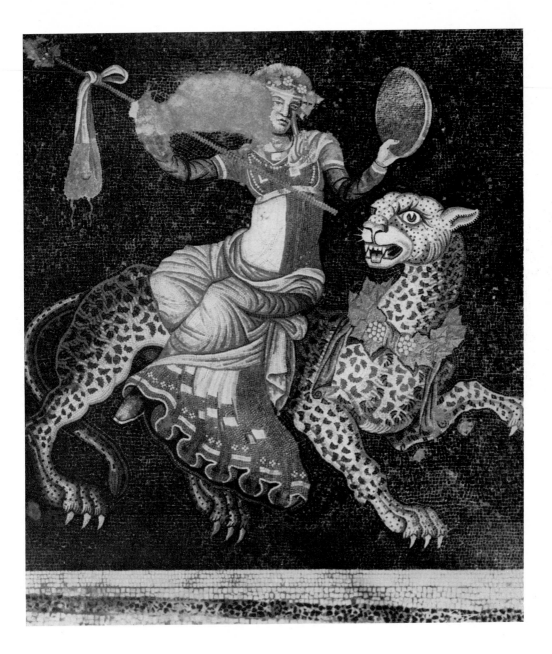

21. Dionysus riding a cheetah, mosaic in the House of the Masks, Delos, *c.* 100 B.C.

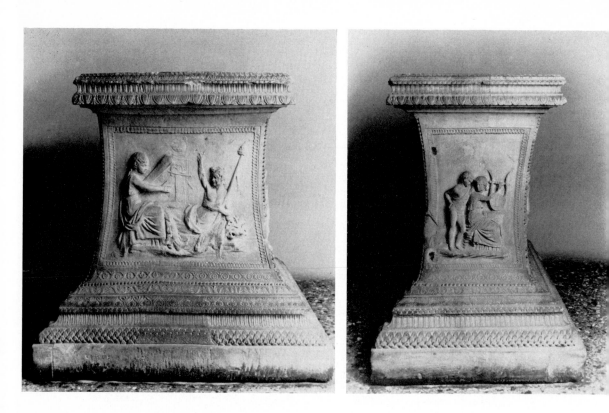

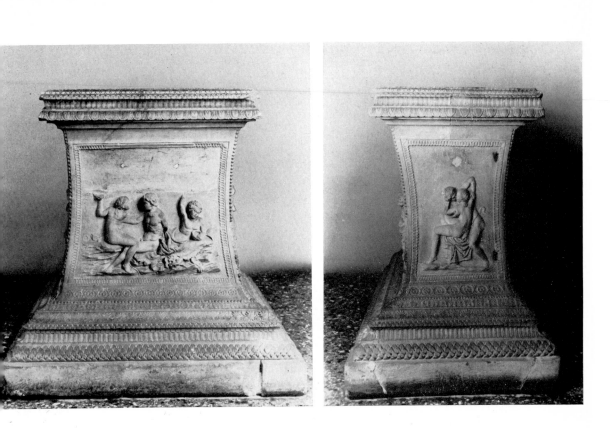

22. Genre and mythological figures on the four sides of the Grimani 'altar', first century B.C.
Venice, Museo Archeologico

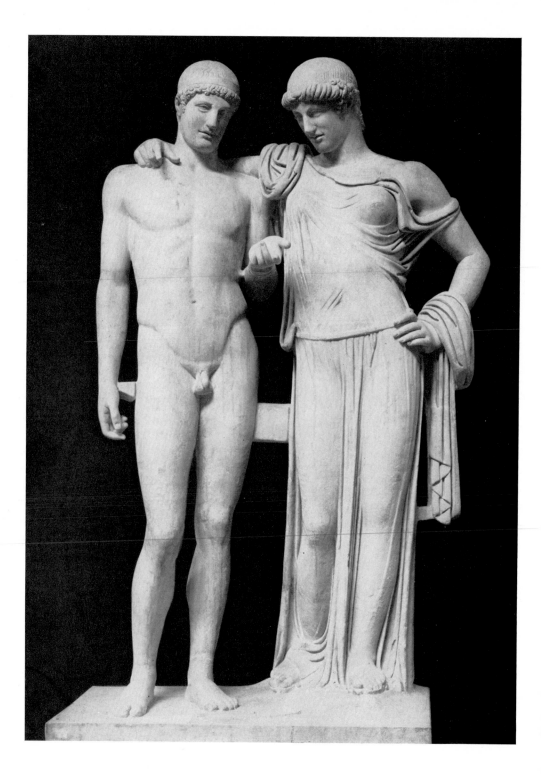

23. Pasitelean group of 'Orestes and Electra', first century B.C. *Naples, Museo Nazionale*

24. First style decoration in the House of the Centaur, Pompeii, second century B.C.

25. Second style decoration in the House of the Griffins on the Palatine, Rome, first century B.C.

26. Second style decoration in the House of Marcus Obellius Firmus, Pompeii, first century B.C.

27 and 28. Odyssey landscapes: Odysseus in the Land of the Laestrygones, and the Destruction of Odysseus' Ships, wall paintings from the Esquiline, first century B.C. *Vatican, Museo Profano*

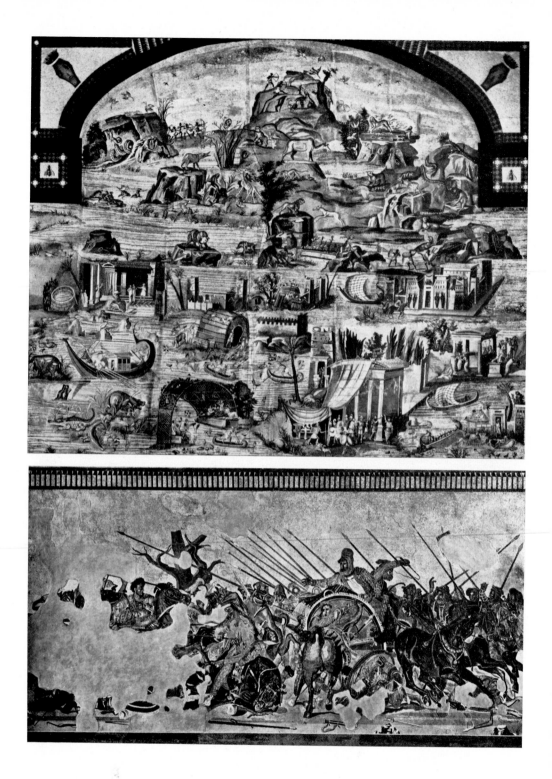

29. Nilotic mosaic in the temple of Fortuna, Palestrina, first century B.C.

30. Alexander mosaic, from the House of the Faun, Pompeii, first century B.C. *Naples, Museo Nazionale*

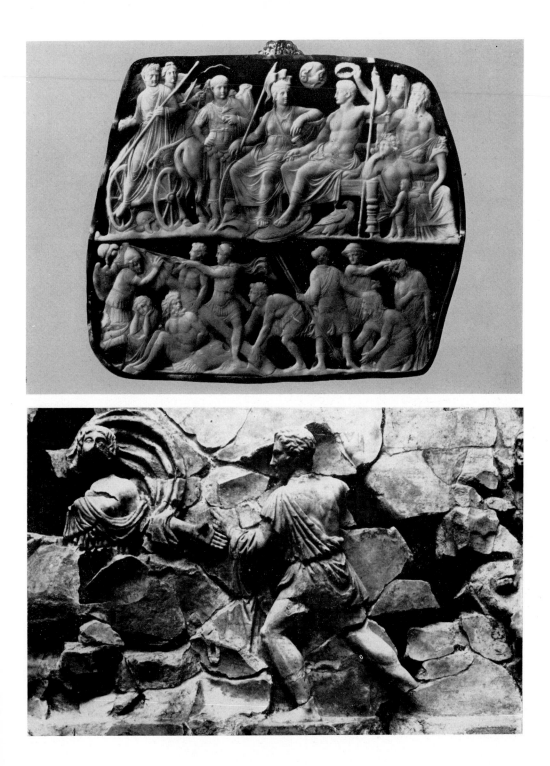

31. Imperial group, etc., on the Gemma Augustea (a sardonyx cameo), first century A.D. *Vienna, Kunsthistorisches Museum*

32. Punishment of Tarpeia, part of a frieze from the Basilica Aemilia, late first century B.C. *Rome, Antiquarium of the Forum Romanum*

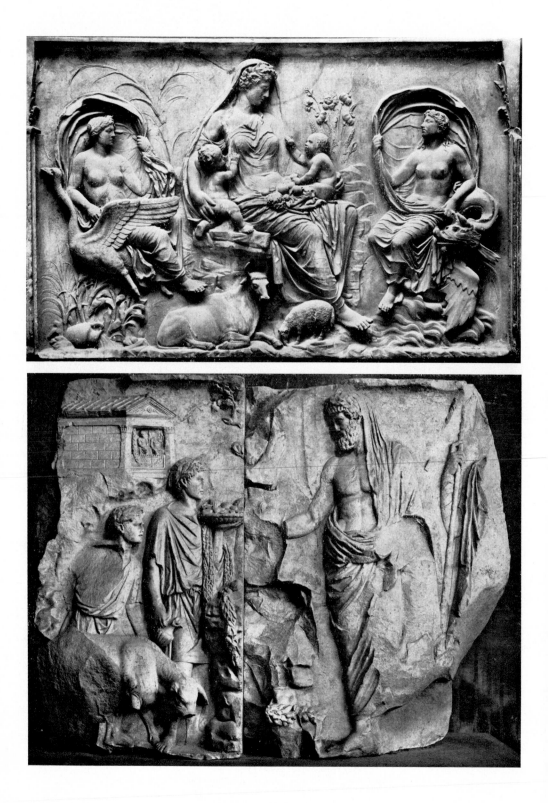

two fragments of acanthus scroll frieze, on the Ara Pacis Augustae, Rome, late first century B.C.

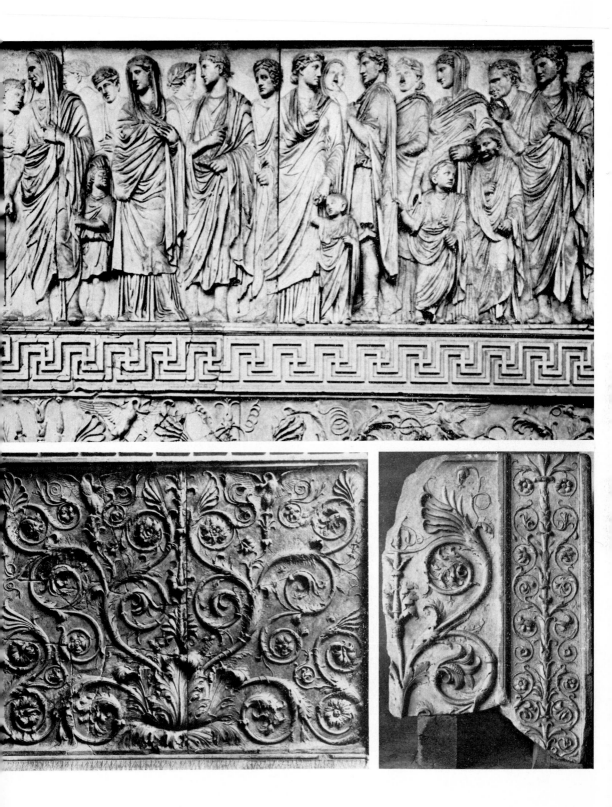

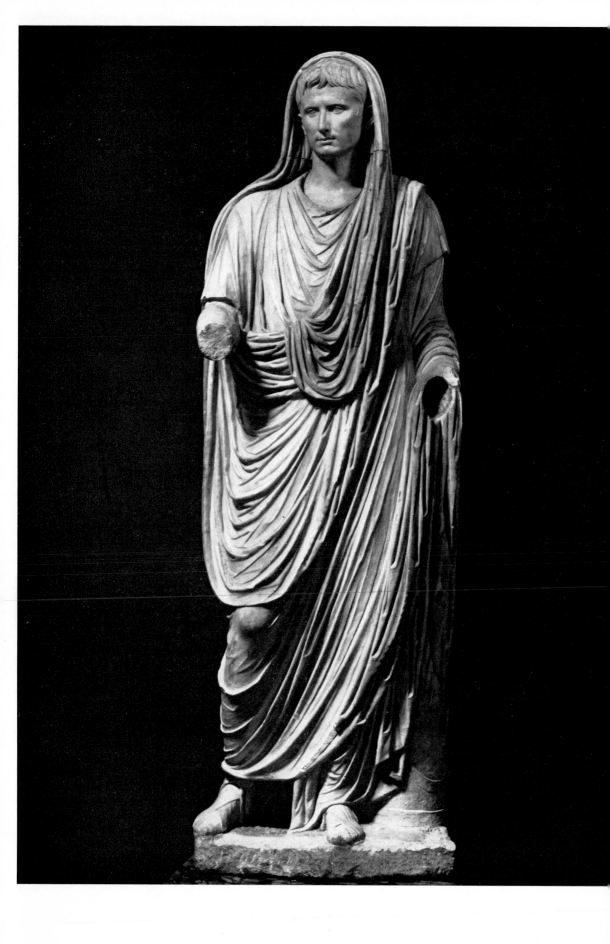

38 (*opposite*). Augustus as a veiled priest, from the Via Labicana, Rome, first century A.D. *Rome, Museo Nazionale Romano*

39. Augustus with cuirass, from Prima Porta, early first century A.D. *Vatican Museum*

40. Battle between Romans and Gauls, early first century A.D. *Mantua, Palazzo Ducale*

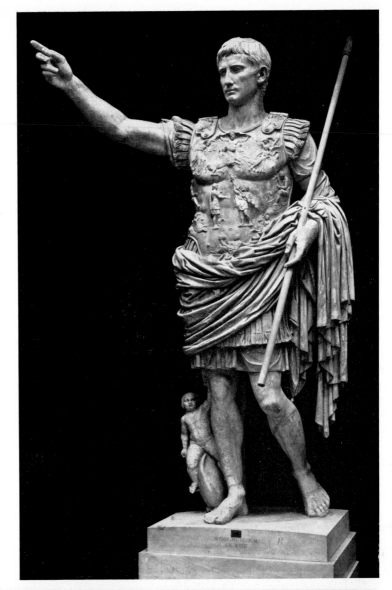

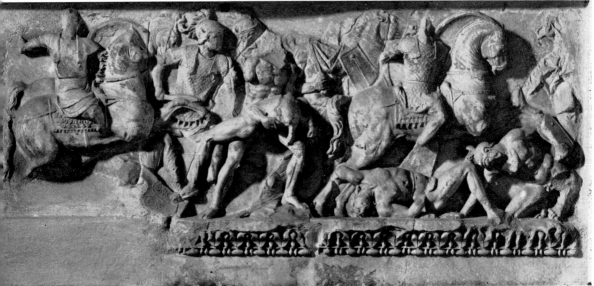

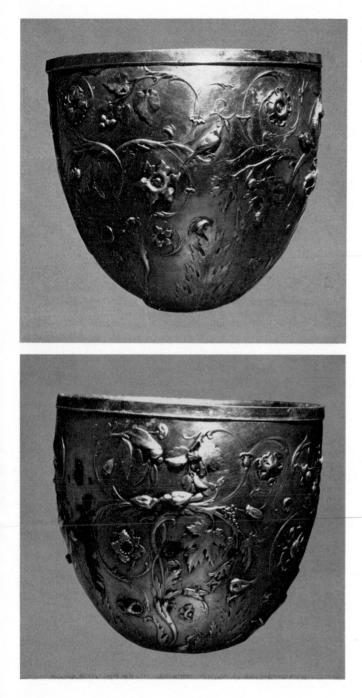

41 and 42. Cups with scrollwork, first century B.C. or A.D. Silver. *London, British Museum*

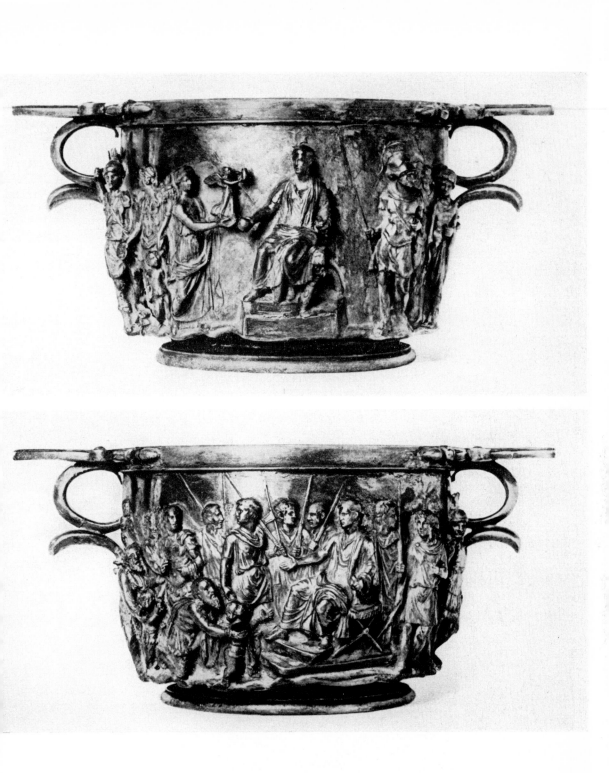

43 and 44. Cups with historical scenes, from Boscoreale. Silver. *Paris, Élie de Rothschild Collection*

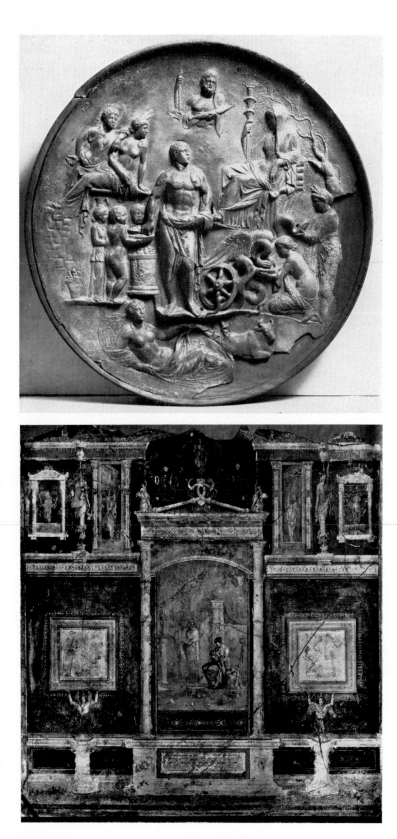

45. Triptolemus dish, from Aquileia, first century A.D. Silver. *Vienna, Kunsthistorisches Museum*

46. Painted architectural wall scheme, from the Farnesina House, Rome, *c.* 20 B.C.(?). *Rome, Museo Nazionale Romano*

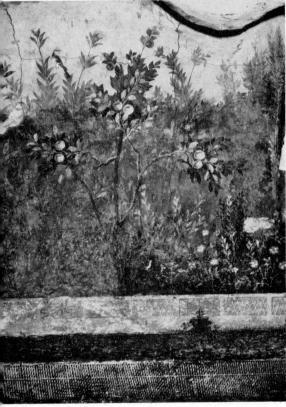

47 and 48. Garden scene, with detail,
wall painting from the villa of Livia at
Prima Porta, late first century B.C. *Rome,
Museo Nazionale Romano*

49 (*opposite*). Grisaille frieze from the *tablinum* of the house of Livia on the Palatine, Rome, first century B.C.

50. Theseus and the Minotaur, wall painting from the basilica at Herculaneum, first century A.D. *Naples, Museo Nazionale*

51. Wall mosaic in the house of Poseidon and Amphitrite, Herculaneum, first century A.D.

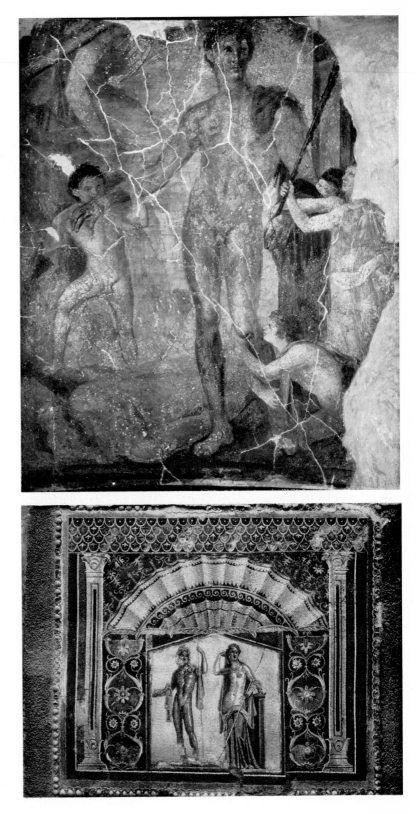

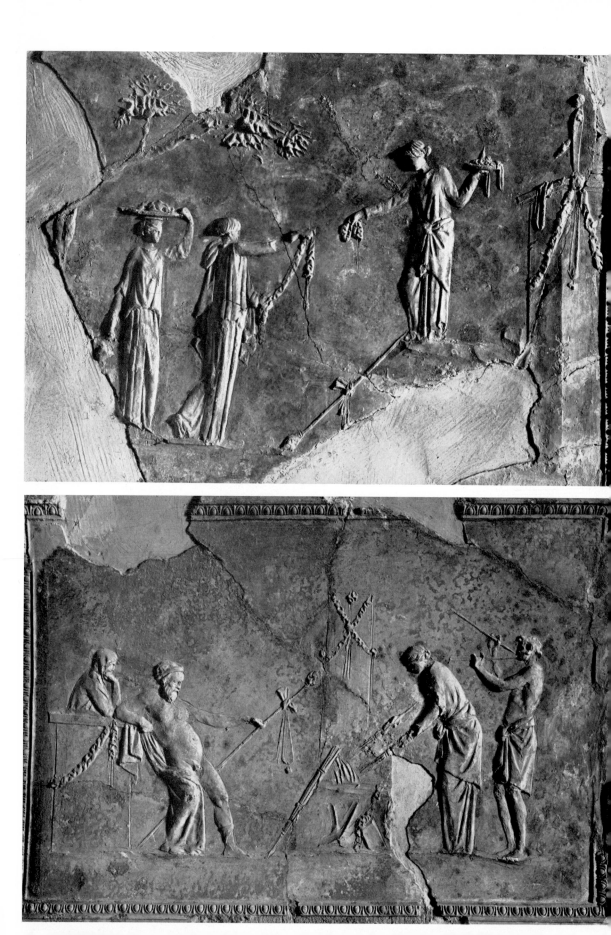

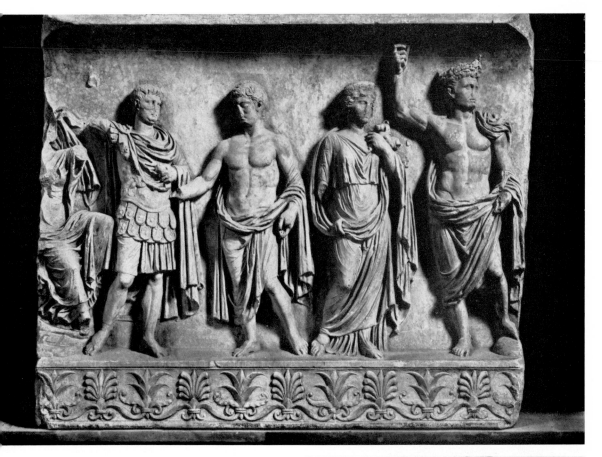

52 and 53. Stucco decoration with cultic scenes from the Farnesina House, Rome, first century B.C. or A.D. *Rome, Museo Nazionale Romano*

54 and 55. An imperial group and a scene of sacrifice, fragments of reliefs, first century A.D. *Ravenna, Museo Nazionale*

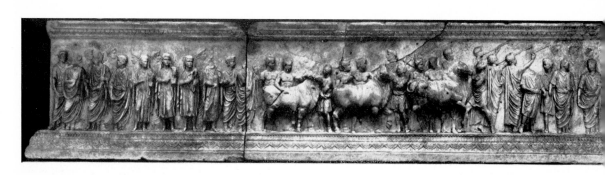

56. Vicomagistri, etc., relief frieze from the Cancelleria, Julio–Claudian period. *Vatican Museum*

57. Scene of sacrifice and a temple, reliefs from the Ara Pietatis Augustae, Rome, first half of the first century A.D. *Rome, Villa Medici*

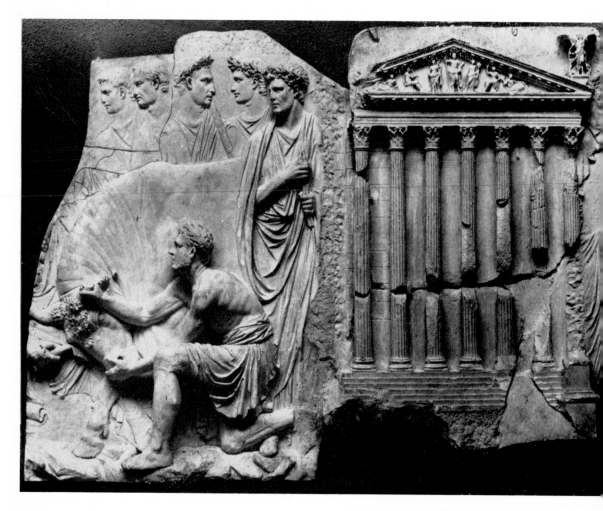

58. Tiberius, A.D. 4–14. *Benghazi Museum*

59. Personified cities, relief on a basis from Pozzuoli,
c. A.D. 17. *Naples, Museo Nazionale*

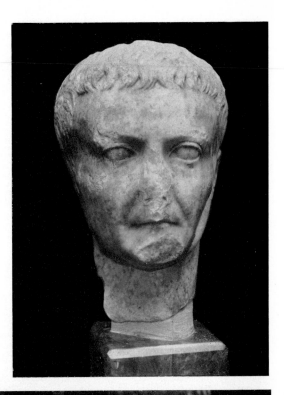

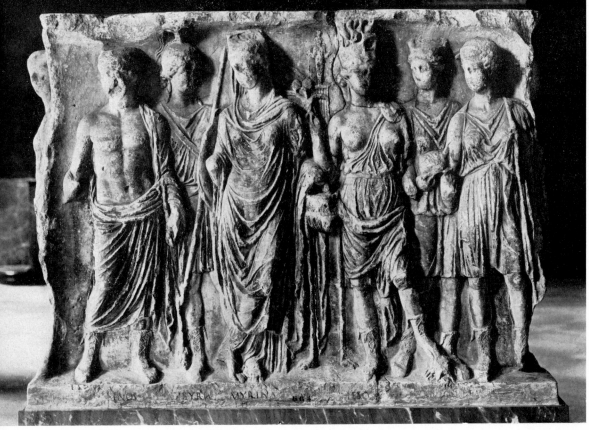

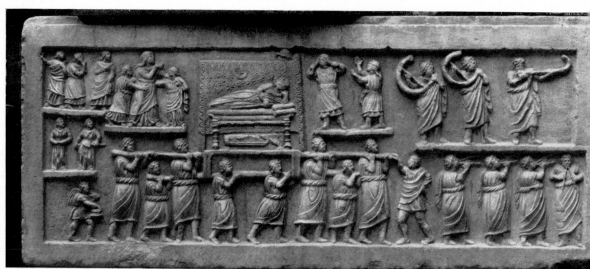

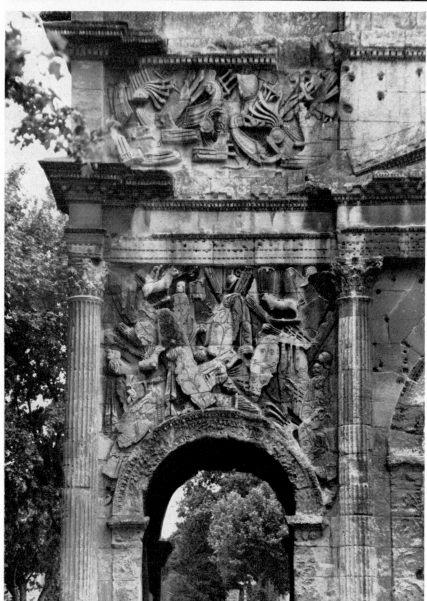

60. Funeral procession, relief from Amiternum, first century A.D.(?). *Aquila, Museo Aquilano*

61. Relief of arms on the arch at Orange, Tiberian period

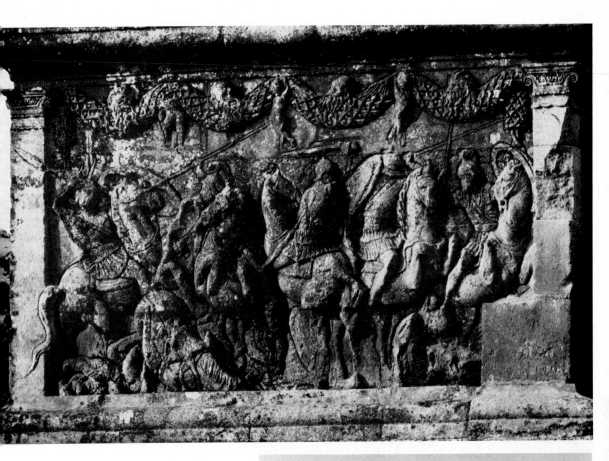

62. Battle scene, relief on the monument of the Julii at Saint-Rémy, first century B.C. or A.D.

63. Frieze with scrollwork on the Maison Carrée, Nîmes, late first century B.C.

64. Shipwrecked helmsman, from the grotto at Sperlonga, Tiberian period. *Sperlonga Museum*

65. Third style decoration in the House of Lucretius Fronto, Pompeii, first century A.D.

66. Fourth style decoration in the House of the Vettii, Pompeii, first century A.D.

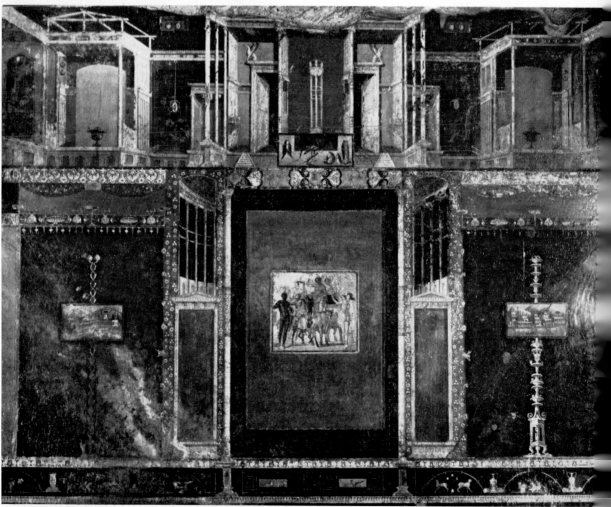

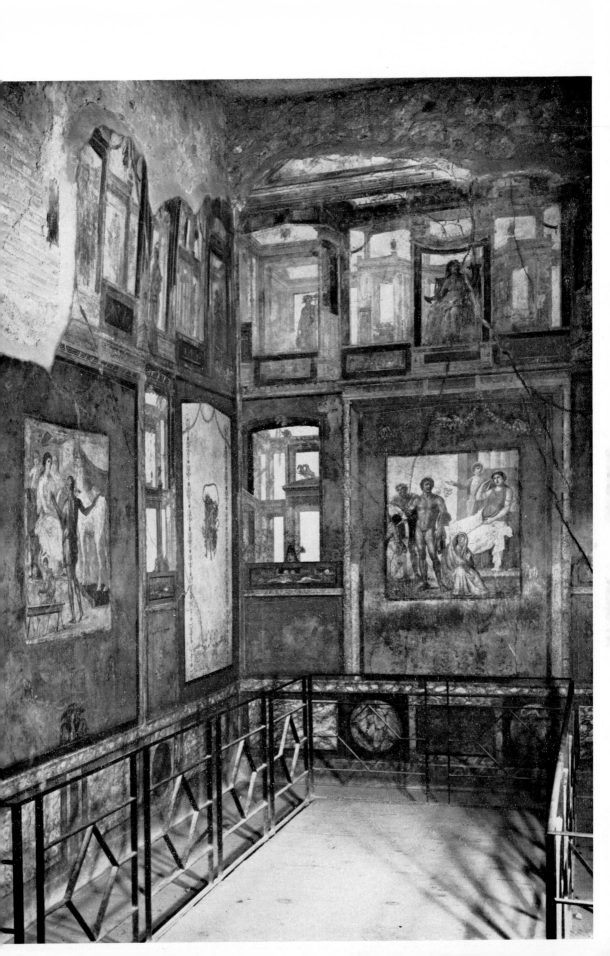

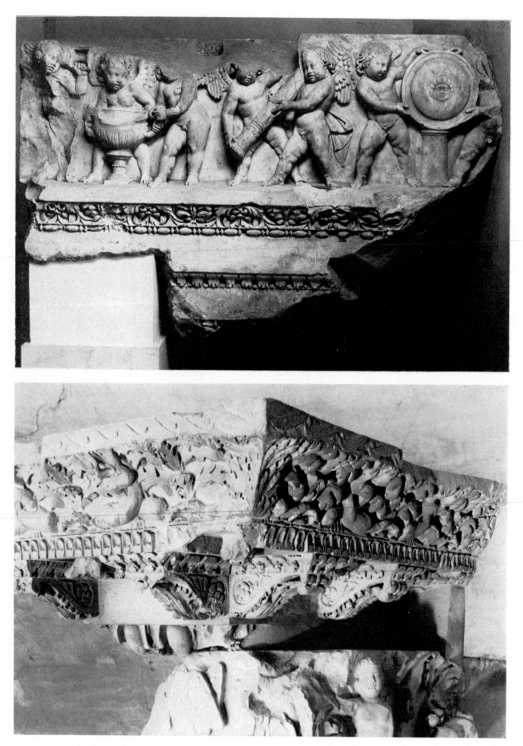

67. Putti, relief from the temple of Venus Genetrix, Rome, Flavian/Trajanic. *Rome, Museo Capitolino*

68. Cornice fragment with floral ornament, from the Flavian palace, late first century A.D. *Rome, Palatine*

69 and 70. Triumphal procession, reliefs on the passageway of the arch of Titus, Rome, *c.* A.D. 81

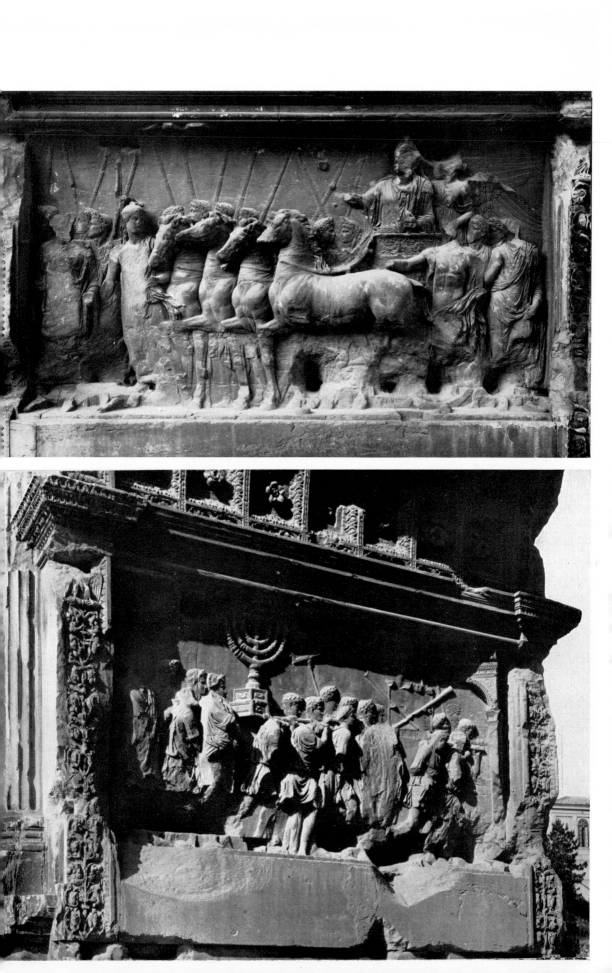

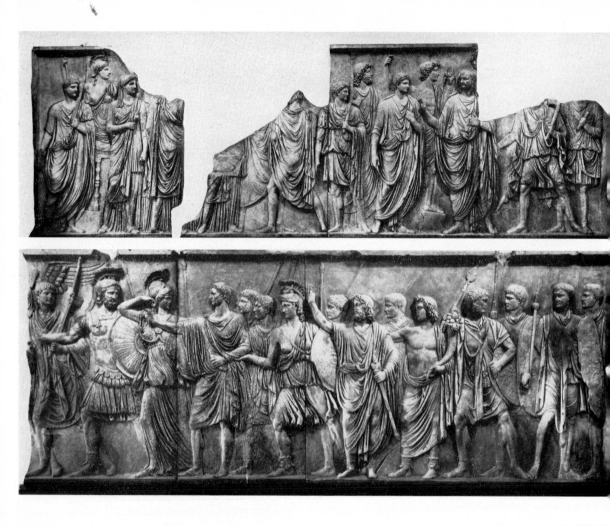

71 and 72. *Adventus* of Vespasian and *profectio* of Domitian, friezes from the Cancelleria, late Flavian period. *Vatican Museum*

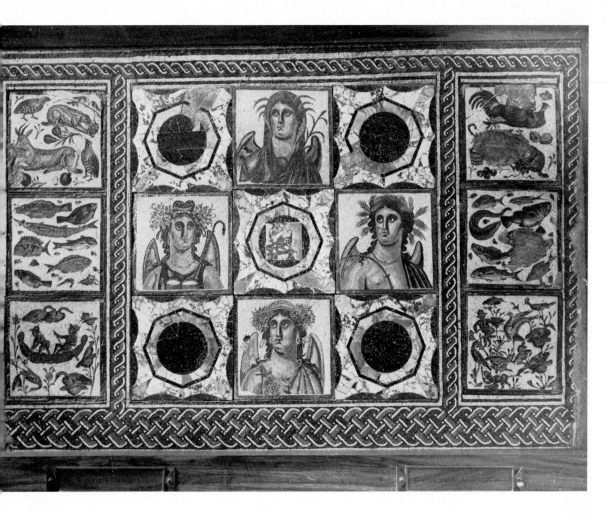

73. The Four Seasons, etc., from the villa at Zliten, Tripolitania, late first century A.D. *Opus sectile* and *opus vermiculatum* mosaic. *Tripoli Museum*

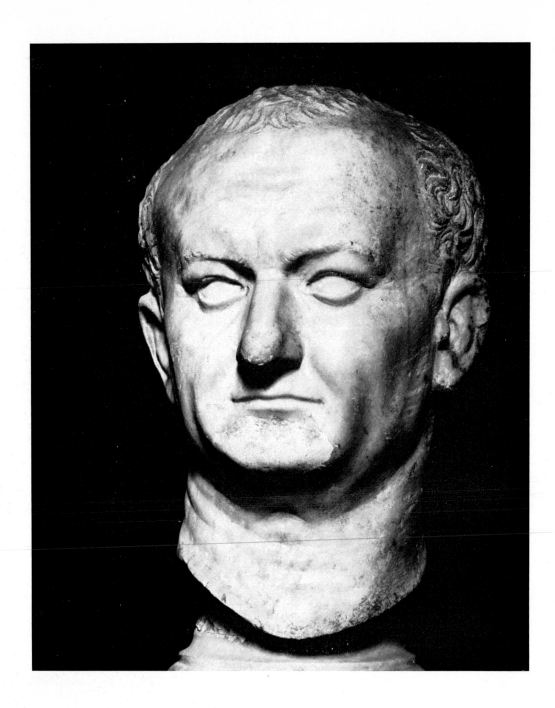

74. Vespasian (A.D.70–9). *Rome, Museo Nazionale Romano*

75. Domitian (or Titus), colossal head from Ephesus, Flavian period. *Izmir Museum*

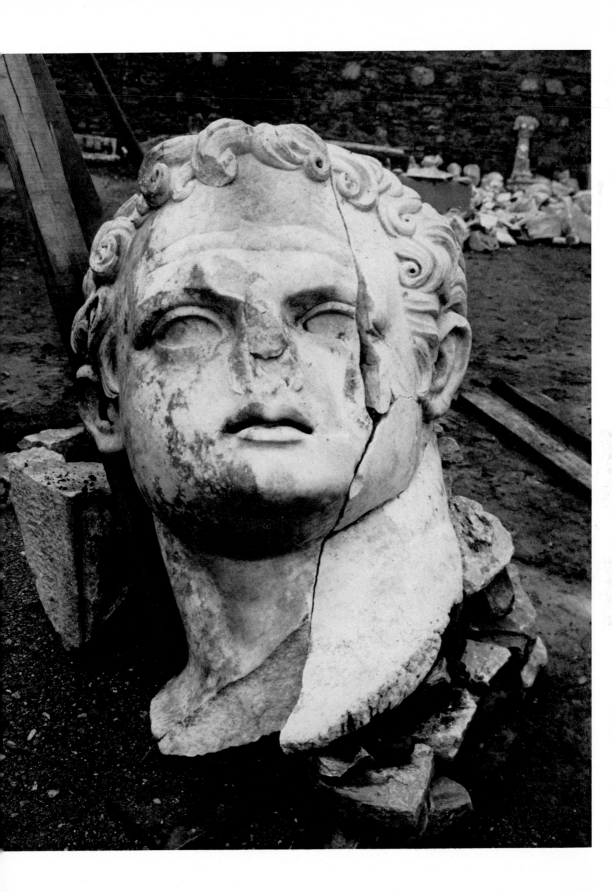

76 and 77. Construction of a mausoleum and a lying in state, and another lying in state, reliefs from the tomb of the Haterii, late first century A.D. *Vatican Museum*

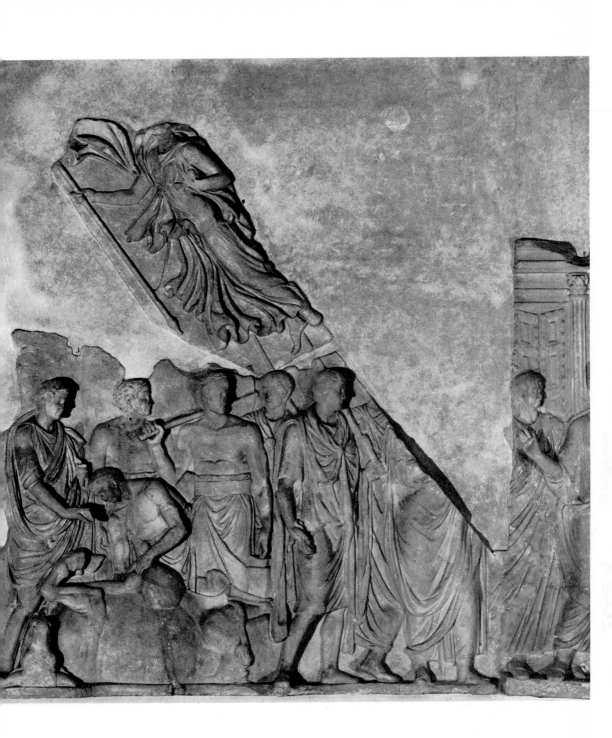

78. *Extispicium* (inspection of entrails), late first century A.D. *Paris, Louvre*

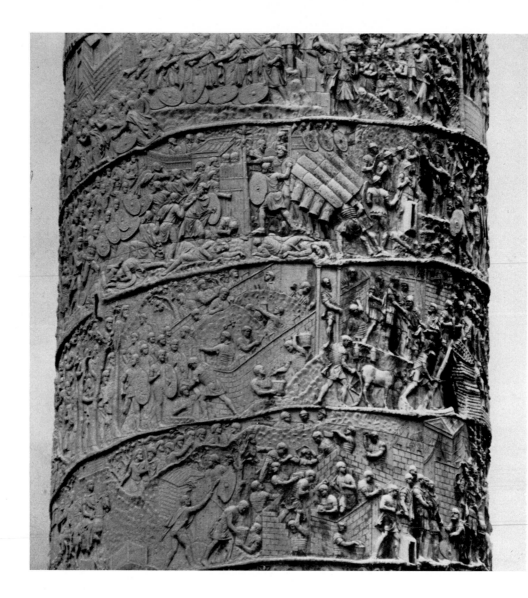

79. Detail of the lower part of Trajan's column in the forum of Trajan, Rome, 112–13

80 and 81. The Roman army crossing the Danube, and Dacian prisoners brought before the emperor, details of Trajan's column

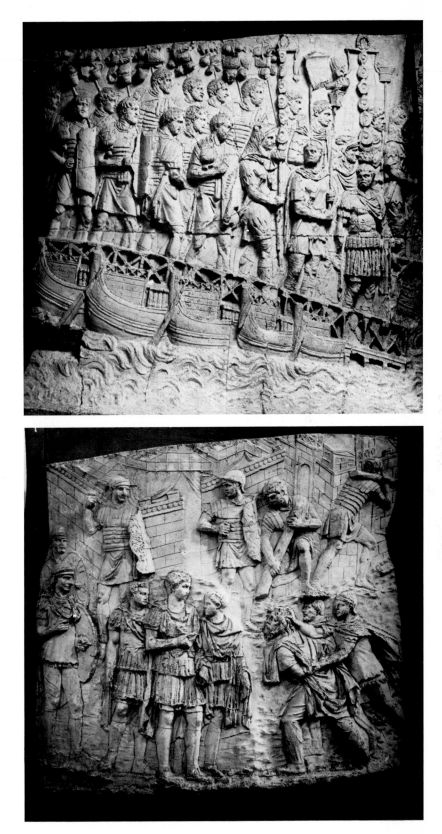

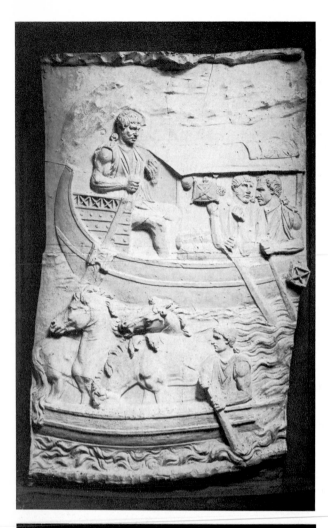

82 and 83. Roman ships on the Danube, and the emperor rewarding soldiers, details of Trajan's column

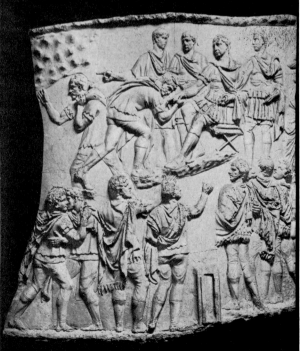

84 and 85. The emperor with Dacian envoys, and submission of Dacians at the end of the first war, details of Trajan's column

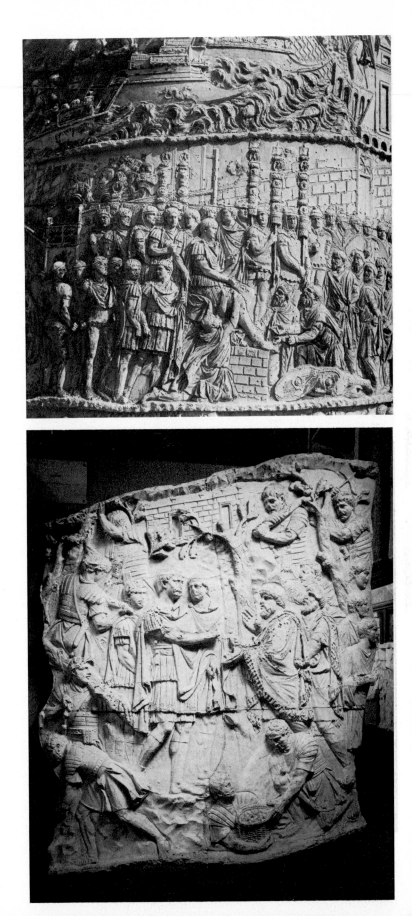

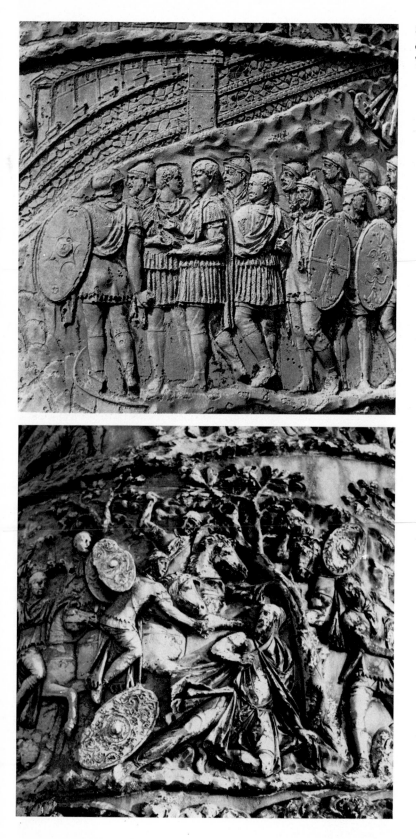

86 and 87. Dacian fortress, and death of Decebalus, details of Trajan's column

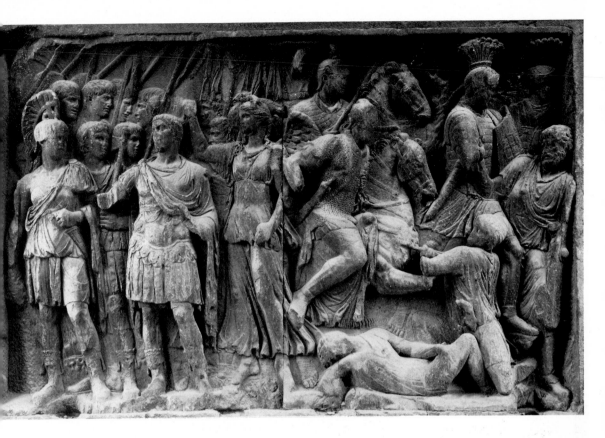

88. *Adventus*, from the 'Great Trajanic Frieze', *c.* 117(?), re-used on the arch of Constantine, Rome

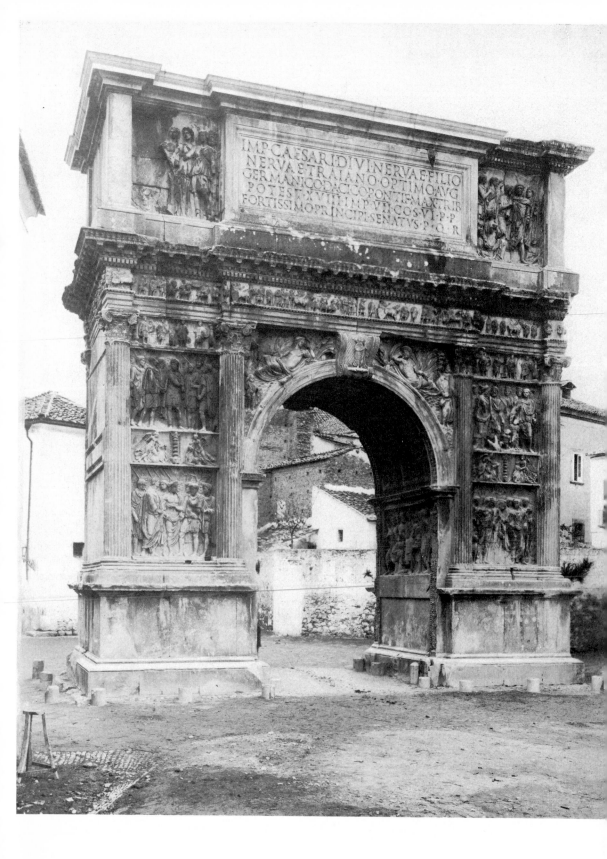

IMP.CAESARI.DIVI.NERVAE.FILIO
NERVAE.TRAIANO.OPTIMO.AVG
GERMANICO.DACICO.PONTIF.MAX.TRIB
POTEST.XVIII.IMP.VII.COS.VI.P.P
FORTISSIMO.PRINCIPI.SENATVS.P.Q.R

89. Trajan's arch at Benevento, *c.* 117, the side facing the country

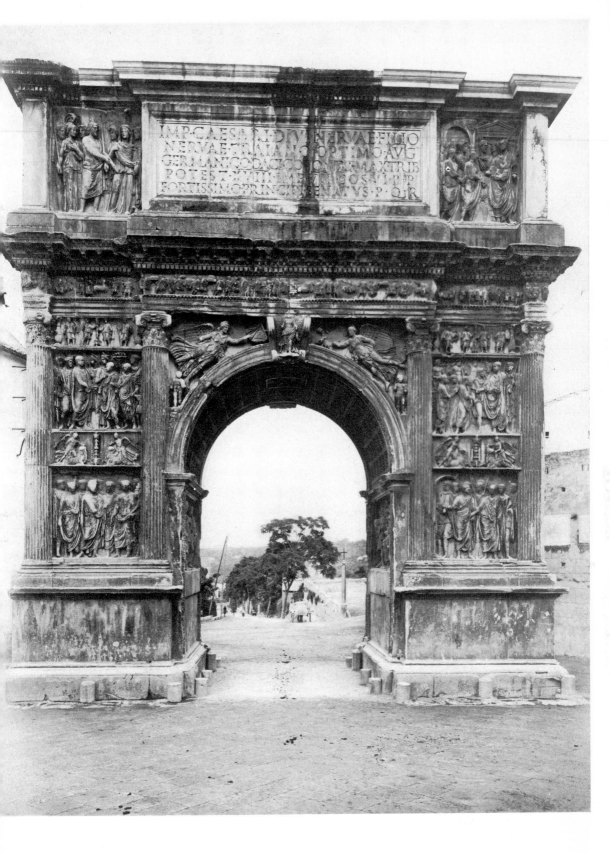

90. Trajan's arch at Benevento, *c.* 117, the side facing the city

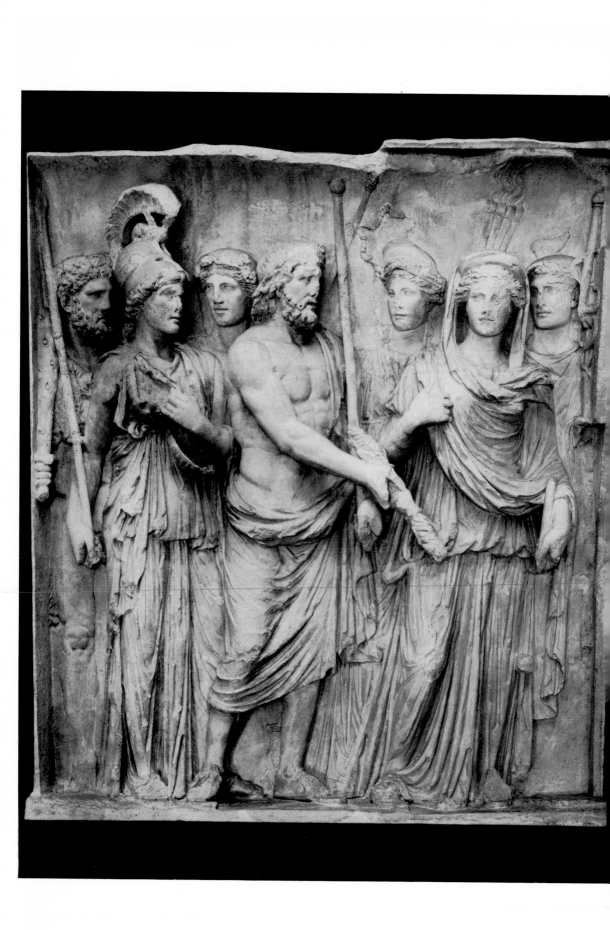

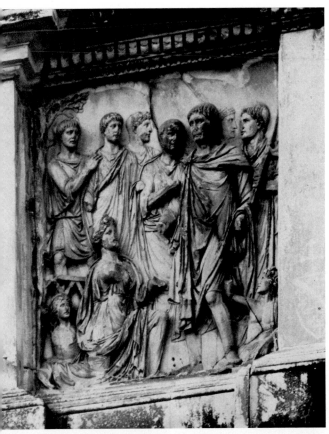

91–3. Trajan's arch at Benevento, *c.* 117, reliefs with Capitoline Triad, Mesopotamia between Tigris and Euphrates, and *alimenta* scene

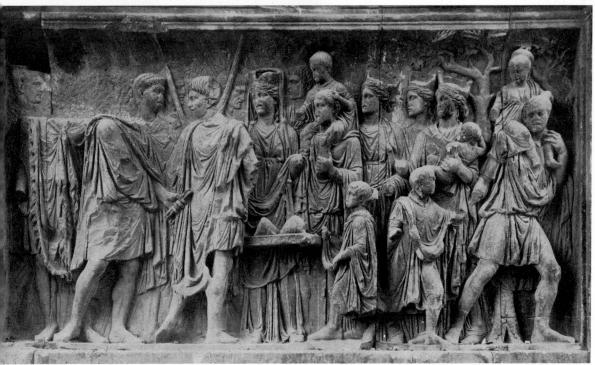

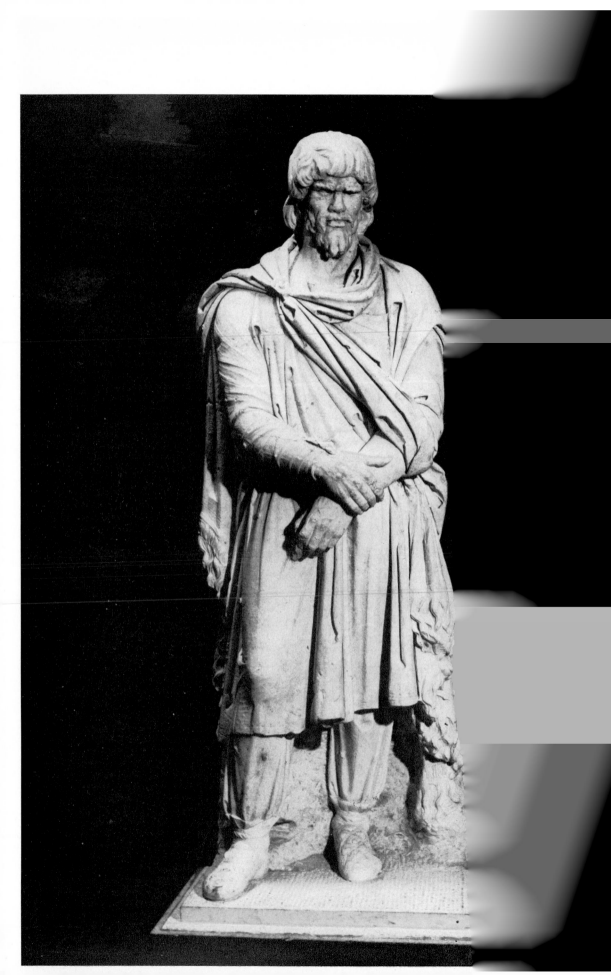

94. Dacian, from Rome (?),
Trajanic period.
Pavonazzetto. *Vatican
Museum*

95. Trajan (98–117).
London, British Museum

96. *Imago clipeata* of
Trajan (?) (98–117).
Bronze. *Ankara, Archaeo-
logical Museum*

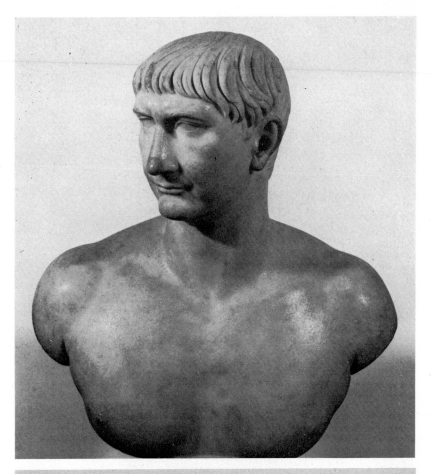

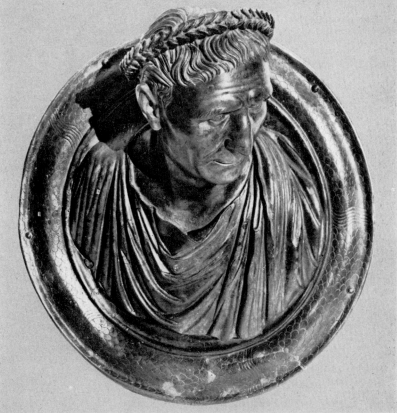

97. Friezes on the exterior of the theatre at Arles, Augustan period

98. Altar with swans, from the theatre at Arles, Augustan period. *Arles, Musée Lapidaire*

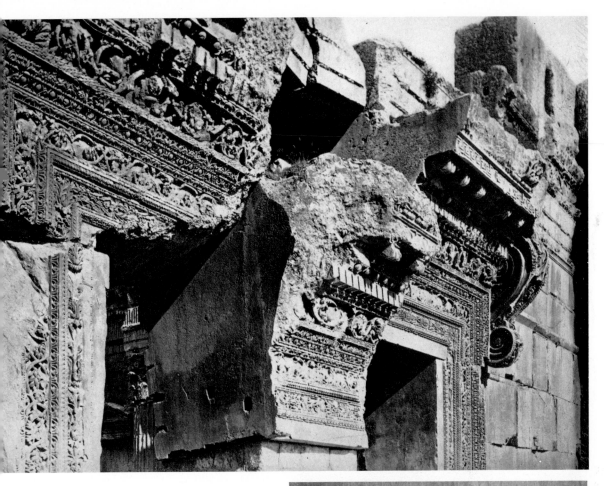

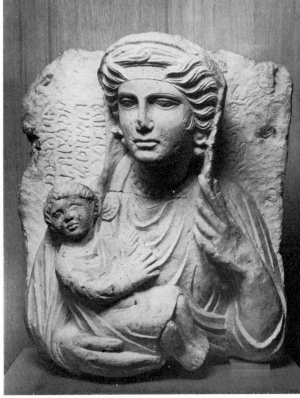

99. Carving at the main entrance to the 'Temple of Bacchus', Baalbek, second century

100. Palmyrene funerary portrait of a mother and child, second century(?). *Oslo, Nasjonalgalleriet*

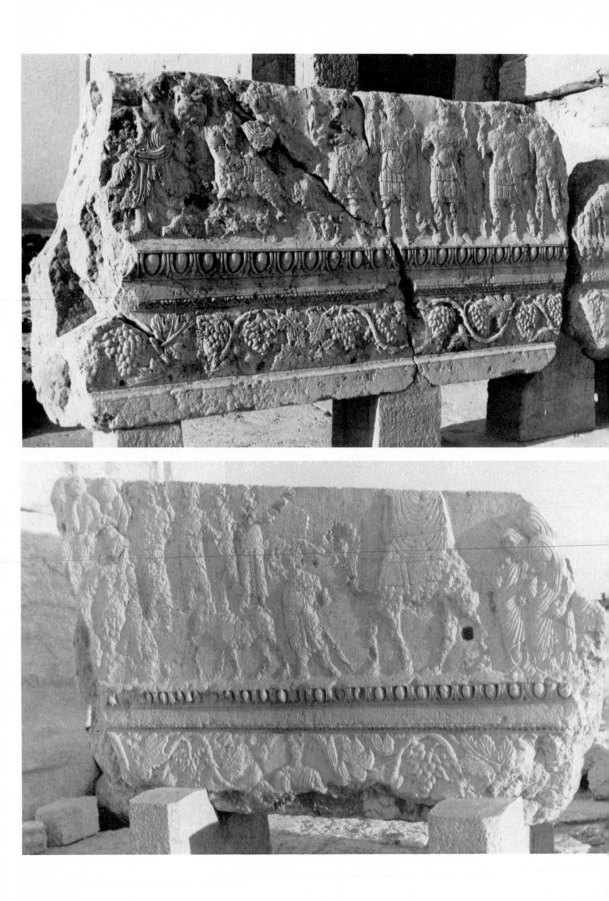

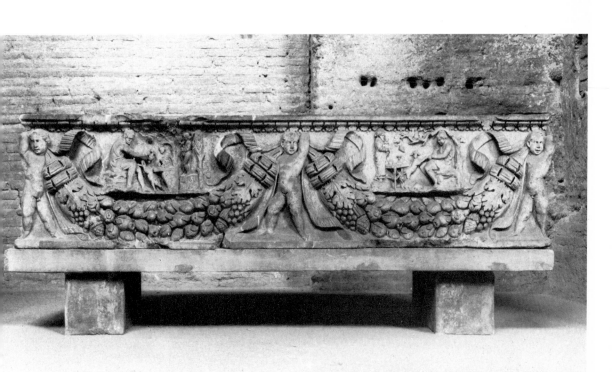

101 and 102. Palmyrene gods and worshippers, and processional scene, from the frieze of the temple of Bel, Palmyra, first or second century

103. Garland sarcophagus, from the Via Labicana, Rome, early second century. *Rome, Museo Nazionale Romano*

104. Elaborate funerary altar, early second century. *Vatican Museum*

105. Sabina, idealized portrait, Hadrianic period. *Rome, Museo Nazionale Romano*

106. Hadrian (117–38). *Athens, National Museum*

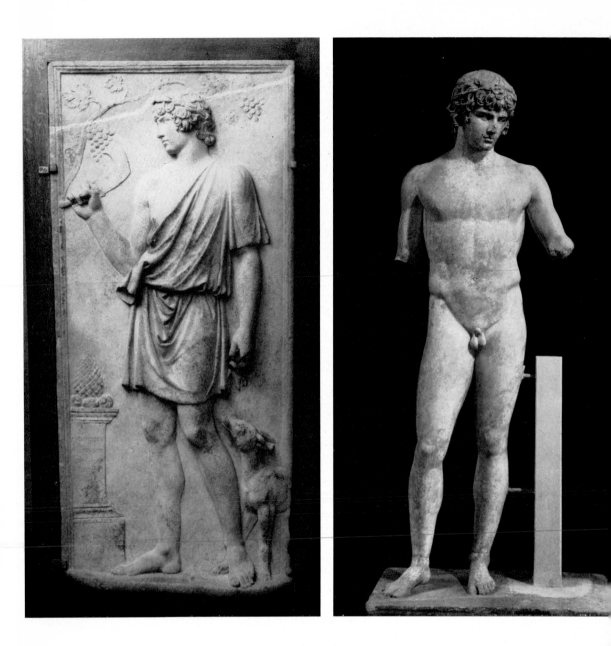

107. Antinous/Silvanus, relief signed by Antonianos of Aphrodisias, Hadrianic period. *Rome, Banca Romana*

108. Antinous, Hadrianic period. *Delphi Museum*

109. Caryatids from the
Canopus of Hadrian's
villa, Tivoli

110. Imperial family
group from the 'Great
Antonine Altar', from
the library at Ephesus,
c. 138. *Vienna, Neue
Hofburg*

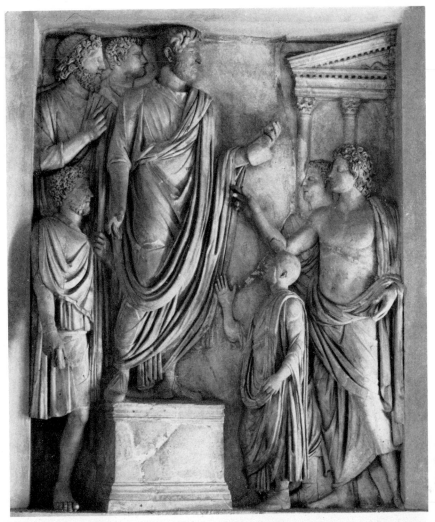

112. *Adlocutio*, Hadrianic period. *Rome, Palazzo dei Conservatori*

113. *Adlocutio* and *alimenta* scenes on the 'Anaglypha Traiani', early Hadrianic period. *Rome, The Curia*

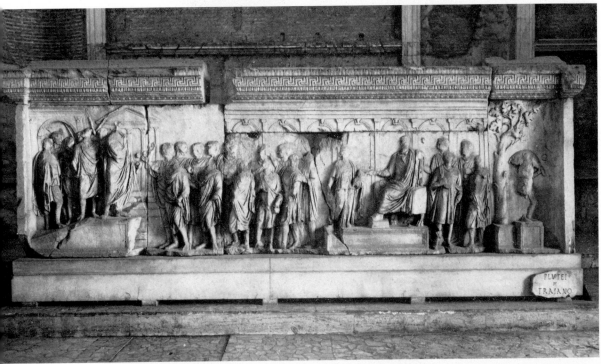

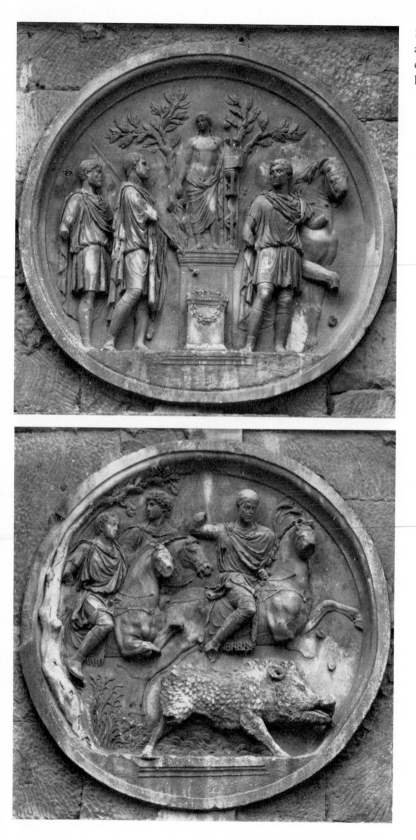

114 and 115. Sacrifice to Apollo and boar hunt, 'tondi' re-used on the arch of Constantine, Rome, Hadrianic period

116 and 117. Personified provinces (the second perhaps Mauretania), from the Hadrianeum, *c.* 139. Rome, *Palazzo dei Conservatori*

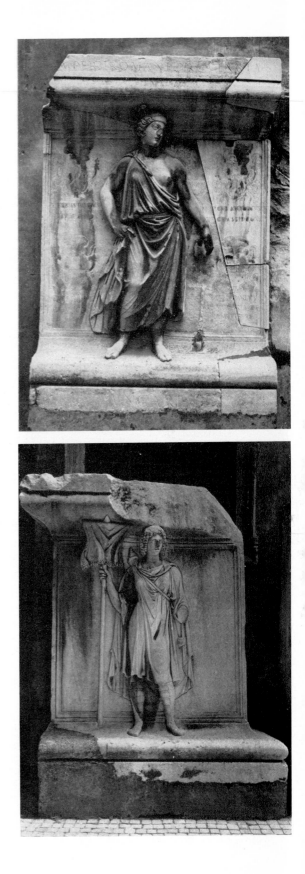

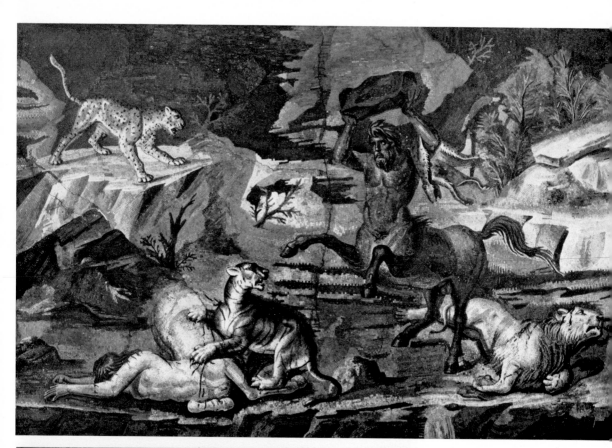

118. Centaurs and wild
animals, mosaic from
Hadrian's villa, Tivoli.
(*East*) Berlin, *Pergamon-
museum*

119. Marine mosaic in the
baths of Neptune, Ostia,
second century

120. Wall painting with detail
from Room 5 of the House of the
Muses, Ostia, second century

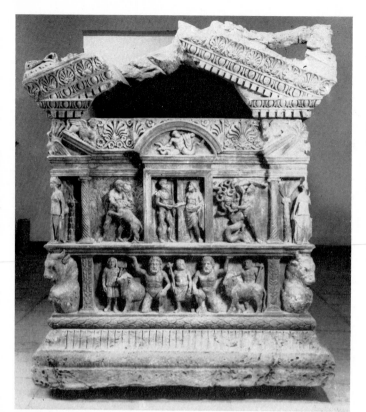

121 The Velletri sarcophagus (two sides), Hadrianic period(?). *Rome, Museo Nazionale Romano*

122. Sarcophagus depicting the Indian triumph of Dionysus, from the tomb of the Calpurnii Pisones, Rome, second century. *Baltimore, Walters Art Gallery*

123. Orestes sarcophagus, Hadrianic period. *Vatican Museum*

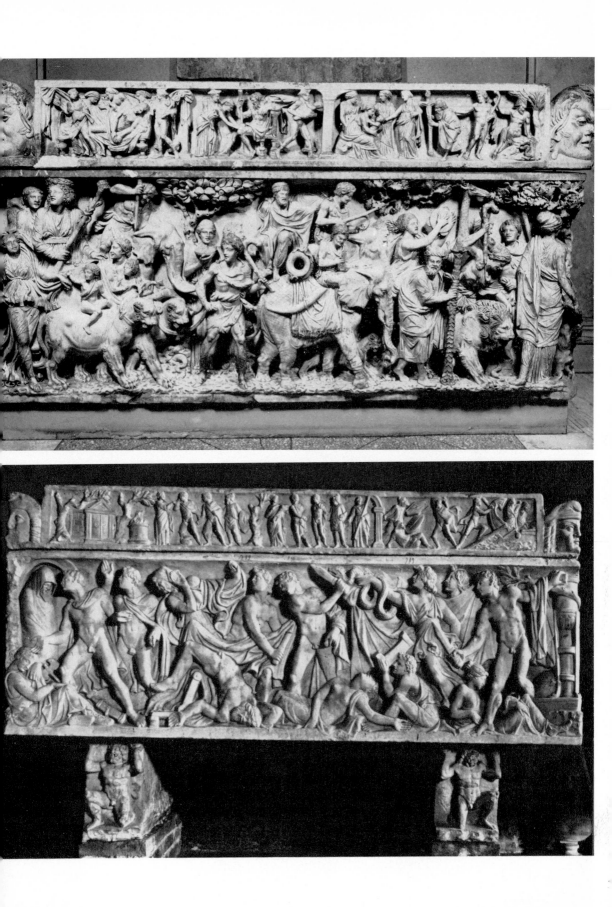

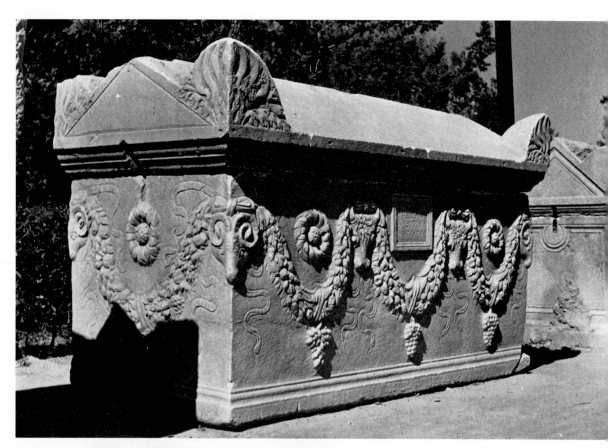

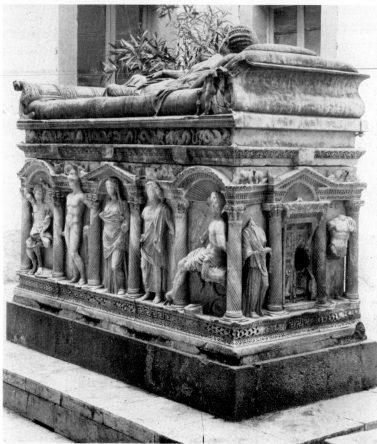

124. Attic garland sarcophagus, second century. *Salonika Museum*

125. Asiatic sarcophagus, second century. *Melfi Cathedral*

126 (A)–(G). Bronze sestertius types (reverses) representing provinces: Arabia (Trajan), and Africa, Britannia, Aegyptos, Dacia, Mauretania, Sicilia (Hadrian); (H) bronze sestertius of Marcus Aurelius and Lucius Verus (reverse), showing the column of Antoninus Pius, 161. *London, British Museum*

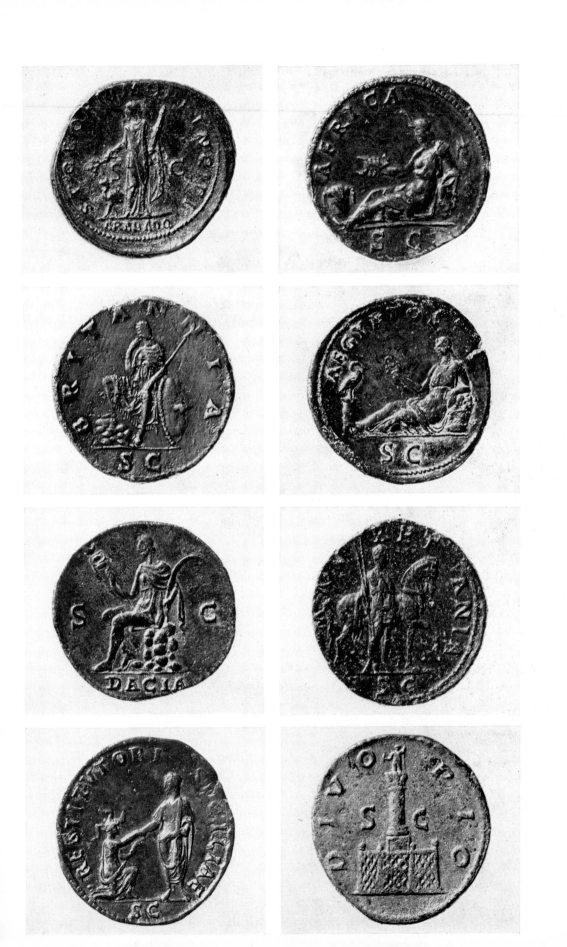

127 and 128. *Apotheosis* and *decursio* on the base of the column of Antoninus Pius, *c.* 161. *Vatican Museum*

129. Frieze on the temple of Antoninus and Faustina in the Forum Romanum, Rome, *c.* 161

130. Sarcophagus of Euhodus depicting the death of Alcestis, second century. *Vatican Museum*

131. Sarcophagus depicting the Gigantomachy, second century. *Vatican Museum*

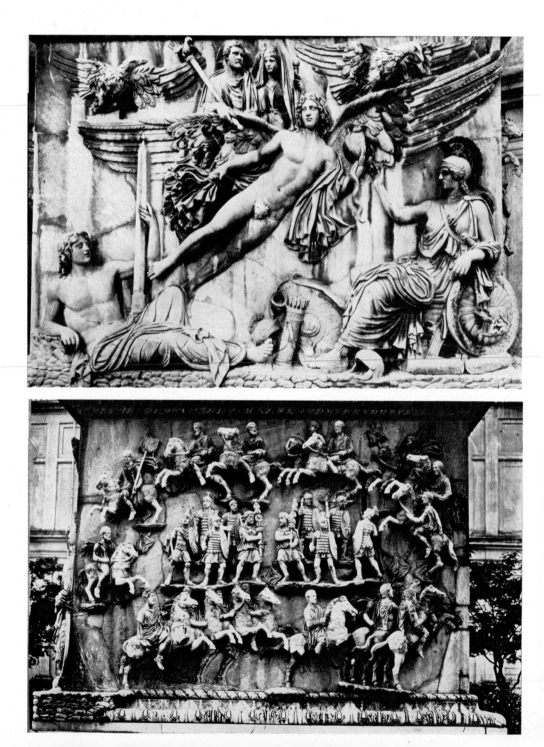

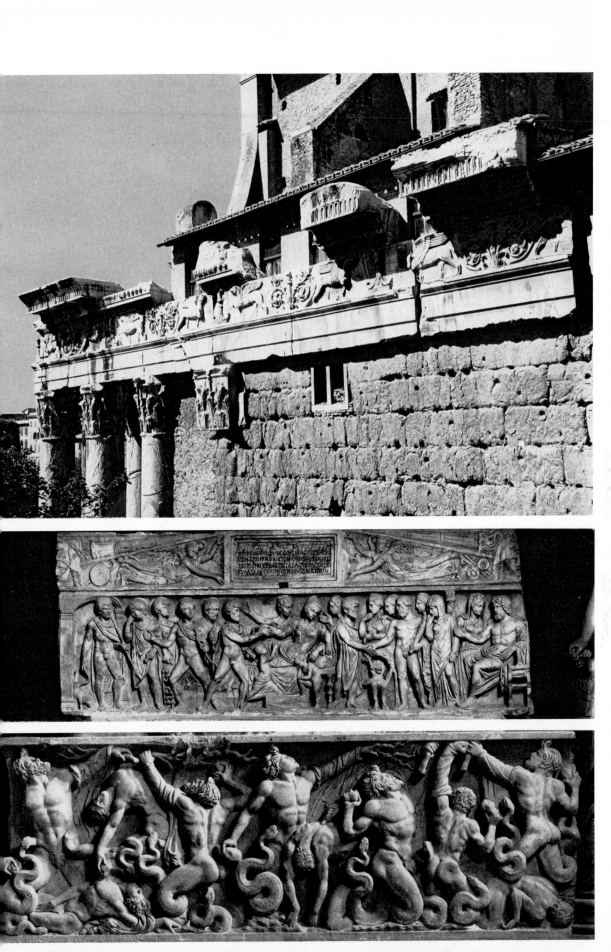

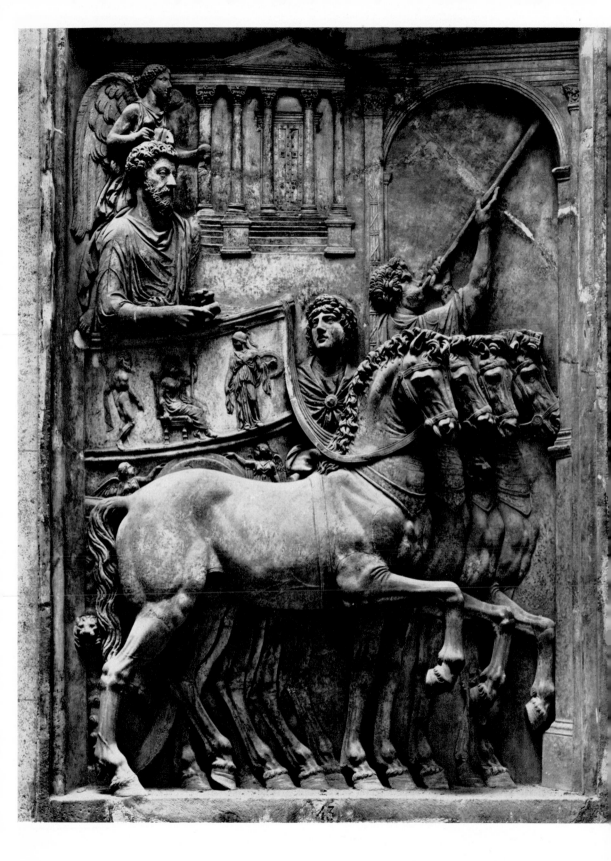

132 and 133. The emperor's triumphal entry into Rome, and the emperor receiving defeated barbarians, panels of Marcus Aurelius (161–80). *Rome, Palazzo dei Conservatori*

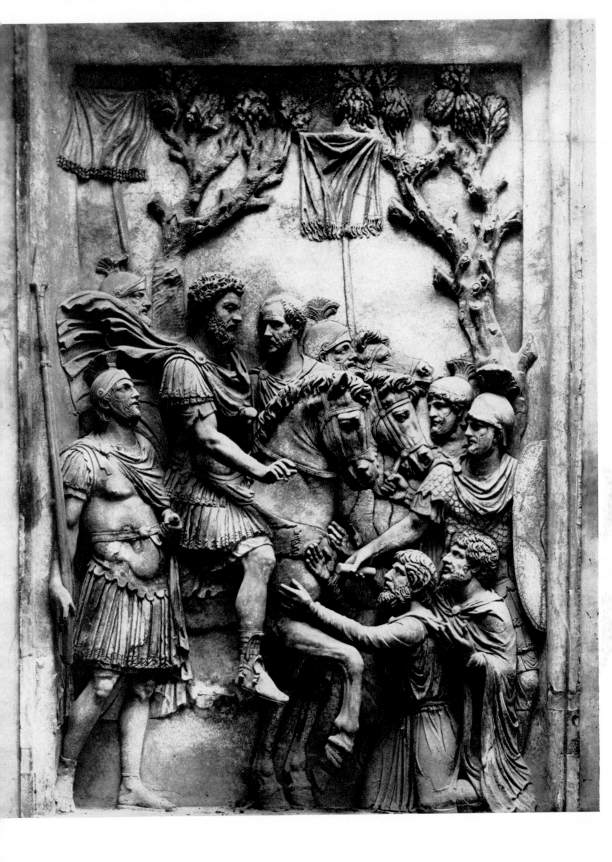

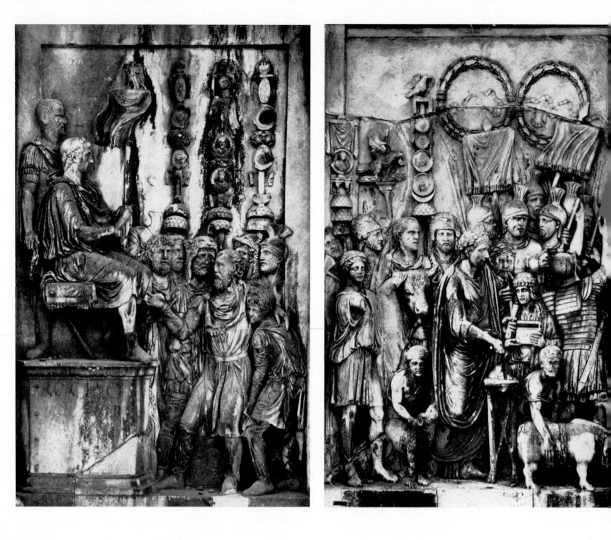

134 and 135. An enemy prince submits to the emperor, and a scene of sacrifice, panels of Marcus Aurelius (161–80) re-used on the arch of Constantine, Rome

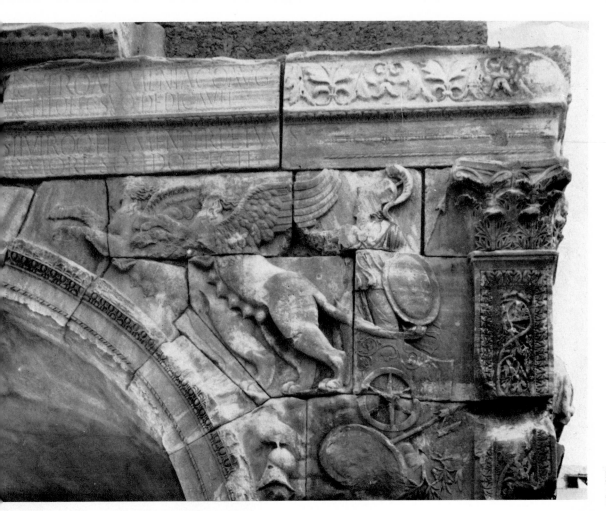

136 and 137. Details of the arch at Tripoli, 163

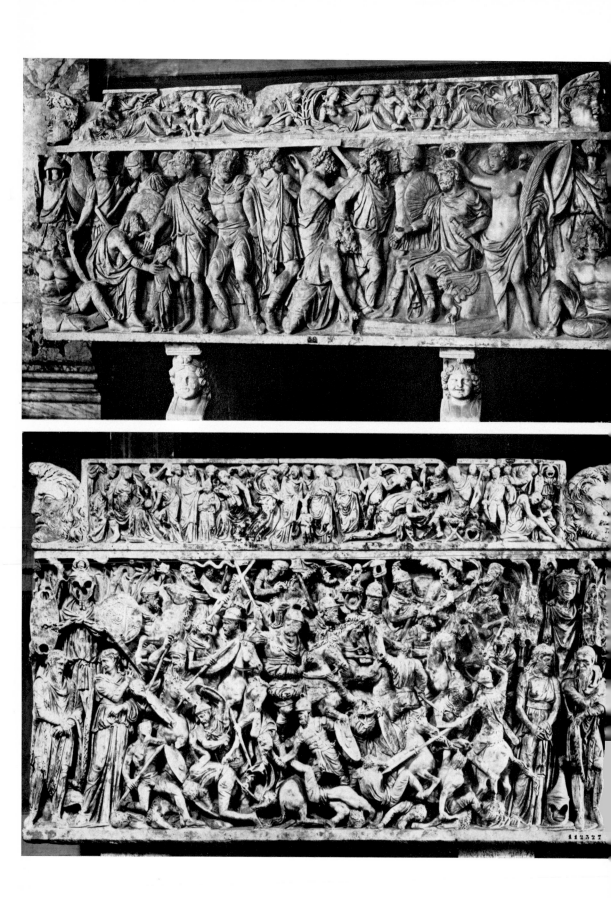

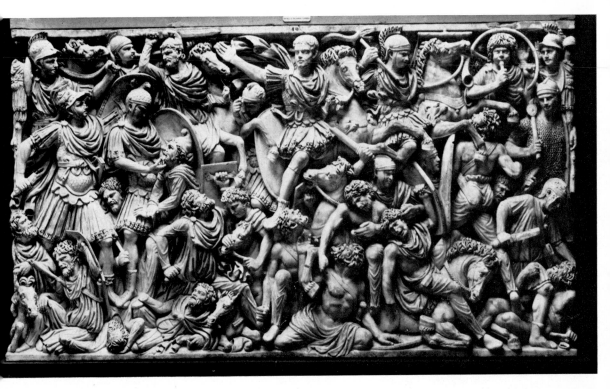

138. Sarcophagus with scenes from the life of a general, second century. *Vatican Museum*

139. Battle sarcophagus from the Via Tiburtina, second century. *Rome, Museo Nazionale Romano*

140. Ludovisi battle sarcophagus, mid third century. *Rome, Museo Nazionale Romano*

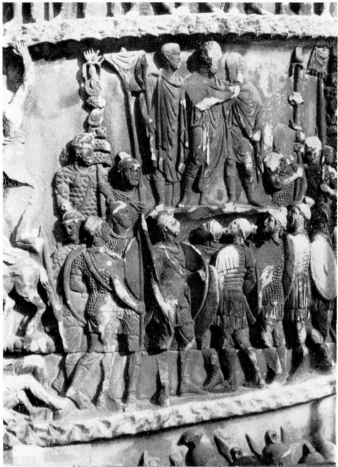

141–4. Reliefs on the column of Marcus Aurelius, *c.* 181, in the Piazza Colonna, Rome: 141 the emperor addresses the troops; 142 the miracle of the rain; 143 destruction of a native village; 144 Roman soldiers marching

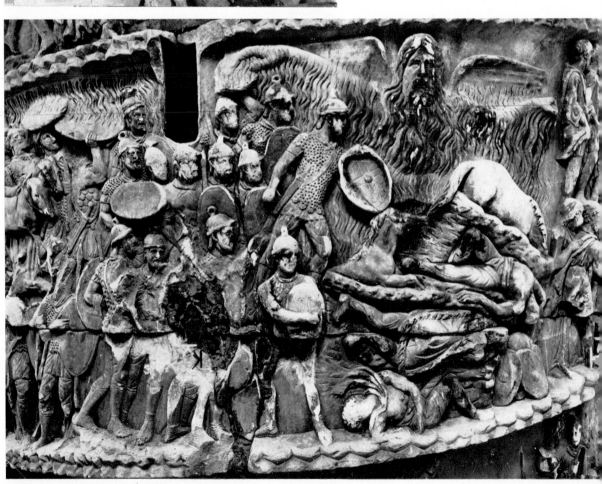

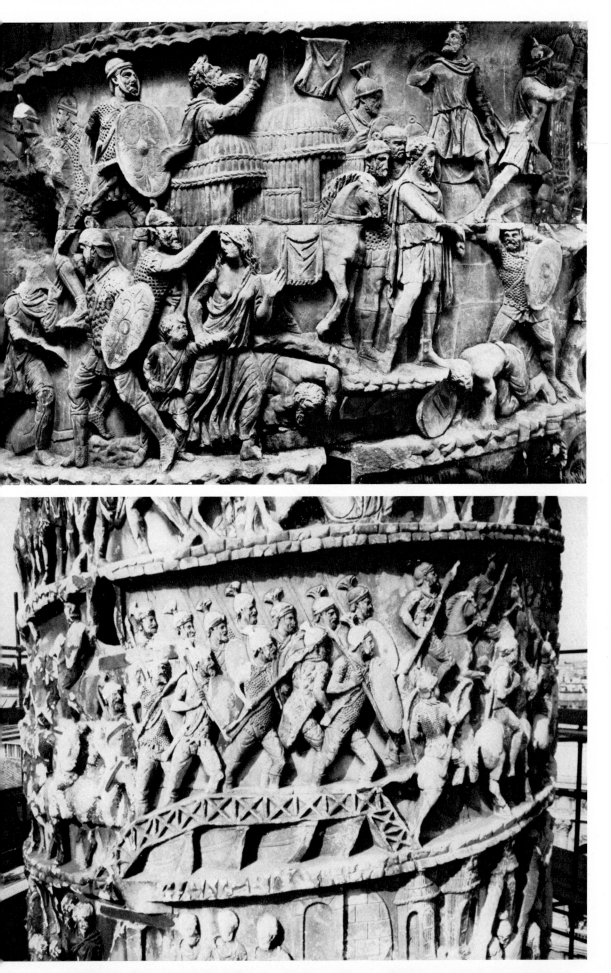

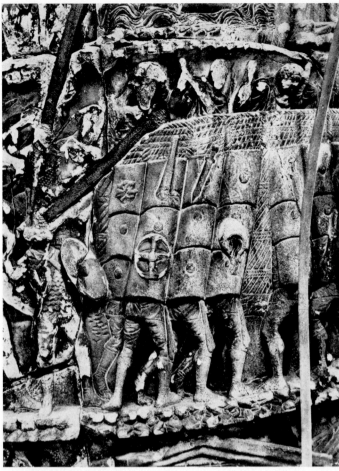

145–8. Reliefs on the column of Marcus Aurelius, *c.* 181, in the Piazza Colonna, Rome: 145 attack on a native fortification; 146 decapitation of native rebels; 147 the emperor receives a messenger; 148 Romans crossing a bridge of boats

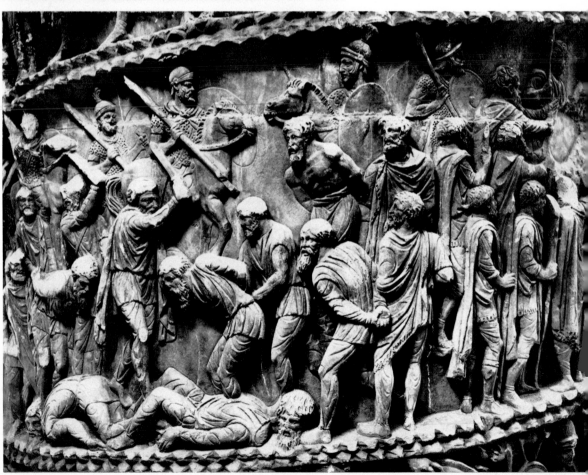

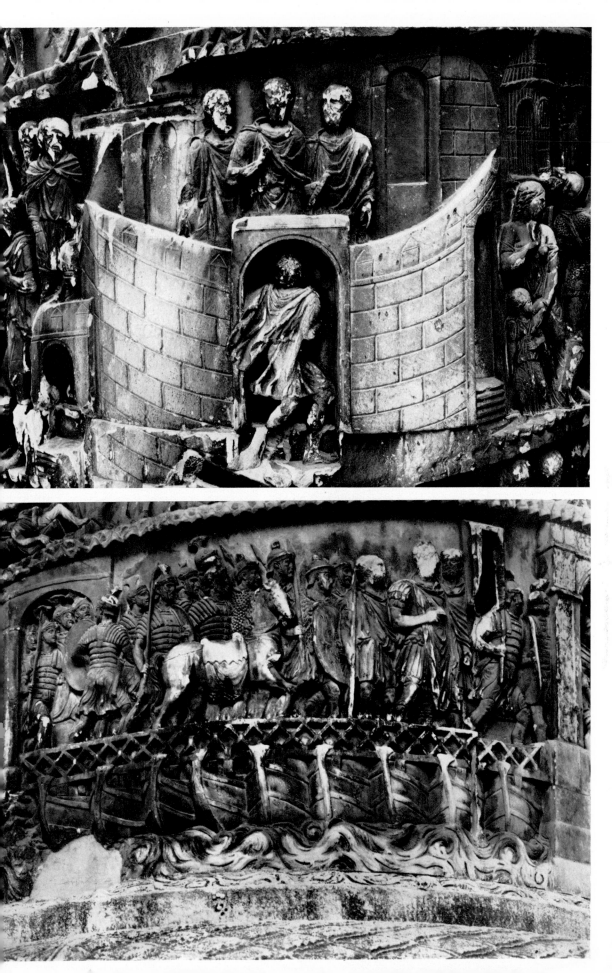

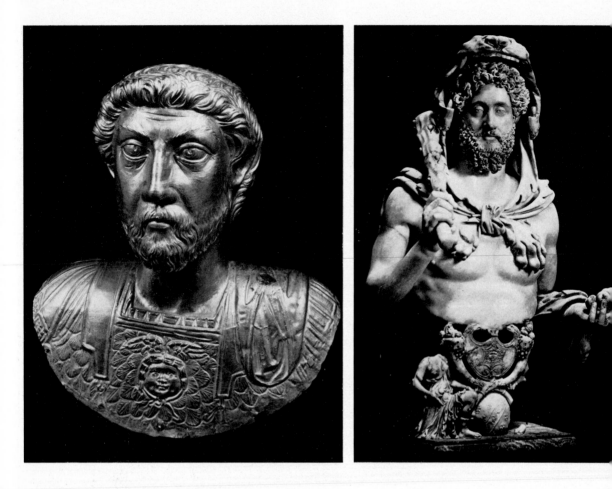

149. Marcus Aurelius (161–80). Gold. *Avenches, Musée Romain*

150. Commodus (180–92) as Hercules. *Rome, Palazzo dei Conservatori*

151. Equestrian statue of Marcus Aurelius (161–80). Bronze. *Rome, Capitol*

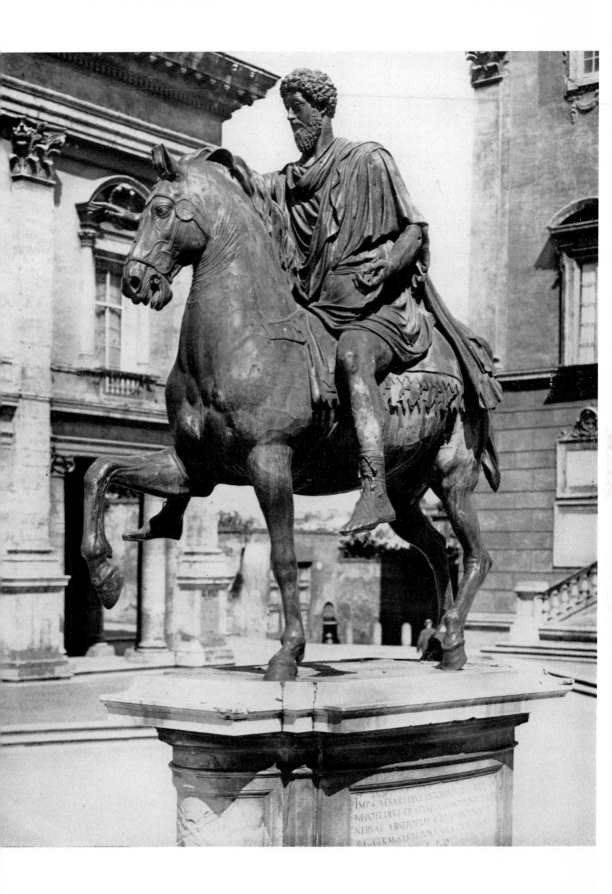

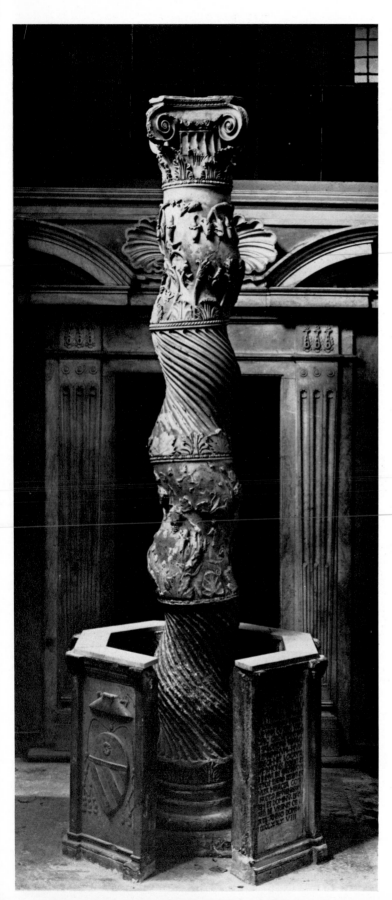

152. Barley-sugar column, early second century. *Rome, St Peter's, Chapel of the Pietà*

153 and 154. The capture of Seleucia and the siege of Hatra(?), reliefs on the arch of Septimius Severus in the Forum Romanum, *c.* 195–203

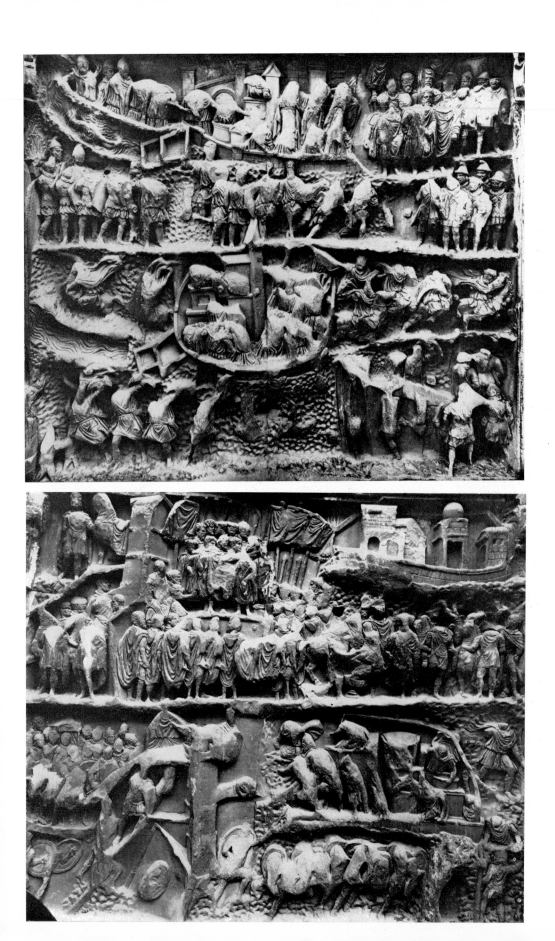

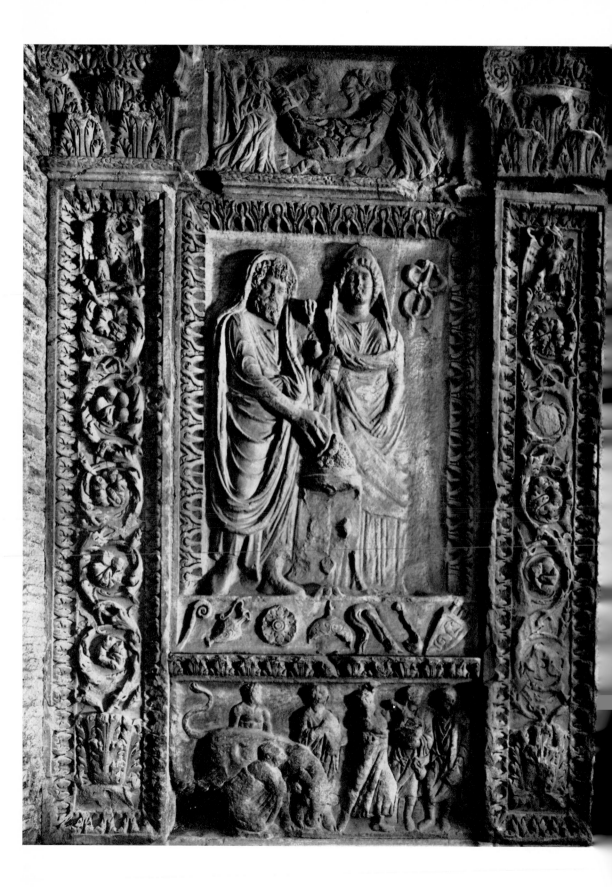

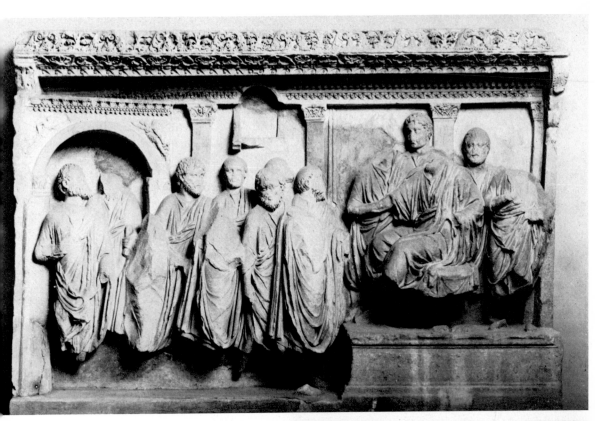

155. Septimius Severus and Julia Domna on the arch of the Argentarii, Velabrum, Rome, 204

156. The presentation of Caracalla to the Senate, *c.* 200. *Rome, Palazzo Sacchetti*

157. Medusa head in the Severan forum at Lepcis Magna

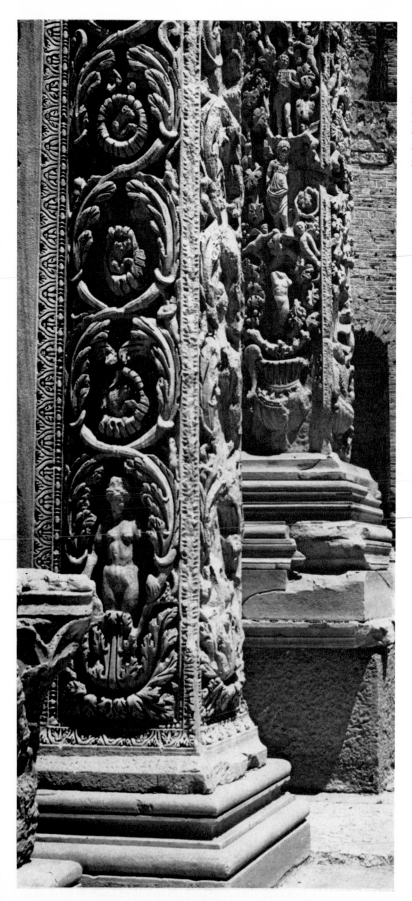

158. Pilasters with inhabited scrolls in the Severan basilica at Lepcis Magna

159–61. Triumphal procession, scene of sacrifice, and the emperor and empress as Jupiter and Juno, reliefs of the Severan arch at Lepcis Magna, dedicated in 203–4(?)

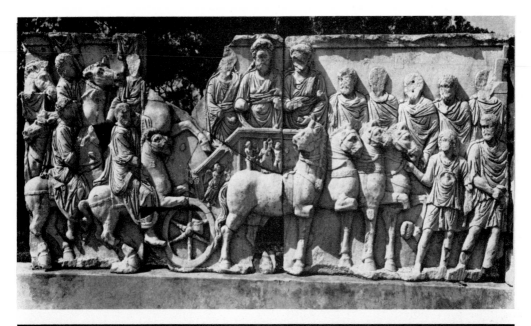

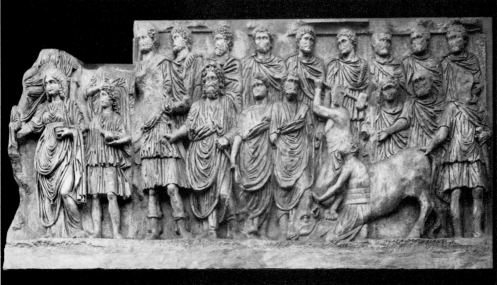

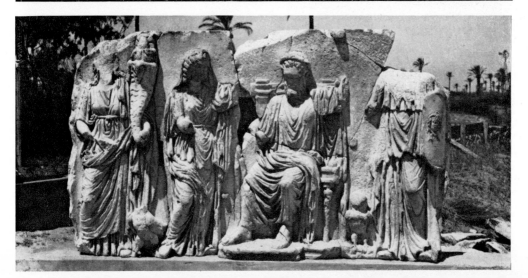

162. The siege of an eastern city, panel of the Severan arch at Lepcis Magna, dedicated in 203–4(?)

163. Barbarian captives from the Severan arch at Lepcis Magna, dedicated in 203–4(?)

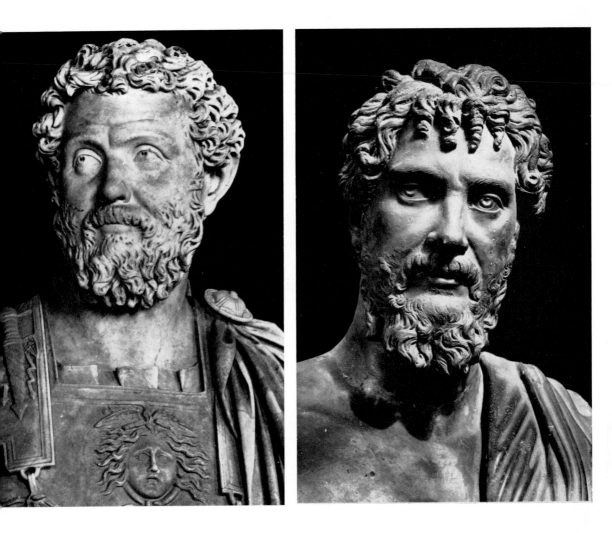

164. Septimius Severus (193–211), Antoninus Pius portrait type, early Severan. *Vatican Museum*

165. Septimius Severus (193–211), head of statue of Serapis portrait type, later Severan. Bronze. *Brussels, Musées Royaux*

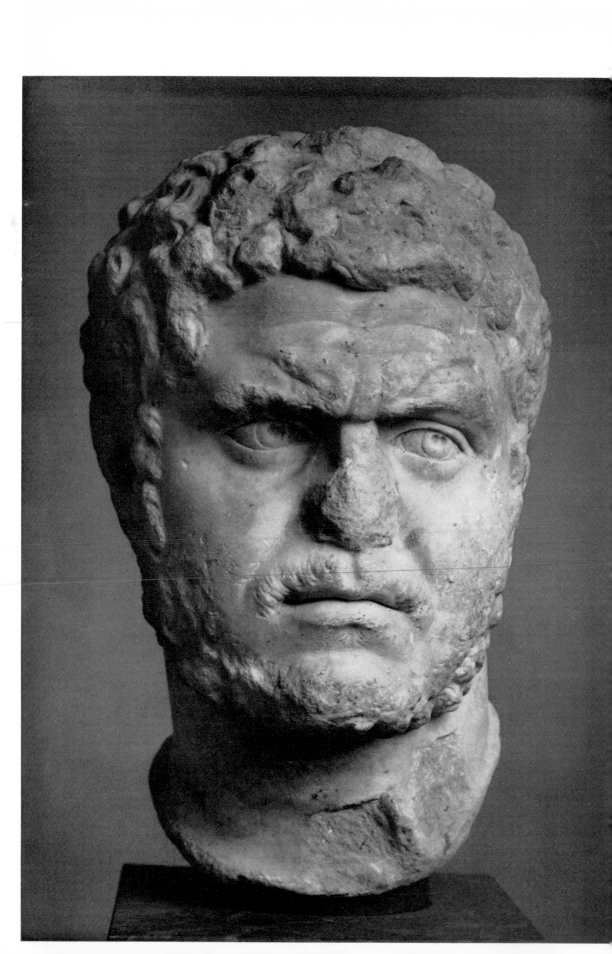

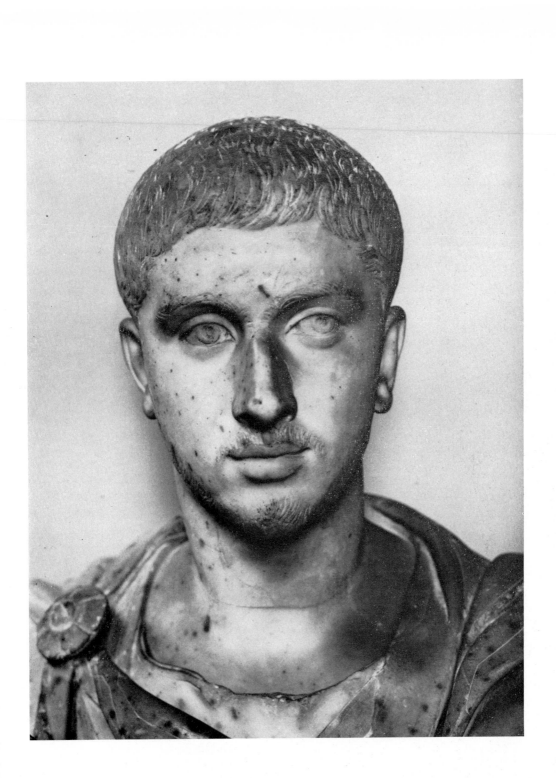

166. Caracalla (212–17). *Copenhagen, Ny Carlsberg Glyptotek*

167. Alexander Severus (222–35). *Vatican Museum*

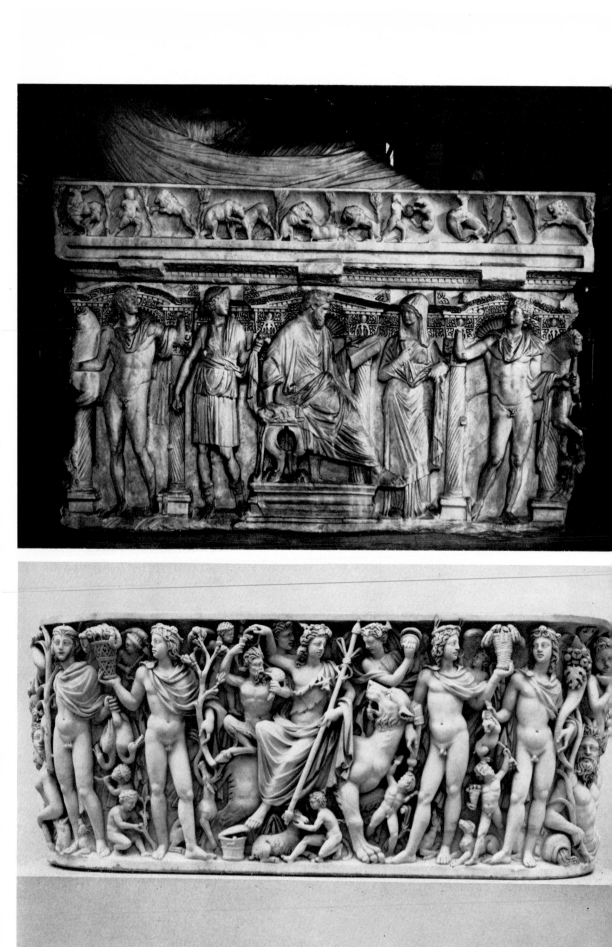

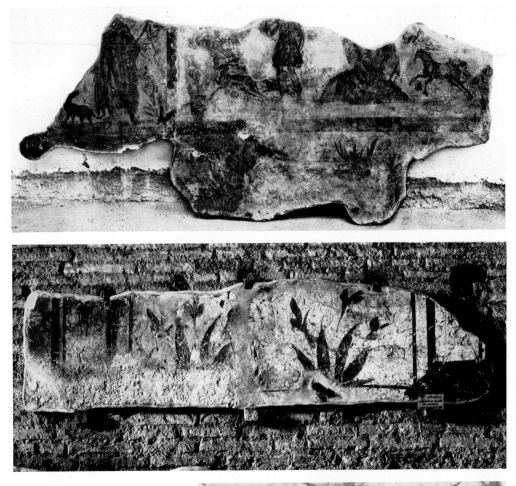

168. Sidamara sarcophagus, Severan period. *Istanbul, Museum of Antiquities*

169. Seasons sarcophagus (formerly at Badminton), Severan period. *New York, Metropolitan Museum of Art*

170 (*above*). Paintings from the Horrea dell'Artemide and from the Caseggiato dell'Ercole, Ostia, late second century

171 (*right*). Christus/Orpheus, ceiling painting in the cata-comb of St Calixtus, Rome, *c.* 200

172. Hercules and the Hydra, painting in the new Via Latina catacomb, Rome, fourth century

173. Penelope and the Suitors, painting in the hypogeum of the Aurelii, Rome, third century

174. The Women at the Sepulchre, painting from the baptistery at Dura Europos, third century. *New Haven, Yale University Art Gallery*

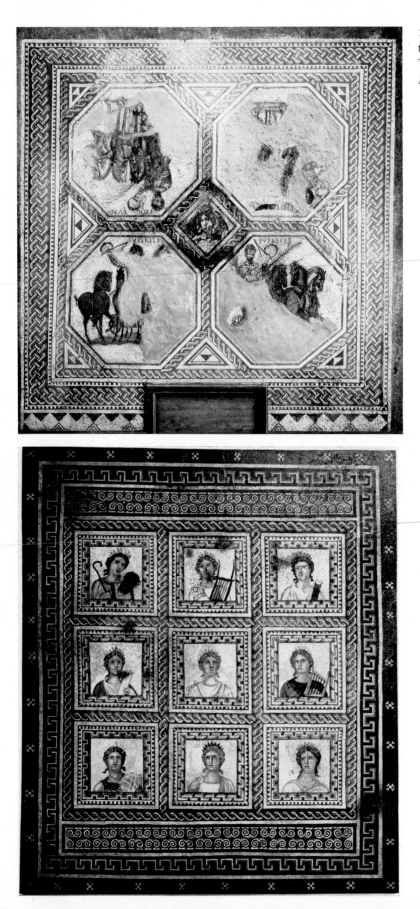

175 and 176. Circus scenes and the Muses, mosaics from Trier, third century. *Trier, Rheinisches Landesmuseum*

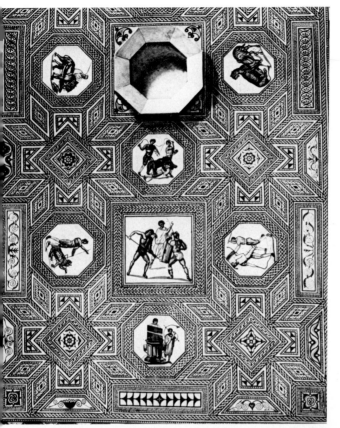

177. Gladiators and wild beasts, mosaic at Nennig, third century

178. Dionysus and Ariadne, mosaic from Antioch-on-the-Orontes, Severan period. *Antioch Museum*

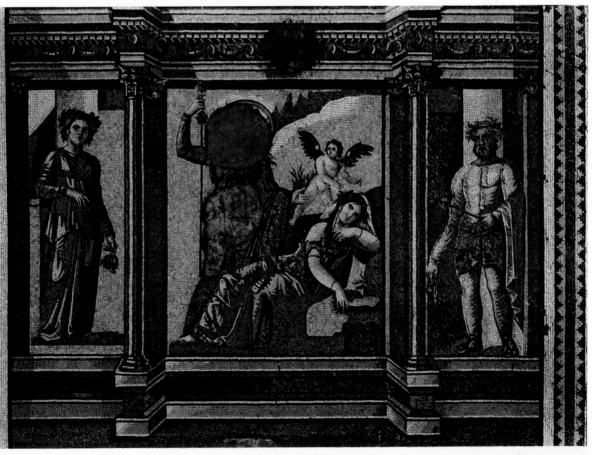

179. Antenociticus, from Ben-
well, Northumberland, third
century. Stone. *Newcastle upon
Tyne, University, Museum of
Antiquities*

180. School scene, relief from
Neumagen, third century.
Stone. *Trier, Rheinisches
Landesmuseum*

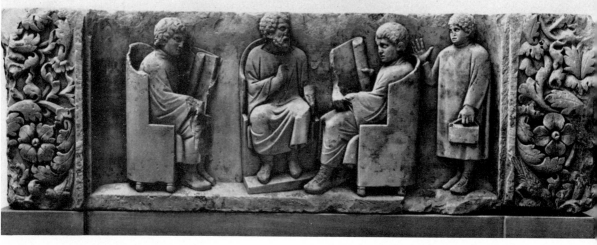

181. The sacrifice of Konon, painting,
with detail, from the temple of Bel,
Dura Europos, second century.
Damascus, National Museum

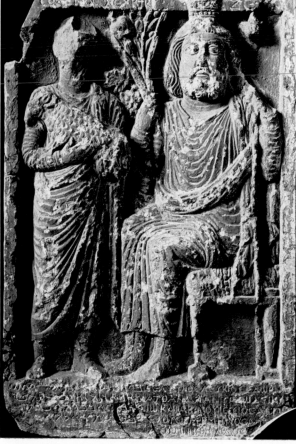

182. The sacrifice of Julius Terentius, painting
from the temple of Bel, Dura Europos, third
century. *New Haven, Yale University Art
Gallery*

183. Zeus Kyrios, relief from Dura Europos,
A.D. 31. Stone. *New Haven, Yale University
Art Gallery*

184. Septimius Severus and members of his family, painted wooden roundel from Egypt, *c.* 199–201. *(West) Berlin, Staatsbibliothek*

185. Maximinus Thrax (235–8). *Copenhagen, Ny Carlsberg Glyptotek*

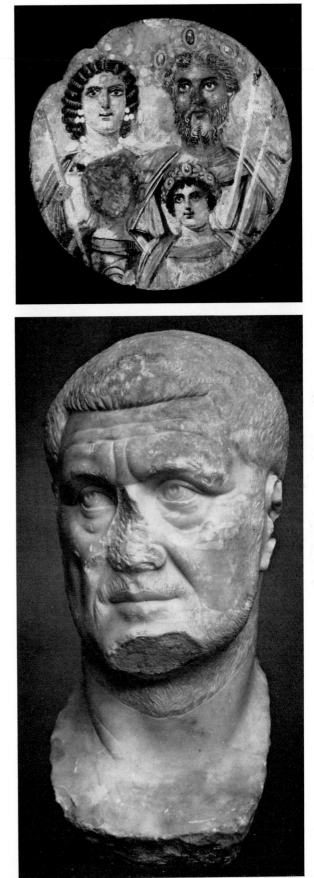

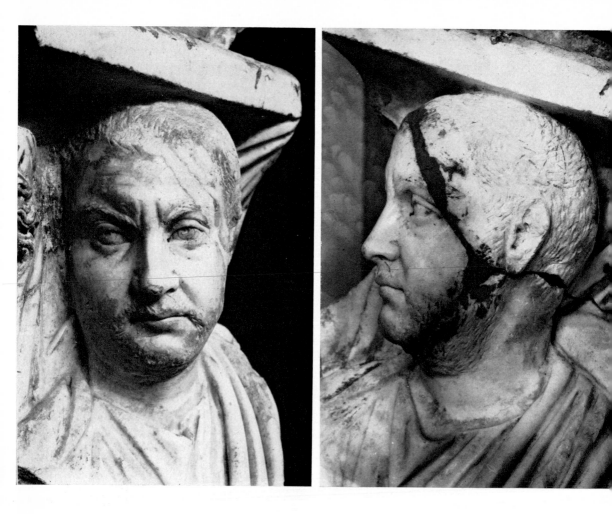

186. Balbinus on his sarcophagus (details), in the catacomb of Praetextatus, Rome, 238

187. Trajan Decius (249–51). *Rome, Museo Capitolino*

188. Early portrait of Gallienus, *c*. 253–60. (*East*) *Berlin, Pergamonmuseum*

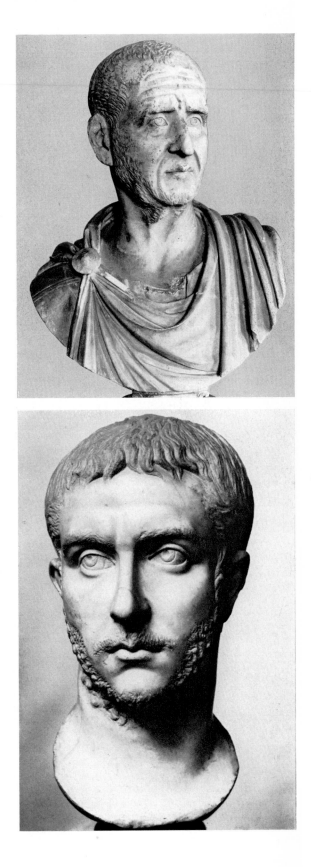

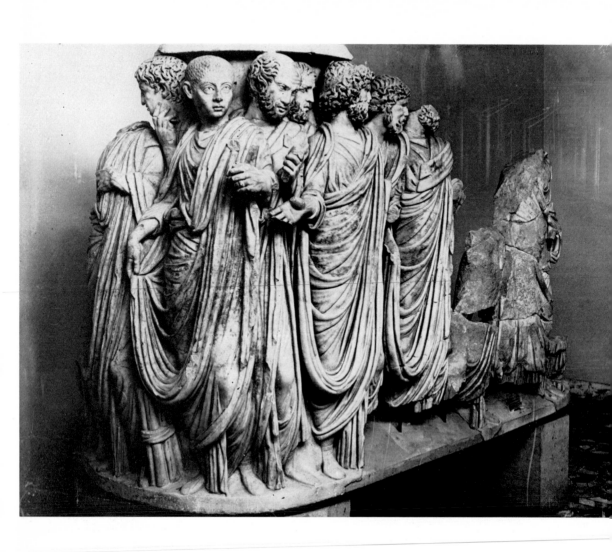

189. Sarcophagus with a portrait of Gordian III(?), from Acilia, 238–44. *Rome, Museo Nazionale Romano*

190. Plotinus(?), *c.* 260–70. *Ostia Museum*

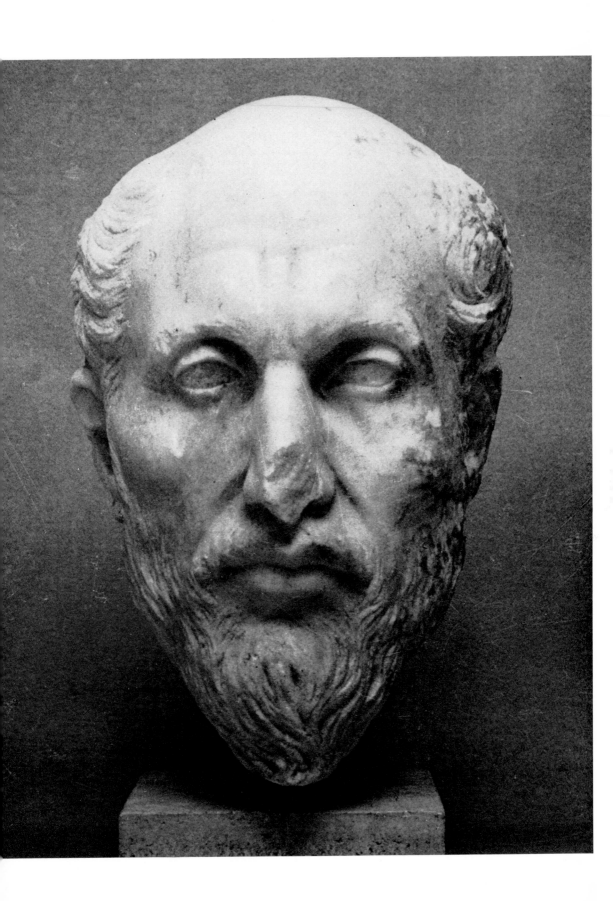

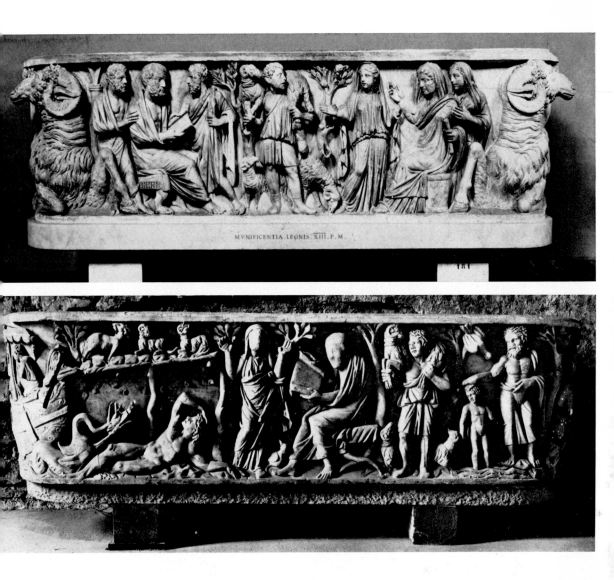

MVNIFICENTIA·LEONIS·XIII·P·M·

191 and 192. The Good Shepherd, and Daniel and the Lions, painted ceilings in the catacomb of St Calixtus, Rome, third century

193. Christian sarcophagus with a kneeling ram at either end, from the Via Salaria, Rome, third century. *Vatican Museum*

194. Christian sarcophagus with reader and orant, third century. *Rome, S. Maria Antiqua, Forum Romanum*

195. Christus/Helios, mosaic in the vault of the mausoleum of the Julii in the necropolis under St Peter's, Rome, third century

196. Ezekiel in the Valley of the Dry Bones, painting from the synagogue at Dura Europos, c. 245. *Damascus, National Museum*

197 and 198. Fayyum mummy portraits painted in encaustic, early second century. *London, British Museum (on permanent loan from the National Gallery)*

199. Constantine's *oratio*, with the Rostra and the Tetrarchic monument in the background, on the arch of Constantine, Rome, c. 315

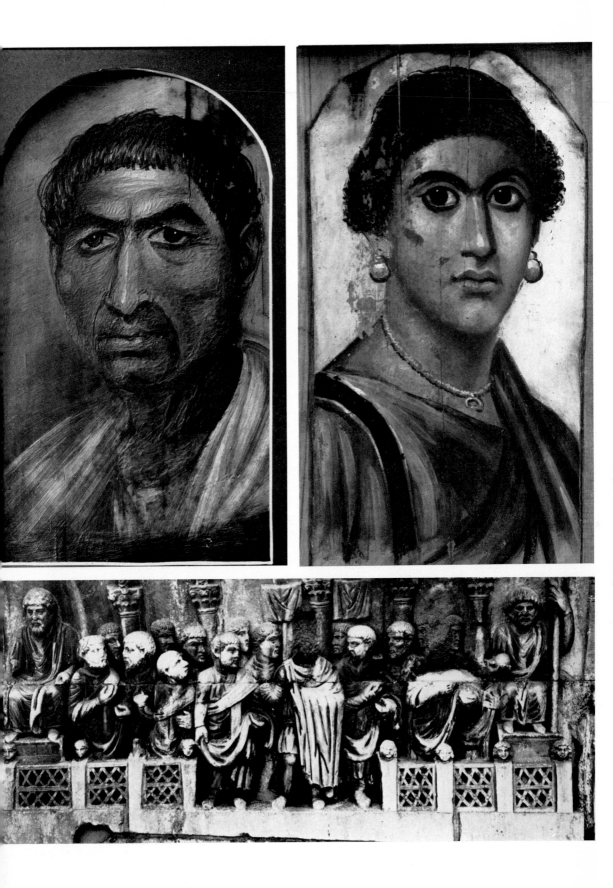

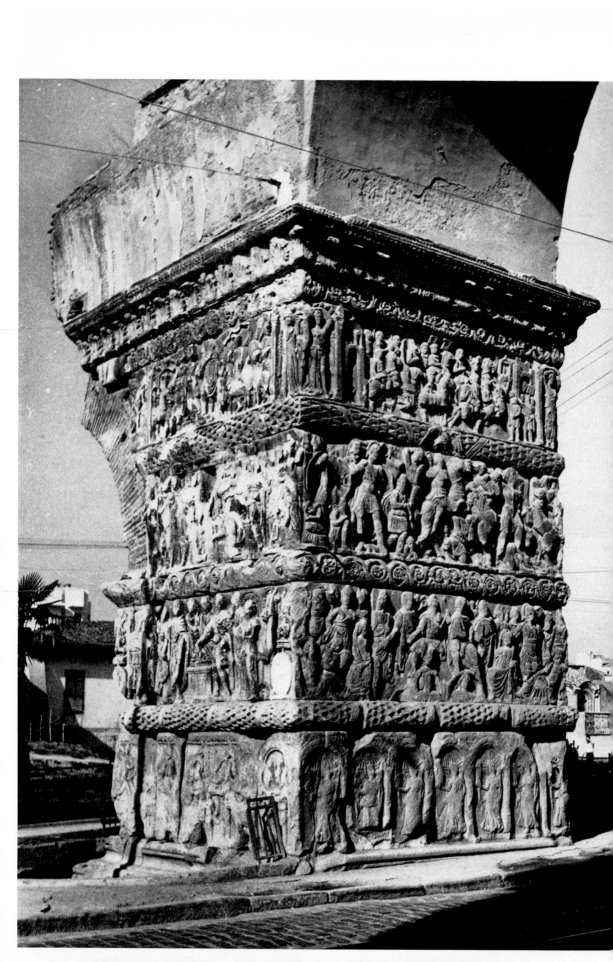

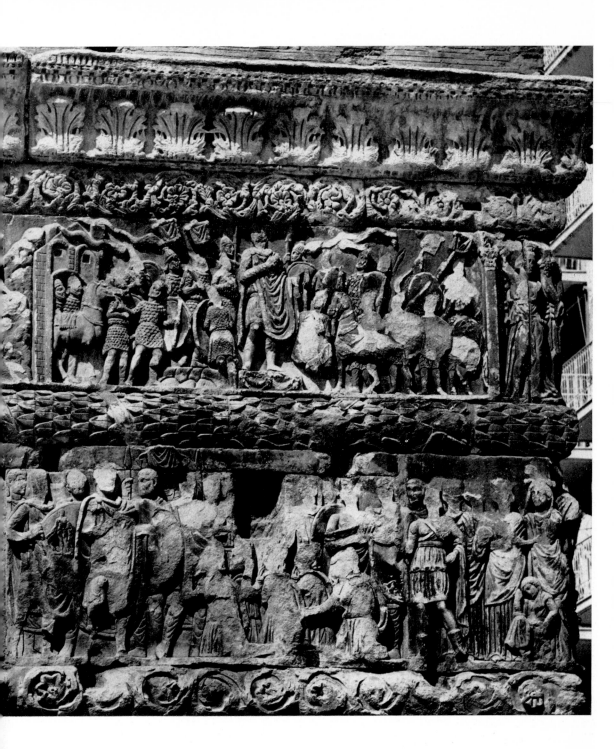

200 and 201. Reliefs illustrating the emperor's wars, and the emperor addressing his troops and other scenes, on the arch of Galerius, Salonika, 296

202. Great Hunt (detail), mosaic in the villa near Piazza Armerina, fourth century

203. Hercules, mosaic in the villa near Piazza Armerina, fourth century

204. Tetrarchs, from Istanbul, third–fourth centuries. Porphyry. *Venice, Piazza S. Marco*

205. An emperor, from Athribis, third–fourth centuries. Porphyry. *Cairo Museum*

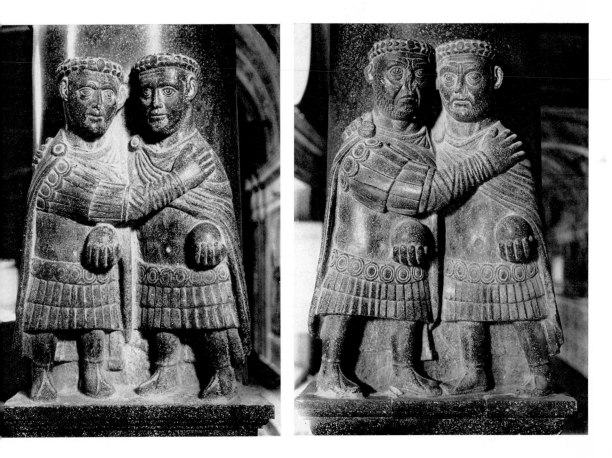

206. Tetrarchs, third–fourth centuries. Porphyry. *Vatican Museum*

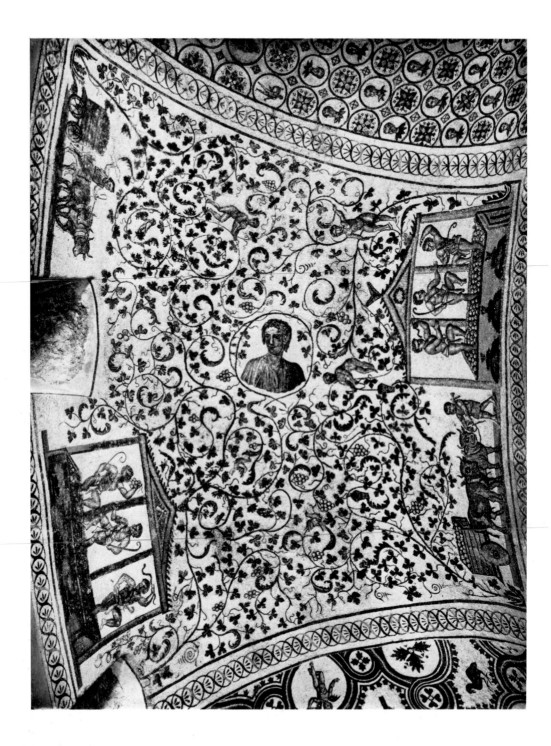

207. Vintage scenes, vault mosaics in S. Costanza, Rome, mid fourth century

208. Constantine's *largitio*, frieze on the arch of Constantine, Rome, *c.* 315

209. Sol, Constantinian roundel on the arch of Constantine, Rome, *c.* 315

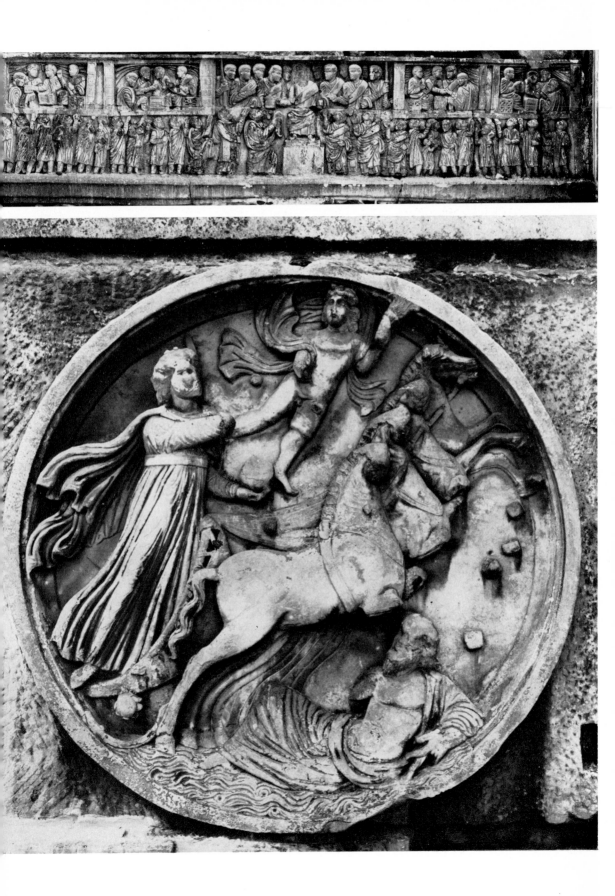

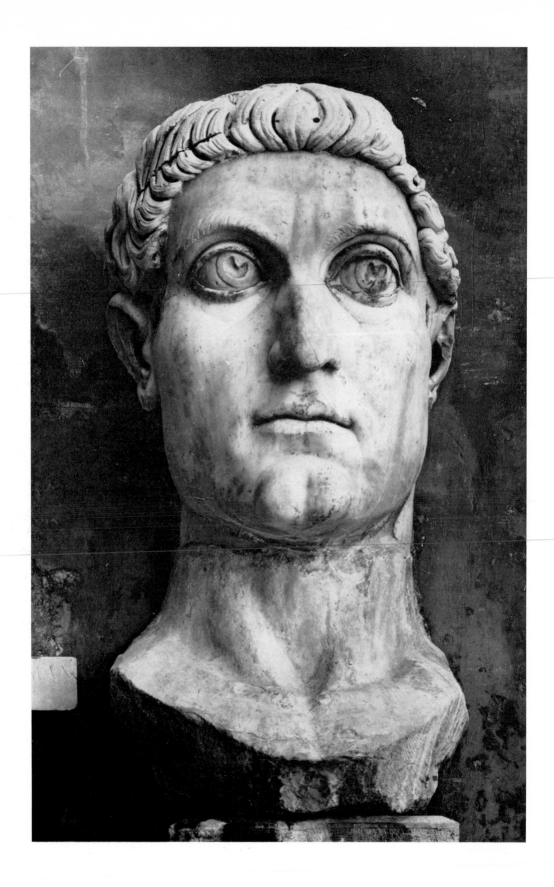

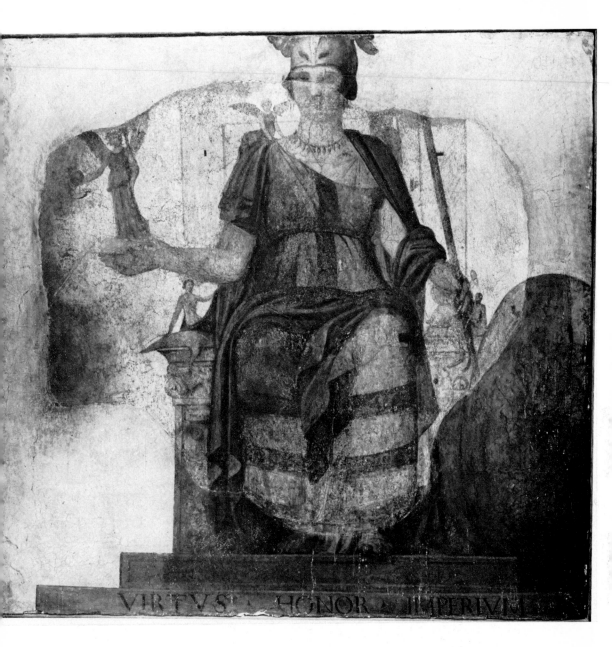

VIRTVS · HONOR · IMPERIVM

210. Constantine I, colossal head, *c.* 313. *Rome, Palazzo dei Conservatori*

211. The 'Roma Barberini', fourth century. *Rome, Museo Nazionale Romano*

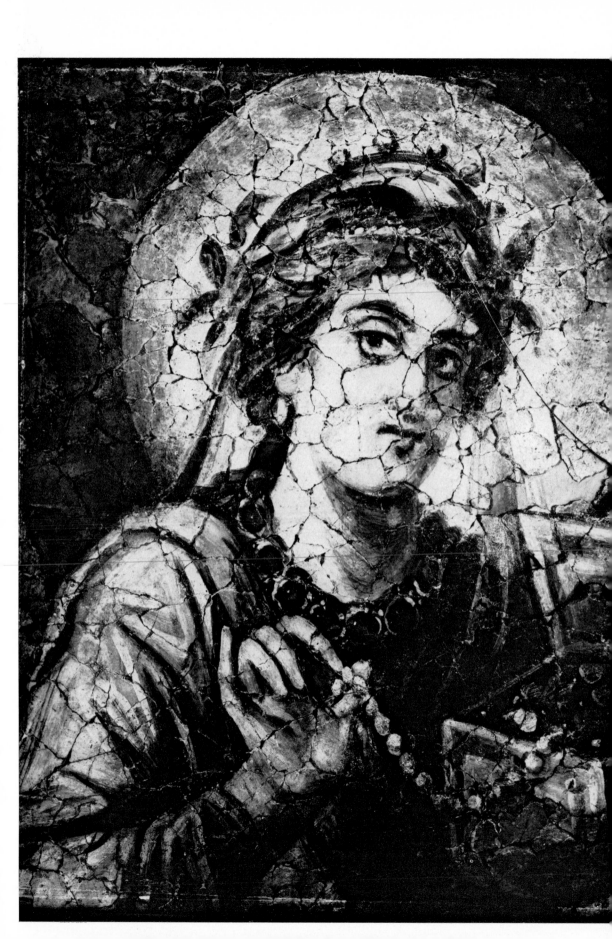

212 and 213. Lady with a casket and putti on painted ceiling panels from the imperial palace, Trier, early fourth century. *Trier, Bischöfliches Dom- und Diözesanmuseum*

214. Mythological painting in the Casa Celimontana under SS. Giovanni e Paolo, Rome, early fourth century

215. Consular procession, *opus sectile* wall mosaic from the basilica of Junius Bassus, Rome, c. 330. *Rome, Palazzo dei Conservatori*

216. Painted tomb at Silistra, fourth century

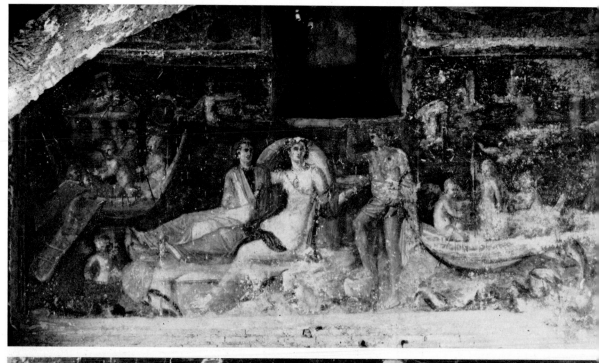

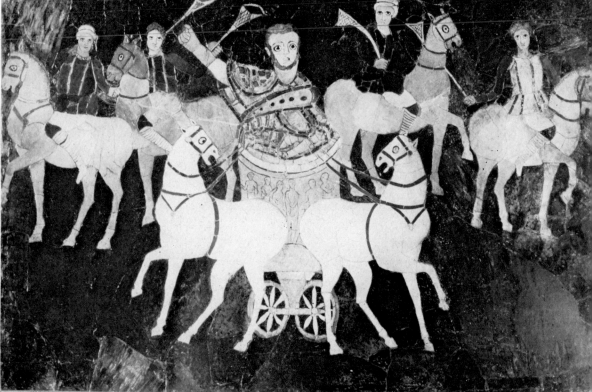

217. Good Shepherd, floor mosaic in the basilica at Aquileia, early fourth century

218. Lycurgus, floor mosaic, early fourth century. *Vienne, Archaeological Museum*

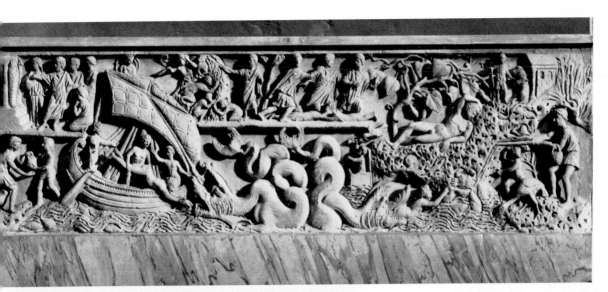

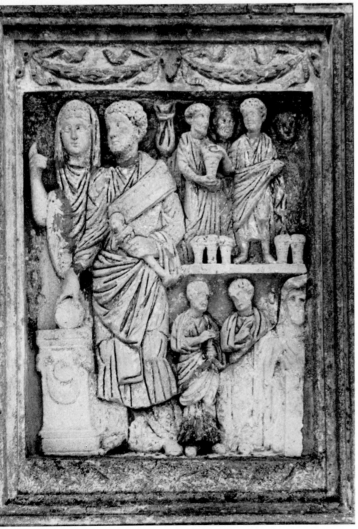

219. Jonah sarcophagus, early
fourth century. *Vatican
Museum*

220. Pagan wedding rite on
a fragment of a Christian
sarcophagus, fourth century.
Rome, Villa Doria Pamfili

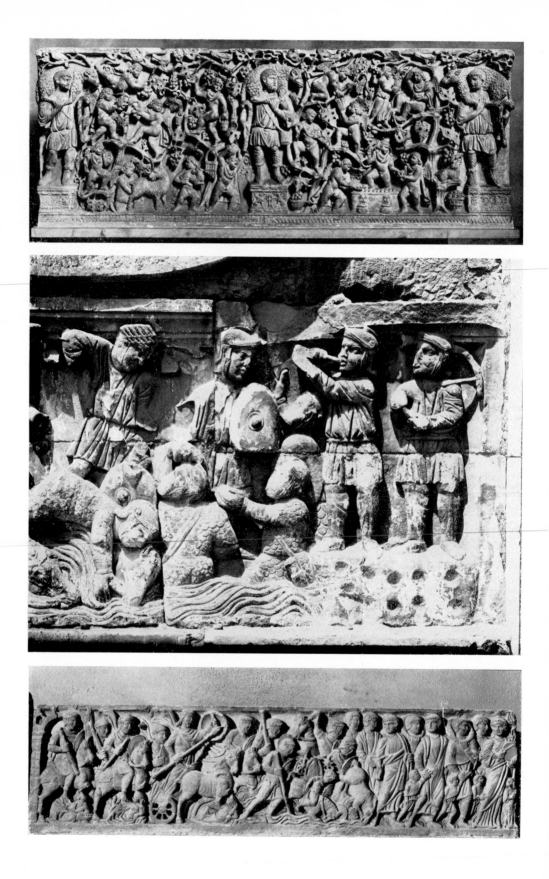

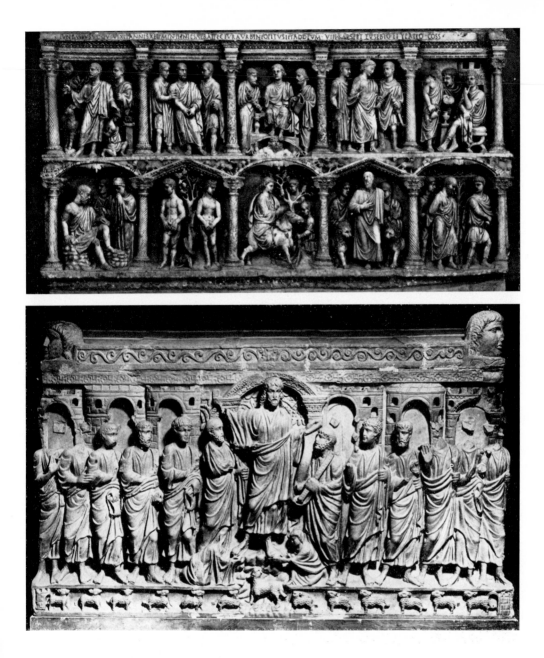

221. Vintage sarcophagus with three Good Shepherd figures, fourth century. *Vatican Museum*

222. The Battle of the Milvian Bridge, detail of a frieze on the arch of Constantine, Rome, *c.* 315

223. Sarcophagus showing the Crossing of the Red Sea, fourth century. *Vatican Museum*

224. Sarcophagus of Junius Bassus (front), 359. *Vatican Museum*

225. Christ and the Apostles on the back of a 'city gate' sarcophagus, mid fourth century. *Milan, S. Ambrogio*

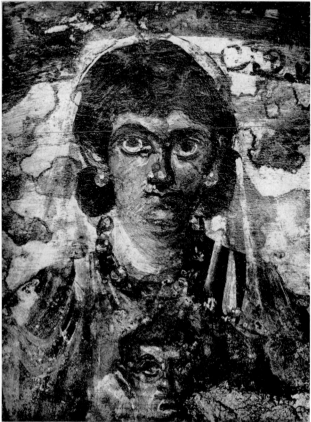

226 and 227. Mother and Child, with detail, painting in the Coemeterium Maius catacomb, Rome, fourth century

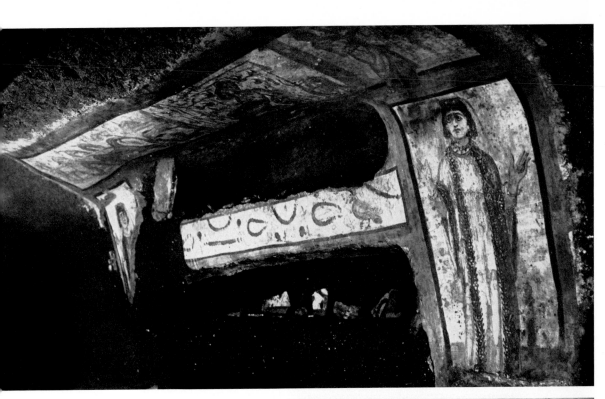

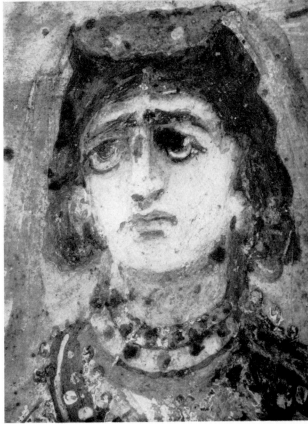

228 and 229. Woman orant, with detail,
painting in the catacomb of Thraso, Rome,
fourth century

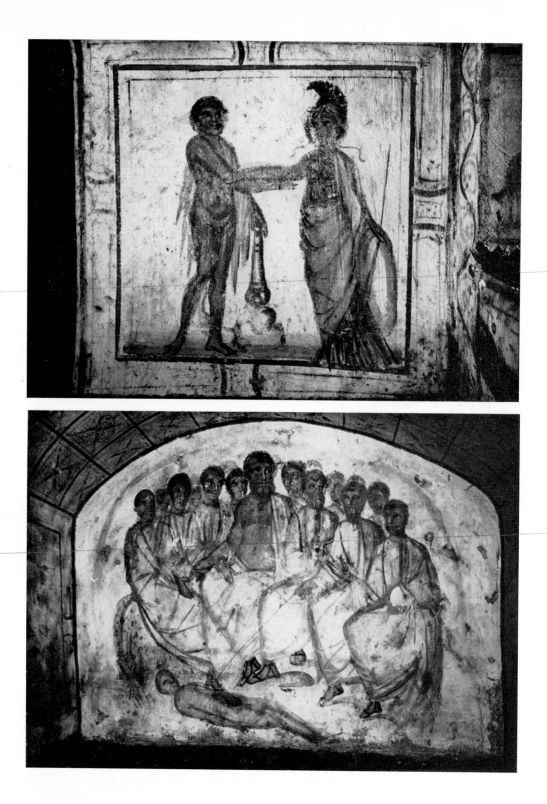

230 and 231. Hercules and Minerva and a Medical Class(?), paintings in the new Via Latina catacomb, Rome, fourth century

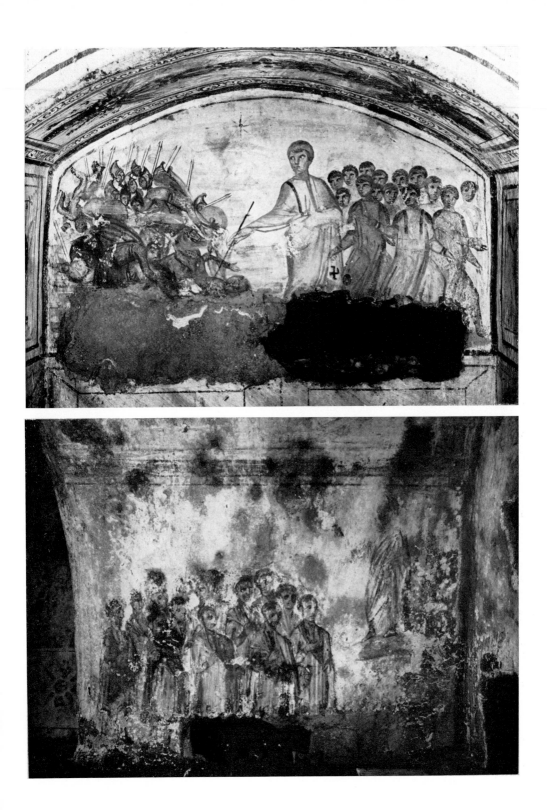

232 and 233. The Crossing of the Red Sea and the Sermon on the Mount, paintings in the new Via Latina catacomb, Rome, fourth century

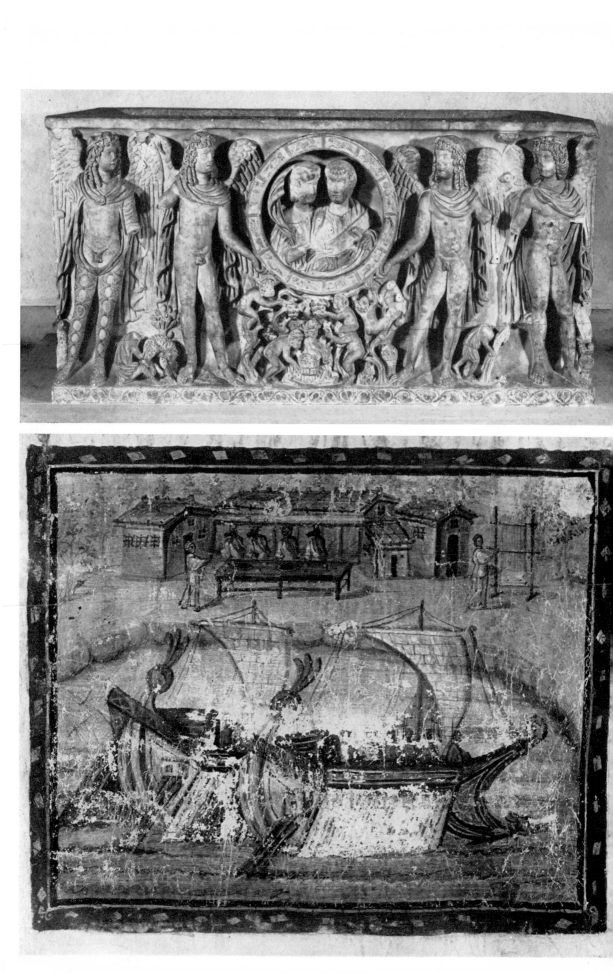

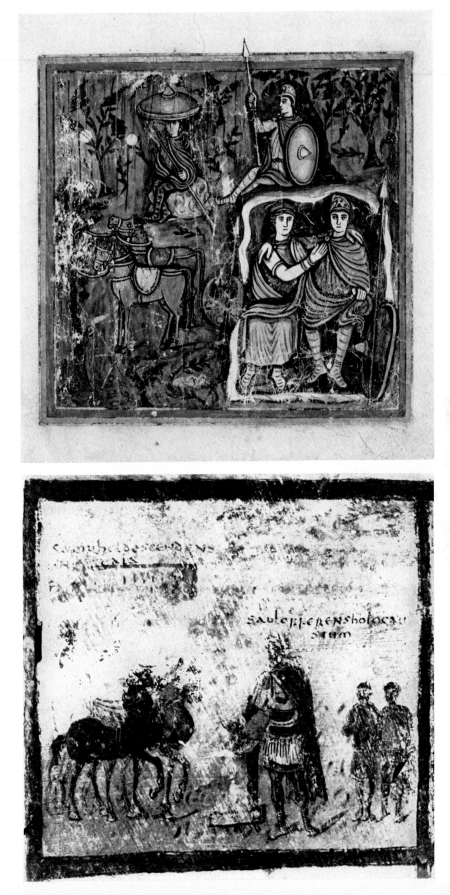

234. Seasons sarcophagus, mid fourth century. *Washington, D.C., Dumbarton Oaks*

235. The House of Circe (*Aeneid* VII), miniature in the Vatican Virgil (Cod. Vat. Lat. 3225, f. 58r), *c.* 400(?). *Vatican Library*

236. Dido and Aeneas in the Cave (*Aeneid* IV), miniature in the *Vergilius Romanus* (Cod. Vat. Lat. 3867, f. 106), *c.* 500(?). *Vatican Library*

237. Quedlinburg Old Testament fragment (MS. Theol. Lat. 485, f. 2r), fourth century. (*East*) *Berlin, Deutsche Staatsbibliothek*

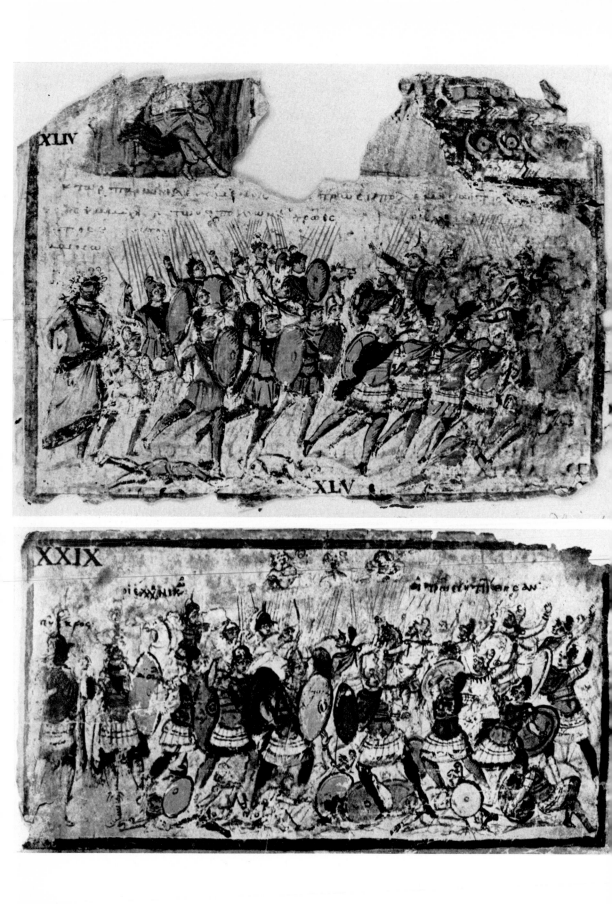

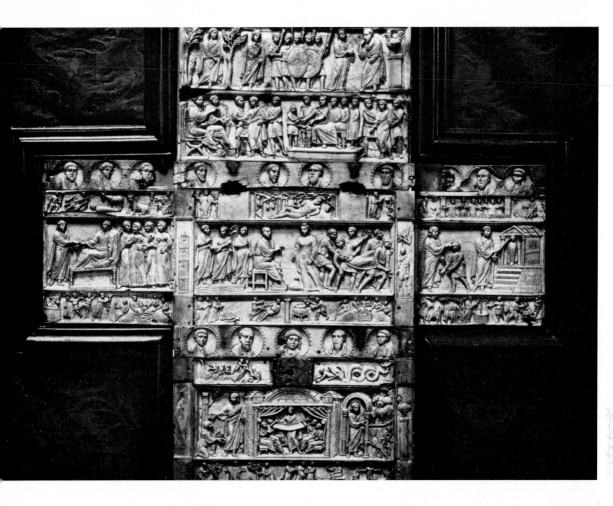

238 and 239. Battle scenes, miniatures nos. 44 and 29 in the *Ilias Ambrosiana*, *c*. 500(?). *Milan, Biblioteca Ambrosiana*

240. Brescia casket, late fourth or early fifth century. Ivory. *Brescia, Museo Civico Cristiano*

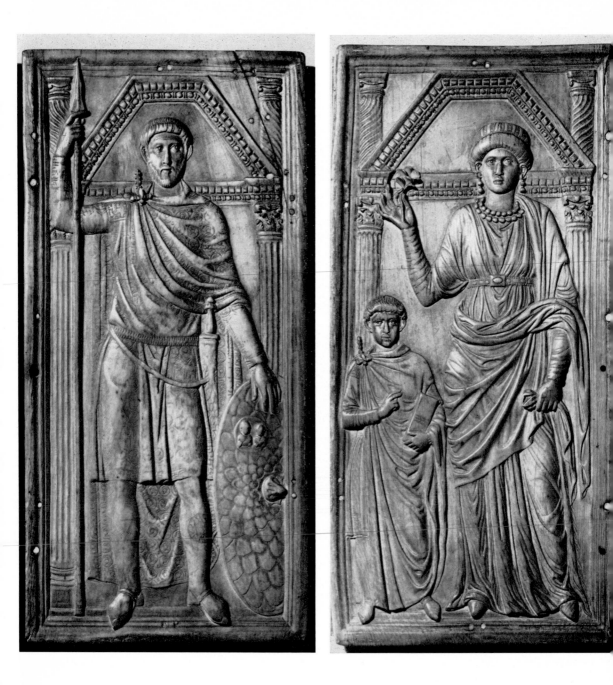

241. Stilicho and his wife and son, Serena and Eucharius, two leaves of a diptych, late fourth
century. Ivory. *Monza Cathedral Treasury*

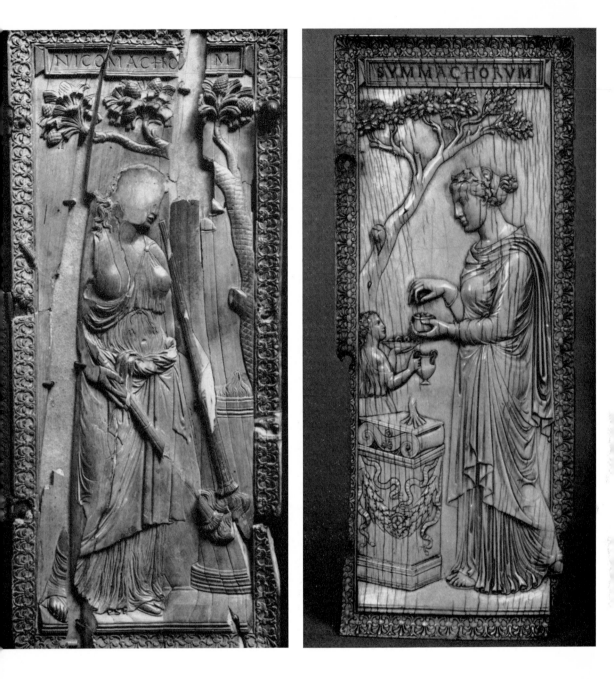

242. Nicomachi leaf of the Nicomachi and Symmachi diptych, late fourth century. Ivory. *Paris, Musée de Cluny*

243. Symmachi leaf of the Nicomachi and Symmachi diptych, late fourth century. Ivory. *London, Victoria and Albert Museum*

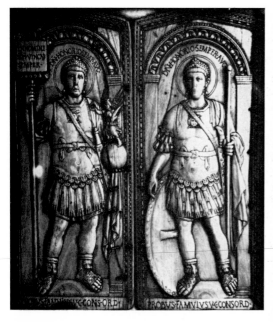

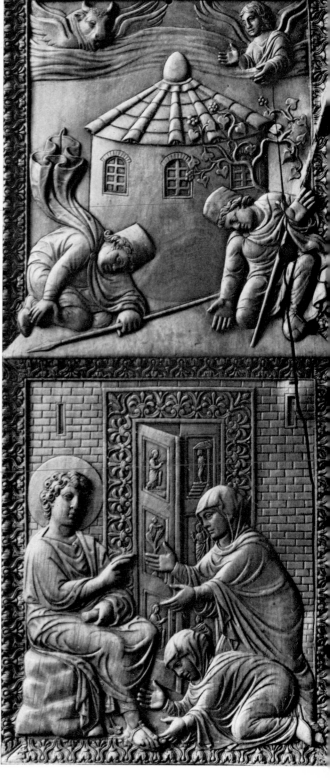

244. Probus diptych with portraits of Honorius, 406. Ivory. *Aosta Cathedral Treasury*

245. Panel with scenes at the Holy Sepulchre, early fifth century. Ivory. *Milan, Castello Sforzesco*

246. Julian the Apostate crowned by Constantinopolis, 361–3. Sardonyx cameo. (*West*) *Berlin, Staatliche Museen, Antiken-Abteilung*

247. Lycurgus cage cup, fourth century. Glass. *London, British Museum*

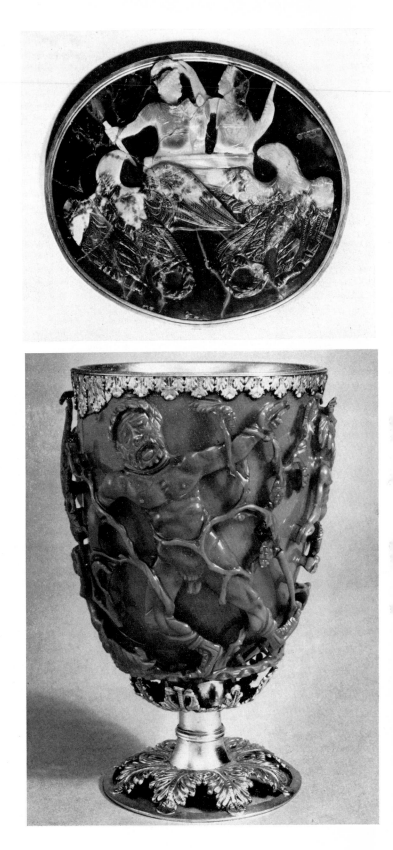

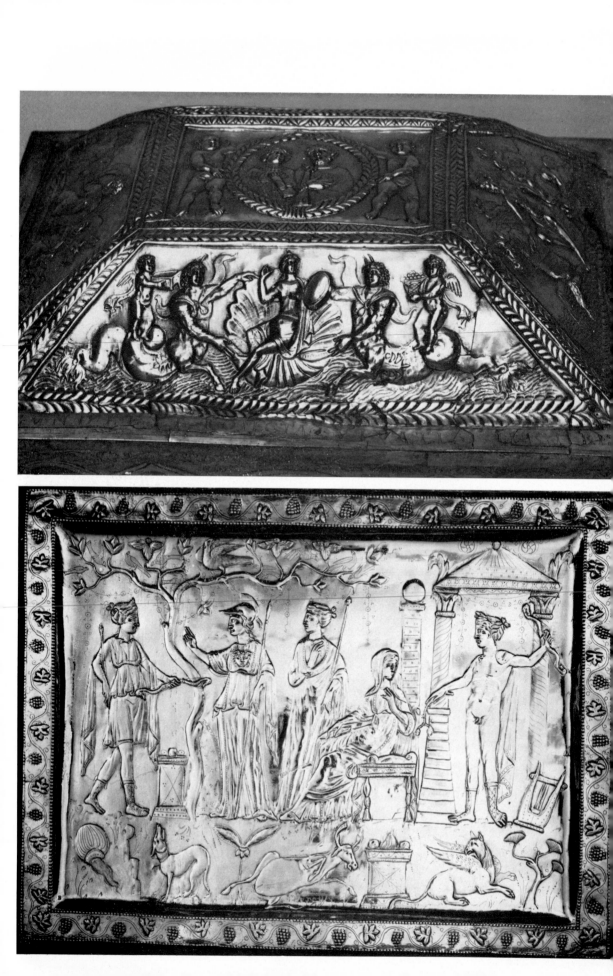

248. Lid of the casket of Projecta, late fourth century. Silver. *London, British Museum*

249. Pagan deities on a *lanx* from Corbridge, fourth century. Silver. *Private Collection*

250. *Missorium* of Theodosius I (378–95), late fourth century. Silver. *Madrid, Academia de la Historia*

251. Dionysiac scene on a *lanx* from Kaiseraugst, fourth century. Silver. *Augst Museum*

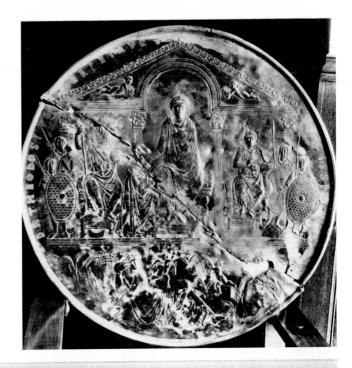

252. Battle scene on the sarcophagus of Helena, mother of Constantine I, from the Via Labicana, Rome, fourth century. Porphyry. *Vatican Museum*

253. Vintage scene on the sarcophagus of Constantina, daughter of Constantine I, from S. Costanza, Rome, fourth century. Porphyry. *Vatican Museum*

254 and 255. Two sides of the base of the obelisk of Theodosius I (378–95) in the hippodrome at Istanbul, late fourth century

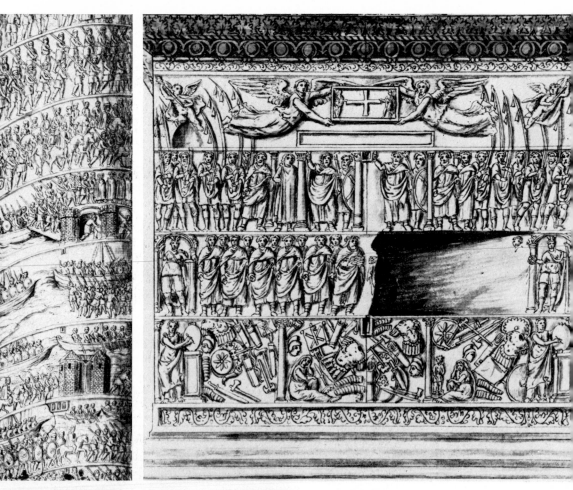

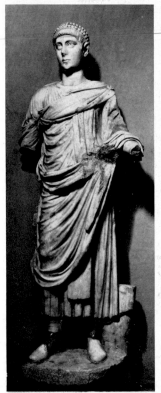

256 and 257. Drawings from the Freshfield
Album of the column of Arcadius (383–408)
and its base, Istanbul, early fifth century.
Cambridge, Trinity College

258. Valentinian II (375–92), from the
Hadrianic baths, Aphrodisias. *Istanbul,
Museum of Antiquities*

259. Aelia Flaccilla(?), daughter of Arcadius,
fifth century. *Paris, Bibliothèque Nationale*

260 and 261. Hunter, and boys riding a
camel, details of the peristyle mosaic in the
Great Palace of the Emperors, Istanbul,
fifth or sixth century

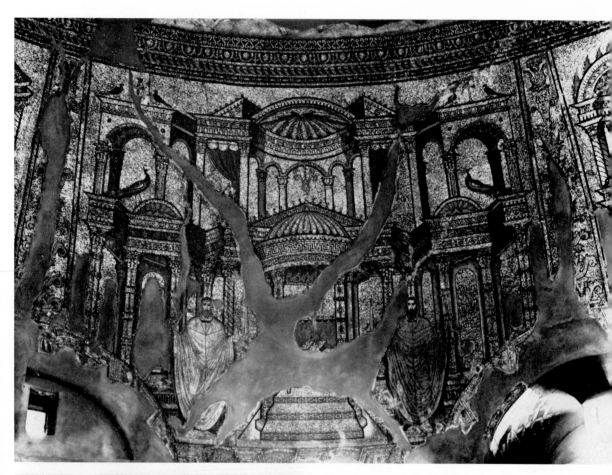

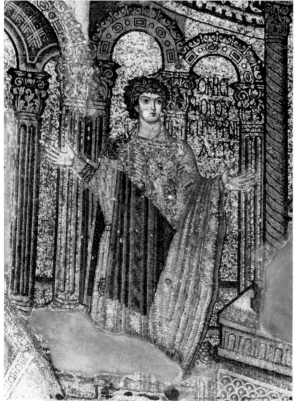

262 and 263. Details of the vault mosaic in
Hagios Georgios, Salonika, fifth century

INDEX

Numbers in *italics* refer to plates. Regnal dates are given for emperors.

A

Abgar VIII (177–212), king of Edessa, 117

Acilia, sarcophagus from, 137; *189*

Acilius Glabrio, M. (consul in 191 B.C.), monument of, 13

Actium, battle of, 48, 49

Adamklissi (Tropaeum Traiani), sculpture from, 87

Aelia Flaccilla (daughter of Arcadius, early fifth century), portrait (?), 172; *259*

Aeneid (Virgil), 165

Aeschines (Greek orator), 11

Africa, North, mosaics, 56, 77–8, 127, 131, 150–1, 164; *73*; painting, 78, 131; sculpture, 30, 45, 48–9, 64, 97, 102, 110, 115, 120–2; *58, 136, 137, 157–63*; see also Egypt

Agatharchos (Greek painter and writer), 28, 59–60

Agias, statue of, by Lysippos, 97

Agrigento, Attic sarcophagus, 102

Agrippa, M. Vipsanius (c. 63–12 B.C.; general), 42, 44, 50, 66, 67

Agrippa Postumus (12 B.C.–A.D. 14; son of above), 50

Agrippina Minor (15–59; mother of Nero), portrait, 83

Agrypnus (Roman sculptor), 58

Alba Longa, see Castelgandolfo

Albano, Lake, Ninfeo Bergantino, 68

Alexander the Great (356–323 B.C.), 87, 92, 131; mosaic from Pompeii, 15, 24, 36, 37, 48, 66; *30*; portraits, 14, 39, 113, 123, 138, 166; sarcophagus, 104

Alexander Severus (222–35), portraits, 123, 136; *167*

Alexandria, 51, 173; coins, 151; mosaics, 24; paintings, 27

Alkamenes (Greek sculptor), 16

Ambrose, St, 161

Amiternum, relief from, 65; *60*

Ammianus Marcellinus (b. c. A.D. 330; Roman historian), 82, 86

Ampurias, mosaics, 37, 55

'Anaglypha Traiani', 98; *113*

Ancus Marcius (640–616 B.C.; legendary king of Rome), coin portrait, 16

Ankara, Archaeological Museum: portrait of Trajan, 90; *96*

Antenociticus (Celtic god), head of, 130; *179*

Antinous (d. A.D. 122; favourite of Hadrian), portraits, 96–7, 105; *107, 108*

Antioch-on-the-Orontes, 146; coins, 155; mosaics, 126, 129, 158; *178*; Tyche of, 133; villa (A.D. 400), 173

Antiphilos (Greek painter), 27

Antonianos of Aphrodisias (Greek sculptor), 97; *107*

Antoninus Pius (138–61), 107–9; altar, 97, 115; *110*; column and temple of, see Rome; portraits, 107, 108, 109, 123; *127*

Antony, Mark (c. 43–30 B.C.), 42; portraits, 40–1

Aosta, cathedral treasury: Probus diptych, 166; *244*

Aphlad (oriental god), relief (Dura), 134

Aphrodisias, sculpture, 29, 58, 59, 92, 97, 115, 121, 168, 171, 172; *107, 258*

Aphrodite, statues (baths of Caracalla), 71; (Knidos), 173; (Ostia), 59

Apollo, representations of (Antinous as), 97; (Arles), 91; (Budapest), 48, 49; (Carthage), 48; (coin of L. Pomponius Molo), 15; (Constantine as), 162; (Corbridge *lanx*), 167; (Miletus), 114; (Naples), 147; (Piombino), 26; (Timarchides), 26; (Tripoli), 19; (Tuscan), 5

Apollodoros of Athens (Greek painter), 60

Apollodoros of Damascus (Greek architect), 82, 85, 90

Apollonios (Greek sculptor), 29–30

Aquila, Museo Aquilano: relief from Amiternum, 65; *60*

Aquileia
basilica, mosaics, 158; *217*; paintings, 156
coins, 164
funerary portraits, 48
mosaics, 55
relief from, 65
Triptolemus dish from, 50; *45*

Arcadius (394–403), 169; column and forum of, see Istanbul; portraits, 167, 168, 169, 170, 171; *250*

Arians, 163

Aristotle, 28, 45, 59, 160

Arkesilaos (Greek sculptor), 20, 28, 40

Arles, theatre, sculpture, 90–1; *97, 98*

'Arringatore' (Aules Metelis), statue from Perugia, 11

Arsinoe (queen of Ptolemy II), portrait, 49

Artemidoros (Greek sculptor), 26

Artemis of Ephesus, 16

Asia Minor, xx, 26, 67, 79, 90, 92–4, 97, 109, 114–15, 120, 121, 131, 134

Asiatic sarcophagi, 102, 104, 115, 123, 140, 142; *125*

F

G

H

INDEX

S